Jo Sonja's® Guide to Decorative Painting

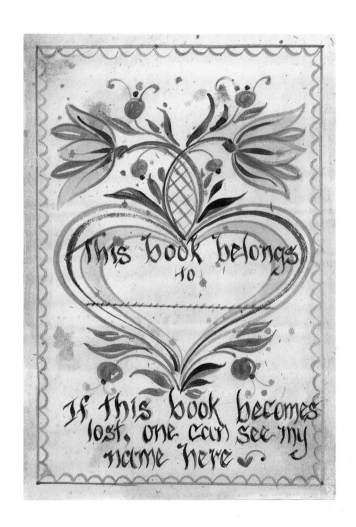

This book belongs to

If this book becomes lost, one can see my name here.

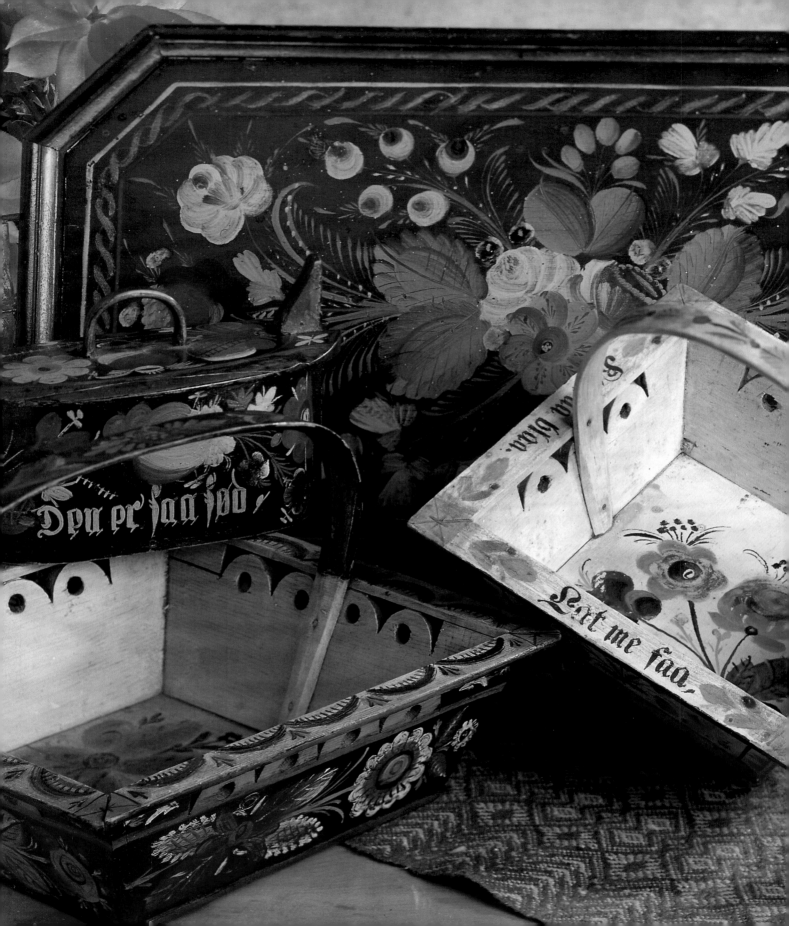

Jo Sonja's® Guide to Decorative Painting

Traditional Inspirations

Contemporary Expressions

Jo Sonja Jansen, MDA, VGM

WATSON-GUPTILL PUBLICATIONS/NEW YORK

On pages 2–3: Examples of the Os style of Norwegian rosemaling dated from the late 1800s to the early 1900s. See pages 158–163 for more information on this painting style.

Senior Editor: Candace Raney
Edited by Joy Aquilino
Designed by Areta Buk
Graphic production by Ellen Greene

Principal photography by Patrick J. Cudahy,
P.O. Box 4725, Arcata, California 95521.
The photographs on pages 115, 116, 122, and 123
are by David Jansen.

First published in 1999 by Watson-Guptill Publications,
a division of BPI Communications, Inc.,
1515 Broadway, New York, N.Y. 10036

Library of Congress Cataloging-in-Publication Data

Jansen, Jo Sonja.
 Jo Sonja's guide to decorative painting : traditional
inspirations/contemporary expressions / Jo Sonja Jansen.
 p. cm.
 Includes index.
 ISBN 0-8230-2562-4
 1. Painting. 2. Decoration and ornament. I. Title.
TT385.J39 1999
745.7'23—dc21 99-18469
 CIP

Manufactured in Italy

First printing, 1999

1 2 3 4 5 6 7 8 9 / 07 06 05 04 03 02 01 00 99

IN GRATITUDE

Is this a peculiar place to express appreciation and offer thanks? I think not, for I consider the entire work an expression of gratitude.

To my family and friends, especially my husband Jerry, my son Mark, Bill and Billie Colley, and Nathan Bush, for their loving support and encouragement.

To my business associates and professionals in related industries, for their contributions to and recognition of the art form.

To the staff at Watson-Guptill Publications—Candace, Joy, Areta, and Ellen—for the opportunity, encouragement, and help.

To the folk artists who began the tradition, and to the folk artists who will continue the tradition, may your endeavors bring you joy and remain a tribute to your faith in the human community.

Contents

3 Design and Color 44

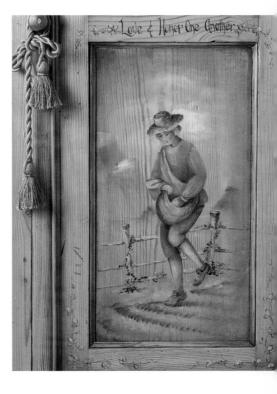

4 Working with a Brush 62

5 Essential Painting and Finishing Techniques 76

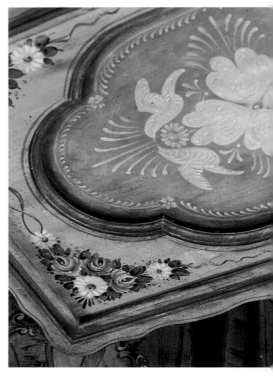

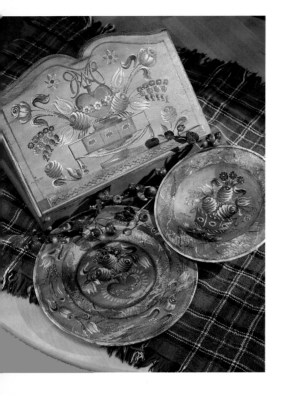

6 *Traditional Influences*

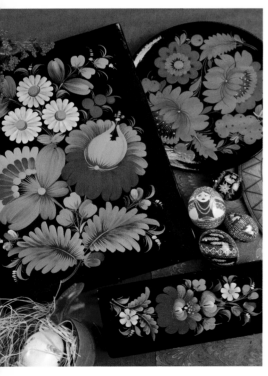

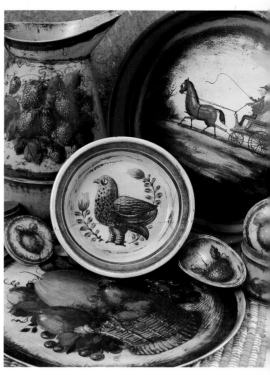
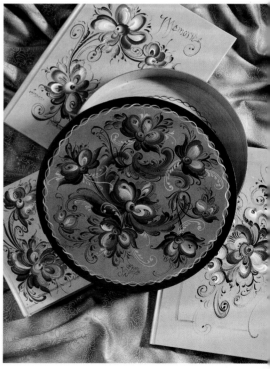

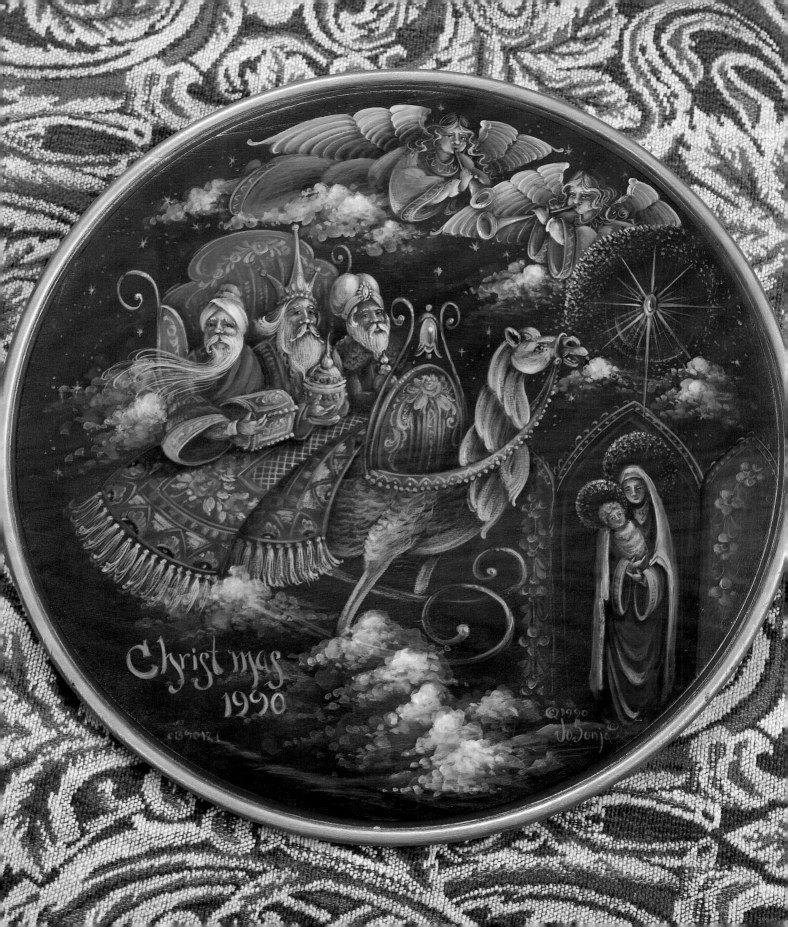

Christmas
1990

©1990
JoSonja

Introduction

A DEFINITION

The traditions, spirit, and character of the common folk have produced a unique form of artistic expression. Simply put, decorative painting is the work of artists who adorn objects rather than flat surfaces with paints and brushes, but this definition seems lacking when one considers that the best decorative painters have always been driven by a love of color and shape, as well as a creative urge equal to that of any "fine" artist. Although this style of art is primarily decorative, it reflects profound beliefs and feelings, which are frequently those of the group of people to whom the artist belongs rather than his or her own. In addition, decorative painting often incorporates symbols and lettering and may be influenced by major decorating trends.

In the United States, the term *folk art* has become virtually synonymous with primitive or tribal art, so American decorative artists are more apt to refer to their work as decorative art, for primitive it is not. True, you may see many "quick-stroke," mass-produced pieces at local street fairs, but these should not be confused with the works of more serious artists. In Europe, the beloved term for this type of decoration remains folk art—the art of the people.

CRAFT OR ART?

Perhaps you're wondering whether decorative painting is a craft or an art. This very complex question has no simple answer. As with any other creative endeavor, decorative painting includes examples that reveal a wide range of artists' interests, abilities, and painting skill. Some artists are clearly more adept than others, but that's true of any art form, and the appeal of a finished piece is really a matter of a viewer's individual preference. What, then, sets some pieces apart and causes viewers to look again, with an awareness of their singularity? Even an uninformed viewer can distinguish between a unique, well-done landscape and an "assembly-line" landscape sold by a sidewalk vendor who turns out dozens of copies purely for quick profit.

I think it's impossible to answer the question of "craft or art?" without considering a work's intent. Certainly many mass-produced objects are not only beautiful but reflect great technical skill, and their method of production makes reasonably priced items available to a broad segment of consumers. But special attention must be given to those items that express significant creative effort because they tell a story, record an event, signify love or friendship, teach a spiritual lesson, or recall special times. These objects have extraordinary appeal, and their personal content confers on them a certain prestige, no matter what the artist's degree of skill. Because some of these pieces exude a special quality that provokes an enthusiastic response and an awareness of their allure from their viewers, they must be considered as works of art. I suppose that some critics and intellectuals will always fumble around with painted objects, reserving the term "art" for work that is done on canvas, while you and I can simply decide on our own terms whether an artistic endeavor merits special attention.

A BRIEF HISTORY

Many attempts have been made to explain the origins of decorative painting, though it could be said that the human urge to decorate interior environments is evident even in cave paintings.

Of great influence has been the early Christian or "church" art, frescoes that were first found in the Roman catacombs. This form of decoration was continued throughout Europe, and can still be seen in various regional churches. The paintings, many of which depict Bible stories, were of great importance to the multitudes who could not read. Since most people lived in tiny homes with no chimneys, the accumulation of soot defied wall decoration. The painted walls and ceilings of even the smallest church must have seemed marvelous indeed!

In Europe during the Middle Ages, painters joined together to form local guilds that controlled not only the sale and distribution of artworks but also set standards of quality for their members.

(Opposite) I painted this Christmas plate for the cover of our 1990 Christmas journal, *Painted Sleighs*. I began by sketching some ideas right on the surface so that I wouldn't hamper the spontaneity of my thoughts. I like to slip subtle surprises into my paintings, and in this piece I devised a camel sleigh powered by a magic carpet to integrate the biblical story of the birth of Christ with an element of the European Christmas tradition.

As the power and influence of the guilds grew, it was not uncommon for laws to be passed that prohibited nonguild members from painting their own items. Because individual expression was largely limited to guild-sanctioned activity, there was little evidence of "country painting" or folk-decorated items until the late 1600s and early 1700s, when protectionist legislation began to be repealed and decorative painting could be enjoyed by the common folk.

Decorative painting's more recent roots can be traced to the styles of folk art that developed at that time. Early attempts by untutored artists were usually very primitive, but as they gained experience and expanded their design awareness, they produced many fine examples of very creative work. Because many early works were unsigned and the names of the artists forgotten, it is common practice today to identify styles by region, such as Alpbach (Austrian) or Telemark rosemaling (Norwegian), but each piece represents the work and style of an individual. If a particular individual's work became popular, it was copied by many others in the area, or if the individual taught others to paint, the amount of work in his or her style could dominate. Almost every folk artist developed his or her own personal style, so that today a scholar can identify the hand that produced them even though the pieces are unsigned.

This explosion of country painting was to last until the mid-1800s, when industrialization and commercialism accelerated the decline of handicrafts, and decorative painting began to die out. With the advent of the Industrial Age, people sought the modern, the commercially produced. It must be noted, however, that after nearly 200 years, the work of many country painters had become too precise, heavy, and overdone. A once fresh, creative simplicity had been replaced by fussy, overworked, multihued creations of such complexity as to be almost impossible to enjoy in the average home.

Luckily, painted decoration did not disappear completely, but it had languished to the point that when interest in decorative arts began to revive during the 1940s and 1950s, the old traditions had nearly been lost. Many early attempts at decorative painting in this country consisted of traditional fine-art techniques applied to objects. It took more research and study to discover the beautiful stroke-oriented styles of our folk-art forebears.

A DUAL FOUNDATION: STUDYING THE PAST, ATTAINING TECHNICAL KNOWLEDGE

The attempt to document some of these early styles became a focal point of my initial interest in decorative painting. I studied each style as the opportunity arose, as there was almost no printed information available to the general public at that time. People generously brought me their family heirlooms and took slides of pieces here and abroad, especially European examples.

Many people expressed a desire to study these works with me, and what better way is there to record and preserve the heritage? We began by studying the old and, quite frankly, copying some of the more interesting and important techniques. A range of skill levels can be developed through such a course of study, with some artists finally achieving a high level of brush control through dedicated perseverance. Many go on to develop a unique personal style, which is in keeping with the true spirit of the art form.

As the works of the impressionists prove, individual experience unfettered by rigid rules can lead to many wonderful creative expressions. But creativity without a proper technical foundation or an unskilled knowledge of materials can lead to works that do not withstand use or time, problems that are encountered time and again by many collectors and conservators. While it is possible to enjoy the freedom and spontaneity of unencumbered creativity, a solid understanding of the use of materials and techniques is necessary for a decorative artist's success.

The renewed interest in the origins of decorative painting has resulted in the establishment of many "open-air museums"—historically accurate recreations of entire villages—and small private collections throughout Europe. As these collections grow and interest in the origins of folk art expands, more individuals are researching the lives of the early folk artists. This important research is helping to raise an awareness of each painting style's unique appeal.

Armed, as it were, with such a foundation, we can begin to explore new ideas and techniques in a more intelligent manner, in the hope that more of our undertakings will be successful and stand the test of time. For while we might wish to intrigue admirers today, don't we all hope that some of our efforts will survive for generations to become heirlooms?

ABOUT THIS BOOK

Jo Sonja's Guide to Decorative Painting is about painting that decorates, that is stylized rather than realistic, and that acknowledges the shape and dimension of the painting surface in the composition's design. I'd like to introduce you to the art form, show you how it differs from fine-art painting, and give you a little bit of its history as we know it today.

As you look through these pages and begin to understand some of the techniques, please note that the study pages I've painted were done with a sincere desire to record the old and acknowledge the contributions of our predecessors, but that my stylistic preferences are nonetheless evident; I've been painting too many years for them not to be. The ultimate goals of studying the art form are to gain an understanding of it, then to contribute our own personal style to its continuation.

For me, what began as an interest became a passion; what began as a hobby eventually became a small family business. The interest in decorative painting continues to grow as many people turn again to handcrafted items with a renewed appreciation of their worth. My work is that of an artist who simply loves to decorate, who prefers the challenges of dimensional items rather than a flat canvas, and who has found great satisfaction in sharing this art with others. I owe my family, friends, and hundreds of supporting artists my deepest gratitude for the opportunity to share and for continued support and encouragement over the years. If you find the journey through these pages enjoyable and informative, then the effort has been worthwhile and this decorative artist is grateful.

1 Gathering Your Materials

Artists today have an unprecedented variety of materials available to them with which to express their creativity. This book is written so that the theory and practice of decorative painting can be adapted to the medium you prefer, whether acrylics or oils.

Many teachers feel that before beginners can successfully navigate the creative aspects of decorative painting, they must learn about and understand its craft aspects, which include how to assess the quality of paints and brushes, how to choose a medium for a special technique, and how to select an appropriate finish for a painted object. The answers to these kinds of questions need to be addressed as they arise, so that developing artists can build a knowledgeable foundation upon which their creativity can flourish with confidence.

In this book, we begin with decorative painting's craft aspects, progressing in a logical fashion, touching on as many of the old techniques as possible, but with a newer, more creative approach to design and color. The goal is to encourage you to begin your search for self-expression much sooner.

Paints and Pigments

A *pigment* is a coloring agent that, when properly ground, can be used to impart color to a surface. Suspending pigment in a liquid makes it much easier to apply and far more likely to adhere well to a surface. This liquid is called a *vehicle,* which has two ingredients: the *binder,* which eventually forms the basis of the dried paint film, and the *solvent,* which controls the binder's consistency while it is liquid and evaporates so that the binder and pigment will cure to a hard finish.

Though many kinds of paint can be used for decorative painting, acrylic paints and oil paints are the most widely used. How are they different? The pigments that are used to color them are same, but their binders and solvents are very different, which in turn affects how each one responds during the painting process. Take oil paint, for example: Because its binder (usually linseed oil) is slow-drying, and its solvent (either gum turpentine or mineral spirits) evaporates relatively slowly, oil paint has a long "open" or working time. This attribute allows plenty of time to blend and fine-tune the paint, but it may also mean a long wait between steps. By contrast, acrylic paints, which contain a synthetic polymer resin binder and water as a solvent, dry very quickly, in as little as 15 to 30 minutes. This characteristic suits them to layering, with each layer of paint being allowed to dry before the next is applied.

COMPATIBILITY
Thanks to various technological advances (see "Working with Paint Mediums," page 18), acrylics can be used in much the same way as oils. Nevertheless, oils and acrylics are not compatible: They must NEVER be combined, and acrylics should NEVER be applied over an oil-painted surface, or the paint film will not adhere to the surface properly. Oils can be used over acrylics—keep in mind the old artist's rule "fat over lean," which means that oil-based paints can be applied over water-based paints— but acrylics can't be used over oils. Some

manufacturers of water-based varnish claim that their products can be used over oil paints, but I've never found this combination to have long-term permanence.

HEALTH AND SAFETY
Generally speaking, the type of paint that an artist first learns to paint with is the one that he or she tends to like best. Many artists who began painting with oils find it almost impossible to switch to acrylics unless they are forced to for health reasons (gum turpentine is known to cause skin allergies, and prolonged inhalation can cause lung damage). While it is true that someone can develop a sensitivity to any substance, whether it is used with oils or acrylics, fewer people seem to have health problems with good-quality acrylic paints. Perhaps this is due to the simple fact that water is the only necessary solvent for acrylics, but even here problems can arise, since water can harbor mold.

Another important safety consideration for oil painters is the flammability of its solvents. Rags soaked in linseed oil are highly flammable at room temperature. A friend of mine went to answer the telephone during a painting session, and when she returned, the trunk she had been working on was on fire, set aflame by a linseed oil–soaked rag that combusted spontaneously. Consult your local fire department for advice on handling and disposing of these materials.

Some pigments are also potentially hazardous. The fumes of cadmium pigments—reds, yellows, and oranges—are toxic, and therefore should not be inhaled; special precautions should be taken when they are airbrushed or sanded. Also, rags that have been used with cadmium pigments should NEVER be burned. As mentioned above, all soiled rags, solvents, and rinse water must be disposed of safely; consult your municipal authority for local regulations. Because I work with acrylic paints, the flowers in my garden can enjoy the rinse water from my painting sessions—

they thrive on minerals! (I avoid working with the cadmium pigments, which require special handling and disposal.)

CHOOSING YOUR PAINTS

Start with just a few colors—red, blue, yellow, black, and white. Learn how to mix colors instead of buying premixed paints. Experiment on backgrounds of various colors to see how they affect your palette colors, perhaps making toning or a reduction in intensity necessary (see page 53). Also, test each paint to see whether its pigment is transparent or opaque; this will tell you which painting techniques it is best suited for.

To create the paintings shown in this book, I used Jo Sonja's Artist's Gouaches and mediums, which are manufactured by Chroma Acrylics. The term *gouache* (pronounced GWASH) refers to a type of opaque watercolor paint. Traditional gouache has good handling properties and coverage, but its brittle binder undermines its long-term durability. The acrylic version enables artists to enjoy the positive attributes of traditional gouache along with the durability of a high-quality acrylic binder.

It's important for artists to educate themselves about pigments. Start by reading the labels on your paints. In addition to toxicity and lightfastness ratings, the labels indicate pigment composition so that consumers can make informed choices. As you add a new color to your palette, question its quality. Cheaper paints usually contain less pigment, less durable binders, and cheaper solvents.

Decorative artists typically use traditional artists' pigments as well as some pigment "blends" or "fashion colors." Artists' pigment names are fairly standard throughout the paint industry, though slight variations in color occur among paints made by different companies because they obtain their pigments from different sources. Because so-called fashion colors are mixtures of various pigments, there is no standardization, either of names or colors. In order to help readers obtain or mix similar colors, I've included a small swatch of each color that is used to paint the various regional and historical styles demonstrated in this book; however, note that because color reproduction technology is not entirely accurate, the colors should be considered approximate.

A full exploration of the physical aspects of paints and pigments is beyond the scope of this book. Because paint technology is continually evolving, it is possible to spend years researching these subjects in depth. More information can be obtained by investigating the suggested readings listed on page 284. Regardless of which brand or formulation of paint you use, always use them safely and cleanly so that you can enjoy your painting experience for many years to come.

Working with Paint Mediums

When you begin to work with your paints, you should think of them as basic color choices. For ease of application, your color choices come already mixed with a binder and a little solvent. You can use each color choice in one of two ways: either as is, straight from the tube; or as a sort of "concentrate" whose consistency and working characteristics can be modified with the addition of a compatible substance. Such substances are called *mediums*.

The medium you use will depend on how you want your color to perform. If you're working with acrylic paints and you want to make transparent strokes that hold firm edges, you would use gel medium or Kleister Medium. If you want to extend your paint's "open" time, perhaps so that you can blend other colors into it, you would use retarder for acrylic paints and linseed oil for oil paints. A medium can also increase a paint's durability, which is especially important for functional pieces.

As is the case with so many other art materials, the quality and purpose of paint mediums vary greatly among manufacturers, so that generalizations about any one category of medium can be misleading. Before you use one of the products described below, carefully read through the technical literature provided by the manufacturer. If you need additional information, you should contact the manufacturer directly. Many manufacturers set up toll-free numbers and Web sites so that they can answer their customers' questions.

Also, I recommend that you use mediums that are formulated specifically for the brand of paints you use, since intermixing brands may yield inferior results. All of the mediums I use are made by Chroma Acrylics, which also manufactures the line of acrylic paints I prefer.

When you're working with a paint medium, it's a good idea to place a small amount of it in a small container (like a bottle cap) on one corner of your palette so that it's easily accessible. You can also combine some mediums with your paints by using the following techniques:

- You can use a palette knife to mix it into a puddle of paint on a dry area of your paper palette before storing the mixture on your wet palette (see page 28).
- You can mix it into the paint as you dress the brush (page 65).
- You can brush it over the painting surface, then apply color on top of it (see "Retarding a Surface," page 79).

Don't try to save old paint mediums that have been sitting out on your palette. Usually enough oxidation has occurred to affect their binding abilities. One exception is retarder, which can be kept out and open for weeks.

MEDIUMS FOR ACRYLICS

The consistency and translucency of acrylic paints can be manipulated with many different mediums, each of which produces a specific effect. By working on projects and experimenting, you'll begin to develop favorites. Local climatic conditions will also affect your choices.

- *Water.* Water is added to acrylic paint to increase its fluidity and translucency. Water is the most economical medium for acrylics, but it has some drawbacks. To begin with, it may contain impurities such as molds or minerals that could contaminate the paint. Also, acrylics thinned with water will raise the grain of, or roughen, a wood surface. (Note that technological advances have eliminated some of the problems of earlier acrylic paint formulations, so that good-quality acrylics that haven't been diluted with water won't affect the grain of wood any more than oil paints will.) Finally, thinning acrylics with water to make the paint film more translucent can reduce the proportion of binder. If you experience problems with regards to this, make sure you also use a paint medium that will build up the ratio of binder to color to ensure proper adhesion. For all these reasons, Flow Medium and Clear Glaze Medium are preferable alternatives for thinning acrylics.

- *Flow Medium.* A medium of choice for hot and/or dry climates because it increases the fluidity or flow of the paint so that brushstrokes are less visible when basecoating. This product is also excellent for thinning acrylics for airbrushing.

- *Retarder.* Use a retarder when you want to extend the drying time of your paints so that you have more time to work with them. Staining, glazing, blending, and a variety of faux finishes are just some of the techniques that would benefit from the addition of retarder.

- *All Purpose Sealer.* This is a highly durable preparatory sealer for wood and metal. It seals wood surfaces so completely that they become impervious to stain. All Purpose Sealer is also a very good adhesive, and may be used to glue fabric, lace, paper, and other materials to a painting surface. When mixed with tube paints or background colors, it creates a one-step paint that seals and basecoats in

a single application (see page 35). It seems that every paint company makes a sealer, but they vary greatly in performance.

- *Clear Glaze Medium.* Referred to generically as matte medium, Clear Glaze Medium is somewhat similar to All Purpose Sealer, but wood can be stained through it, allowing you to control the depth of the stain more easily. Commonly used as a protective "barrier coat" between layers of paint (see page 78), it is used to build depth within the layers of the paint film, heightening its translucency. It is especially effective with transparent colors. It can also be mixed with paint to make it more fluid for various brushstroke techniques. Clear Glaze Medium can be added to paint to make a one-step basecoat, but it does not form as impenetrable a paint film as All Purpose Sealer.

- *Kleister Medium.* Thicker and more gel-like than either All Purpose Sealer or Clear Glaze Medium, Kleister Medium (also called

Paint mediums give artists more creative options, as they increase the versatility of paints.

gel medium) has much longer drying and cure times than either product. When it is added to acrylics, it produces translucency and texture, so that they can be manipulated to create interesting faux finish effects. For more information, see "Kleister Painting," page 89.

- *Texture Paste.* This medium, which is also known as texture medium, can be used to build a variety of textured effects, depending on how it is used. It can be used alone to provide a translucent textured ground or to adhere objects such as seashells or pottery shards to a painting surface. When mixed with paint, it can be used to create a one-step textured basecoat, highly textured stroke-painting effects, or act as a sort of filler for a rough wood surface.

- *Varnish.* Like All Purpose Sealer, a good-quality acrylic varnish can be added to tube color to increase its fluidity as well as the hardness and durability of the paint film.

MEDIUMS FOR OILS

The traditional paint medium for oils is boiled linseed oil, which can be purchased at hardware stores and art supply stores. Don't buy raw linseed oil and boil it yourself—it's highly combustible—buy it already boiled. There are other commercially prepared oil mediums available as well, some of which are known as *fat mediums,* which indicates that they contain more oil, or fat, than solvent. Have fun investigating their possibilities. Experience has taught us that mixing different brands may produce inferior results, so only use mediums that are made by the manufacturer of the brand of oil paint you use.

You can mix a painting medium that is more durable than just plain linseed oil by combining 2 parts McCloskey's Heirloom Varnish with 2 parts mineral spirits and 1 part boiled linseed oil. Mix only a small amount at a time—just 2 to 4 ounces—and store it in a small bottle. Note that a heavy cloudiness or curdling indicates an adverse chemical reaction, usually an incompatibility between the varnish and the mineral spirits. If this occurs, discard the mixture and try a different brand of mineral spirits. A small amount of sediment is all right, probably due to additives in the varnish. Just shake the mixture well before using it. Your medium should always feel nice and oily, not sticky or gummy, as this will affect blending.

If you make your own oil paint mediums and incorporate mineral spirits or other thinners into the mix, keep in mind that each layer of an oil painting must contain more oil than solvent in order to ensure proper adhesion.

Before you use an oil paint medium, always investigate potential health hazards. Never ask a salesperson to recommend his or her company's products. Instead, depend on research reports conducted by consumer groups or testing by independent laboratories.

Choosing Your Brushes

When choosing your art materials, you should always buy the highest quality that your budget will allow, a guideline that is especially important when selecting paintbrushes. There's no point in purchasing the best paints if you'll be applying them with poor-quality brushes (or with brushes that haven't been cared for properly), since inferior tools almost always produce inferior results.

How do you choose from among the overwhelming assortment of brushes on the market? Good brushes are expensive, so you'll want to spend your money wisely. The following is a crash course in brush basics that will help make you an educated consumer.

ANATOMY OF A BRUSH

Every brush has three components. A brush *handle* can be either long or short; generally speaking, short-handled brushes are better for decorative painting because they allow for tighter control and facilitate the rendering of fine detail. The *ferrule,* which is usually made of metal, attaches the brush's hairs to the handle and holds them in a particular shape.

The *hairs* are the most important part of a brush. Natural hairs can be either soft (sable, squirrel, or goat, for example) or stiff (like boar); stiff hairs are also called bristles. Synthetic hairs are made from manmade fibers such as polyester or nylon. (Taklon is a brand of synthetic fiber used to make paintbrushes.) Brushes can be made from either natural or synthetic hairs, or a combination of the two.

SHAPES AND SIZES

The shape of the ferrule, which can be either cylindrical or flat, gives the collection of hairs part of their shape. Brushes with cylindrical ferrules are called *rounds,* while those with flat ferrules are known as *flats.*

Rounds. The traditional brush of the folk artist is the round brush, probably because it was the easiest to make: You could snare a badger, or cut some bristles off a pig, or out of an ox's ear, pull them through a hollow goose quill, glue and tie them to a fairly straight stick and, voilà—you had a brush. True, this is a bit of an oversimplification—the ox just might object to having the hair cut out of his ear, and you would have to catch the pig first—but the fact remains that the round brush was the easiest to make. Several brushes fall into this category, including rounds, detailers, liners, and deerfoot stipplers.

- *Basic round.* There are actually many different types of "basic" round brushes; each is designed to fulfill a particular role. The selection of special individual tapered hairs for a round brush provides a shape that is wider near the ferrule and tapers gently to a very fine tip.

- *Detailer.* A handmade round with very select tapering hairs that is used to paint fine details. This brush has a very full "belly," or midsection, and a very fine long tip.

- *Liner.* A long, thin round brush. With few exceptions (those designed for rendering specific styles of lettering), its hairs should taper to a fine point. There are several lengths available; the longest is called a *script liner.* Another type, the *striper,* which has a knifelike shape, is used to paint pinstripes and decorative lines.

- *Deerfoot stippler.* The hairs of this brush are cut at a gentle angle. It can be used for stipple blending and stenciling.

- *Mop.* The domed shape of this large, fuzzy soft brush fits well into corners and nooks, making it perfect for applying and softening glazes.

Flats. There are several types of flat brushes, including flats, brights, and filberts or cat's tongues.

- *Basic flat.* Standard flat brushes appear narrow when seen from the side and wide from the front, though their width and thickness varies, depending on size. The hairs should be fuller at the ferrule and taper to a nice, even chisel edge. The basic flat is just the right length for strokework.

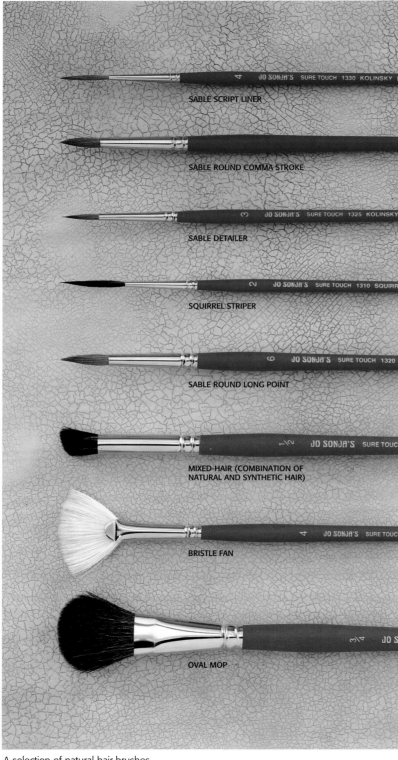

A selection of natural-hair brushes.

- *Bright.* This type of flat, which has shorter hairs, is preferred by some artists for blending.
- *Filbert or cat's tongue.* The tip of this brush is oval or dome-shaped, appearing wide from the front and narrow from the side. Its individual tapering hairs are wider at the ferrule, then narrow uniformly to a nice chisel edge.

Brush sizes can be perplexing, especially for a beginning artist. Good-quality artists' brushes are generally produced in series, or lines, each of which is designed for a specific painting task. Within each series, the brushes are made in a range of sizes, from very small to large, and each brush is identified with a number, with the smallest brushes assigned the lowest numbers. (In series of larger brushes, each one is identified by its width in inches.) It's important to note that sizes and numbering systems are not uniform among brush manufacturers. For example, a no. 8 natural-hair flat brush designed for blending oil paints from one company may not be the same size or length as a similar brush made by another company.

MAKING A SELECTION

The misconception that synthetic brushes should only be used with acrylics and natural-hair brushes only with oils probably arose because some artists don't clean their brushes very well. I've been using expensive sable brushes with acrylics for over 20 years and have never wrecked a brush, and I don't even clean my brushes very often during a painting session, as I prefer to work with "dirty" brushes when blending. What's my secret? In addition to always using paints of the highest quality, when I work with fast-drying paints I keep the brush moving—load and paint, load and paint. When I stop actively working with a brush, I rinse it out well. If I don't plan to use a brush for a period of time, I dip it in a little retarder or stop and wash it out with soap and water.

Fine-quality brushes were originally made to be used with water-based media—such as watercolors, casein, egg tempera, and pottery glazes—which were used long before oil paints were developed and synthetic brushes were available. Quality products and proper use and care are the definitive variables. I would never use an expensive sable brush with a poor-quality

paint, whose less expensive and sometimes gummy binders could possibly ruin it.

There is one exception: Boar or hog bristle brushes do soften with prolonged use in water-based media, so for specialized techniques in which a bristle brush is more suitable (such as stenciling), thin water-based paints with retarder instead of water. Retarder won't soften the bristles as quickly as water will, and the brush can be used for extended painting sessions. After a good wash and dry, the bristles will regain their original body, just like your hair after a shampoo.

There is one further consideration that should be mentioned concerning brush selection: An animal did have to die in order for a natural-hair brush to be made. If this point is important to you, be assured that superior-quality synthetic brushes are available. Cost is determined by the quality of the synthetic fiber and the method of production (whether hand- or machine-made).

When shopping for any brush, you should evaluate its *spring*. This term means that a brush will respond as you exert pressure on it, then bounce or spring back gently as you release pressure. A brush should have enough spring so that you only need to load about half the length of its hairs to make a complete stroke. Art supply stores that are familiar with the needs of decorative artists will allow you to test a brush by using only water to make strokes.

For Starters. A brush kit that comprises just a few essential shapes and sizes will start you on the right track.

- *No. 3 or 4 round.* The hairs of this brush should have a moderately firm touch. Avoid softer rounds until you acquire some brush control and begin to develop an individual style. Also avoid rounds that have short "filler" hairs, which stick out when strokes are pulled and cause unsightly marks that detract from their flow or movement.

- *No. 2 liner.* Choose one that isn't too thin; it should be large and full enough to hold a generous amount of paint so that you don't have to constantly reload it. Less spring is desirable for this brush, especially if you use it to paint scrolls, squiggles, and swirls.

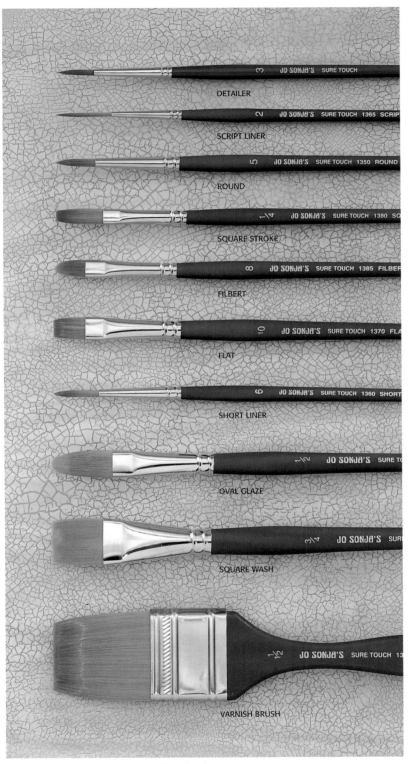

An assortment of synthetic-fiber (Taklon) brushes.

23

- *No. 6 flat or filbert.* Some decorative painters favor these brushes, which should have a moderately firm touch, over the basic round. If you do, you'll want a no. 4 and a no. 8, and possibly other sizes. These flat brushes are easier to sideload than rounds (see page 71) but wear out faster because their hairs are shorter. When choosing one of these brushes, make sure there are no short filler hairs. Also, a filbert shouldn't be so thick that it's hard to clean, but it should be thick enough to give it the proper resiliency for the consistency of the paint you wish to use.

- *1-inch flat.* Use this large "workhorse" brush for jobs like basecoating, varnishing, and applying paint mediums until you can afford some specialty brushes (see below). The hairs should have a firm touch—and the longer the hairs are, the longer the brush's life.

Specialty Brushes. You can supplement your basic kit with these brushes when your budget permits.

- *No. 2 or 3 striper.* Although a liner can do most of the work that a striper is designed to do, the striper holds more paint, resulting in a more professional line with fewer breaks. You can stripe an entire large trunk or chest in about 5 to 10 minutes with this brush. Your striper will probably last your entire life, so choose it well and carefully.

- *1/2-, 3/4-, or 1-inch mop.* Use this brush dry, then wash it and allow it to dry fuzzy. (A wornout no. 10 or 12 filbert is a good substitute.)

- *1-, 1 1/2- or 2-inch varnish brush.* Use the 1-inch for small items, and the 1 1/2- or 2-inch for furniture. As for the 1-inch flat, longer hairs mean a longer life. This brush is expensive, but it will last for years with proper care.

Your collection will grow over the years as you search for the "perfect" brush. Happy hunting! It's part of the fun.

ESSENTIALS OF BRUSH CARE

Without a doubt, taking good care of your brushes will extend their life and yield a return on your investment. Most of the brushes I've used have lasted 4 or 5 years, and I paint with them almost every day.

When you buy a new brush, wash it with soap and warm water to remove the packing material with which the hairs are shaped. If you work in acrylics you can use your new brush right away; if you work in oils, shape the hairs with a little soap and let them dry before using the brush for the first time.

Treat your brushes gently. If a brush loses short hairs, you might be cleaning it too roughly and cutting off hairs at the ferrule. However, a brush that loses long hairs might be defective— it might not have been glued or tied properly at the factory.

Below are some guidelines for cleaning and caring for your brushes.

Brushes Used with Acrylic Paints. Wash dirty brushes with soap and lukewarm to cool water; rinse well. Dress the hairs with soap, shape them, then store the brushes so that the hairs aren't bent or crushed. (Never leave the hairs unshaped after cleaning a brush.) Simply rinse the hairs and your brushes are ready for painting. Note that some artists dress their brushes with retarder before storing them, because retarder prevents any paint residue from hardening near ferrule, where a buildup of paint can wreck a brush.

Change your rinse water frequently (water that is too soapy can affect the durability of your paints), and wash your brushes with soap several times during a painting session, as needed. You'll quickly learn that when a brush doesn't respond the way it should it probably needs cleaning.

Brushes Used with Oil Paints. Clean dirty brushes in mineral oil or baby oil, wipe the hairs well on a clean rag, then rinse them in a container of mineral spirits. Wipe the hairs again, dress them with mineral oil or baby oil, return them to their original shape, then store the brushes so that the hairs aren't bent or crushed. (Never leave the hairs unshaped after cleaning a brush.) Before using the brush, rinse the hairs in mineral spirits and blot them on a clean rag.

Keeping mineral spirits clean is another way of extending the life of your brushes. Allow the pigments to settle at the bottom of the container, then carefully pour off the clean mineral spirits into another clean container for reuse.

Other Supplies

In addition to your paints, a compatible medium, and a basic set of brushes, you'll need the following tools and supplies to create your art.

FOR ACRYLICS

- *Water jar.* A recycled, clean jam jar is a good choice for holding water for rinsing your brushes.
- *Isopropyl alcohol (optional).* Available at most drug stores and supermarkets, isopropyl alcohol can be used to remove dried acrylic paints from surfaces and to create some interesting decorative effects. (See "Tortoiseshell," page 95.)
- *Small, shallow plastic container with cover.* You'll need one of these to make a wet palette for your acrylic paints (see page 28). The trays that many frozen TV dinners are served in would be just right for this purpose.

FOR OILS

- *Mineral spirits.* This product is used as a cleansing rinse for dirty brushes. Keep the container covered when not in use. If needed, keep a small covered container clean at hand.
- *Mineral or baby oil.* Either of these oils can be used to clean oil paint out of dirty brushes and off hands, and to dress clean brushes before storage.
- *Oil-based varnish.* Oil-based varnish is the only finish recommended for oil paints.

PROJECT NECESSITIES

The following items are absolute essentials, many of which you may already have on hand. To save precious time, I like to make sure they're all in one place so they're always easy to find and readily available.

- *Sandpaper in various grits.* Keep a small piece (about 2 to 4 inches square) of #200- to #250-grit and #300- to #400-grit sandpaper on hand for touch-ups.
- *Fine synthetic wood finishing pad.* Safer than steel wool, this item is used for sanding touch-ups and special techniques.
- *Stenographite.* This product, which comes in gray and white, is used to transfer designs to the painting surface. (See "Transferring a Design," page 51.)
- *Stylus.* Use this tool to imprint designs when making transfers.
- *Pencil, chalk, or soapstone pencil.* Sketch your designs and/or indicate the positions of motifs and borders with these implements.
- *Ruler.* Use a ruler as a guide to accurately position motifs and other design elements.
- *Rags or paper towels.* Use these to clean up spills, to blot brushes and surfaces, and to make a blotter pad for a wet palette (see page 28).
- *Brush holder.* A small jar can serve as a holder for extra brushes.
- *Palette knife.* This tool is used to mix paints and mediums.
- *"Dry" palette.* Use either a disposable paper palette pad or a plain ceramic plate to mix colors and dress brushes. With the former, you can just tear off the top sheet when you've finished a painting session, or whenever you need a clean palette.
- *Bottle lids.* You'll need two or three of these to hold mediums while you're painting.
- *Film canisters.* Use recycled film canisters to store leftover bits of mixed colors on a long-term basis.
- *Sea sponge.* A variety of faux finish techniques require a sea sponge, so you'll need to keep a small piece on hand.

TOOLS FOR PLANNING DESIGNS

Make sure the following items are readily available so you can record your ideas as they come to you. I try to remember my ideas when I don't have a pencil and a piece of paper handy, but I invariably forget them. Let no thought be fleeting—jot it down in your sketchbook!

- *Sketchbook.* You must have a sketchbook. Its size, its feel in your hands, the weight and tone of its paper, and the way your pencil touches it will all influence your creativity level, so choose it carefully. You'll enjoy sketching more if you like the feel and response of the paper you've chosen.

- *Pencils for sketching.* I have a drawer full of artists' pencils—all unused. Every time a new pencil or charcoal comes out it must be purchased. How else can you become an artist? My favorite pencils for drawing are two cheaper ordinary everyday pencils, one with a dark soft lead and one with a hard lead. What about the drawer of pencils? Maybe you need one, too. At least it looks good when you leave the art supply store with a new purchase.

- *Eraser.* Since you'll most likely want to make adjustments to your sketches (and transfers), an eraser is absolutely essential. If you don't have a separate eraser, be sure you at least have one on your pencil. There are many types of erasers available, but after years of experimenting with different brands, I've gone back to the simple Pink Pearl eraser. I especially like the inexpensive one that fits over the end of my pencil; that way, I never have to look for it. Hooray!

- *Practice board.* Prepare a practice surface for developing your brushstroke skills and for working out color schemes. I like to work on a 140-lb. hot-pressed Arches watercolor block. The papers are held securely against a heavy backing and can be removed when dried. You can also basecoat a stiff, thick piece of cardboard, Masonite, or thin plywood cut to 8½ by 11 or 9 by 12 inches; that way, you'll be able to save the good ones in your file.

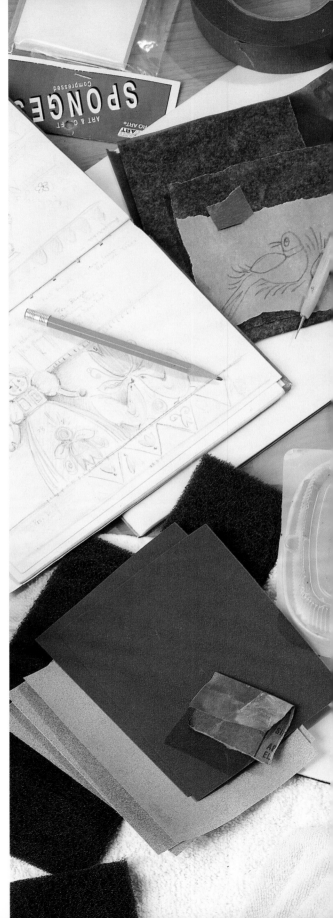

Some of the things a well-equipped decorative painter needs to practice his or her craft.

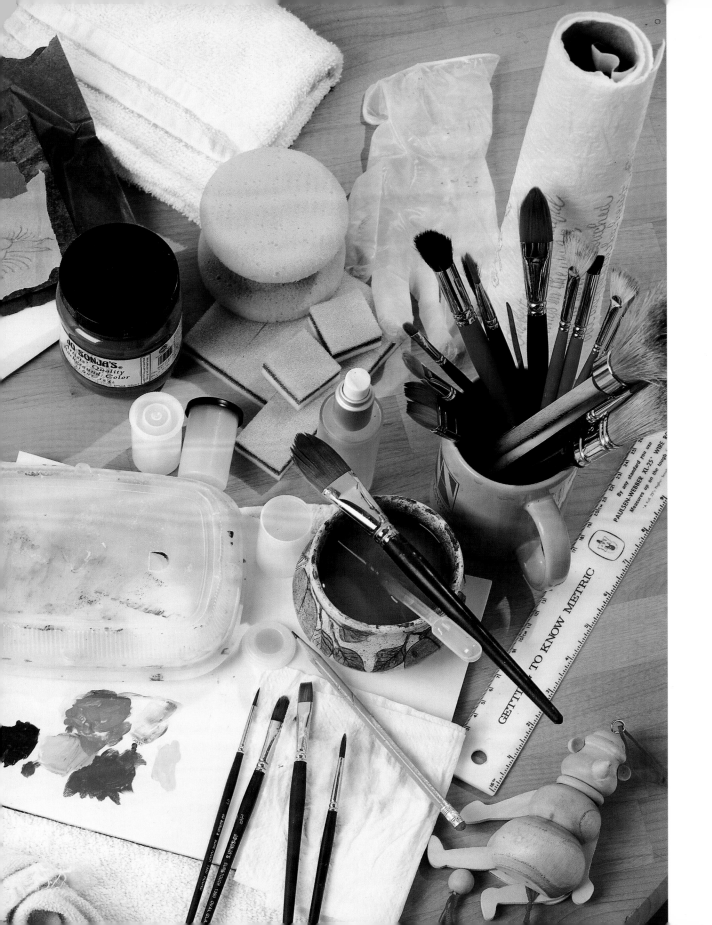

Your Painting Area and Palette

A highly personalized, precious place needs to be reserved for your painting area. This is a small space set aside only for you, a place where you can go and paint, paint, paint, and paint. It may be a rolltop desk or cupboard that you can close in order to hide the mess, or it may be a desktop or table—whatever works for you. Begin by placing your essentials around you in an organized way. Minimize the clutter.

I once read that if you wish to paint beautiful things, you must surround yourself with beauty. With this principle in mind, I put my paint tubes in a beautifully decorated French cachepot, my brushes in a ceramic rabbit, and my rinse water in a special ceramic piece. I paint at an antique French desk, sitting in an antique carved chair, with one or two puppies asleep on my foot. It's taken me years to get things just right, though I frequently change the look of the area by cleaning it up and refreshing a few things. It's a spot I love to go to, a place where I can refresh my spirit, a healing and creative place. We all need such a place. In fact, the busier your life is, the more you need it.

A PALETTE FOR ACRYLICS

Acrylics really need two palettes: a wet palette for storing paints and a bottle lid of medium, and a dry palette for mixing colors and loading brushes. A wet palette is the most important time-saving idea for painting with acrylics because it eliminates the need to set up paints all over again every time you want to paint. Now when I can find 10 or 15 minutes for myself, I go to my special painting spot, remove the lid from the wet palette, and paint.

To prepare the wet palette, begin by folding a single sheet of paper toweling so that it fits in a TV dinner or other small plastic tray that has a cover. (I prefer to use a rather small container for this purpose, one that occupies only a corner of the dry palette.) Pour clean water over the paper towel until it is soaked, then tip the tray and allow the excess water to run off until you only have a slow drip (about 1 drop every 2 seconds).

Squeeze out a small amount of each color on the wet paper towel. For ease of use, develop a systematic way of placing your colors on your palette; any way that appeals to you is fine. As long as the paper towel is wet, Jo Sonja Artist's Gouaches will stay usable. (Craft acrylics and traditional acrylic formulations will dry out more quickly.) To remoisten the paper towel, slowly pour a little clean water on it. If you're painting under very warm, dry conditions, you may have to rehydrate the paint by remoistening the paper towel, then covering the tray for 10 to 15 minutes—just enough time for a good coffee break! If needed, you can use a small spray bottle with a fine misting pattern to occasionally mist your paints with water while you're painting.

Following this method, I've used a wet palette for 2 to 3 months. Eventually, though, some mold will begin to grow, either on the paper towel or the paint, at which time a new palette has to be made. When this happens, discard the paints and paper towel; the tray may be reused by washing it, then rinsing it with vinegar or a mild Clorox solution. The development of mold has many variables, including the local climate, the number of mold spores in your water source or air, the length of time that the palette is left open, and the cleanliness of the container. If mold forms quickly, you can try to hamper its growth by using distilled instead of tap water, changing the filters in your heating system, using an air purifier, and giving the room in which your painting area is located a thorough cleaning.

Note that it's possible to save bits of mixed acrylic colors for touch-ups on a long-term basis. I've stored a tablespoon of paint in a plastic 35mm film canister for 6 years now, and it's still in perfect condition.

A PALETTE FOR OILS

Because traditional oils can remain "open" for weeks, a wet palette isn't necessary. Simply squeeze out a little of each color onto a surface that can be used for mixing, either a disposable paper palette or a ceramic plate. Organize your

colors in a way that makes sense to you, so that you can use and mix them easily. Cover the palette when you're not using it.

ORGANIZING YOUR PAINTING AREA

Spread a clean hand towel over your work surface, then place your palette setup on one corner of your towel, on the right for righties and the left for lefties. Arrange whatever else you need—a water container for acrylics, a small container of mineral spirits for oils, any mediums you're using, paper towels or rags—in close proximity.

If you're working in oils, leave the lid on the mineral spirits until you're ready to use it, then cover it once you're done. To minimize your exposure to any oil paint thinner or turpentine, clean your brushes with mineral or baby oil whenever you change colors, as well as when you've finished painting for the day.

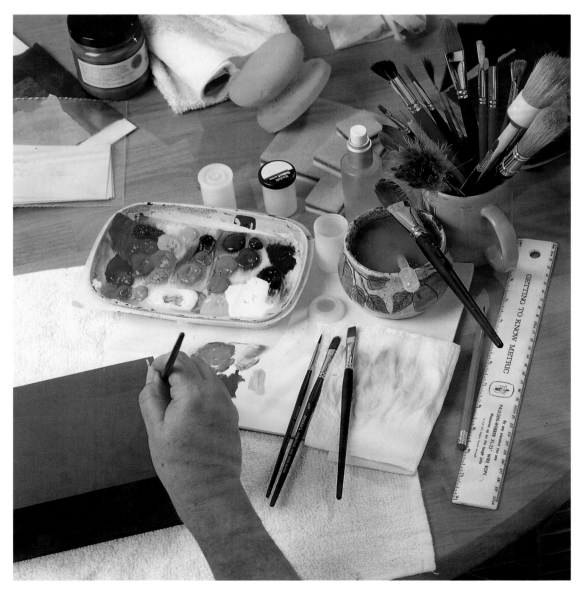

Take the time to arrange your painting area. A lack of organization can interrupt the creative process. Also, your tools and paints should be close enough that you don't have to reach for anything, as reaching can cause tension in your painting arm.

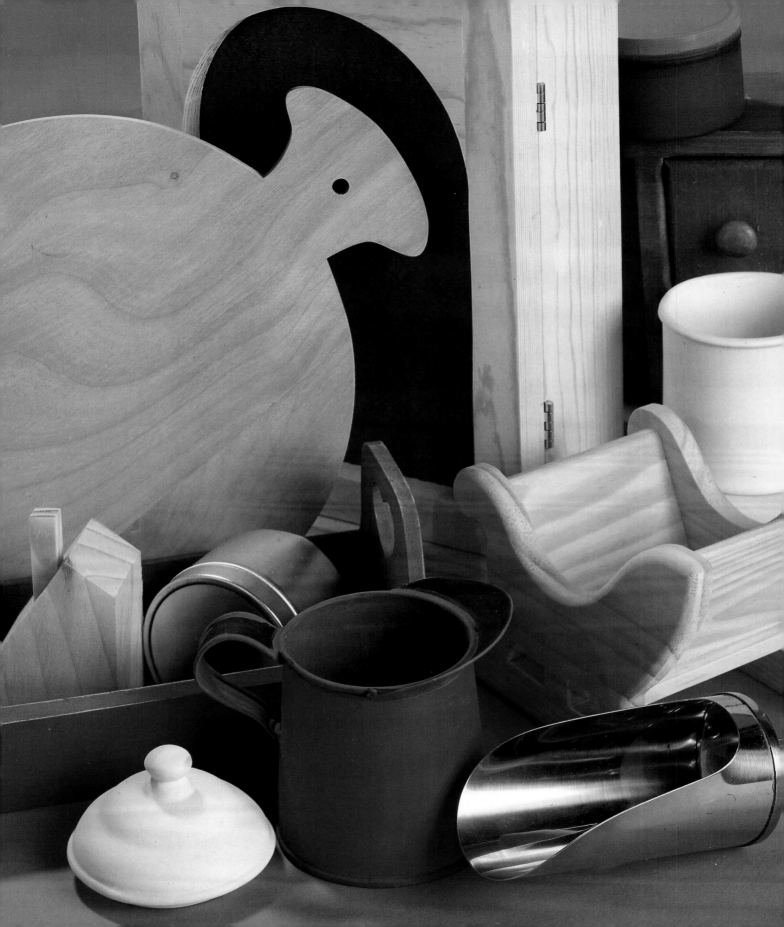

2 *Preparing the Painting Surface*

A well-prepared surface instills a feeling of pride in the craftsmanship of the piece you've chosen to paint. When you're ready to paint your piece, you'll naturally want to do the best job you can.

Enjoy the experience of preparing your object. Start with small objects, or with objects that will be easy for you to do. Avoid big challenges until you really want to try them. Make your painting experiences happy ones by finding pleasure in simple tasks. I love to sand—sometimes. I enjoy basecoating a piece—sometimes. I usually work on several pieces at once, each in a different stage, so I can do what is of interest to me at a given moment.

There are times when I need to sand a piece. Sanding can help you forget problems. The very act of scraping wood can ease tension or pull you away from sitting at your desk paying bills. When you need some quiet time to yourself and want a creative moment, pick up a piece of sandpaper and work on a piece.

Also, you don't have to know everything that's going to happen to a piece before you begin. Sand it, basecoat it, and, as it develops, let it tell you what to do next. This is how the very best pieces happen. They evolve slowly as you become more involved with the creative process.

Along the same lines you may also ask, "When is a piece done?" It is finished when there is no longer anything else you want to do to it, when there is no other place to touch it with your brush. Then, and only then, is it finished.

Preparing Wood

SURFACE PREP
SUPPLIES

Safety Equipment

Smock or apron

Dust mask

Safety glasses

Newspapers

Presanding

Mineral spirits (paint
thinner)

Nailset, hammer, and
screwdriver

Water-based wood
filler or putty

Sanding

Two grades of
sandpaper (#180- to
#200-grit and #320-
to #400-grit)

Sanding block

Clean, lint-free cloth

PRESANDING

The preparation required before you begin sanding will depend on the condition of the wood piece you're planning to paint.

New Wood. Remove labels and price tags. Use mineral spirits (paint thinner) to remove their gummy residue. Recess nails with a nailset and hammer, and remove hinges, doorknobs, and any other hardware with a screwdriver. Place loose pieces in a small plastic bag or envelope so you won't lose them.

Fill holes and defects with water-based wood filler or putty. If you plan to distress or age your piece (see page 99), you may skip this step and proceed to sanding.

Old Wood. Generally speaking, older wood pieces come in three conditions or states.

- *Finish in good condition.* Begin by cleaning the piece thoroughly with the cleaner that is commonly called trisodium phosphate (also known as TSP). Let dry, then sand well with a fine-grit (#220 to #320) sandpaper. Repair any defects, such as broken parts or separated veneers. There are many fine books on furniture repair, and if you are going to be redecorating a lot of old pieces, it is well worth your time to invest in one. (See page 284 for some suggestions.)

 In an inconspicuous place, test a 1:1 mixture of acrylic or latex paint + All Purpose Sealer. Let dry well (for a day or two), then check to see if the paint is adhering to the surface. If you can remove the test area, then you'll either have to strip the piece with a commercial paint and varnish remover, or try priming it with Benjamin Moore's Aqua Grip, Jo Sonja's All Purpose Sealer, or Jo Sonja's Tannin Block Sealer. As all three of these products are less than 20 years old, I can't attest to their performance over a very long period of time, but I've experienced great success thus far on those pieces I've used them on.

- *Finish in poor condition.* If the finish on an old wood piece is chipping or crumbling, it usually means that it has deteriorated. Think carefully about whether you want to paint over an inferior surface, because it will continue to deteriorate and flake off no matter how many coats of varnish you apply over it.

 Try sanding over a chipped area. Does the finish flake off even where it looks fairly good? If it does, strip the piece with a paint and varnish remover following the manufacturer's directions.

- *Oiled surfaces.* An old breadboard or salad bowl can be absolutely charming when decorated, but you must remove all the grease or oil first. I've tried hot soapy water, stripper, and soaking in lye, and have found that soaking these pieces in a lye-and-water solution works best but is very dangerous and should only be done by a professional. An easier (and safer) alternative is to soak your piece in a solution of boiling hot water and a strong dishwashing liquid. Scrape it, let it dry, then sand it. Repeat until you've removed all the gummy, rancid oil-soaked wood and reached "good," clean wood.

 If you're going to finish the cutting surface of a breadboard with oil, don't use vegetable oil, which will turn rancid. Instead, use a good-quality mineral oil (available at drug stores) or a fine specialty wax made for food surfaces, such as Clapham's Salad Bowl Wax.

SANDING

This part of the preparation process can be confusing because there are so many different kinds of sandpaper on the market. You need at least two grades: A coarser, general-duty type (#180- to #220-grit) and a finer grade (#320- to #400-grit). Simply remember that coarser (lower) grades are for *cutting*—removing something, such as a rough spot or excess paint, wearing away an edge, or distressing a piece a little—while finer (higher) grades are for smoothing. Always cut rough areas first with a coarse grade, then smooth out and finish them with a finer grade.

Part of the price of a new wood piece reflects how finely it has been sanded. If the woodworker has just roughly sanded it, its price will be cheaper. If he or she has "fine-sanded" it, you'll pay a little more because you won't have to sand it yourself. Before buying a new piece, check it carefully by running your hand over it and examining its edges. A quick look at the edges will tell you about the sharpness of a saw or router bit and where you'll have to work hard with the #180- to #220-grit sandpaper before using a finer grade. You may need to use some wood

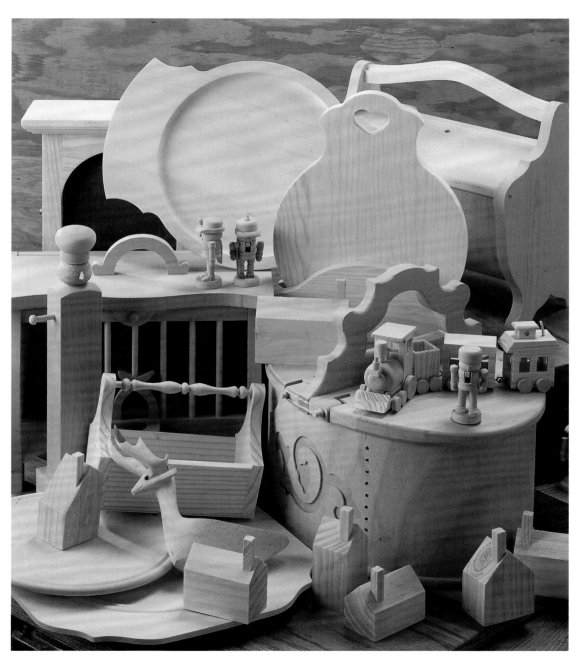

An assortment of wooden pieces to tempt the decorator's brush.

filler (putty) before sanding some of the nastier edges. Honestly, I'd rather pay another dollar for a piece and have those edges well sanded.

NOTE: Pieces that have been final-sanded with only #100- to #120-grit sandpaper can feel fairly smooth to the touch but still be too rough to work on. Sometimes inexperienced painters attribute their piece's roughness to the first coat of paint having "raised the grain," but most often it is due to the coarseness of the sandpaper that the woodworker used for the final sanding. Sanding with #200- to #220-grit yields a far nicer surface for basecoating. Just a little patch of paint on an inconspicuous spot will let you know how finely sanded a piece has been.

I should also point out that wood can be sanded *too* finely. You want the surface to have enough "tooth" to ensure proper adhesion; if you don't, your brush will just slip and slide around when you try to apply the first coat of paint. I always say that the best painting surface should feel like a gently buffed eggshell. To ensure good paint adhesion, I usually use no finer than #400-grit sandpaper, and generally prefer what is called wet/dry sandpaper, which is charcoal gray in color and seems to last longer—and that very old piece of #400 is most precious! (I use mine until it is falling apart.) It will even smooth between final coats of varnish when needed. An electric sander may be the first item on your next Christmas wish list!

For health reasons, you should always wear protective clothing (a smock, apron, or large shirt), safety glasses, and a dust mask when sanding. Work in an area that can be cleaned easily, and cover your work area with newspapers. It is possible to become allergic to wood dust, so be sure to safeguard yourself and family.

1. Sand the piece well, first using #180- to #200-grit sandpaper on rough areas, then sanding the entire piece with #320- to #400-grit. Pay special attention to edges and areas where the *end grain,* or the cut surface of the wood, is exposed. Rough end grain, and sometimes routed areas, can be a real problem and look very bad. A thorough sanding with two grades of paper, first coarse, then fine, is the only way to get rid of them.

To sand flat surfaces, wrap your sandpaper around a small piece of wood or sanding block. This allows you to sand the surface evenly and avoids removing the softer "summer growth" wood from between the darker streaks of "winter growth" grain. Sand with the grain of the wood in most situations. Sometimes when I'm doing the final sanding and using a very old piece of soft sandpaper, I give the surface a gentle semicircular "buffing" just before painting. Smooth drill holes with a small round file or roll of sandpaper.

2. Once the sanding is completed, vacuum the piece, yourself, and your work area well to remove wood dust. Wipe the piece well with a clean, slightly water-dampened lint-free cloth or dust it off with a large brush. (NOTE: Do NOT use a tack cloth to remove sawdust or dirt! Tack cloths usually contain oil-based products whose residue can prevent acrylic paints from adhering properly.) Change your smock before you begin priming or basecoating.

BEFORE BASECOATING: THE FINISHING TOUCHES

* *Removing a dent.* Place a drop of water on the dent, then apply steam from a hot iron, holding the iron just above the surface. The steam causes the wood cells to expand so that they fill the dent, thus eliminating the need to apply putty.

* *Gluing.* Always glue wood pieces together before painting. Wood must touch wood for the bond to adhere properly. Use a good wood glue and clamps or weights to maximize adhesion. A piece of properly glued wood will break somewhere else before it breaks at its glued joint.

* *Sealing knots.* I've tried every product available for pitch and knot problems and Jo Sonja's Tannin Block Sealer is the very best product I've ever used. Painted wooden items should not be displayed or placed in store windows or left in parked cars in the summertime. The heat generated in these areas will cause the pitch to "rise" and the wood to warp. All wood is sensitive to extreme changes in temperature and humidity!

Sealing and Basecoating Wood

In today's decorating world, painted finishes are very popular. In fact, almost all the decorative painting styles shown in this book are done on painted rather than stained backgrounds.

When acrylic products are used, background preparation is easy and safe, both for you and the environment, and the surface is compatible with any medium you use for decorating.

THE RIGHT SEALER

The first coat of a product that touches a wooden surface is the one that will penetrate it the most. Some people like to prime wood with gesso, but every nick will expose a white spot. Also, when an oil-based paint film turns brittle (after about 12 to 15 years), it tends to flake away from a gesso-primed background, especially if a cheaper grade of gesso has been used. Others prefer sanding sealer, which is a better choice, but it also prevents deep penetration of the color coat. If the piece is nicked, you'll see the wood underneath.

Over the years, I've learned to mix a little sealer with my basecoat colors to achieve deeper color penetration and reduce the process to a single step. So why not just buy a paint that has been premixed with sealer? There are a few good reasons not to. Different painting techniques require different degrees of surface tooth; for example, icon and Chinoiserie styles require very smooth backgrounds, while very watery, transparent techniques work best over matte, or more porous, surfaces. Also, outdoor pieces need a stronger sealer than indoor projects. Lastly, some sealers are intended for wood, while others are formulated specifically for use on metal or other surfaces.

Today's high-quality water-based sealers are no more likely to raise wood grain than traditional oil-based sealers, especially if the surface has been sanded with #180- to #220-grit sandpaper or finer. Note that the addition of a good-quality sealer such as All Purpose Sealer tends to increase the paint's degree of gloss.

THE RIGHT PAINT

Basecoat colors should be richly pigmented, able to cover a surface with just one coat, contain a certain level of clay and/or filler (for the proper filling of wood grain), and have a durable binder that will provide years of service under any condition. In contrast, cheaper paints contain commercial-quality instead of artists'-quality pigment (and less of it) and use lower-quality binders. This is one time when you'll really get what you're willing to pay for.

If your paint is heavily bodied and richly pigmented, you can add the type of sealer you need and still get one-coat coverage (keep in mind, however, that some pigments are more transparent than others). If the paint is poorly pigmented (which is usually the case with cheaper paints), then you'll end up wasting time and money trying to achieve adequate coverage. Unfortunately, only experimentation and experience will tell you how a product will perform. Joining a painting class or organization will be an invaluable source of information in this regard.

ONE-STEP BASECOATING

This is the simplest way to seal your piece and apply your basecoat color(s) in one quick step.

1. Using a 1:1 ratio, mix the paint with either All Purpose Sealer or Clear Glaze Medium. When using more transparent colors, use less sealer or matte medium in your mixture. (The exact proportion varies, depending on how transparent the pigment is.) The sealer and paint can also be brush-mixed. This method may create slight surface irregularities in your basecoat, but these will disappear when the finished painting is varnished.

 When more "open" time is required, such as when you're working two or more colors onto a surface, or if the paint is drying too quickly, you may add a small amount of retarder or extender to your paints. To decrease the likelihood of raising the wood grain, thin paints with Flow Medium instead of water.

SUPPLIES FOR WATER-BASED SEALING AND BASECOATING

Sealer
All Purpose Sealer or other good-quality water-based sealer OR Clear Glaze Medium or other good-quality matte medium

Basepaint
Heavy-bodied artists'-quality acrylic paint

Applicator
Brush, sponge, rag, OR airbrush

Optional
Retarder
Flow Medium

Sealing and Basecoating Wood

Basecoating techniques: *(Right)* A slip-slap and smooth-out technique is excellent for applying heavily pigmented background colors. *(Opposite, top)* A dome-shaped dusting or ring brush reaches into small drawers or boxes easily. *(Below)* The "petit four" sponge is most convenient for small surfaces and edges. *(Opposite, bottom)* Large objects and surfaces can be basecoated quickly using a very dense, larger sponge.

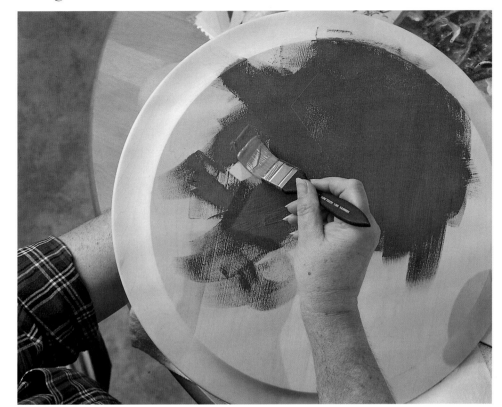

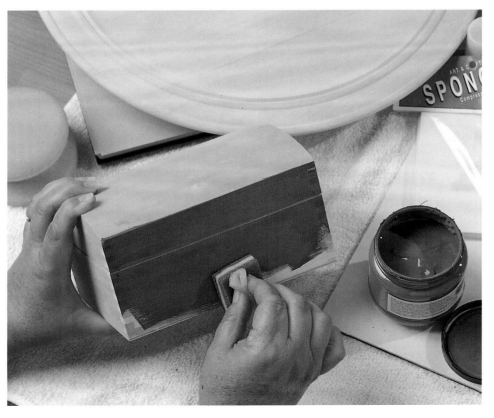

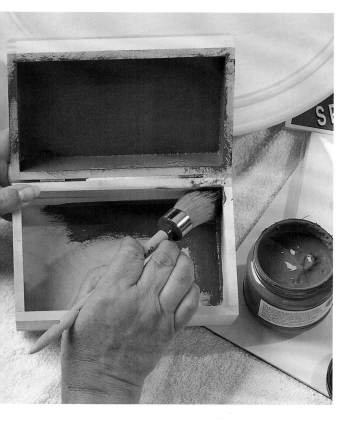

NOTE: If you plan *not* to varnish a decorated piece that will be kept outdoors, use a 1:1 mix of All Purpose Sealer or other water-based sealer with all your paints, which will increase the durability of the paint film. If you use oil paints instead of acrylics to basecoat an outdoors project that will be left unvarnished, you should mix them with a good-quality oil-based varnish.

2. Apply your basecoat with an airbrush, a sponge brush, a bristle brush, or a rag. To brush on thicker or more heavily bodied paints, use crisscross strokes to distribute the color more evenly over a small area. Smooth the areas with a few strokes following the direction of the wood grain. Continue working on the surface in this manner until it is completely covered.

 Heavier-bodied paints can also be easily applied with a sponge-rub technique. Dab the side of a small piece of dense sponge into thick paint, then rub it over the surface. Apply the final strokes in the direction of the wood grain.

3. Let the paint dry thoroughly. You may speed up the drying process with a hair dryer, but note that maximum adhesion develops over time (known as the *cure time*).

 I find that if I've sanded a piece well before basecoating, I usually don't need to sand it afterward. If you do decide a little sanding is needed here and there, don't worry about "scuff marks"—they'll disappear once you apply your finish (see page 102).

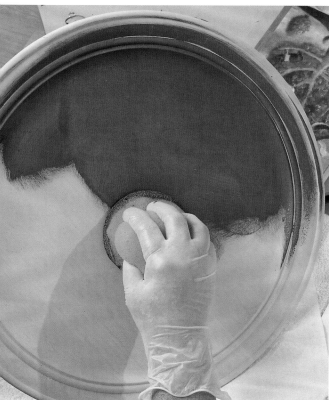

Staining Wood

**SUPPLIES FOR
WATER-BASED
STAINING**

Paint
Artists'-quality acrylic
paint

Mediums
Clear Glaze Medium
or other good-quality
matte medium
Retarder

Miscellaneous
Brush
Rags (optional)
Hair dryer (optional)
Fine-grit sandpaper

Applying a thin coat of translucent color to a wood surface is called *staining*. In this book, only acrylic paints are used for staining techniques. The one drawback to using acrylic stains is that most of them dry to a duller finish than oil stains, but this problem can be solved by applying a gloss varnish over the completed painting.

Traditional wood stains are made from earth colors (see page 61). For example, "golden oak" stain is usually mixed with raw sienna; "maple" is typically burnt sienna or a blend of burnt sienna and a little burnt umber. The traditional earth pigments tend to be opaque, while their synthetic equivalents are more transparent and give even richer results. Any color may be used for staining, but opaque pigments must be thinned so that they appear translucent when they are applied.

Wood can be sealed and stained in one step by mixing the paint into Clear Glaze Medium (matte medium) or some other type of penetrating medium that provides a little binder. The amount of paint you use will depend on how dark you want the stain to be. Add retarder to the stain if you need to extend its working time. Start with a mixture of 3 parts Clear Glaze Medium + 1 part retarder, add the paint or glaze (see mixtures below), then test the stain on a small piece of scrap wood to evaluate (1) the depth of its color and (2) how long it stays "open" or workable. If the stain dries too quickly and leaves brushmarks, add more retarder. If you're working on a large surface and add just the right amount of retarder to the mix, you can brush on your stain, have it remain wet for about 30 minutes, then easily wipe it down like an oil-based stain. As you gain experience working with stain you'll be able to reduce the amount of retarder in your mixture so that you can take full advantage of its fast drying time. Experiment to find the right ratio for the climatic conditions in your area.

Applying stain to a decorative cutting board.

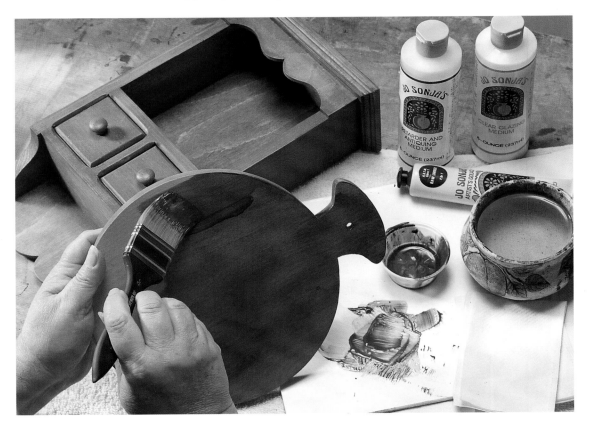

1. Prepare the wood as described on pages 32–34. Because the end grain is more porous than the *face grain,* or the finished face of the wood, it will absorb more color. Before staining, apply a coat of Clear Glaze Medium to the end grain, let dry, then sand. You must be careful not to slop any medium onto other areas.

2. Shake or stir your stain mixture well to bring the color up from the bottom of the container. Working on a single surface at a time (one side or defined area of the object), brush on one coat of your stain mixture. (To speed up the application on large pieces, use a big brush.) Wipe off the excess, if desired.

3. Let dry. If desired, use a hair dryer set on warm to reduce drying time.

4. Sand lightly if needed.

5. Repeat steps 1 through 4 on each remaining surface, letting each dry before beginning the next. Once the staining is completed, you can either apply additional coats to darken the color or begin decorating your piece. Additional coats of color may be repeated for darker color or special effects.

TRADITIONAL STAIN MIXTURES

Now for some color choices. Because every piece of wood absorbs stain differently, you'll devise your own variations. Mixing stains yourself gives you total control of the color.

Paint Stains. The following mixtures are paint colors only. Add each one to a Clear Glaze Medium + retarder base (see above for recommended proportions) until the desired color is reached.

- Fruitwood = 3 parts transoxide yellow Wood Stain Glaze (see "Glaze Stains," below) + 1 part brown earth
- Colonial cherry = burnt sienna
- Dark mahogany = 3 parts burnt umber + 1 part burgundy
- Light mahogany = 2 parts burnt sienna + 1 part burnt umber + a touch of burgundy

- Antique maple = brown earth
- Oak = transoxide yellow Wood Stain Glaze
- Danish pine = 1 part raw sienna + a touch of raw umber
- Walnut = 1 part raw umber + 1 part brown earth

Glaze Stains. The red, yellow, and blue Wood Stain Glazes I use are just red, yellow, and blue transparent pigments in a Clear Glaze Medium base. Add retarder as desired to increase working time, and add Clear Glaze Medium to thin the depth of color. The proportions cited below will vary, depending on the brand of paint you use.

- Royal fruitwood = 1 part red + a touch of blue
- Deep mahogany = 2 parts red + 1 part magenta + a touch of blue
- Rosewood = 2 parts magenta + 1 part red + 1 part blue
- English yew = 1 part red + 1 part yellow

PICKLING

The term *pickling* means to stain wood with white or a light-value color. Simply mix a little white or light-color paint with some Clear Glaze Medium and apply it to the wood following the instructions above; how much paint you use depends on how much of the grain you want to see. Start by mixing Clear Glaze Medium with just a little color. Apply it to one surface at a time; if desired, streak a little more paint here and there over the damp surface. Alternatively, you can brush on more color once the stain has dried, or you can let the surface dry and then moisten it with retarder before brushing on additional color. Once the stain is to your liking, let it dry, sand it lightly, and you're ready to decorate.

If you want just a very light pickled effect, seal the wood with one coat of matte medium or other wood sealer (don't use a multipurpose sealer, which may be impervious), let it dry, then sand it lightly before applying the stain.

Preparing Metal

SURFACE PREP SUPPLIES

Cleaning/Stripping

Dishwashing liquid *(for cleaning new unfinished pieces and stripping old finished ones)*

Lacquer thinner *(for cleaning old unfinished pieces)*

Removing Rust

Naval Jelly or similar product

Removing Old or Baked-On Dirt

Oven cleaner

Sanding

Emery cloth OR medium-grit sandpaper OR coarse synthetic finishing pad

Priming

All Purpose Sealer (water-based) OR oil-based spray or brush-on primer

Benjamin Moore Aqua Grip (to be applied over oil-based primers)

Basecoating

Acrylic paint, any color(s)

All Purpose Sealer OR water-based gloss-finish varnish (added to increase the durability of the paint)

The successful preparation of metal demands cleanliness and attention to detail. Handle metal objects as little as possible and always with clean hands, as body oils and lotions will inhibit the adhesion of paint to the surface.

The condition of the metal object will dictate which procedure for preparation is followed. Because the process of preparing metal can be time-consuming, I like to prepare several pieces at a time, then let them sit on an open shelf in a clean area for a month or more before I paint them, in order to give the sealer or primer plenty of time to cure.

One alternative to seeking out and preparing metal pieces yourself is to buy them preprimed. Check out local painting conventions for some possibilities. At a recent national convention, one enterprising booth displayed already cleaned and primed old metal pieces for sale. As wood becomes more expensive, you can expect metal to become more popular. Another option is to box up those wonderful old pieces and find a professional auto body shop that will clean and prime them for you. Some people who like painting on metal have construction or restoration contractors sandblast their old painted or rusted metal objects, then spray them with an acrylic primer.

PREPARING UNFINISHED METAL, NEW AND OLD

1. Wash new pieces well to remove all surface dirt, as well as the protective oil coating with which they are most likely treated. You can use the dishwasher for this step. Dry the piece well, then proceed to the sanding step.

 Some older pieces—typically, the ones that still look shiny and bright—are treated with a protective lacquer to prevent tarnishing, which must be removed with lacquer thinner. How can you tell whether your piece has this coating? If you've followed surface prep procedures carefully and the sealer or primer scratches off with just a touch, chances are that the piece is coated.

2. This part of the process is critical. Shiny metal surfaces must be scuffed with emery cloth or medium-grit sandpaper or buffed thoroughly with a coarse synthetic finishing pad. The fine grooves that are created provide "tooth" for proper adhesion, allowing the sealer or primer to cling to the metal.

3. Prime the sanded surface with a good-quality metal primer. For water-based preparation, apply All Purpose Sealer undiluted with a sponge or soft-fibered brush. Let dry.

 If you use an oil-based brush-on primer or Penetrol, let it dry well, then basecoat it with an oil-based paint. If you use an oil-based primer but prefer to basecoat your piece with acrylic paint, let the primer dry, then give the surface a coat of Benjamin Moore's Aqua Grip. (This product comes in white, but it can be tinted gray with black acrylic paint.) Let dry, then basecoat with acrylics.

4. You may basecoat the surface with acrylic paint as soon as the primer or sealer is dry to the touch, but it's better to wait overnight— or longer, if possible. For extra hardness and durability, mix the paint with an equal amount of All Purpose Sealer or water-based varnish (use less with the more transparent colors). You can "quick-set" the painted piece by baking it at 200°F for 20 minutes, but maximum hardness only develops over time. (The amount of time depends on the humidity in your area.)

 Pieces that are primed and painted with good-quality acrylic products are more durable than those that are prepared with oils or inferior-quality acrylics. Oil-based coatings turn brittle in 10 to 15 years, while good-quality acrylic coatings remain pliable, an important feature for metal, which is sensitive to changes in temperature. (Poor-quality acrylics will also deteriorate more quickly.)

STRIPPING ALREADY FINISHED METAL

If an existing finish is in poor condition, the paint must be removed or sanded down until no further chipping is detectable. Since there was a reason for the chipping in the first place (improper surface adhesion), I recommend complete stripping. Metal is hard to strip. Commercial preparations cause metal to become cold and contract, which tends to hold the paint even more firmly to the surface, whereas a good soaking bath in hot, soapy water will usually cause the paint to peel right off. Once the piece is completely stripped, dry it well, then sand, prime, and paint it as directed above in steps 2 through 4.

REMOVING RUST

Rust is "infectious" and must be treated before sealing or priming, although it is impossible to remove completely and usually progresses over time. You must carefully consider this fact before investing in a heavily rusted piece.

Remove rust with Naval Jelly or another rust-removing product (these can be found at automotive shops). Follow the directions on the product carefully. Dry the piece well, then sand, prime, and paint it as directed above in steps 2 through 4.

CLEANING HEAVILY SOILED METAL

The following procedure can be used on such items as cookie sheets, teakettles, or muffin tins. It works on all types of metal, even old cans from the mechanic's shop, but note that oven cleaner will pit aluminum, chrome, and brass after about 15 minutes. If you plan to cover the surface with a coat of paint anyway, you can use this method and remove the oven cleaner before 15 minutes have elapsed.

As with other methods of metal surface prep, it's best to prepare many pieces at once. Be sure to wear rubber gloves and safety glasses. Check the label of your oven-cleaning product for metal surface precautions before you begin.

1. Spray the pieces generously, place them in a large plastic garbage bag, and tie it shut. Let stand for 4 hours. Remove the pieces from the bag, taking care to avoid breathing the fumes.

2. Rinse away loosened soil with water or wash the pieces in the dishwasher. Any remaining grease can be treated again.

Once the pieces are completely clean, dry them well, then sand, prime, and paint them as directed above in steps 2 through 4.

The variety of shapes and decorative treatments available in metal make it an irresistible surface for painted decoration.

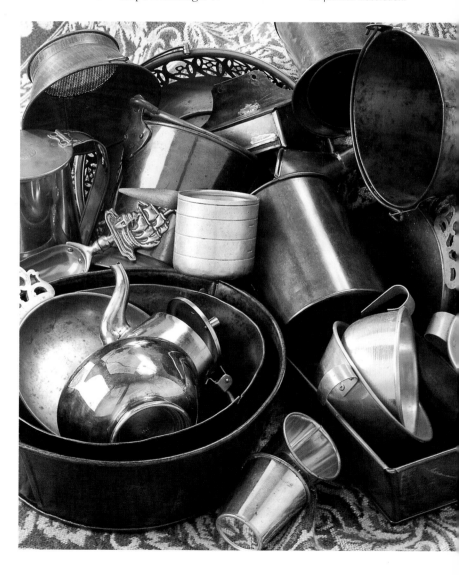

Other Surfaces

Decorative artists have a saying: "If it stands still, paint it." And this is really very true, since they have applied their strokes to everything from cars to broomsticks.

Glass, Porcelain, and Tile. Before decorating glass or porcelain, you must mix your acrylic paints with a special glass medium formulated for these surfaces. (Acrylic glass medium cannot be mixed with oil paints.) Note that items painted in this manner are for decorative use only, and can only be gently handwashed.

Instead of painting them with acrylic paint and glass medium, tiles that will be grouted onto permanent surfaces (such as kitchen backsplashes and bathroom walls or floors) should be decorated with ceramic paints, then fired as needed. There are "one-step" ceramic paints that can be used to paint simple stroke designs on tile and glass that usually require only one firing. For help on specific projects, check with your local ceramist.

Light- to Midweight Fabrics. Mix paints with a textile medium following the label directions. Transparent painting techniques work especially well, as they maintain the soft *hand* or drapability of lighter weaves. Heat-set paints with an iron according to the manufacturer's instructions.

Heavyweight Fabrics. Items such as cloth window shades or canvas-covered articles can be painted without adding textile medium to the paint. To make surfaces easier to work on and to facilitate cleanups, a coat of sealer may be applied first.

Leather. If needed, remove wax with mineral spirits. Buff shiny surfaces gently with a fine-grade synthetic scrub pad. Rewax the surface when the painting is thoroughly dry.

Candles and Other Wax Items. Buff the surface gently with a piece of nylon hosiery or a fine synthetic scrub pad, then decorate as desired. Mix acrylic paints with a small amount of All Purpose Sealer to make them more durable; oil paints may be applied directly to the wax surface. Some people like to give the finished painting one or two coats of varnish, either to make the surface more durable or just because they like the sheen.

Paper and Papier-Mâché. To prevent these porous materials from absorbing paints inconsistently, you can either give the surface a barrier coat (see page 78) or brush on or mix your paints with a compatible medium. Some oil paints may bleed out onto some untreated papers, creating a "halo" effect around the painting, but this depends on the amount of oil in the paint, which varies widely.

Insets, Borders, Banding, and Stripes

Insets, borders, banding, and stripes are a very important aspect of decorating. It's best to plan on including them at the very start of a project, before you begin to decorate. If you're not sure where you want them, basecoat the piece first, then take a little time to think about it before proceeding.

Begin by basecoating the entire piece in a single color. Positioning elements is mainly a matter of measuring or eyeballing their shapes and/or the space they require. If you like things to be very precise, then you must measure. Because I prefer to eyeball, I must live with imperfection, which I seem to enjoy or, at least, not to mind.

3 Design and Color

One of the unique things about teaching decorative painting is that students can follow designs or patterns if they so desire. This approach has encouraged thousands of people to pick up a brush and learn to paint. As their technical skills develop, questions concerning design and color arise. Opportunities are available to those who wish to learn how to devise their own designs, and many teachers include color awareness studies right from the start. I like this approach because it offers something for everyone, and artists may participate at their own comfort level and desired degree of involvement.

Design: The Creative Process

A bit of paint, a few mediums, and some simple tools can be used to create magical illusions in the form of unique decorative effects. The process of creating these effects provides pleasurable activity, from the planning to the actual execution of the technique, then a continued satisfaction and a positive sense of accomplishment, which linger long after the project is completed.

A lot of the fun comes from the planning. So often in our busy world we push to get things done quickly. In our haste we completely ignore the joys of planning the activity, discussing color, shopping for supplies, searching for inspiration, and involving our families in our decisions and inviting them to participate in the process. My husband and I have had the unique opportunity to watch our three children and their families use many of these ideas in their homes as well as in our studio. Although planning a project may take more time than the doing and completing, it's often more fun.

Careful planning leads to satisfactory results. Begin by making as many samples as you need. When you're ready to start your project, do one step at a time, then evaluate your progress. If you like the results, proceed to the next step. If you don't, figure out why! Take your time and give yourself permission to enjoy the experience. It will be over too soon and the greatest joy is in the doing. If you can't complete something on your own, involve others. Have a party. Invite your guests to learn a new painting technique. Trade hours, for instance, by babysitting for a friend so that she will lend a hand for part of your project. There are many solutions if we just think about it and make some plans.

The pieces shown on the opposite page are a fusion of several decorative techniques. In addition to being partially wallpapered, the dark piece was basecoated, then glazed, while the light piece has a heavily textured background on the door panels and has also been lightly glazed.

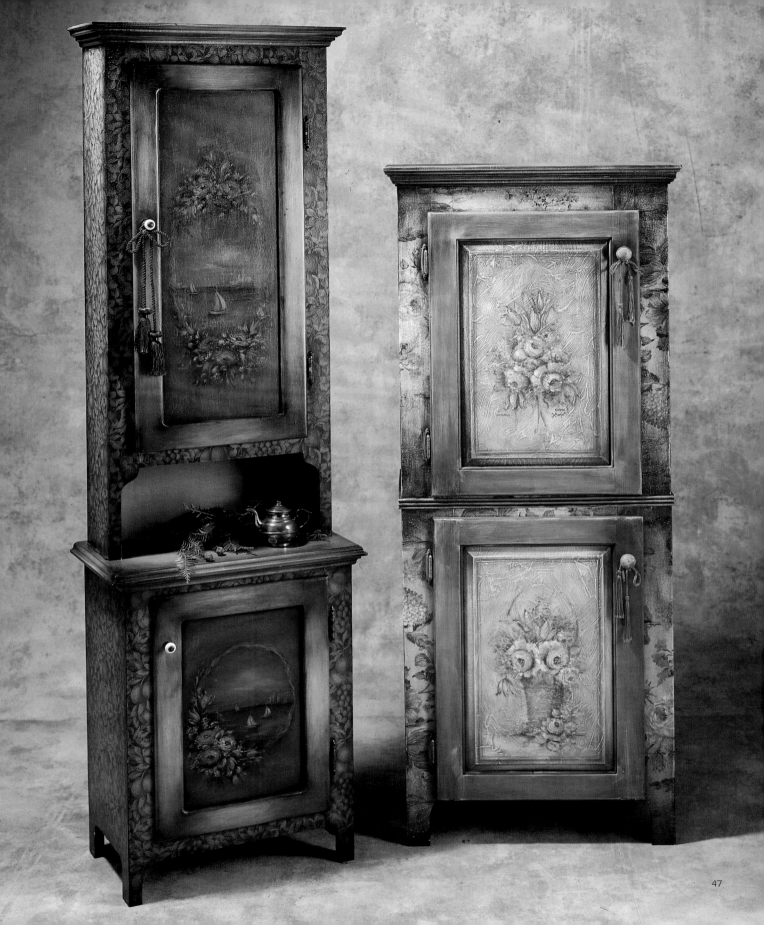

Sketching Your Own Designs

Take your sketchbook with you wherever you go. It should sit on your bedside table at night (along with a flashlight), rest on your desk or near your favorite chair during the day, and travel with you to the ballgame or the grocery store. Creativity is like a muscle: You must exercise it in order to develop it. Your confidence will grow as you fill your sketchbook's pages. You may occasionally use it to develop a refined drawing, but most of the time you'll use it to quickly note bits and pieces of ideas. It's fun if you remember to date them. Years from now you'll still find inspiration in your notations, and experience amazingly different ideas every time you look at them. This book will also contain recipes, addresses, and important thoughts—everything you need in your busy, creative life.

If you're making your first attempt at drawing, begin by touching the paper in your sketchbook, then try some pencils on its surface. Very lightly, and with a gentle touch, begin your sketch with a hard lead pencil, which makes light marks. Then, when you begin to bear down, before you make holes in your page, switch to a darker, softer lead. Your eye and mind want to create contrasts in the drawing. Sometimes you'll use your finger (the special stump for shading would be better but I can never find mine) or the corner of your hanky to softly blend out some shadows.

Develop your drawing skills by learning to draw some simple shapes and lines that can be repeated or sequenced. Combine them to make simple compositions. Borders are probably easier to sketch at first; from there, you can use shapes to form objects. Begin to train your eye to see basic shapes when you look at objects. Take a simple shape and see how many ideas you can find to fit or change it. There are no rules as to what shape you can assign to an object. The shape you give an object represents the way you see or wish to see it, and becomes a reflection of your style.

Always remember that you don't have to draw perfectly to do a simple sketch for painting, since you'll be painting over the transferred sketch. (See page 51 for instructions on how to transfer a sketch to the painting surface.) Advanced drawing skills are only needed when you intend to present the pencil sketch as finished artwork. As your confidence and experience grow, you'll be able to begin painting with less planning, and perhaps even become comfortable enough to create a brief pencil sketch right on the painting surface. Eventually, you might even replace your pencil with your brush, and make a few sketchy brushstrokes that you'll then incorporate into a more free-flowing design.

When painting a symmetrical design (in which one side is a fairly accurate mirror-image of the other), you may need to trace the sketch on one side, reverse it, then transfer its basic outline to the opposite side. Another method for making a uniform design is to draw a grid over the completed sketch so that you can place the motifs on the opposite side with some accuracy. I would like to note that the artists who created my favorite antique pieces usually avoided slavishly balancing their symmetrical designs, although they were attentive to creating a balanced placement of colors. For example, on a right cupboard door there may be a vase of flowers, one of which is a red rose, and in the same place on the left door is a red tulip or carnation instead. These fun, imaginative variations are inspiring.

SKETCHING YOUR OWN DESIGNS

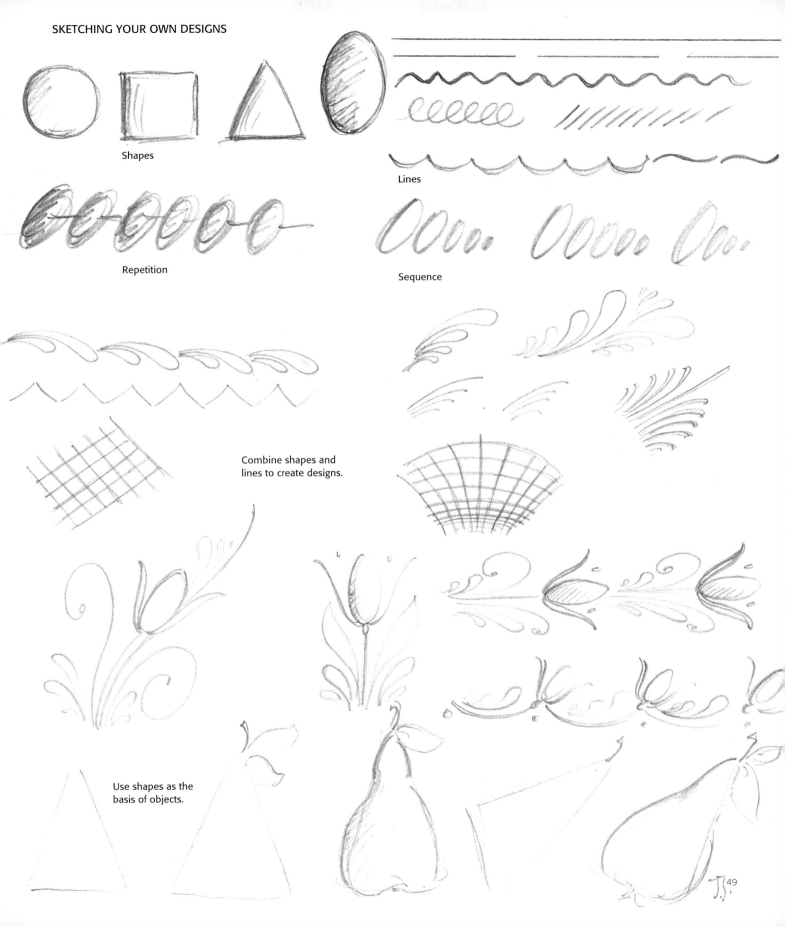

Shapes

Lines

Repetition

Sequence

Combine shapes and
lines to create designs.

Use shapes as the
basis of objects.

49

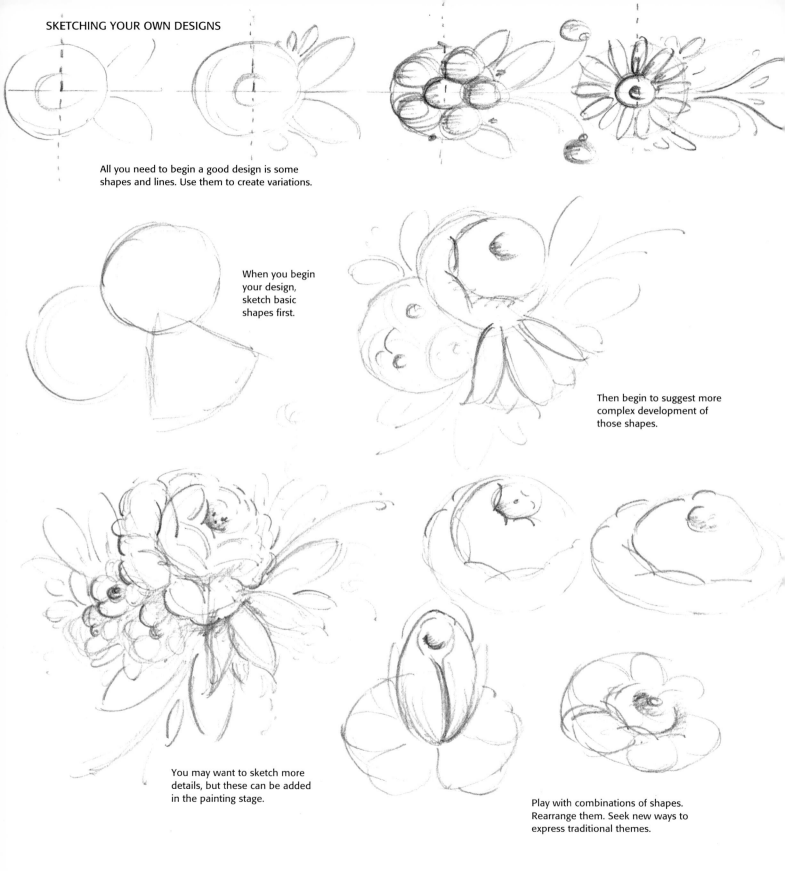

SKETCHING YOUR OWN DESIGNS

All you need to begin a good design is some shapes and lines. Use them to create variations.

When you begin your design, sketch basic shapes first.

Then begin to suggest more complex development of those shapes.

You may want to sketch more details, but these can be added in the painting stage.

Play with combinations of shapes. Rearrange them. Seek new ways to express traditional themes.

Transferring a Design

There are many ways to make your own carbonlike paper to transfer a drawing or *cartoon* to the surface of the object that you are decorating. You can rub one side of a sheet of tracing paper with white chalk (to make "white carbon" for dark backgrounds) or a soft lead pencil (to make "gray carbon" for light backgrounds), then wipe off the excess with a tissue before tracing.

I prefer to use gray stenographite, which is available at stationery and office supply stores. This product makes very light gray lines that are easy to erase. You can really get into trouble with traditional carbon papers used for typing and some of the dark stenographite papers, and the yellows are impossible to remove. Also, if your basecoat is fresh and tender, your graphite lines may bond permanently with it. If you use any of these products, you basically have to live with whatever problems are created by the transfer.

Another, newer type of transfer paper, Chacopaper, can be easily removed with water, so there is no danger of it bonding with your basecoat. The drawback to this feature is that the transfer can't be initially moistened with water or retarder or it will be removed from the surface. In addition, if the weather is humid, the transfer will begin to fade in a few hours.

1. Lay a piece of tracing paper over your design or sketch, then trace over it with a fine-tip pen or a liner brush loaded with black paint.

2. Position the traced design over the prepared painting surface, then tape it in place with masking or Scotch tape.

3. Insert a sheet of transfer paper between the tracing and the painting surface, making sure that the graphite or chalked side is against the painting surface.

4. Using light pressure, trace over the design with a stylus. When the tracing is complete, lift the tracing and transfer paper to check your work. Erase or dust off any heavy lines before painting.

TRANSFER SUPPLIES

Tracing

Tracing paper

Fine-tip pen OR brush and black paint

Transferring

Tracing paper, white chalk or lead pencil, and facial tissue

OR

Gray or white stenographite

OR

Chacopaper

Masking or Scotch tape

Stylus

Eraser

Transferring a design to a basecoated surface.

Color Basics

Color is the artist's most important tool. As an artist, you will continue to learn about color all your life. Color theory—which provides the terminology that artists use to talk about color—is really very simple, though it can be somewhat confusing because there are so many conflicting bits of information in print. Color is fun and exciting, not something to be afraid of. Let's start with some basics.

It's useful to place the most basic divisions of color into a circular shape, which is called a *color wheel.* Using this configuration, it's easy to understand color relationships and color schemes and to identify how various mixtures are made. It's important to note that the number of colors in a color wheel can vary, but here we'll use the most commonly accepted color wheel, which is made using twelve colors. The colors are placed in the order in which they appear when a ray or beam of light is refracted through a prism. This separation of white light into color, which is called the *spectrum,* can also be seen in a rainbow. The colors that form the twelve-part color wheel can be categorized by dividing them into primary, secondary, and intermediary colors.

- *Primary colors.* Red, yellow, blue are called "primary" because all other colors are mixed from them, but they cannot be mixed from any others.

- *Secondary colors.* These three colors can be made by mixing two primary colors together: orange = red + yellow; green = blue + yellow; violet = red + blue.

- *Intermediary colors.* These six colors—red-orange, yellow-orange, yellow-green, blue-green, blue-violet, and red-violet—are created by mixing a primary and its closest secondary on the wheel.

To make your own color wheel, place any one of the colors at the top of a circle, then arrange the others in regular increments around it following the arrangement of the spectrum. Many artists start with yellow because it is the lightest in value of all the colors. I always begin with red because

it is the most important color in the traditional folk art palette. If you wish to make a color wheel that includes more than twelve colors, you could mix an intermediary with the color next to it, then place it between the two. The color between red and red-orange, for example, would be red-red-orange. Such colors are called *second intermediaries.*

If you continue to mix colors, it's possible to make an even larger color wheel. In yet another category are the *tertiaries,* which contain all three primary colors. Tertiary colors are always very low in intensity (brightness), but the amount of each primary color contained in a tertiary mixture may vary, as will its value (see "Color Vocabulary," below).

The position of colors on the wheel can also tell us something about their relationships. *Complementary colors* lie directly opposite one another on the color wheel; for instance, green is the complement of red, orange is the complement of blue, and so on. By looking at a color wheel, we can easily identify complements. When we need to soften or tone a color, the easiest way to do it is to add a bit of its complement. The resulting mixture is a tertiary color, as it contains all three primaries.

COLOR VOCABULARY

There are just a few more terms that an artist must know in order to understand color theory.

Hue. This is the most basic color name that can be assigned to a color. For example, we would say that a color called "pumpkin" is a yellow-orange, or that a color called "candy apple" is a red.

Value. Basically, value is how light or dark a color appears. We might routinely describe a color as "dark blue," but just what do we mean by this? How dark is dark blue? In order to clarify the subtle gradations of dark to light, artists use what is called a *value scale.* Most value scales have ten steps, or increments from dark to light, beginning with black as step 1 and ending with white as

step 10. Steps 2 through 9 are grays that gradually and systematically lighten as they approach white. Steps 2, 3, and 4 are commonly called dark values, steps 5 and 6 medium values, and steps 7, 8, and 9 light values. I've noticed that each person perceives value a little differently (in fact, I see colors 1¹/₂ value steps darker with my left eye than I do with my right). But it doesn't matter exactly how we perceive an individual color, as long as the colors in our paintings all work well together.

- A *tint* is made by increasing a color's value, or lightening it, by adding white or a light-value color. A *sunshine tint* is a color to which white and just a small touch of yellow has been added, which not only lightens its value but warms it as well.

- A *shade* is made by reducing a color's value, or darkening it, by adding black or a dark-value color to it.

- A *tone* is made by mixing a color with gray or any other color. (Some people refer to this procedure as *graying* a color, regardless of whether gray has actually been added.) If the resulting mix contains two primaries it will be less intense than the pure primary colors, but if the mix contains all three primary colors (a tertiary color) it will be very toned or dull.

Intensity. Also known as *chroma* or *saturation,* intensity means how bright or dull a color is. When two or more colors are mixed together, the resulting color is duller, or less intense, than any of the colors used to mix it. If you're trying to reduce the intensity of a color and it doesn't look dull enough, figure out which primary colors it contains, then add the missing one. For example, to reduce the intensity of green (yellow + blue), add a touch of red, or any color that contains some red.

In decors, toned colors blend better, in part because they are less intense. Because tertiary colors contain all three primaries they are very low in intensity. The earth colors, which include burnt umber, raw umber, burnt sienna, raw sienna, brown earth, and yellow oxide, are the basis of many traditional wood stains, and can be mixed from different proportions of red, yellow, and blue. That's why stained wood works well in any decor.

Temperature. Temperature is how warm or cool a color appears. The colors on one side of the color wheel, from red-violet to yellow-green, appear warm, while those on the other side appear cool. Note, however, that our perception of a color can be modified or changed by how the color is used, and by which colors appear next to it. For example, red is usually thought of as a warm color, and when it is seen on or near green, blue, or violet, that quality is heightened. But when red is seen on a yellow background—especially a relatively cool red like naphthol crimson—it probably looks cool. If you're a beginning artist, this news may be confusing. Relax! Color's adaptability is its most fascinating characteristic.

YOUR COLOR PERSONALITY

You have a distinct color personality that is unique to you and yours alone to express. Your perception of some colors seems keener or sharper. It's difficult to explain, but you're happier painting with them, and when you're happier you do a better job of painting!

Throughout my years of teaching, I've always listened closely to the artists I've worked with. I've wondered why, for example, someone would love painting strawberries but dislike pears. When I looked at their work I could see nothing wrong with either subject, but the artist continued to express dislike. This bothered me, so I tried many different approaches to other similar subject matter and watched and listened. I've tried many experiments in the classroom, and am now convinced that a properly chosen personal color palette is the key to beautiful artistic expression.

So now the task becomes one of self-discovery, of searching for a personal palette. This process won't happen overnight, so you must not be impatient! It took me about three years to start to feel comfortable with my personal palette, and I know I'll spend the rest of my life learning about color and how to use it in my work. To begin your own program of self-discovery, go to a local paint store that has a generous display of sample colors from which to choose. Very carefully select your favorite red, yellow, and blue; these can be any value, either toned or clear. Also look at the earth colors, blacks, and whites. Can you find favorites there? Take the samples, put them in an envelope, seal it, date it, and forget about it. One month later go to another store and repeat the process. Take these samples home and compare them with your first set of choices. In most cases—about 95 percent of the time—the second set of colors is within one to two values of the first, and if a warm red was chosen the first time it will be chosen the second as well. Small differences between colors are probably due to different pigment sources used by manufacturers, or to the ratios of various colors they use in their standard bases.

If you're one of the few whose second set of colors is way off from your first, seal up all the samples in an envelope and begin to search through magazines, greeting cards, fabrics, papers, and other sources for colors that you like. Select your colors over a long period of time so that your earlier choices won't influence your more recent ones. When you have a good selection, sit down with your choices and begin some comparisons. You need a place to start, so look at the red first. Do you seem to like a cool (blue) red or a warm (orange) red? Evaluate your blue and yellow using the same criteria. You may have selected a blue that is more of a green. That says something also—no fact is unimportant in the color search. Are your colors toned or clear? Now you can go to the art supply store and select tubes of blue, red, and yellow that come closest to your color samples. If you've chosen toned versions of these colors, you'll have to choose the closest "parent" primary

color of each and be sure you have the earth color or a gray that seems to be their common toner. You'll also need white. Black is optional; your toner may be dark enough for your dark values. Take your red, yellow, and blue home and begin to play with your choices. Try using them to make a color wheel. It's all right if, for instance, your yellow is duller than a primary yellow. Eventually you'll need a primary yellow, but at this point it's most important for you to see that your choices can work for you.

As part of a group of about twenty-five people, I had my personal colors done by a wonderful colorist. Without having met any of us before, she correctly described the personality characteristics of each person based solely on observations she had made about his or her color choices. This bit of magic totally fascinated me. Are we so personally connected to certain colors that they actually reflect our identity? Maybe. We can also be influenced by others in making our color choices. For example, my mother told me not to wear pink with orange, yellow, and purple. But just look at these colors in children's clothing today!

Let me share a few general observations using a popular system of classifying colors, keeping in mind that there are other ways of categorizing color preferences.

- *You are a "winter/summer" color personality* if you prefer a strong blue, like phthalo blue or Prussian blue hue; a cool red, like naphthol crimson; a tertiary yellow, like raw sienna, though a summer might select yellow oxide instead. Winters like black, white, and strong, clear colors, while summers prefer grays, taupes, and toned colors. Winters prefer painting with a lot of contrast; summers prefer a softer, misty look.

- *You are an "autumn/spring" color personality* if you like a warm blue (ultramarine blue) that is relatively weak; a warm red like naphthol red light; and a strong, warm yellow like yellow medium or yellow deep. Springs prefer clear colors; autumns, toned ones. Autumns like a wider contrast of values than springs do, but their contrasts won't be as strong as a winter's.

If we recognize the fact that each of us has a distinct color personality, we can approach how we use color in our painting more sensitively. We can understand why it's so difficult to paint something for someone else if we don't understand their color preferences. If you participate in an art show and don't sell anything, you should re-evaluate your color choices and how you've used them and make an effort to understand current color influences.

Open the door to color. Allow yourself to become aware of your color preferences, with the confidence that your choices are good for you. Be receptive to others' preferences, and expand your knowledge by trying to understand them. Join an artists' group so you can talk about color and technique. There is no one way to use color, or a "right" way to do something. Because decorative painting is so fundamentally linked to the past, it's essential to the health and growth of the art form that each artist develop and express him- or herself in a completely unique way. I wish you much joy as you continue to explore the world of color.

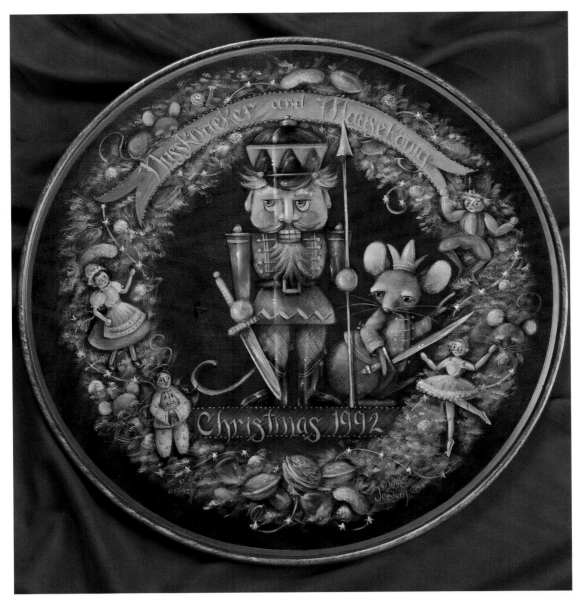

I painted this Christmas plate using my favorite colors from my personal palette—burgundy, naphthol red light, yellow oxide, Turner's yellow, Prussian blue hue, and sapphire—which are jewel-like in their intensity.

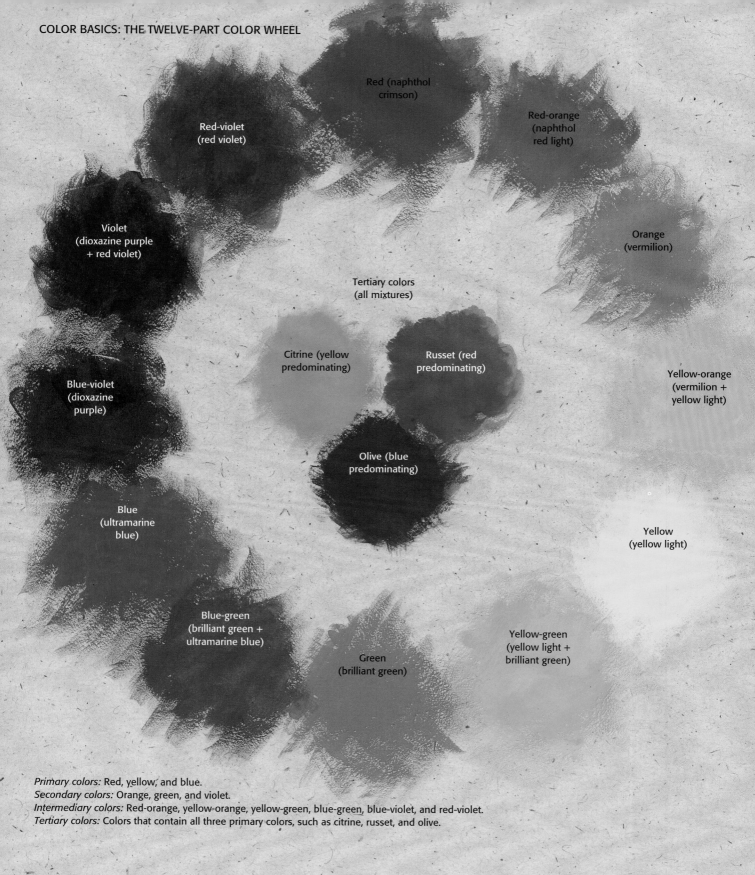

Red (naphthol crimson)

Red-violet (red violet)

Red-orange (naphthol red light)

Violet (dioxazine purple + red violet)

Orange (vermilion)

Tertiary colors (all mixtures)

Citrine (yellow predominating)

Russet (red predominating)

Yellow-orange (vermilion + yellow light)

Blue-violet (dioxazine purple)

Olive (blue predominating)

Blue (ultramarine blue)

Yellow (yellow light)

Blue-green (brilliant green + ultramarine blue)

Yellow-green (yellow light + brilliant green)

Green (brilliant green)

Primary colors: Red, yellow, and blue.
Secondary colors: Orange, green, and violet.
Intermediary colors: Red-orange, yellow-orange, yellow-green, blue-green, blue-violet, and red-violet.
Tertiary colors: Colors that contain all three primary colors, such as citrine, russet, and olive.

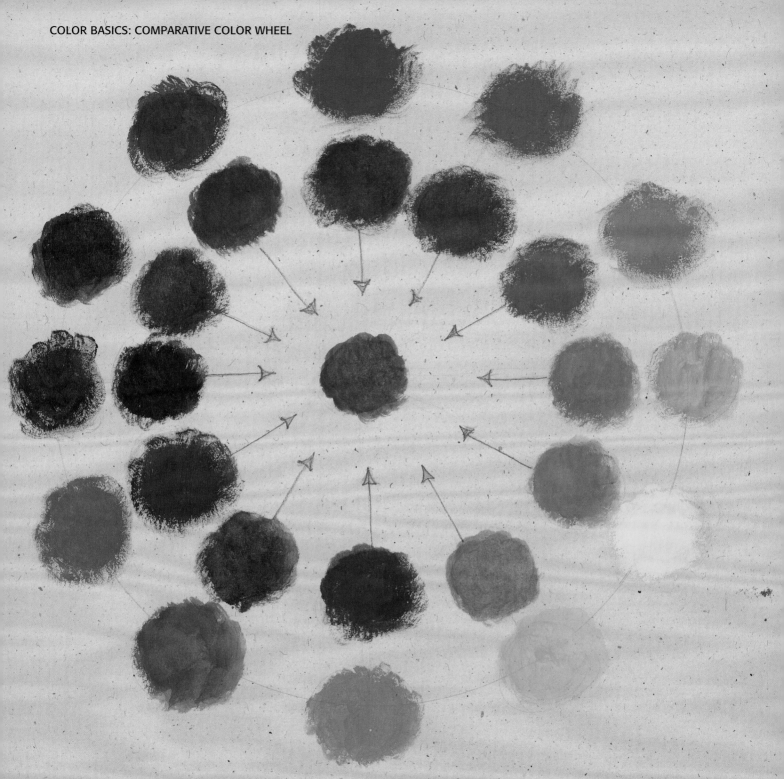

The outer ring is a twelve-part color wheel comprising primary, secondary, and intermediary colors.
The inner ring comprises twelve tertiary colors made by mixing two colors on the outer ring that are directly opposite.
Note how much brighter the colors of the outer ring are.

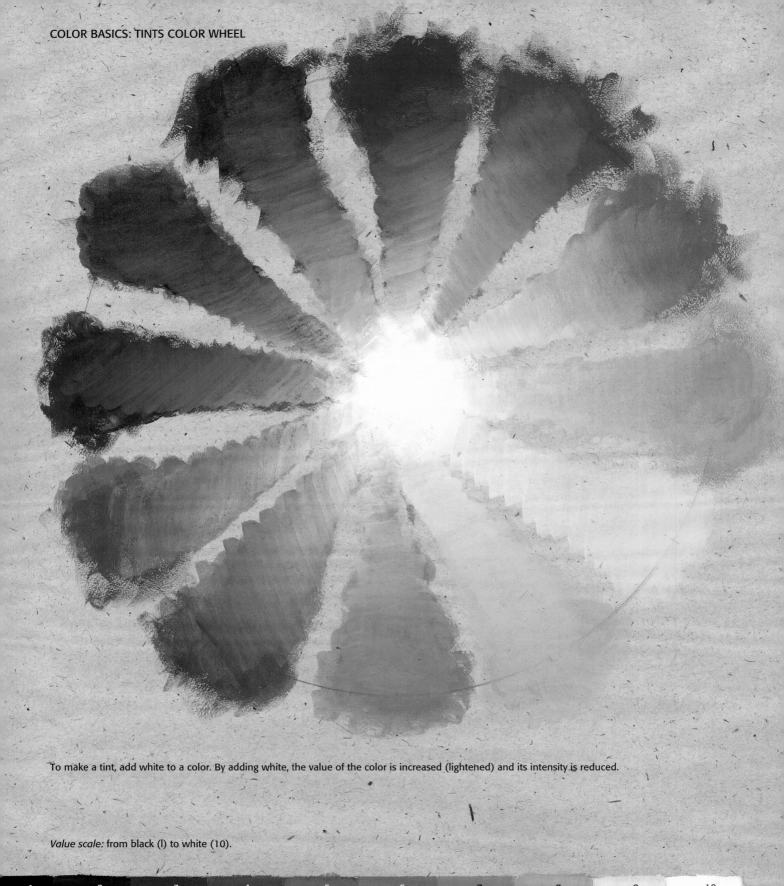

To make a tint, add white to a color. By adding white, the value of the color is increased (lightened) and its intensity is reduced.

Value scale: from black (l) to white (10).

| 1 | 2 | 3 | 4 | 5 | 6 | 7 | 8 | 9 | 10 |

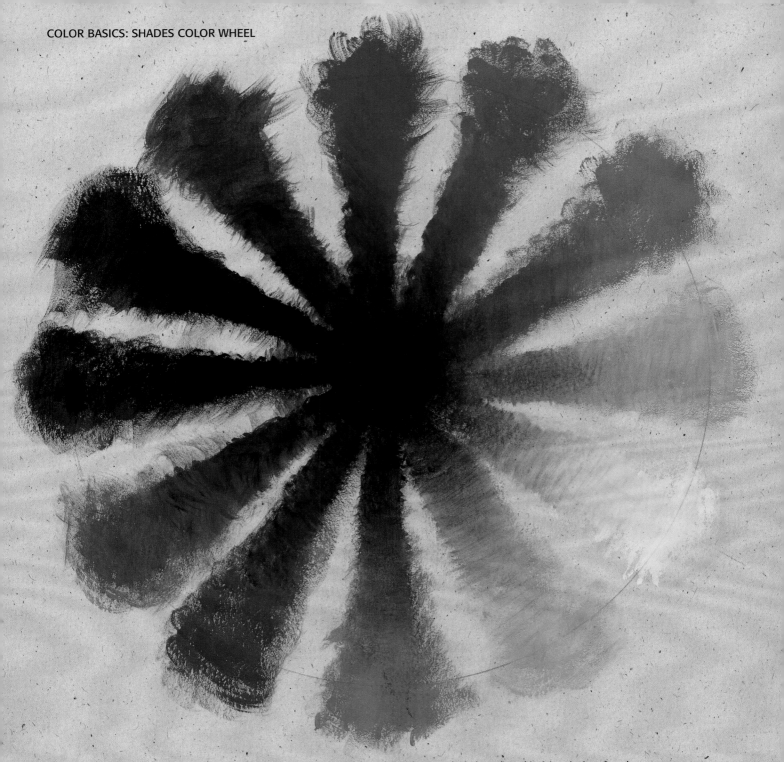

To make a shade, add black to a color. By adding black, the value of the color is decreased (darkened) and its intensity is reduced.

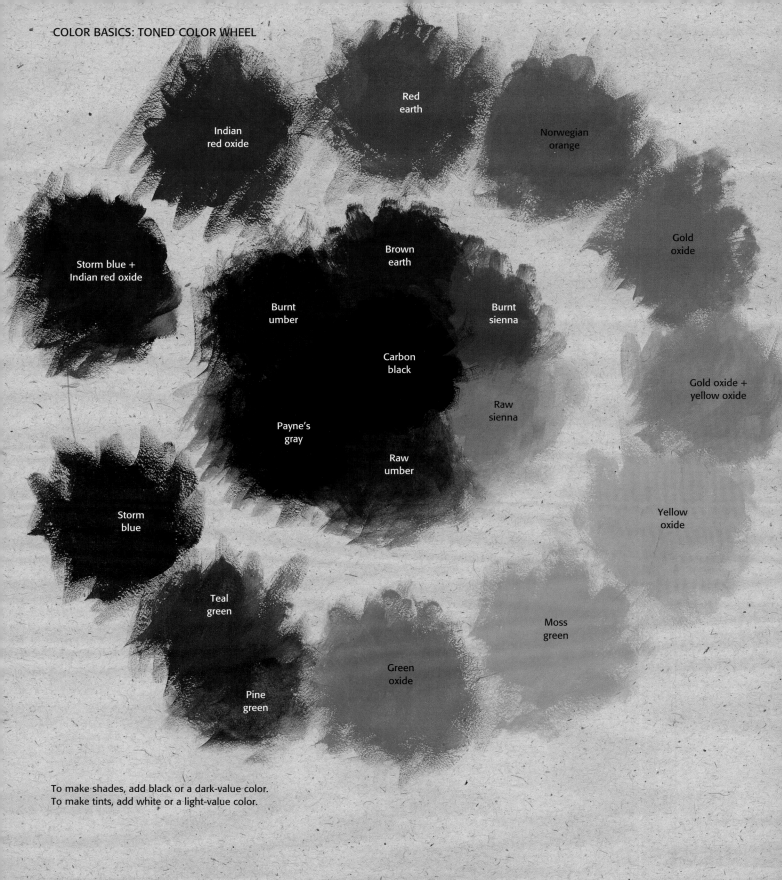

Indian
red oxide

Red
earth

Norwegian
orange

Storm blue +
Indian red oxide

Brown
earth

Gold
oxide

Burnt
umber

Burnt
sienna

Carbon
black

Raw
sienna

Gold oxide +
yellow oxide

Payne's
gray

Raw
umber

Yellow
oxide

Storm
blue

Teal
green

Moss
green

Pine
green

Green
oxide

To make shades, add black or a dark-value color.
To make tints, add white or a light-value color.

COLOR BASICS: EARTH COLORS

TRADITIONAL EARTH COLORS (ALL TERTIARIES)

Burnt umber

Once mined from the earth, earth colors are reasonably priced, dependable, and considered permanent. The "burnt" versions are calcined, or roasted, in furnaces. Today many companies make their earth colors from artificial sources.

Raw umber

NEW POSSIBILITIES

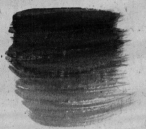

Brown earth (burnt sienna + burnt umber)

Indian red oxide

Burnt sienna

Gold oxide

Raw sienna

Green earth
(pine green + raw umber; proportions may vary)

Yellow oxide
(yellow ochre)

The most popular toners of Colonial-period decors, earth colors are also the traditional foundation for wood stains. When making paints, pigments with good coverage (those that are as opaque as possible) should be used. When making stains, the most transparent pigments are preferred.

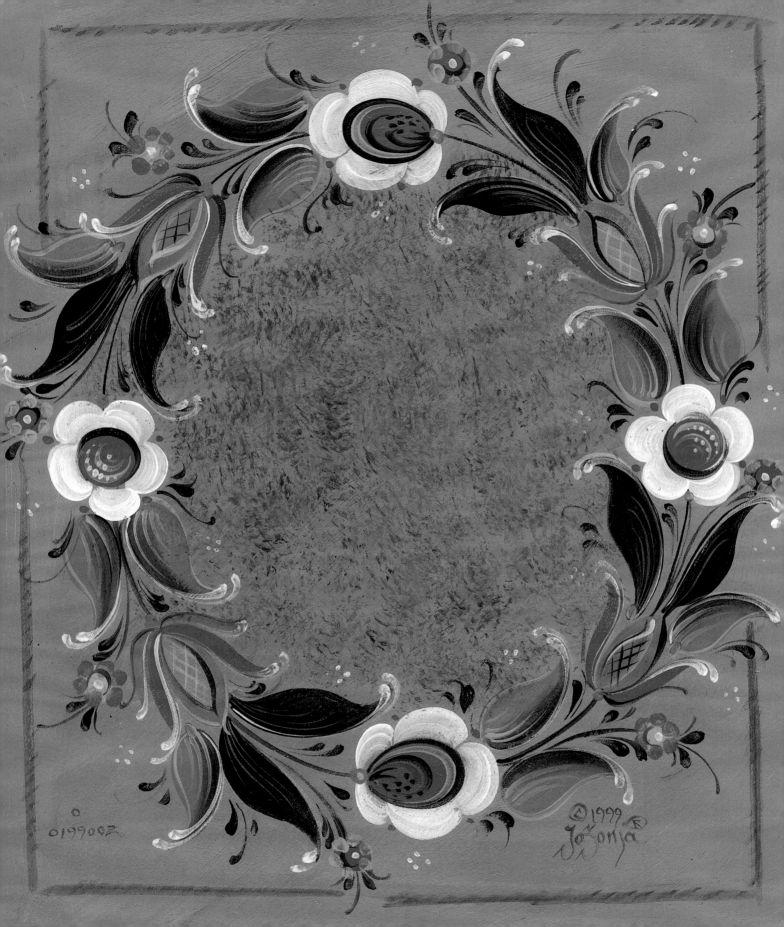

© 1999
JoSonja

0199002

4 *Working with a Brush*

Well, we've prepared a surface and found a few brushes and paints to our liking—at last we're ready to actually begin placing some color on an object. So here we sit, questions flooding our thoughts:

- Which brush should I try first?
- How do I get the paint on the brush?
- Can I pick up more than one color on the same brush?
- What do I do if the paint is too thick?

Let's take a moment to get acquainted with the brushes we've selected, learn how to load them, talk about paint consistency, and consider other pertinent points necessary for developing a successful brush technique.

Strokework

One of the hallmarks of decorative painting is the use of brushstrokes to indicate the various elements of a subject in a simplified way and to provide a sense of movement in a design. When painting strokes, you shouldn't focus on making "perfect" strokes—an emphasis on perfection can make your work look stiff and unimaginative—instead, you should aim to produce beautiful, free-flowing strokes that complement the theme of the work. Totally careless stroking is just as unappealing as an overly contrived effort, accomplishing neither flowing movement nor pleasant viewing.

The main value of strokework for a beginning decorative painter is that it teaches brush control. For more experienced artists, it can promote freedom and control of movement, in the same way that compulsory figures strengthen an ice skater for a complex program, or warm-ups prepare an athlete for a rigorous workout.

From Welsh folk art we learn that the shape of the most commonly used stroke in decorative painting, the comma stroke, represents the human soul. It is a shape that is naturally made by exerting pressure on the brush, then pulling it and lifting it off the surface, all in one motion. I use the comma stroke frequently in my work, and I love to remember that beautiful metaphor. In the pages that follow, I've used arrows to show the direction in which I've pulled the strokes, but note that these are only suggestions.

Getting Started

The basic strokes—the comma, the S, the C, and the teardrop—can be painted with quill, round, flat, or filbert brushes. The brush that is traditionally used for strokework is the round. Begin with a round; eventually, though, you might come to prefer another brush shape.

See page 26 for instructions on how to prepare a practice board. If you use a watercolor block as a practice surface, you can simply tear off sheets as you use them, then either keep them or discard them as desired. Because paper is very porous, you will need to apply a barrier coat or use a paint medium as well, whether you work in oils or acrylics (see page 42).

If you've cut and basecoated a piece of cardboard, Masonite, or plywood, give the surface a "barrier coat" before you start so that you can wipe off your practice strokes and use it again. For acrylics, seal the surface with matte medium, then let dry for at least 24 hours. With this method, you'll be able to remove acrylic paint up to a couple of hours after painting, though you may have to scrub the surface a little with some soap if you wait that long. Working over a coat of retarder will give you more "open" time.

If you're working in oils, apply a coat of oil-based varnish, then let dry. If the varnish has a gloss finish, lightly sand it with #400-grit sandpaper before proceeding. To remove your strokes from the surface, simply wipe them off with a rag dampened with mineral spirits.

If you're happy enough with a practice board "study" that you want to refer to it later, protect it against accidental paint spills and marks with a coat or two of matte medium or varnish when the painting has dried.

Paint Consistency

The consistency of your paint will have a direct affect on the appearance of your strokework. Strokes can be painted casually with a drybrush technique, which requires a brush that is very lightly loaded with thinned paint. Sometimes very fluid or watery strokes have more appeal. Heavily textured strokes give paintings dimension, and are especially lovely when painted in gold and used to frame a composition. In addition, the strokes themselves may dictate the consistency of the paint you use.

Since paint taken right from the tube is thick, chances are you'll need to mix it with

a medium before you begin painting. Squeeze some paint on your palette, placing acrylics on your already prepared wet palette and oils on a clean sheet of a disposable paper palette. (See "Your Painting Area and Palette," page 28, for detailed instructions on setting up a palette.) Use your palette knife to move some paint to a dry area. Using a gentle "mash-and-scrape" motion, mix the paint and the chosen medium together with the palette knife to the desired consistency, finally scraping the mixture into a tidy pile before loading the brush. Mixed acrylic color may be returned to the wet palette for storage.

Below are recommended paint consistencies for various types of strokework.

- *Basic strokes.* Mix paint with a little medium to the consistency of heavy cream. For acrylics, you can try using gel medium or matte medium.

- *Lines, stripes, and dots.* In general, use paint with a thin, "soupy" consistency. Dots may be made with either end of the brush, and may be either perfectly round or dabby. Stripes may be one color or touched with a little shading and highlighting.

- *Dimensional strokes.* If you're working in oils, use paint straight from the tube. For acrylics, mix paint with a texture medium, or a 1:1 mixture of texture medium + gel medium.

- *Translucent strokes.* Paint that has been mixed with a compatible medium until it's thin enough to see through can be used for strokework as well as a variety of other painting techniques, including glazing, colorwashing, staining, and antiquing. (See "Working with Glazes," page 82.)

DRESSING THE BRUSH

To *dress* a brush means to pick up some paint with the brush's tip, then to push the paint into the center of its hairs instead of just coating its outer surface. This technique increases stroke control because it loads the brush uniformly and eliminates the need for frequent reloading. In most cases, you should avoid loading a brush clear up to the ferrule, which just makes it hard to clean. A good-quality brush doesn't need that much paint to respond properly. (Liner and striper brushes are two exceptions to this rule.) Before you begin, prepare your palette and practice surface.

1. On your paper palette, mix a small amount of paint to the consistency used for basic strokes (see above), then move it to the wet palette.

2. Pick up your round brush. Hold it as you would hold a pencil, very comfortably, without tension.

3. Push the tip of the brush into the center of the puddle of paint until the paint covers about one-third of the length of its hairs.

4. Lift the brush from the paint puddle and move it to a clean area of the paper palette. Gently press the brush against the palette two to three times. Flatten the tip of the brush in preparation for making a comma stroke, and leave it pointed for a C, a teardrop, or an S stroke. Do not twist the brush to point its tip; instead, establish a track of paint by stroking the brush back and forth until the hairs are aligned and loaded, then gently and slowly lift the brush from the palette, allowing the paint to hold the hairs together at the tip.

5. If you want a stroke with more texture, dip the tip of the dressed brush back into the puddle of stroke-consistency paint.

6. Now you're ready to paint. Once the brush has been properly dressed, you can use it until you feel that it should be reloaded. Wipe, rinse, or clean the brush when you see a buildup of pigments beginning to dry on the outside of the hairs or when it no longer responds properly to your touch.

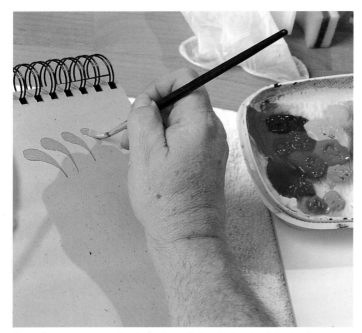

To make a comma stroke, leave the palette with the tip of the brush flattened. Start the stroke by gently pressing the brush on the surface. Pull down slowly, then lift off so that the tip comes to a point.

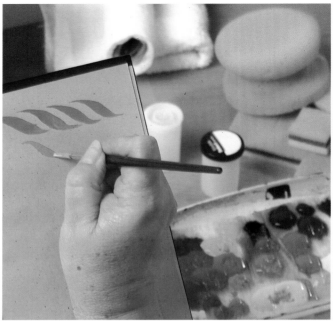

To make an S stroke, leave the palette with the tip of the brush pointed. Start the stroke with a gentle touch, gradually increasing pressure through its center, then releasing it as you slowly pull up, allowing the hairs to regroup.

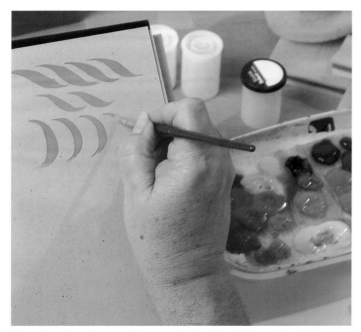

To make a C stroke, use the same technique for painting an S stroke, but make a C shape instead.

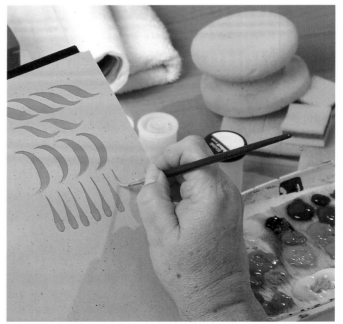

To make a teardrop stroke, leave the palette with the tip of the brush pointed. Begin with lightest pressure, increasing it as you pull the stroke, then stop and lift off cleanly to end.

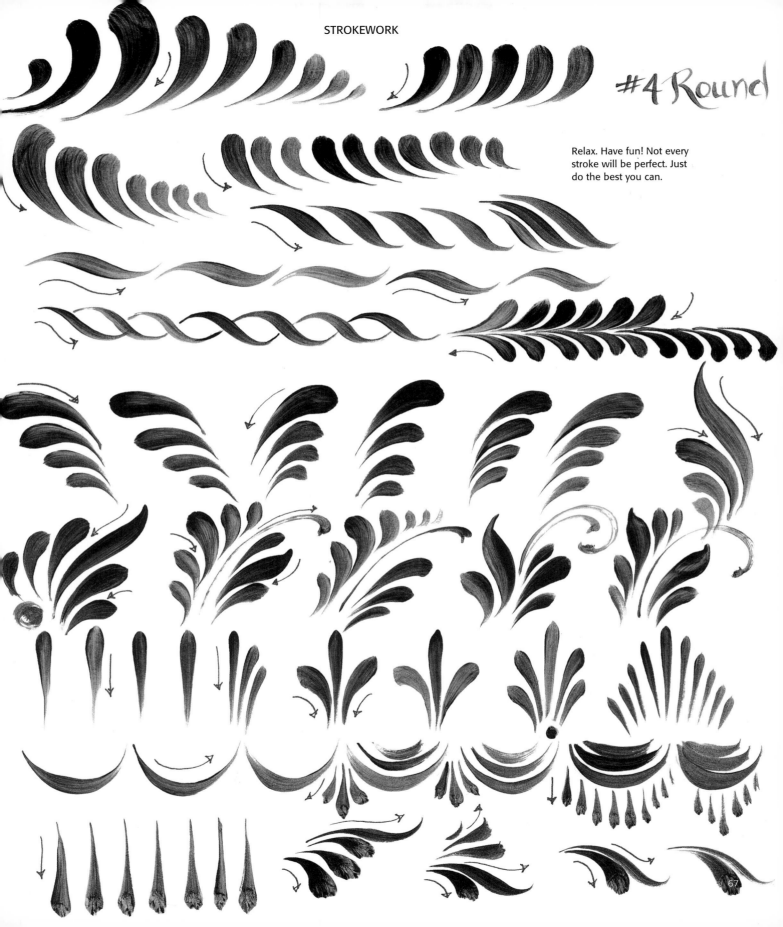

#4 Round

Relax. Have fun! Not every stroke will be perfect. Just do the best you can.

Brush Sketching

#3 round

Learning to draw with your brush is a great way to begin your personal search for style and to develop brush control.

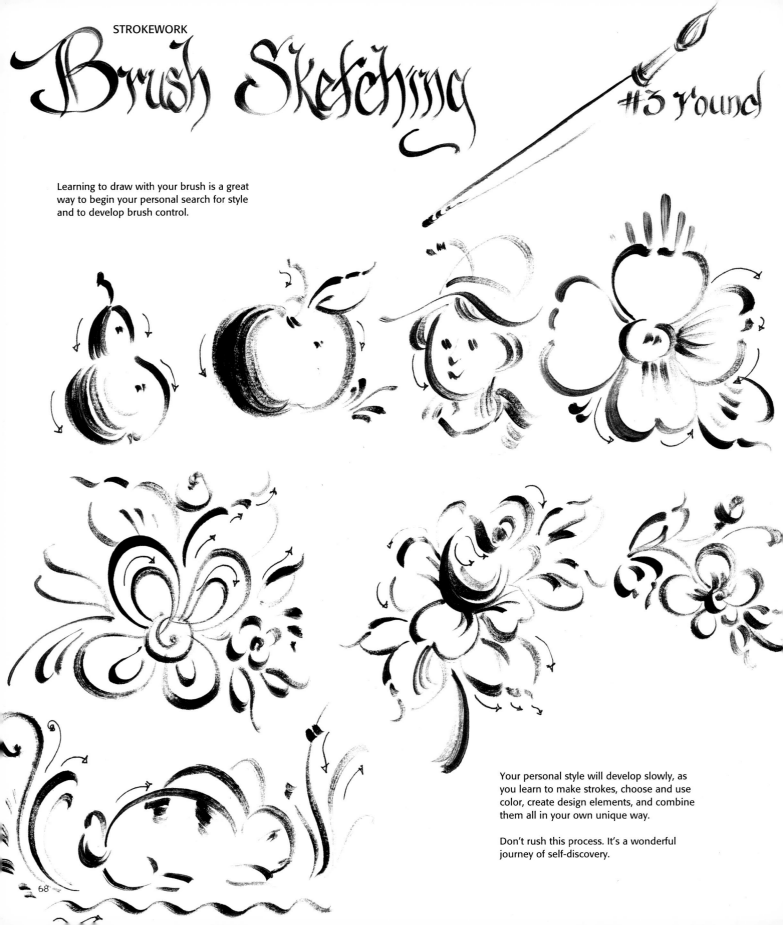

Your personal style will develop slowly, as you learn to make strokes, choose and use color, create design elements, and combine them all in your own unique way.

Don't rush this process. It's a wonderful journey of self-discovery.

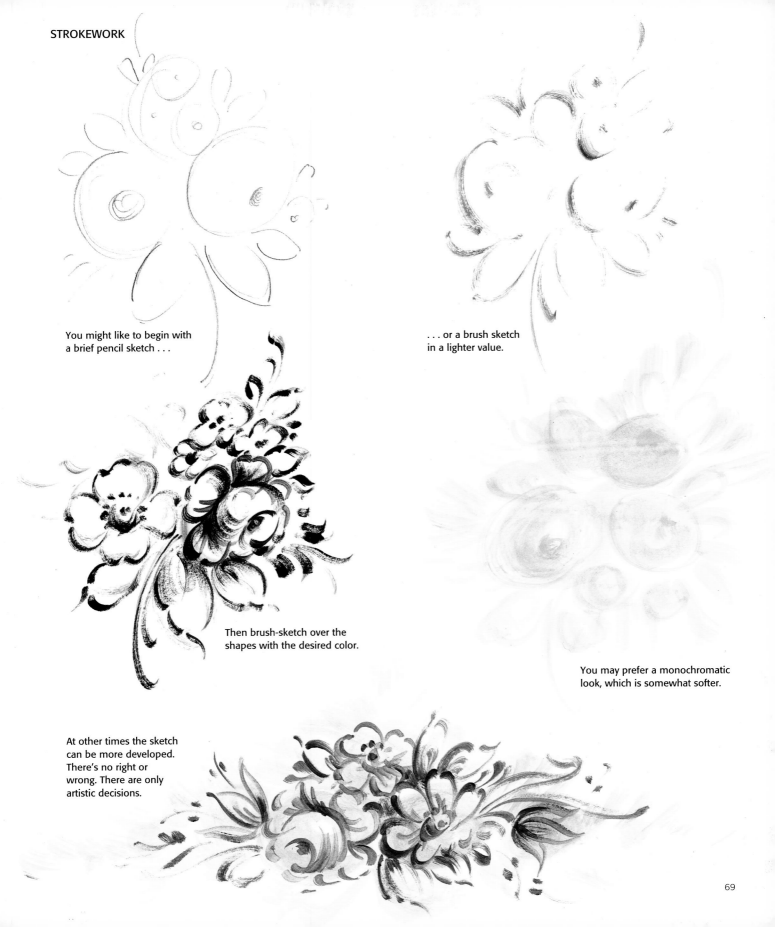

You might like to begin with a brief pencil sketch . . .

. . . or a brush sketch in a lighter value.

Then brush-sketch over the shapes with the desired color.

You may prefer a monochromatic look, which is somewhat softer.

At other times the sketch can be more developed. There's no right or wrong. There are only artistic decisions.

69

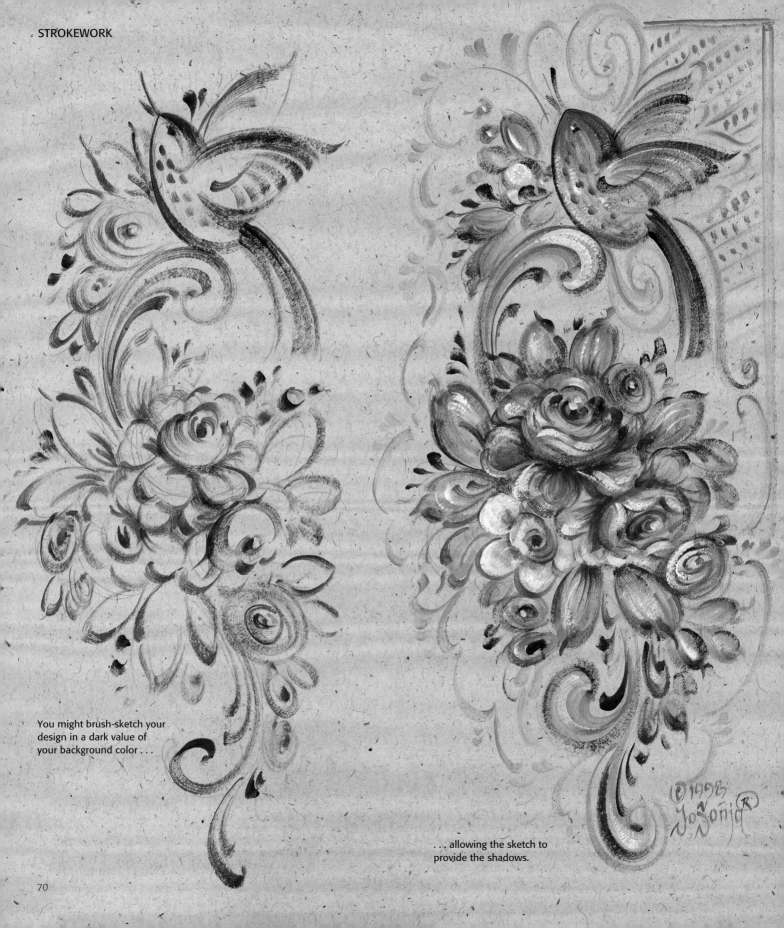

You might brush-sketch your
design in a dark value of
your background color . . .

. . . allowing the sketch to
provide the shadows.

©1998
JoSonja ®

Special Brush-Loading Techniques

In addition to the standard method of dressing a brush described on page 65, a brush can be loaded in unusual ways to create special effects. All brushes can be loaded using the techniques described below. Artists generally feel that flat and filbert brushes are easier to sideload or doubleload, and that round brushes are easier to tip. Being a round brush artist, I learned all these techniques with my round brush.

SIDELOADING

This technique is excellent any time you want gradated color.

1. Dress the brush with a paint medium (any medium will do), leaving the palette with the tip flattened (see page 65). Blot the brush on a paper towel if it seems too wet.

2. Position the brush so that the chisel edge is pointing down, then "slice" the leading edge or corner through creamy consistency paint (see page 64).

3. On a clean area of your paper palette, carefully stroke the brush back and forth several times in one spot, forming a stripe about 1/2 inch long. The brush should be loaded with paint only on one side, then the color should gradually fade to just clear medium on the other.

"Floated" Color. This very old brush-loading technique is essentially the same as sideloading, but the brush contains more medium, which causes the paint to literally "float" on the edge of the stroke as you pull it into the desired shape.

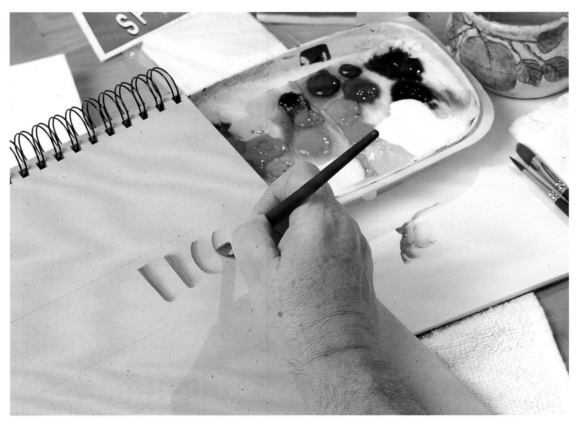

Stroking with a sideloaded brush.

DOUBLELOADING

As its name implies, this technique loads a brush with two colors of paint. The color on the edge of the brush is gradually blended into the main color by stroking the hairs back and forth on the palette. This beautiful old technique is often used today in mass-produced work because it applies two colors in the time it takes to apply just one.

1. Dress the brush with the main color of paint, whose consistency should be creamy. Leave the palette with the hairs flattened.

2. Prepare the second color of paint so that it's just slightly thinner in consistency than the main color. Position the brush so that the chisel edge is pointing down, then "slice" the corner of the brush's edge through the second color.

3. Stroke the brush back and forth in one spot on a clean area of the paper palette so that the color on the side of the brush gradually blends into the main color. (Note that because the stroking usually lessens the intensity of the colors, when doubleloading for rosemaling designs I just load the brush as described in steps 1 and 2, then blend the colors together directly on the painting surface.)

If you want to give a doubleloaded stroke a textured edge so that it will have some dimension, gently touch the corner of the brush that is loaded with the second color to the paint a second time, or leave the palette with a little extra paint on that side of the hairs.

Here, two sets of strokes were made with a doubleloaded brush.

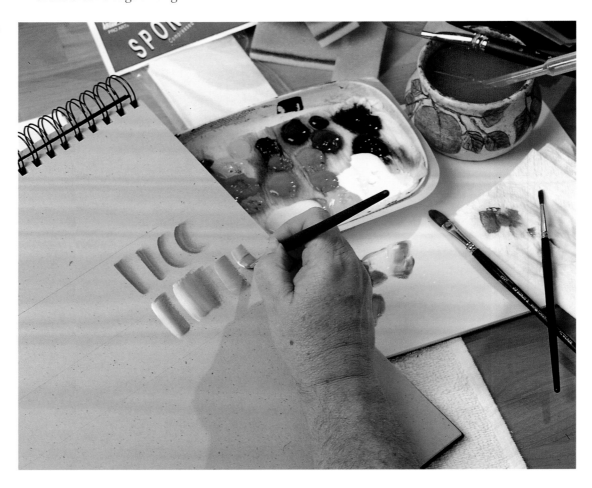

TIPPING

This technique gives decorative artists another way to present two colors in a single brushstroke. The main color of paint should have a creamy consistency, while the second color should be slightly thinner.

1. Dress the brush with the main color of paint. Leave the palette with the hairs pointed.

2. Dip the tip of the brush into the second color.

3. You may use the brush as is, or blend the second color into the main color by gently tapping the brush on the dry paper palette a couple of times.

HEAVILY TEXTURED STROKES

Use this technique whenever you want a dimensional effect.

1. Dress the brush with creamy consistency paint. Leave the palette with the hairs flattened.

2. Using the brush like a spatula, gently scoop the hairs into the side of a puddle of paint (usually the same color with which the brush is dressed). Lift the hairs out of the paint so that the paint sits on top of the flattened brush.

3. Keep the brush in this position as you pull the stroke, so that the extra paint remains on the top side of the brush.

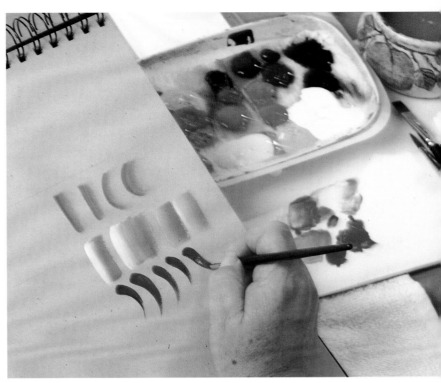

Stroking with a tipped brush.

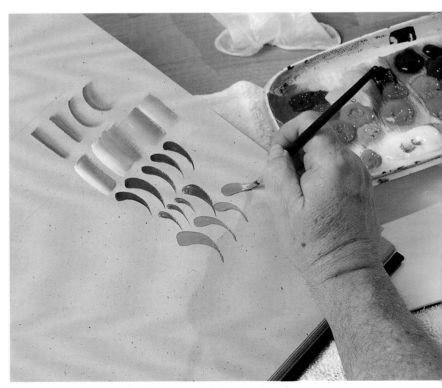

Two sets of heavily textured strokes, one in red, the other in teal.

Lettering

Lettering is another important aspect of decorative painting. If you're a beginning painter and you would like to include some lettering on your piece, here are a few helpful guidelines:

- Define the space or area to be lettered by marking it off with chalk or pencil lines.

- Choose the angle you want the letters to have by making a few slanted guidelines in pencil or chalk.

- All letters should take up about the same amount of space.

- Lowercase letters look best at about two-thirds the height of capitals.

- Allow for the equivalent of two letterspaces between sentences.

- If you're just learning to letter, you may want to lightly pencil or chalk your letters as a guide to painting them, but with experience (which will give you confidence) you'll find it easier to paint them freehand.

While beautiful lettering can add an elegant touch to your design, don't forget the charm of lettering that is slightly imperfect. It's delightful to see old samplers in which the needle artist, having run out of room or simply forgotten, had to stitch a word or letter slightly above a line. Mixing upper- and lowercase is also charming, as is reversing a letter. Of course, such decisions not only proclaim that an artist is very secure about his or her work, but should fit into the overall presentation of a piece.

Practicing strokes and lettering skills within ruled guidelines.

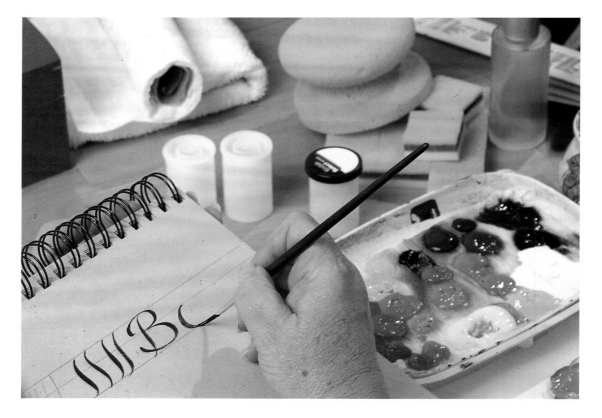

A B C D E F G
H I J K L M N O P
Q R S T U V W X
Y Z 1 2 3 4 5 6 7 8 9 0
a b c d e f g h i j k
l m n o p q r s t u v
w x y z

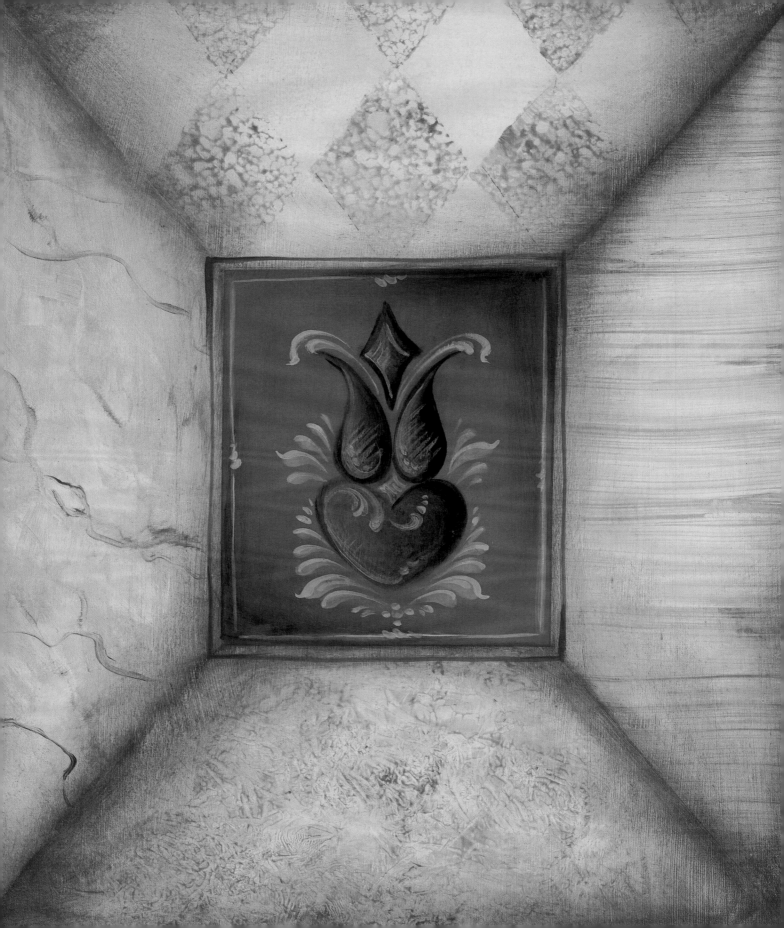

5 Essential Painting and Finishing Techniques

*I*n this chapter, I explain some of the techniques I use to achieve specific decorative effects. In general, the techniques are very accessible and can be easily adapted to accommodate local climatic conditions and personal color preferences. Since results may vary, it's recommended that you practice these techniques on smaller pieces until you develop the confidence and product knowledge necessary for larger surfaces.

Great fun and exciting creative moments can happen when you vary the procedures a little to fit your own tastes. By all means, experiment! To help you explore your own creativity, I want to share my ideas—what I've found helpful, especially in classroom situations, where they've been fully tested, successful, and, most important, fun.

Painting Fundamentals

QUICK DRYING

Unless specifically noted, the drying times of all of the acrylic painting techniques described in this chapter can be accelerated by gently flowing warm air from a hair dryer over the painted surface. Be careful about the use of *hot* air, though, as it may cause the pitch or sap to "rise" from the wood grain. On rare occasions, when many layers of different mediums and varnish have been used, one may see a little *crazing,* or crackling, here and there from using too hot an airflow. This effect is not necessarily unpleasant or undesirable, but it can be avoided by using warm rather than hot air.

An old technique for drying a thin application of oil paints was to "stove" them overnight in a warm oven. This technique also causes some oil colors and varnishes to yellow more quickly, which imparts an antique look to the painting. Quick-drying thickly applied or impasto oil paints must be avoided, because rapid drying forms a tough skin over the top of the paint and inhibits proper curing beneath it.

USING A BARRIER COAT

A *barrier coat* is a transparent coating that is used to seal and protect a painted or decorated surface before the next step or technique is applied. A barrier coat is especially useful if you're a little unsure of what you're about to attempt, either because you have no experience with a particular technique or because you're ambivalent about a color or palette.

If you're working in acrylics, use matte medium or water-based varnish (most sealers form too impenetrable a coating); if you're working in oils, use oil-based varnish. Note, however, that due to the hardness of its resins, varnish may not bond as easily or as well with other layers. In addition, matte mediums and varnishes may contain inexpensive matting agents that will tend to mask or block out some of the previous techniques. If the varnish you've used to isolate the surface has a gloss finish, lightly sand it with #400-grit sandpaper before proceeding to the next step.

Quick-drying an acrylic stain.

Retarding a Surface

When working with acrylics, sometimes it's easier to paint on a slightly moistened surface, especially when blending colors, applying stains and certain faux finishes, or glazing. Water can be used, but retarder allows for a longer "wet time." For oils, a slow-drying medium like linseed oil is the traditional choice for this technique. The main purpose of this technique is to extend the "open" or working time of your paints, and to produce softer and more fluid effects. Every paint company makes its own wetting and retarding agents, so check the technical information of the line of paints you're using, as they can vary greatly. As mentioned earlier, it's best to stay with the brand you've chosen to ensure proper adhesion and maximum durability.

1. Using your 1-inch flat brush, apply a very thin, even film of medium over the area on which you plan to work. Hold your piece so that you can see the sheen of the medium on the surface as you apply it, until the entire surface is covered.

2. Blot the brush well (if you're working with retarder, give it 15 to 20 seconds to penetrate the surface), then brush over the area lightly in all directions to make sure the medium is evenly distributed. The surface is ready for painting.

There are a few special considerations for retarder. When the surface begins to dry, stop painting, then dry the surface well with a hair dryer. Let the surface cool, then reapply the retarder as described above and continue painting. Retarder can dry on its own, but how long that might take depends on how much of it you've used and the climatic conditions you're working under. If retarder is applied too heavily, the colors will run together. If this happens, blot the excess off the surface with a paper towel and brush out the remaining retarder to ensure even coverage.

RETARDER BLENDING FOR ACRYLICS

This technique is very versatile and can be used in conjunction with most of the others in this book if you find that your acrylics are drying a little too fast.

1. Apply retarder following the instructions for "Retarding a Surface," above.

2. Apply a mixture of the undercoat color + retarder. (The proportions will vary, depending on the transparency of the color and the desired effect.)

3. Load your brush with your shading color, pick up a little retarder with it, then pat it on the paper palette to mix them together. Apply the shading color, exerting a little pressure on the brush to soften the application. By picking up a little of the base color underneath, you'll achieve a softer, blended effect.

4. Rinse your brush in water, dip it in retarder, and blot it. Load the brush with the highlight color, add a touch of retarder, then pat the brush on the paper palette to distribute the paint and retarder evenly. Start blending wherever the color will be the lightest.

5. If the surface gets too tacky, stop, let it dry (or quick-dry it as described above), and repeat. It's much better to stop and repeat the process than to continue once the surface has started to dry. You may repeat the process as many times as necessary to achieve the desired effect.

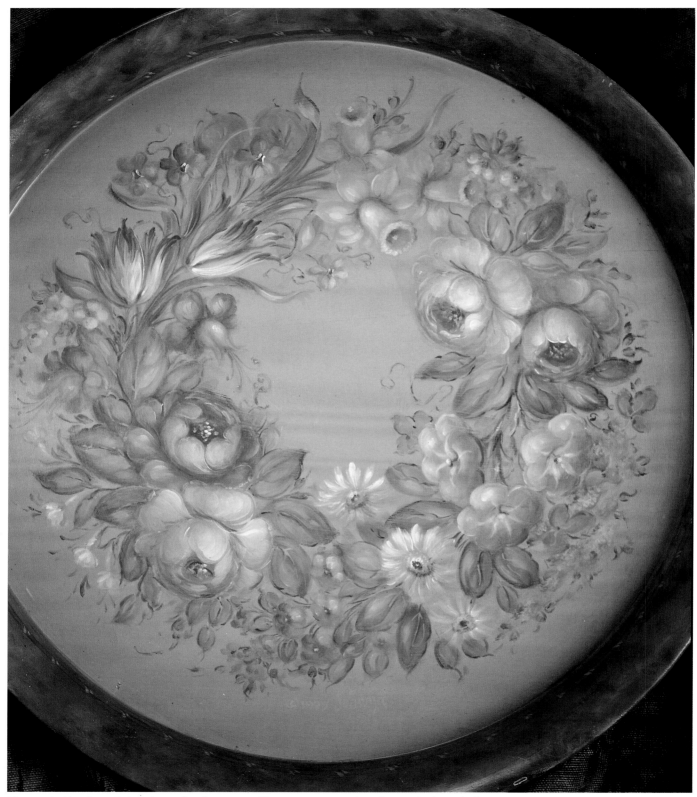

The retarder blending technique for acrylic paints was used here to create smooth gradations of color and value.

Drybrush

The term *drybrush* means to gently brush on small amounts of paint so that the paint film breaks and granulates as it adheres to the surface. Drybrush is wonderful for soft color effects, yielding a lovely look that is especially attractive in today's decors, in which the art of the impressionists is often prominently displayed.

Moisten a 1-inch flat brush with water or retarder, blot it well, dress the very tips of the hairs with a sparse amount of paint, then gently dust the surface. This procedure requires patience and a little practice. At first you'll probably make the brush too wet, or pick up too much paint. Because of this, it's recommended that you work over a barrier coat so that you can wipe off areas you don't like with a water-dampened rag.

The drybrush technique can also be used with oil paints. To ensure proper adhesion, just make sure that any previous layers are completely dry, and moisten your brush with linseed oil or another "fat" medium.

If you want to apply a basecoat with the drybrush technique, you'll find it easier to work with a large boar bristle dusting brush. Not only is its domed shape particularly convenient for reaching into corners and long grooves, but its dense, strong bristles provide the tension and resistance needed for drybrushing on a larger scale.

This effect can also occur while painting strokes if you use a thicker consistency paint and pull the strokes a little faster. I like this look for strokework designs or borders.

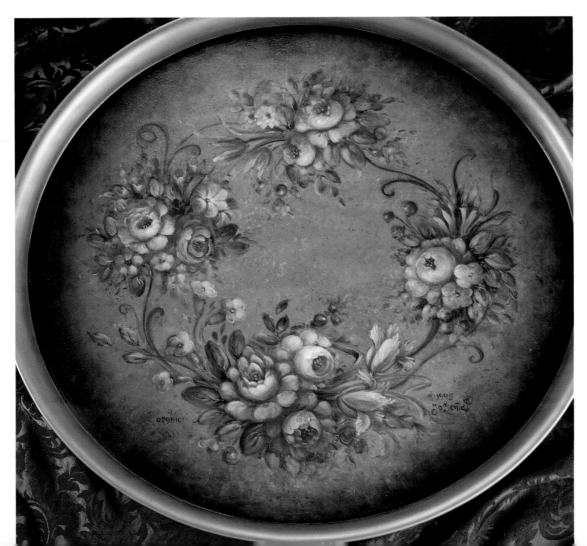

The flowers on this tray were drybrushed over a stippled background. Note the soft, powdery texture of the dried paint. (See page 92 for a discussion of stippling.)

Working with Glazes

These two old pine pieces are decorated with the stain-painting technique. The hutch on the left is painted with a whimsical trompe l'oeil "Blackbird Pie Shoppe" theme for a kitchen, while the smaller cupboard on the right is painted with flax and tiny ivy and will be used for linens. The man sowing flax seed and the woman harvesting flax complete the linen theme (linen is made from flax).

Paint that's been diluted to a translucent liquid—using water, retarder, or a gel medium for acrylics, and mineral spirits or a "fat" medium for oils—is used to create a variety of decorative painting effects, including staining (see page 38), glazing, stain painting, colorwashing, and antiquing. Although these techniques are somewhat similar, and some artists use these terms interchangeably, a stain is generally applied to an entire wood surface and is specifically intended to penetrate and enhance the wood grain, while the other techniques commonly use glazes as paints, so that the dried film sits on top of the surface instead of penetrating it.

STAIN PAINTING

This painting method, which can be done with either acrylics or oils, yields beautiful translucent images that incorporate the color and surface design of the wood grain. Although this technique was originally developed to imitate marquetry, I use it to create a more delicate decorative effect.

1. In most cases, you should prepare the wood as described on pages 32–34, then apply one coat of matte medium. Let dry, then sand well with #320- to #400-grit sandpaper. Wipe the surface with a damp cloth to remove sanding dust. Repeat this step to minimize the possibility of the raising the wood grain, which may be caused by applying multiple coats of retarder.

 Note that the original finish on the antique cupboards shown at left had already been stripped, then paste wax had been applied to the bare wood. I carefully removed all the wax by cleaning the pieces with mineral spirits several times. Because the wood was very old and well-seasoned (hardened by time), it did not need a coat of matte medium before I began painting it.

2. Following the instructions on page 51, lightly transfer your drawing or design with gray stenographite or pencil-rubbed tracing paper, or lightly pencil-sketch your design directly on the prepared surface.

3. Undercoat the elements with thin washes of color. If you're working in acrylics, thin the paint with water; if you're working in oils, use mineral spirits or a "fat" medium. Let dry.

4. Apply a light coat of retarder (for acrylics) or linseed oil or "fat" medium (for oils) over the painting area, which may be the entire painting area, or just the area or element that you want to paint first.

5. Apply background color around the element, fading off or blending its edges into the wood. Since you're working over a wet surface, you may not have to thin your paint, but if you want to, use a compatible medium (either

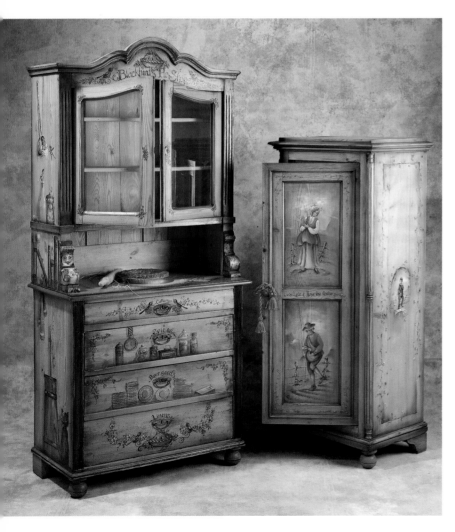

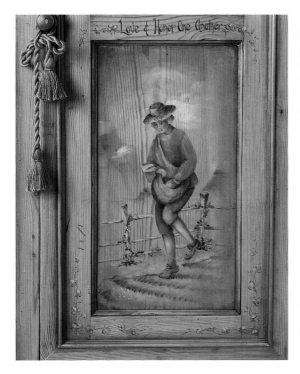

Far left: A detail of the linen cupboard's door panel. Note how the colors blend softly into the wood.

Near left: This view shows one side of the linen cupboard and the top of a tiered cake stand that is also decorated with the stain-painting technique.

retarder or linseed oil). If you're painting a figure in a landscape, the background color might be sky above the horizon line, and grass or ground color below it. Try to work out the color unevenly—more in some areas, less in others—to avoid forming a halo or ring around a motif. Let dry.

6. Again working over a thin coat of retarder, shade the painting by applying dark-value colors. If you wish to thin the color, use the retarder or wetting agent you used on the surface. Let dry.

7. Highlight the elements with light-value colors. Add final details, such as clouds and flowers. A small amount of textured stroking can be a wonderful additional touch to this unusual technique. Usually paint right from the tube has enough texture for this purpose, but a texture medium could also be added for an even stronger contrast.

Acrylic stain paintings can be finished with either varnish or paste wax. Oil stain paintings should only be finished with varnish, as paste wax may soften and remove parts of the painting. Of course, you can paste-wax an oil-painted surface *after* it's been varnished, as long as it's fully cured.

COLORWASH

Colorwash is a dual technique, as it can be used to stain wood as well as to create a decorative painting.

As it relates to staining, the term *colorwash* is used to refer to colors other than those used for traditional wood stains. (The staining of wood with white or a slightly off-white color, called *pickling,* is really a type of colorwash.) In contrast to conventional staining, the colors can be opaque rather than translucent, may penetrate the wood more deeply, and, when allowed to dry between layers, yield more intense coloration. With the colorwash painting technique, a coat of very thin paint is applied to a motif or surface, either by sponging it on or applying it with a brush or rag.

For both types of colorwash, thin acrylics with water or matte medium and oils with linseed oil, and add retarder to acrylics if a longer open time is needed. Paint can be applied evenly or left streaky so that it looks like graining.

GLAZING AND ANTIQUING

The term *glazing* means to apply a thin coat of usually transparent color over a completed painting to enhance textural details, tone down intense colors, simulate aging, or tint specific areas, such as when a yellow glaze is applied over a white flower. *Antiquing* is a glazing technique that is used to enhance the lines and emphasize the structural details of an object rather than just the painting. This type of glazing is applied in the same way as other glazes, but more attention is paid to the development of contrast in order to enhance the details of the object and to merge the painting with the painted surface.

In addition to enhancing the details of a painted object, an antiquing glaze can be used to shade elements of a painted design. Shading and antiquing with the same glaze can help harmonize and tone your palette. Also, applying an antiquing glaze during the painting process—for example, after undercoating, or before highlighting—can give you some beautiful translucent effects. When I'm painting a piece with these techniques I like to begin by antiquing the object. Then, when the painting is finished, I "spot-antique" it, by quickly adding just a few final touches of color, here and there, where more contrast is needed.

Forget all the negatives you've heard about antiquing with acrylics—that they dry too quickly and have a tendency to clump—today's high-quality artists' acrylics are easy to use, fast, odorless, environmentally kind, user friendly, and clean up with soap and water. Before the

These pieces are decorated with the colorwash technique, which intensifies the thinned colors because they are layered over one another instead of blended together.

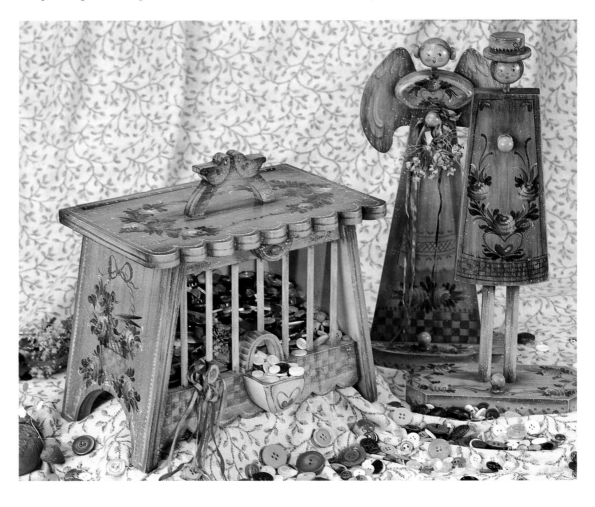

development of acrylics, antiquing was done exclusively in oils, following the technique described below but substituting retarder with linseed oil or another "fat" medium.

Unlike a penetrating stain, in antiquing the color usually sits on the surface of the painting, so proper adhesion between layers is essential. This point is particularly important for oil painters, whose glazes must contain a high enough ratio of "fat" or oil so that they won't flake off the surface over time.

Before you begin, make sure that the paint you're using is heavily pigmented enough to make an antiquing glaze. Because craft acrylics are usually too poorly pigmented to make rich, deep glazes, they often end up making pieces look dirty and coffee stained. Also, it's important that you work out your color choices on a small test item or practice board before committing them to a project.

1. Give the object to be antiqued a barrier coat (see page 78 for complete instructions). Dry to the touch with a hair dryer set on warm or let dry overnight. This step protects the painting and can be omitted when you have more experience with antiquing.

2. Work on only a small area at a time— before you know it, the piece will be done and excitingly beautiful! Apply a thin, even coat of retarder to a specific area, like one side of a small box or the top of a canister. Use a 1-inch brush on small pieces, a 3-inch brush on large ones.

3. Now you're ready to begin antiquing. The brush you use will depend on the size of your piece. For small pieces, use an old no. 10 or 12 or a 1/2-inch flat or filbert; for larger ones, work with a 1- to 1 1/2-inch flat brush.

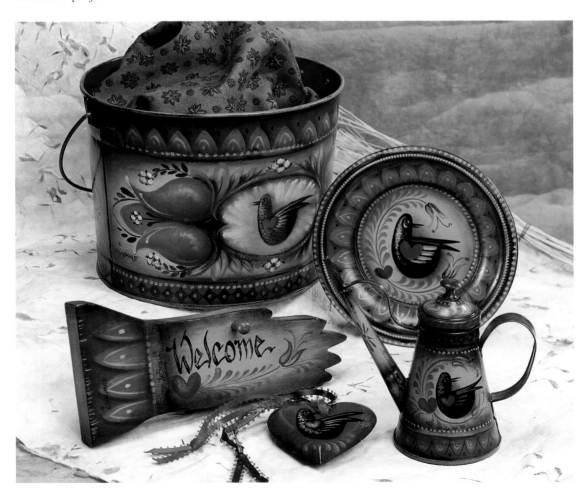

These pieces were antiqued to control the intensity of their basecoat colors and to emphasize the details of the decorative painting.

To ensure that the color will remain workable and to keep "dry" spots from forming, pick up some paint from the wet palette with your brush, bring it to a clean area of your dry palette, add just a tiny touch of retarder, then work the mixture into the brush by stroking it on the dry palette. To keep the glaze looking rich and deeply pigmented, limit the amount of retarder you use. If the glaze is too thin, the piece may look dirty instead of antiqued.

Using a scumbling or small slip-slap motion, apply the glaze, then feather the edges of the application. If you've applied too much, simply blot or pat off the excess with a paper towel.

To soften the effect, stroke the area with a stippler or soft, dry mop brush (on small pieces) or a bristle dusting brush (large ones). Keep this brush dry and wipe it frequently on a clean paper towel as you work. If desired, you can wipe back some highlights with a clean rag.

4. When you're pleased with the result, move on to another area. If you'll be overlapping the area you've just finished, quick-dry it (see page 78), then repeat steps 2 and 3 until the entire piece is antiqued with one layer of glaze.

5. Repeat the process until the desired degree of contrast is reached. If you've obtained a sufficient degree of contrast but you feel the piece looks muddied, you need to use different colors for your glaze. Did you dirty and turn your blues greenish with a burnt umber glaze? Perhaps you'd prefer a Prussian blue + carbon black glaze or a Payne's gray glaze. For you "winter" types, how about a deep purple glaze?

 Sanding back some highlights also helps control the muddy look. Using just a small piece of #150- to #200-grit sandpaper and working on an inconspicuous area first, *gently* cut through the dried glaze, then smooth the surface with #320- to #400-grit. A little bit of Comet cleanser on a water-dampened rag also works well for this purpose, but should be used with care.

6. Once the piece is finished, let it dry thoroughly. The colors may look dull, especially on acrylic-painted pieces, but their sheen will be revived once a varnish is applied. (See page 102 for more information on finishing.)

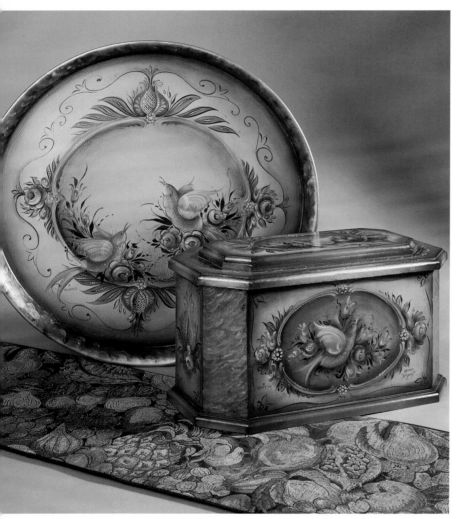

These painted pieces, which also feature a dabby faux tortoiseshell, are further enhanced by antiquing. (See page 95 for a description of the tortoiseshell finish.)

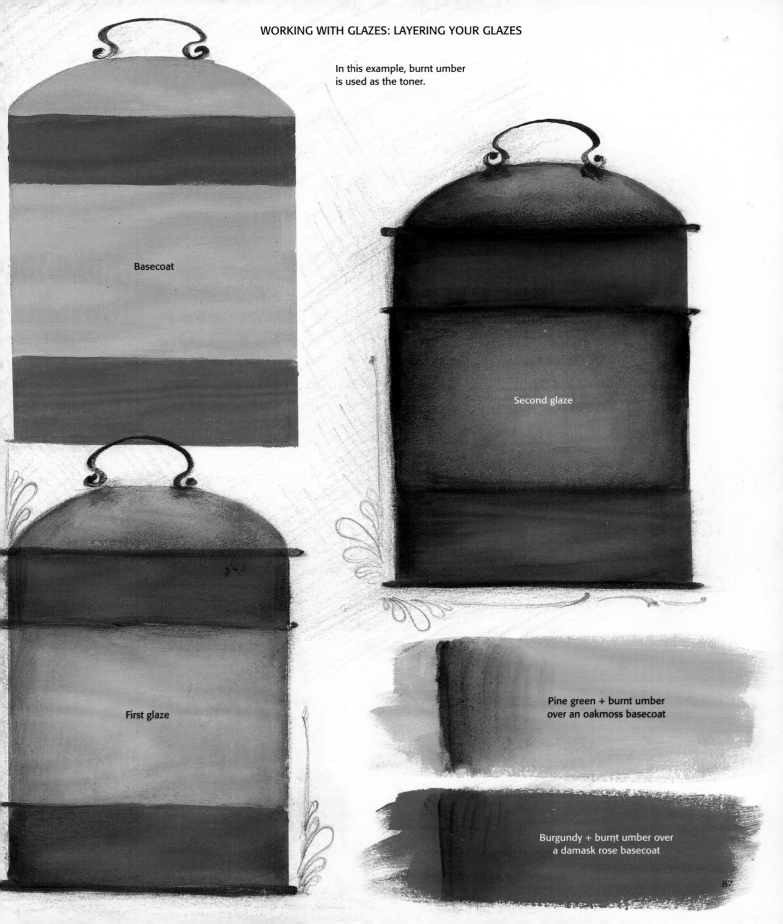

In this example, burnt umber
is used as the toner.

Basecoat

First glaze

Second glaze

Pine green + burnt umber
over an oakmoss basecoat

Burgundy + burnt umber over
a damask rose basecoat

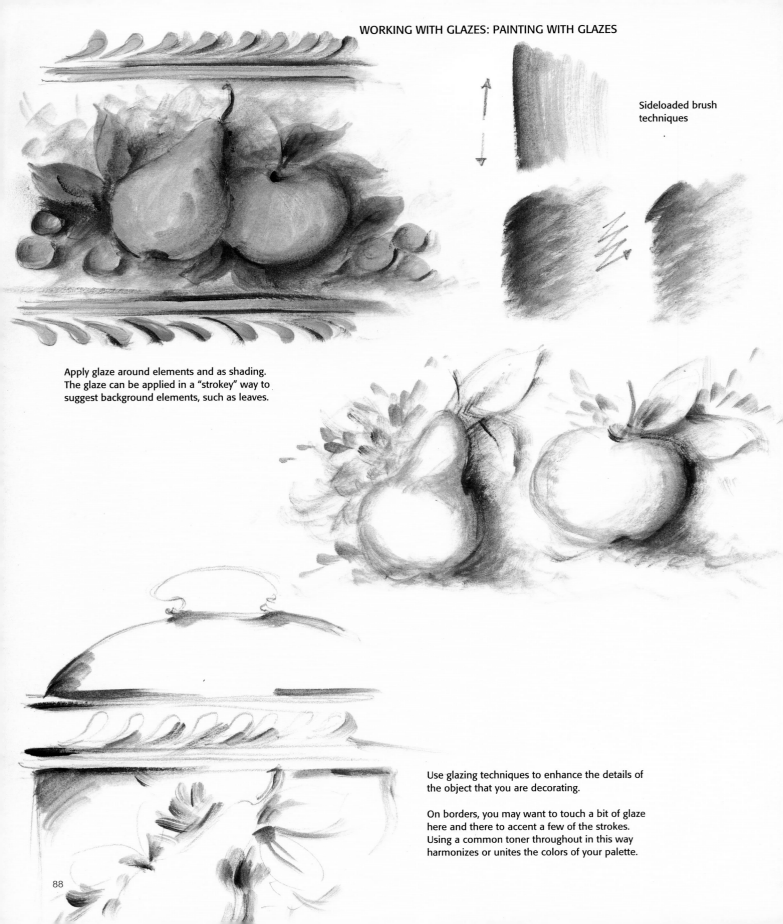

Sideloaded brush
techniques

Apply glaze around elements and as shading.
The glaze can be applied in a "strokey" way to
suggest background elements, such as leaves.

Use glazing techniques to enhance the details of
the object that you are decorating.

On borders, you may want to touch a bit of glaze
here and there to accent a few of the strokes.
Using a common toner throughout in this way
harmonizes or unites the colors of your palette.

Kleister Painting

Kleister is an "old country" term for a faux finish and graining technique that uses a thick medium to create translucent and textural effects. The Swedes and Germans spell it the same but pronounce it differently. (The Swedes say "klee-ster"; the Germans "kleye-ster.") Norwegians were more apt to call it "lasuring."

You probably experimented with some kleister techniques in grade school, using fingerpaints or tempera paints and bookbinder's glue. A flour-and-water mixture consisting of 6 parts water + 1 part wheat flour, bookbinder's glue was the traditional vehicle for pigments for these techniques. The mixture was cooked over medium heat until it reached a boil, stirred frequently to prevent sticking and scorching until it thickened, then removed from the heat and allowed to cool, and again stirred constantly to avoid lumps. The resulting glue remained usable for several days, after which "it stinketh"! Also, little creepy, crawly things loved to eat it.

Today's Kleister Medium, a synthetic water-based paste mixture, is far more agreeable to use. Depending on its consistency, you may be able to use a gel medium to produce similar results. Kleister Medium is added to paints for all traditional kleister graining techniques (see page 90) and for strokework when a combination of transparency and texture is desired, and is used as a fixative for smoked backgrounds (see page 92) and to create depth in marbling.

To realize the possibilities of this medium, place about 1 teaspoon of it on a clean piece of palette paper, then add a small amount of paint to it and mix well. Take a large 1-inch brush and spread the mixture out heavily over a small area. Draw designs in it with a wipe-out tool (a tool that removes paint, such as a comb or the handle end of your brush). Rebrush the area and try some wipe-out effects with a stiff brush. Rebrush it again and try graining techniques with plastic wrap, feathers, or fingers. Still workable! As long as the mixture isn't brushed out too thinly, its texture remains constant.

Extend your working time with Kleister Medium by working in cool, more humid conditions. Stay out of any direct airflow, either warm or cool. Prepare the painting surface well to reduce water absorption through the paint. (In fact, it's a good idea to give the basecoat a barrier coat of matte medium, then let it dry well before applying Kleister Medium.)

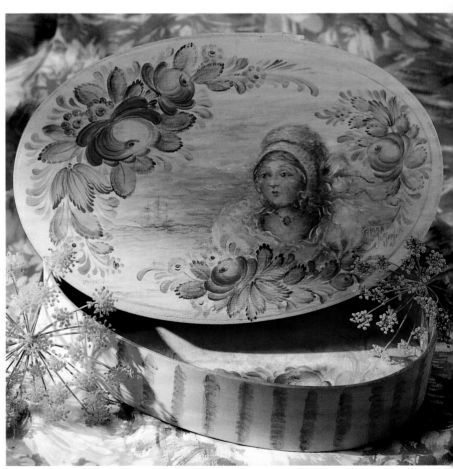

Kleister Medium was used throughout this piece, from the transparent color in the sky and sea to the transparent strokes in the floral design.

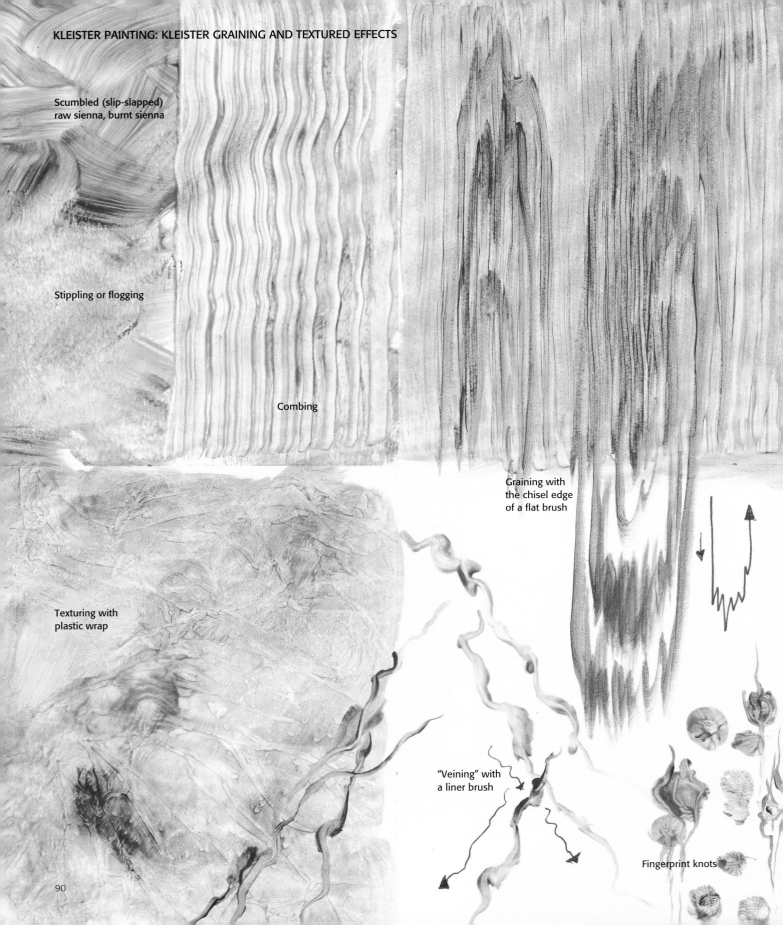

Scumbled (slip-slapped)
raw sienna, burnt sienna

Stippling or flogging

Combing

Graining with
the chisel edge
of a flat brush

Texturing with
plastic wrap

"Veining" with
a liner brush

Fingerprint knots

Faux Finishes

Historically, the faux finishes used by decorative painters were simply decorative effects meant to enhance their painted designs. Marbling, for example, was done very simply, using the colors of the painted design rather than adding new ones to the palette in order to duplicate a material exactly. Imitative techniques are a unique art form in themselves and could compete with the painting. Therefore, our approach is frankly fake and purely decorative. We leave it to the aficionado of faux to imitate.

There are many fine books on faux finishing and other decorative effects that can easily be obtained with a bit of paint, but few are devoted to environmentally conscious techniques using certified nontoxic artist's materials. My emphasis is on decorative treatments that can easily be done at a modest expense, that will provide hours of pleasurable activity and years of enjoyment and satisfaction, that clean up easily with soap and water, and are child and food safe, and durable.

Under normal conditions, most of these techniques will be 80 percent cured in 24 hours and 100 percent cured in two weeks. Unless otherwise stated, all techniques can be layered as soon as the previous layer of paint is dry to the touch. Sometimes overnight drying makes the application of the next layer easier. This is noted wherever applicable. Note that individual differences and environmental conditions—temperature, airflow, and other climatic conditions—can affect the reaction time of some procedures as well as drying and curing times. Test and experiment with a technique before you use it in a project. Just a few minutes of your time and a few scraps of wood or cardboard are all that are required. I cannot stress this enough. These are all techniques that I use and teach, but you must be responsible for how they are used. You must feel comfortable with a technique, making any necessary changes based on your own experience, before you incorporate it into your own projects.

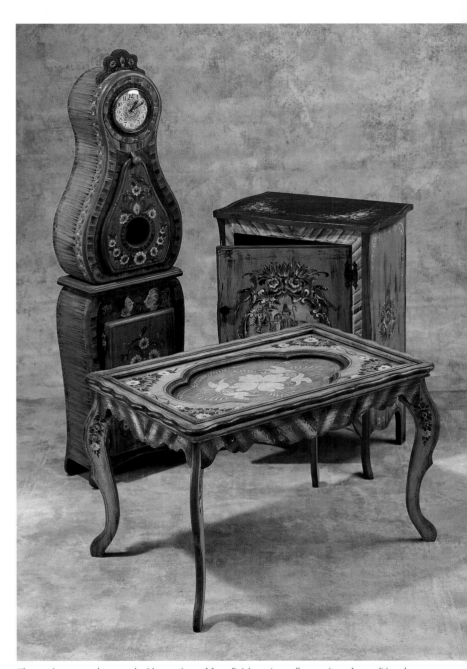

These pieces are decorated with a variety of faux finishes. A smaller version of a traditional Swedish clock (a granddaughter clock) has kleister graining on its sides. The washstand features faux graining and flaking paint (see page 99 for a discussion of this finish). The coffee table is decorated with textured strokes, drybrushing, glazing, spattering, and marbled color stripes.

I've included some projects featuring some faux finishes to entice you and to give you some ideas on how to use them. If you haven't been tempted enough to try the techniques yourself, I hope I've entertained you through my efforts.

MARBLING

Simply stated, marbling approximates the effect of real marble by combining a variegated background with some form of linerwork and dabbing or sponging in contrasting colors.

1. Begin with the basecoat. As you apply its color with a slip-slap motion, pick up another color on your brush and add a touch of it here and there, blending it into the background just a little. Let dry.

2. Lightly retard the surface. If desired, apply a little more of the accent color. Adding Kleister Medium to your paints would help impart a translucent look to the colors that are used. Proportions may vary, and you could use any of the techniques illustrated on the bottom of page 90. Dab, sponge, stipple, or slip-slap some of this color over the surface. Paint "veins" with a liner or striping brush, rotating it gently as you pull it across the surface to give the line a dramatic wiggle. Pull only a few veins at a time, then blend them a little with a fan brush. Repeat until the surface is covered to your liking. Let dry.

3. The finish can be considered complete at this point. If desired, a few more distinctive lines can be added.

SPONGING

With the sponging technique, paint is applied to the surface by pouncing or dabbing it on with a sponge. It is used in various faux finish effects, and can be used to paint simple motifs like trees and bushes. Different sponges will yield different effects. I usually use a small natural sea sponge.

1. Moisten the sponge with water, then wring it dry. Gently load it with a little paint, then work the paint into the sponge on a clean area of the paper palette.

2. Dab the color onto the surface until it is applied as heavily as you want. Reload as needed.

3. If the effect seems too heavy, wash out the sponge with soap and water, then reload it. Wash it again at the end of your sponging session.

STIPPLING

Stippling applies paint by using an up-and-down dabbing motion of a brush. Since it helps if the hairs of the brush you use for this technique are splayed, an old, battered brush of any shape may be used; you could also used a deerfoot stippler or a bristle fan brush. On larger areas, the paint can be brushed on first, then stippled. The size of the area on which you can comfortably stipple the paint before it begins drying will vary, depending on climatic conditions. Using a larger brush will help apply and manipulate paint more quickly on larger areas.

SPATTERING

Known by many names, including splattering and flyspecking, the spattering technique basically sprinkles a surface with paint.

Load a 1-inch flat brush with paint that has been thinned with water, then tap or knock its handle against the handle of another brush. The more water there is in your paint mixture, the larger the dots. A little practice first, please.

SMOKED BACKGROUND

This technique, which creates a mottled effect, is still used today on some Zhostovo trays (see page 149). The traditional method involves giving the prepared painting surface a thin coat of oil-based varnish, then holding it over a burning candle or piece of birch bark. The moist varnish "captures" and holds the soot from the smoke. Careful here—you might burn down the studio! The water-based method, which uses Kleister Medium instead of varnish, is a little safer, but be sure to tie your hair back out of the way or cover it with a shower cap.

1. Basecoat the surface as usual. (Lighter colors work best with this technique.) Let dry, then apply a barrier coat (see page 78). Let dry.

2. Light a candle. Make sure you have a clean palette knife or an old metal spoon on hand.

3. Quickly brush a thick coat of Kleister Medium over the area to be smoked. Holding the surface over the candle flame, touch the edge of the palette knife or spoon to the flame to produce smoke. Work quickly, as the heat from the flame will cause the Kleister Medium to dry quickly. When the Kleister Medium is dry, or you feel that the area is mottled enough, stop.

4. Repeat steps 1 through 3 on the remaining surfaces. If desired, smoke the surface a second time to achieve more depth. (Consider giving the area a barrier coat before resmoking the surface.) With a little practice, you can learn to create subtle patterns.

GRAINING

The term *graining* means to simulate wood grain patterns with paint. These effects can be created with a variety of tools, including commercially manufactured graining tools, a pocket comb, or a 3- to 4-inch-square piece of corrugated cardboard with a few notches cut along one of its edges. (I prefer working with the cardboard.) Graining appears in many different styles of decorative painting, including the English Narrow Boat style, in which oak graining is featured (see page 170).

1. Basecoat the surface with a light-value color such as pale yellow or beige. Let dry.

2. Give the surface a barrier coat (see page 78). Let dry.

3. The next step depends on the effect you want to achieve.
 - *For straight grain,* apply a mixture of a medium-value color + Kleister Medium to the surface. (The ratio of paint to medium will vary, depending on the transparency of the pigment and the depth of color desired.) Comb the glaze with a slightly shaky hand to give the grain some movement. For a more realistic effect, flog the combed grain with a flogger brush by slapping its long bristles against the surface.
 - *For large figured or patterned grain,* load a flat brush with a mixture of medium-value color + Kleister Medium, then use its chisel edge to sketch the grain pattern. Flog the painted grain, then crisp-up areas of contrast with a liner brush loaded with a dark-value color.

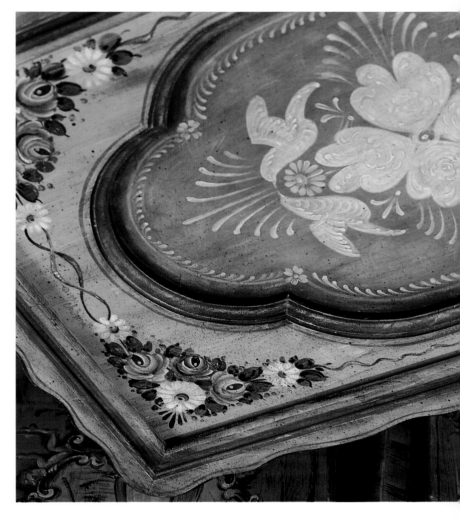

- *To make knots,* use a fingertip lightly loaded with a medium-value color to make a spot, then add details in a dark value with a liner brush.

A closer view of some faux finishes: glazing, drybrushing, spattering, and textured strokes.

Variation: Rosewood Graining. This very old technique, which was popular on early American pieces, looks very attractive as a background for metallic stenciling (see page 95).

1. Basecoat the surface with naphthol red light or naphthol crimson. Let dry.

2. Apply a barrier coat (see page 78). Let dry.

3. Working on one area at a time, apply a mixture of 2 parts Kleister Medium + 1 part carbon black, then comb the wet glaze with a graining tool (such as a piece of notched cardboard), creating any pattern you choose.

Metallic and Iridescent Effects

METAL LEAF

Leafing is a very common method of embellishing painted surfaces. Metal leaf, not only gold but silver, variegated, and copper, are available in small booklets from most art supply stores. From icons to desk boxes, the rich sheen of metal leaf has delighted viewers and made decorated surfaces seem more precious. The following instructions are given for a totally water-based method of applying metal leaf to any surface, as a base for either oil or acrylic paints.

1. Prepare your project as described in Chapter 1, then basecoat or stain the area to be leafed with the desired color.

 Some books and articles on leafing suggest that the surface be painted red to enhance the "glow" of gold leaf, but because I've never noticed any difference, I use whatever color I want. I've heard that, in the past, when real gold leaf was used, an iodine preparation was applied over the basecoat because it reacted chemically with the gold to enrich its sheen, which may explain why everyone seems to recommend a reddish background. Today, imitation gold leaf is generally used for decorative painting.

 Let the basecoat dry, then proceed to step 2.

2. Lightly sand the surface with an old piece of fine sandpaper, then wipe it with a clean, slightly damp cloth. Please make sure the basecoat is smooth, as any surface blemishes will show through the leaf.

3. Use a commercial gold size and follow the label directions, or combine 2 parts Jo Sonja's Tannin Block Sealer with 1 part retarder. Brush on a smooth, even coat of the mixture, then let dry about 10 to 15 minutes, until you can touch it and not leave a fingerprint. It should still feel a little tacky. Apply a second coat of the mixture, then proceed immediately to the next step.

4. As the second coat is drying, cut pieces of waxed paper so that they are slightly larger than the pieces of leaf. Open the book of leaf to the first sheet, then position a piece of waxed paper over the leaf. Gently but firmly press the waxed paper on the leaf until the leaf adheres to the waxed paper and can be lifted away from the book. If you feel you'll need several pieces of leaf for your project, prepare them all at this time.

5. When the surface can be touched without leaving a fingerprint, yet still feels tacky, place the piece of waxed paper leaf side down on the project's surface. Gently but firmly rub the waxed paper until the leaf is pushed down onto the tacky sealer. (Some artists prefer to rub the waxed paper with a cotton ball; I use my thumb.) Gently lift the waxed paper off the leaf. If some of the leaf is still sticking to the waxed paper, continue rubbing until you can remove the waxed paper cleanly.

 Repeat this step, overlapping the edges of the leaf until the desired area is covered. Note that on the tray shown opposite I purposely applied the leaf to create cracks between pieces, but you can apply it so the leaf is seamless. If desired, you can carefully tear the edges of the leaf to avoid creating lines of demarcation where the straight edges of one piece overlap another.

6. If you used a traditional gold size, proceed to step 7. If you used Tannin Block Sealer to adhere the leaf, use a hair dryer to blow hot (rather than warm) air over the leafed surface. As the hot current softens the sealer, the leaf will smooth out and become more brilliant.

7. Allow the leafed surface to cure overnight in a warm area. To remove excess leaf, gently wash the surface with mild soap and water, or lightly brush it with a soft mop brush.

8. Because a leafed surface is extremely susceptible to damage, and because exposed leaf will tarnish, it must be protected with a coat of varnish or sealer. When I want to decorate a leafed surface, I find that All Purpose Sealer provides the greatest adhesion. If you are sealing or varnishing a large leafed area, add a little retarder to the sealer or varnish (about 5 to 10 percent of its volume) so you have more

time to eliminate brushmarks. If you decide you need a lot of retarder (up to 40 to 50 percent of the volume), you should give the leafed area two coats of sealer or varnish.

TORTOISESHELL

The term *tortoiseshell* refers to a dabbed background of several colors, often including gold. Over the years, decorative painters have used many methods to simulate tortoiseshell, as paint provides an inexpensive way to imitate this very costly material. Especially popular on small boxes, fans, and trays of the late 1800s, painted tortoiseshell has been used as a principal embellishment as well as for decorative accents. Designed to be compatible with any surface, the technique outlined below is one of the most beautiful I've ever used, a totally water-based method that can be painted with acrylic or oil decoration.

1. Prepare the surface as described in Chapter 1, basecoating it with the desired color. If needed, use low-tack masking tape to mask off the area to be tortoiseshelled.

2. Thin some gold paint with a little water, then set it aside. Combine equal parts of Clear Glaze Medium and Flow Medium (or use another matte medium and retarder), then apply an even coat of the mixture to the surface. Immediately spatter with the thinned gold paint. While the surface is still wet, spatter it again with isopropyl alcohol. Let dry, or quick-dry as per the instructions on page 78.

3. Brush on a coat of red Wood Stain Glaze. (If desired, substitute the glaze with a mixture of matte medium + transparent brown madder.) Let dry.

4. Repeat steps 2 and 3 until the desired depth of color is reached. On the example shown at right, I spattered the surface with gold paint and alcohol three times and applied two coats of red glaze.

5. Allow the last layer of paint or glaze to dry, then decorate or varnish as desired.

STENCILING WITH METALLIC ACRYLIC PAINTS

There are many different stenciling techniques, but I recommend the following method for those who want to try a totally water-based method of stenciling with metallics. This health-conscious technique uses premixed metallic paints to avoid exposure to toxic metallic powders. For the most satisfactory results, I recommend using only very

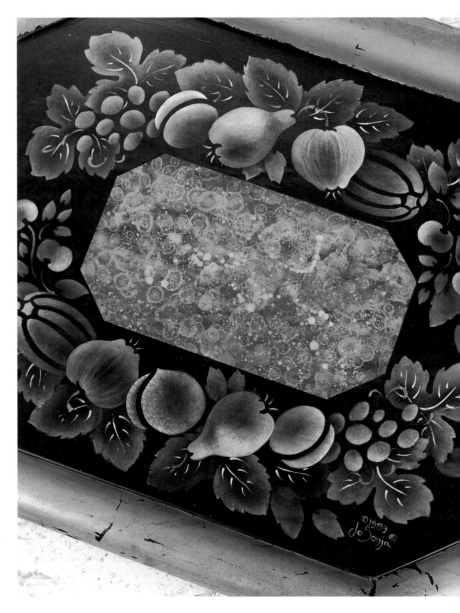

Several metallic effects can be seen on this tray, including gold leaf, tortoiseshell, and stenciling.

high-quality artists' metallic paints, which usually derive their shimmer from bits of crushed mica rather than granulated metal.

For your stencil, you can choose from among the many precut stencils that are sold in home decorating stores, or you can cut your own from Mylar or folder-weight paper. Make your first few attempts at stenciling on practice surfaces; when you feel comfortable with this technique, you can explore other options.

1. Prepare the surface well, then apply a basecoat. Let dry, sand well, then apply a second coat, sanding if needed when dry.

2. Apply a light coat of retarder, wait about 30 seconds for the basecoat to absorb it, then wipe away excess moisture with a lint-free paper towel. Position your first stencil on the slightly moist surface. Hold the stencil in place with one hand, then dip one corner of an old no. 8 or 10 synthetic flat or soft stipple brush into the metallic paint. On a clean area of your paper palette, work the paint into the brush following the instructions for sideloading on page 71. Tap the loaded brush on a clean, dry paper towel to remove excess paint. Using a gentle semicircular dusting motion, begin to apply the paint, starting slightly on the stencil, then brushing it over onto the cutout area. Continue this motion until the desired depth of color is achieved.

 There is a point at which no more color can be added. Also, if the background was too wet, you won't be able to get much pigment to adhere and your color application will seem weak. (The wetter the background, the less color that can be built up.) When this happens, stop, go on to other parts of the stencil (if applicable), then allow the retarder to dry completely before you repeat the entire process. You might also try a gentle pit-pat motion of the brush (called *pouncing* or stippling) to apply more color on the surface, especially in the highlight areas.

 If you have reservations about placing another stencil over an area that is still wet, just handle your stencil units gently and don't push them around. As the retarder evaporates, the possibility of smearing lessens.

3. If there are any "slop-overs," or paint that has seeped underneath the edges of the cutouts onto the surface, don't try to remove them, as it's likely that traces of very fine metallic "dust" will be left behind that won't be visible until you varnish. Instead, let the slop-overs dry, then cover them with a touch-up of basepaint.

4. I encountered only one problem with this technique: When metallic paint is drybrushed or blended this finely, there may be areas in which there is very little binder, which means that loose pigment in those areas can be picked up and moved or smeared when varnish is applied. I found that just by being aware of this problem, and as I gained experience and began to work with the paint more confidently, I was able to avoid it without much effort: I simply do not continue working the paint and moving it out so finely. Therefore, it is essential that you complete a couple of samples before stenciling a project. If you're still anxious about this potential problem, even after running some tests, you have two options: (1) For the areas where you plan to softly blend a very light application of paint, mix the paint with a little Clear Glaze Medium or matte medium (about 10 percent of the volume of paint); or (2) let the completed stencil dry, then spray it with a little fixative before varnishing.

5. Let the first application dry. Use retarder to remoisten only those areas that need more color, then apply more paint as described above.

6. Allow your completed stencil to dry thoroughly for at least 8 hours or overnight in a nice warm place before you glaze or varnish it.

7. Remove dried paint from Mylar stencils with isopropyl alcohol. Eventually the alcohol will remove the Mylar's hazy finish, but I like the stencils better that way because the clear plastic is easier to see through and position.

METALLIC AND IRIDESCENT HIGHLIGHTS

Beautiful effects can be achieved when motifs are highlighted with metallic or iridescent acrylic paints instead of with light-value colors.

- *For basecoating (including insets, borders, banding, and stripes),* basecoat the surface with the desired color, let dry, then apply a light coat of retarder. Starting where you want the strongest highlight to be, slip-slap and blend the metallic colors. The first coat will look messy, so repeat the process two or three times to maximize the beauty and depth of the effect, letting the surface dry naturally or quick-drying it between layers.

- *For decorative painting,* undercoat the composition with medium- or dark-value colors. Let dry, then shade as desired. Once dry, lightly retard the area where you're working, then highlight each element with sideloaded metallic or iridescent strokes. For a softer blend, doubleload the brush by dressing it with the color of the undercoat, then sideloading it with the metallic or iridescent color.

- *For textured highlights,* add a little texture medium to metallic paint. There is a beautiful translucent quality to strokes done with unaltered iridescent paint (to which no texture medium has been added). The peak of a textured iridescent stroke will show a whitish highlight.

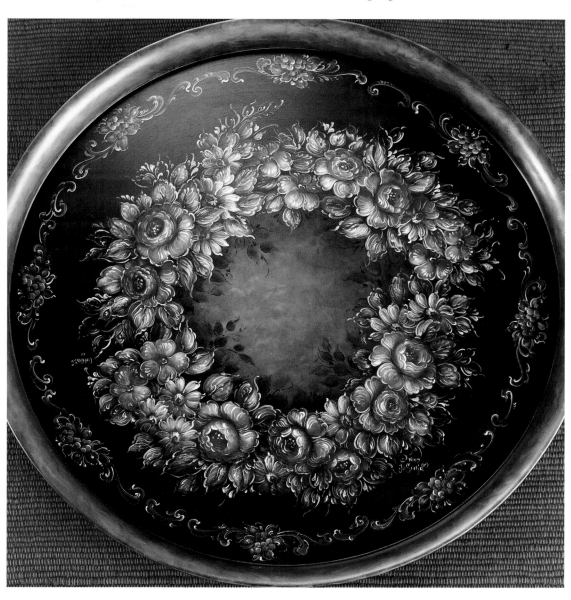

The flowers painted on this tray have been highlighted with metallic and iridescent paints.

MOTHER-OF-PEARL INLAY

Another traditional technique for adding luster to decorative surfaces is to adhere pieces of mother-of-pearl beneath specific areas of a painted design or to incorporate it into a painting. Sometimes mother-of-pearl was cut into a shape (such as a flower); in other instances, small pieces were fit together to create an effect reminiscent of mosaic. Wood, metal, and papier-mâché can all be embellished with mother-of-pearl.

Mother-of-pearl and the materials used to apply it to surfaces can be very hard to find. Investigate its availability at local art supply and craft stores. To avoid inhaling mother-of-pearl dust, which can cause silicosis, a very serious lung condition, wear a dust mask and protective clothing while working with the material.

1. Soften the material by soaking it in very warm water for 5 to 10 minutes. Cut it into shapes with sharp scissors, either working freehand or by transferring a design with gray stenographite to the front of the material before soaking it.

2. Glue the shapes to the surface with a white craft glue or sealer. Let dry overnight.

3. Cover the surface with clay bole or a 1:1 mixture of a good-quality texture medium + basecoat color. (This material serves as a sort of "grout" between the mother-of-pearl "tiles.") Use a rubber spatula to carefully squeegee the excess bole or textured paint from the surface to reveal the mother-of-pearl inlays beneath, then clean the inlays with a water-dampened rag or paper towel. Let dry.

4. Proceed to decorate.

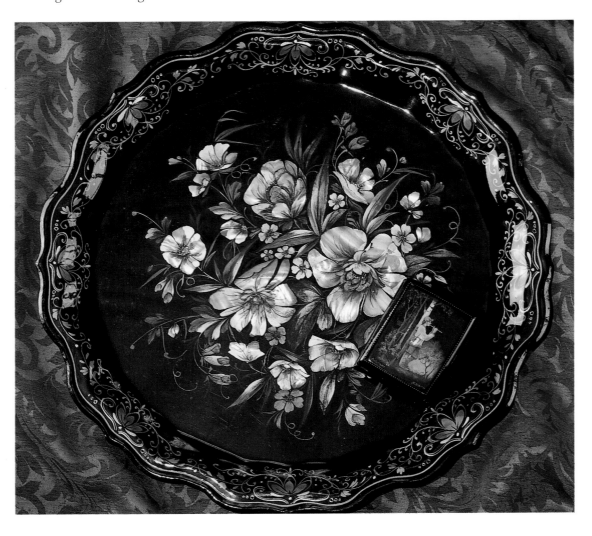

Mother-of-pearl inlays were used on these beautiful Russian pieces.

Distressing and Aging

Exactly when artists began simulating the effects of aged paint is uncertain, but examples of deliberately crackled backgrounds can be found on many old pieces of tin (see page 176 for some French examples), wood, and papier-mâché. The fracturing or breaking of the background color and the painted image tends to soften the overall presentation of the decorated item so that it blends with decors more easily.

FLAKING PAINT

Glue Method. This easy water-based technique is surprisingly realistic. I use LePage's Mucilage glue, which is available at most stationery stores.

1. Stain or basecoat the item as desired. This surface will be revealed in the "chipped-off" areas of the final effect. Let dry well.

2. Combine 2 parts water + 1 part glue. Sparsely load an old flat or filbert brush with the thinned glue, then sparingly brush it on the surface wherever you want the top coat of paint to flake on the finished piece. Keep in mind that it's easy to overdo this effect. Letting the glue "granulate" as you stroke it on, as you would when applying paint with the drybrush technique (see page 81), produces an attractive result. Let dry.

3. Apply the top coat of paint as thinly as possible. You may need to thin your paint a little with water for greater ease of application. Do not overwork the paint or it will blend into the glue.

4. Decorate the surface as you usually would. Simple or more primitive stroke styles are generally better suited to the final effect. Let dry well.

5. Working on one surface at a time, liberally apply hot water. (I apply water that I've run through the coffee machine with a 1- or 1½-inch brush.) Let stand 1 to 2 minutes, reload the brush with hot water, brush it on again, then gently rub the surface with the brush. The paint that was applied over the glue will begin to buckle and flake off wherever it is

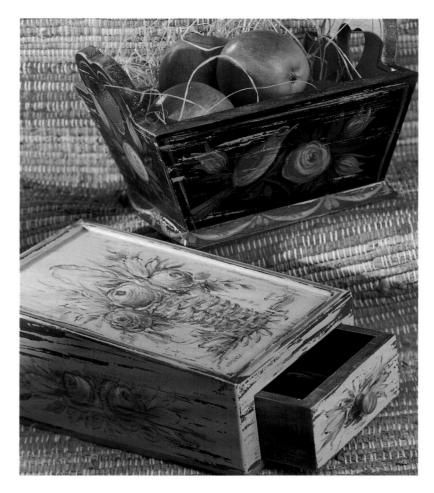

rubbed gently with the brush. Continue to work in this manner until all the glue has been removed. Let dry.

6. Finish the piece as desired, either with varnish or paste wax.

Wax-Resist Method. This method of flaking paint is used with the Tolz rose style of decorative painting. The examples on page 125 and the instructions below feature a fruitwood stain, but you may use any color you wish.

1. Stain-seal the item (see page 38) with a warm fruitwood-colored stain by mixing matte medium with a little raw sienna + a touch of brown earth. Retarder may be added if a longer working time is needed. Let dry.

These pieces were distressed using the glue method of the flaking paint technique.

2. Sand the surface with #320- to #400-grit sandpaper, then remove sanding dust with a clean damp rag. Rub the surface with a piece of wax (a paraffin block or a piece of a candle) wherever you want the flaking paint effect to appear.

3. Apply the top coat of paint using a slip-slap motion, leaving some of the stained wood visible. This layer of paint also looks nice when it's been slightly mottled with other colors or values of paint applied with a drybrush, stipple, or dabby technique. Let dry.

4. Decorate the surface as you usually would, allowing the paint to dry naturally. (No quick-drying here, please.)

5. Use your fingernail or a palette knife to gently scrape off some of the wax. A little mineral spirits on a paper towel may be used to remove more.

6. Finish the piece with a coat of paste wax. (Because wax was used as the resist, paste wax is the only finish that can be used.) If desired, lightly tint the paste wax with a brown oil paint (such as burnt umber) or use a brown shoe wax. To apply the latter, rub a small amount of clear paste wax over the center of the design, then rub the brown shoe polish around its edges, carefully feathering the color into the clear wax in an uneven manner so as not to artificially "halo" the design.

CRACKLING

There are many different crackle products and techniques used today. This one is my favorite. In this method, the crackle medium actually penetrates the paint layer, causing it to separate. With practice, you'll be able to produce a variety of results. The surface can be decorated either before or after applying a crackle finish. If your painting will take a long time to complete (four days or more), you might want to crackle the background *before* you paint, since it may not crackle if it's allowed to dry for too long.

I prefer to use Jo Sonja Crackle Medium for this technique, but since there are many other types and brands of crackle medium available, you should carefully follow the directions provided for the product you've chosen.

Before you begin, consider that the appearance of the crackle pattern is determined by:

- The depth of the background color (the number of coats of basepaint that were applied)

- The freshness of the basecoat (it should not be quick-dried)

- The thickness of the crackle medium

- The rate at which the crackle medium dries. Porcelainlike crackle patterns develop when the medium is permitted to dry at a slow, steady rate, under normal room conditions and air movement. The surface may not crackle in cold rooms, or in rooms that have poor air movement, which is frequently the case in basements.

1. Basecoat the area to be crackled with two to three coats of paint. Let each coat dry naturally (no quick-drying, please).

2. Generously apply Jo Sonja Crackle Medium with a large soft brush. Load the brush with medium, lay the loaded brush on the painting surface, then slip-slap the surface slightly. Some areas will be smoother than others. Once you've applied the medium, leave it alone. The chemical reaction begins immediately, so if you brush over the surface again the process will be disturbed.

3. Check the edges of the piece about 5 to 7 minutes after applying the crackle medium. If you don't see some cracks just starting to develop, move the piece to another area within the room where the air movement is better. If you still don't see any cracks, you probably haven't applied enough crackle medium. Before you can fully assess the results, allow the surface to dry naturally, preferably overnight.

4. If you're pleased with the results, sand the surface, first with #180- to #200-grit sandpaper, then with #320- to #400-grit. (Dry crackle medium sands very easily.) The crackle pattern can be emphasized by applying a layer of dark glaze, such as burnt umber or black.

If you're disappointed with the effect, don't reapply the medium; all you'll get is a very fine frosted look. Sand back the medium completely and start again at the basecoating step.

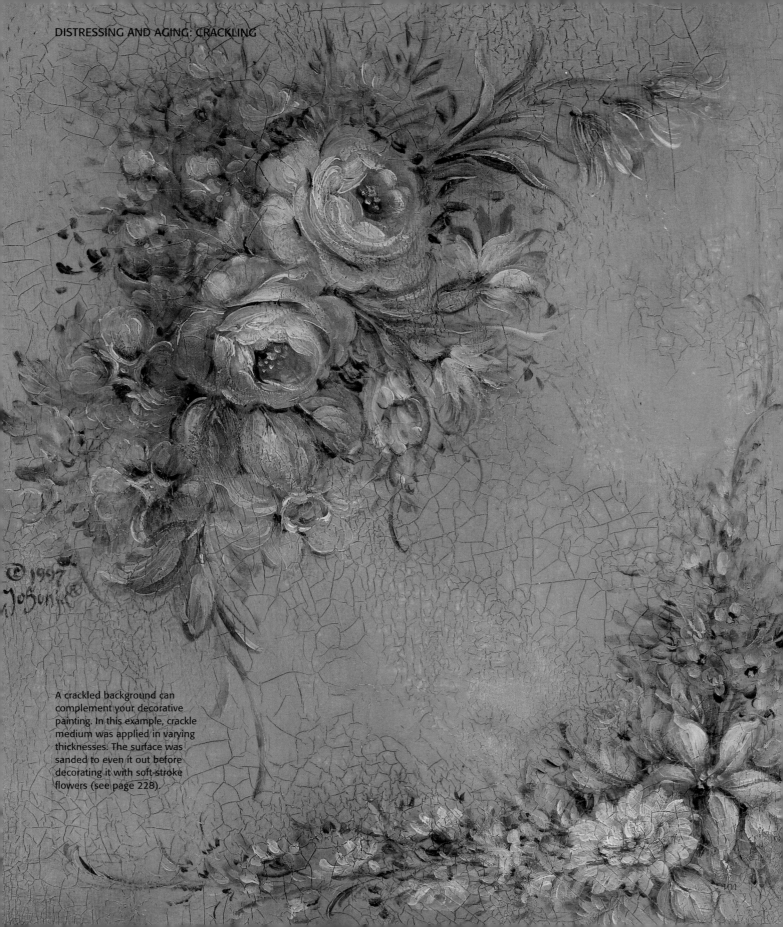

© 1997
Jo Sonja

A crackled background can
complement your decorative
painting. In this example, crackle
medium was applied in varying
thicknesses. The surface was
sanded to even it out before
decorating it with soft-stroke
flowers (see page 228).

Finishing Techniques

In basic terms, a finish is a substance that is applied to a completed project to protect its surface. Although in the past decoratively painted pieces were not ordinarily finished, many of today's decorative painters prefer at least a light bit of finish for the protection it provides.

VARNISH

Not all varnishes are the same, but the differences among them are fairly simple. Polyurethane varnishes are the hardest, most durable finishes available, and are made in both oil- and water-based formulations. While oil-based varnishes are generally easy to apply, they all eventually yellow. (It may take a couple of years, but it will happen.) For this reason, I finish my pieces with water-based polyurethane varnish. High-quality water-based polyurethane varnishes don't yellow, dry more quickly than their oil-based counterparts, are environmentally friendly, and can be cleaned up with soap and water.

I prefer the Jo Sonja line of water-based polyurethane varnishes, which are made in matte and gloss sheens. This brand of varnish has good brushing qualities, dries to a clear finish, is food- and child-safe when cured, has excellent long-term durability, and can be used on indoor or outdoor projects. I've used this varnish on pieces that have been outdoors for over 14 years and their finishes are still in perfect condition.

Regardless of which varnish you use, always follow label instructions and apply it in a clean, lint-free environment. Varnish your piece within a month or two of completing it. For best results, allow a freshly painted surface to cure at least one day to make sure it is thoroughly dry. (Quick-drying can reduce drying time but doesn't necessarily cure the paint.) If you're going to varnish an acrylic-painted piece with an oil-based varnish, it's best to let it cure completely (2 to 4 weeks); otherwise, the varnish may trap any remaining moisture, which could damage the varnish film. A newly completed (but fully cured) piece can be given a barrier coat before varnishing to seal the painted surface and to make the varnish easier to apply.

1. Before you begin, gently shake or stir the varnish well to ensure that the ingredients are evenly disbursed.

2. Dress a dry, soft-bristled brush with varnish. Working on a small, manageable area, apply a very thin film of varnish using a criss-cross pattern or a slip-slap motion, then smooth the strokes in the direction of the wood grain. Repeat until the entire surface is covered.

 If the varnish is applied too heavily, it may "clump," or roll up, on the surface. This problem can usually be avoided by applying thinner coats. (Clumping may also occur over areas that haven't dried completely, especially where retarder was used repeatedly for blending, or where a tack cloth was used.)

3. Additional coats may be applied as soon as the preceding coat is dry to the touch. If you're using an oil-based varnish, apply one or two coats of a high-quality product, either matte or satin sheen. For a water-based varnish, two or three coats are adequate; apply four for an alcohol-resistant finish.

 When working with water-based varnish, applying multiple coats is easier if you allow at least 1 hour between coats, as there will be less "drag" on the brush. Reduce the drying time by blowing a gentle stream of warm air across the surface with a hair dryer. Allow the surface to cool to room temperature before proceeding. (Water-based varnish dries too quickly when it's applied to a warm surface.) NOTE: If water-based varnish is applied over a painting in which the retarder is not fully cured, the varnish will take longer than normal to dry. If the first coat of varnish appears to be drying slowly, simply allow it to dry thoroughly (preferably overnight) so that it will completely seal the surface, then apply the remaining coats.

There's no need to sand between coats if they're applied in rapid succession, but if a layer of water-based varnish has dried for more than 24 hours, a light sanding is required before the next coat is applied. Do not use a tack cloth to remove dust or sanding residue from the dried surface; instead, wipe it with a slightly dampened lint-free cloth, a large dry brush, or your clean hand.

4. Once the varnish is fully cured, it may be paste-waxed with a good-quality, nonabrasive furniture wax. (See "Wax," below.)

Tinted Varnish. Tinted varnish (sometimes called "dirty varnish") was traditionally used to give objects an aged look. In this technique, a brown paint such as raw umber was lightly streaked across the area as the varnish was applied.

1. Dress the brush with varnish, then dip the corner of the brush into some raw umber paint. Stroke the brush several times on a clean, dry area of the paper palette to incorporate the paint into the varnish a little.

2. Using a flowing, back-and-forth motion, apply the varnish, allowing the color to streak across the surface. Be careful not to overblend the color. If you're working with water-based varnish, you may need to thin it with a little water for easier application.

A Touch of Glitter. A very small touch of metallic gold paint may be added to your varnish to provide just a hint of glitter in the finish coat. Practice this technique on the back of an item first, as it is very easy to overdo.

WAX

A very durable (though indoors-only) finish, wax can be applied directly to a completed acrylic painting or over its varnished surface. Oil paintings must be protected with a coat of varnish before wax can be applied.

Applying wax to a stained surface.

1. Apply one thin coat of a good-quality wax, one rich in carnauba and/or microcrystalline wax. (I like Clapham's Wax.) Use a clean rag or terrycloth towel to rub the wax over the surface in a semicircular motion.

2. Let the wax dry about 1 to 2 minutes, then buff it with a soft clean cloth.

 Alternatively, you can let the wax dry for a minute or two, then spray the surface with Pledge furniture wax (the aerosol type). Rub the surface with your hand until the wax separates and water droplets appear. (Don't panic if the wax clumps a little.) Buff to the desired sheen.

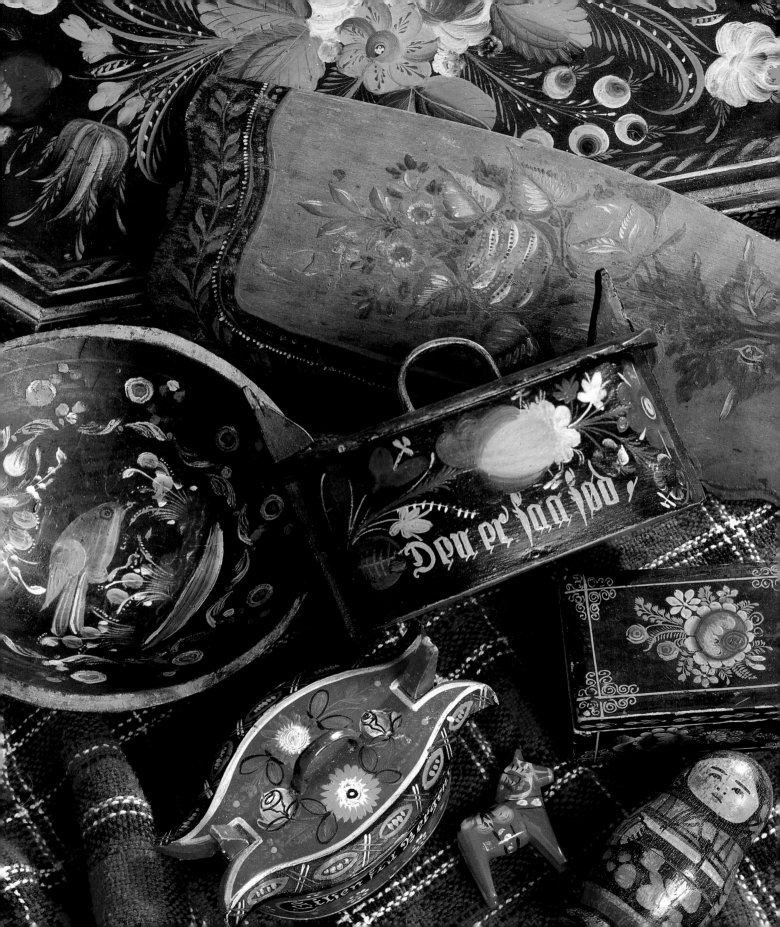

6 *Traditional Influences*

*I*t was a time of change in northern Europe. Travel was becoming easier and safer. Trade between countries was growing. More businesses appeared as opportunities increased.

The firepit in the center of the room became a fireplace or stove in the corner. No longer did the smoke from the fire darken everything with soot before finally finding its way out of the hole in the roof. A special room could be built for receiving company. It needed decorating. Churches were being decorated—could those ideas be reproduced in the home? Decorated items were imported from the Orient. Everything was painted, from window shades to ladies' fans. And what gentleman of fashion would dare be seen without his decorated snuffbox?

Paints, brushes, and books of designs began to be available. The interest in painted decoration grew. And so the need arose for artists who could produce images in a stylized manner, images that could be painted simply, not only so that they could be done quickly (and thus inexpensively) but also to enhance the decorative character of objects.

Who were the folk artists? What did they do? What makes their work different from that of fine artists? And why and how did different styles of painting develop? This chapter is an introduction to decorative painting—its artistic significance, its practical purpose—an overview of the history of several styles and techniques, and a tribute to the pleasure derived from making something for someone else.

The Writing of an Icon

It is said that an icon is written, not painted. To Orthodox Christian faithful, an icon is a visual expression of the Word of God written by the artist's brush.

Tracing its beginnings to the earliest of all Christian arts, the murals of the catacombs, the writing of icons has remained virtually unchanged for almost 2,000 years. Legend is intertwined with this art form's history, which is also accompanied by beautiful feelings and deep spirituality. From Palestine, Syria, and Greece to Russia in the 11th century, the tradition continued. When the Christian church officially divided into the Orthodox church of the East and the Roman Catholic church of the West, the Orthodox church continued the tradition and passed a series of canons (church laws) regarding the writing of an icon.

Because most icons were unsigned, only a few of the names of the old icon masters who wrote these precious works of faith and prayer are known—Theophanes the Greek, Andrei Rublen, and Dionysius. We hear of many different artists working on one icon: one doing the face, another the gold leaf, another adding the buildings. No matter what the task, it was done with deep religious feeling, prayer, and sometimes fasting. Today, an iconographer may sign the back of an icon with "Written by the hand of . . . ," realizing that he or she is simply the instrument of the Holy Spirit and that this creative expression is also a spiritual devotion.

There are a number of broad categories of icon, determined by subject matter, from Christ as a child in his mother's arms, the Immanuel, to pictures of saints. A grouping of several icons is called an *iconostasis*. These groupings grace the walls of Orthodox churches, reminding the faithful to attend to their spiritual needs.

Who can look at these works of art—eyes of compassion gently reminding us of heavenly concern—some of which have survived four or more centuries, and not be impressed by the influence on and the comfort they have given humanity?

TECHNICAL NOTES

Traditionally, an icon is begun by carefully selecting pieces of wood, then gluing them together using best joinery techniques to prevent warping. A finely woven piece of muslin or linen is glued to the board with animal hide glue; once dry, the surface of the cloth is given twelve to twenty coats of white gesso. Repeated sanding and handrubbing leaves the surface exceptionally smooth and hard, ready to receive the image.

The traditional medium for icon painting is egg tempera. After carefully separating the egg yolk from the white, the yolk is gently held in the hand, the sac is pierced, and the soft yellow center is allowed to run into a clean container. The yolk is mixed well with an equal amount of water; this binder is then added to finely ground artists' quality dry tempera pigments. The color is applied to the foundation in translucent layers, each of which is allowed to dry before the next is applied. The painting progresses from dark to light values, reflecting God's creation of the universe.

Acrylics can be used with surprising accuracy to simulate effects that were once achieved with egg tempera. Matte medium stands in for the egg yolk binder and acrylic paints replace the ground pigments. The depth to which the painting surface can be developed simply depends on your patience and your willingness to apply several translucent layers of paint instead of a few opaque ones.

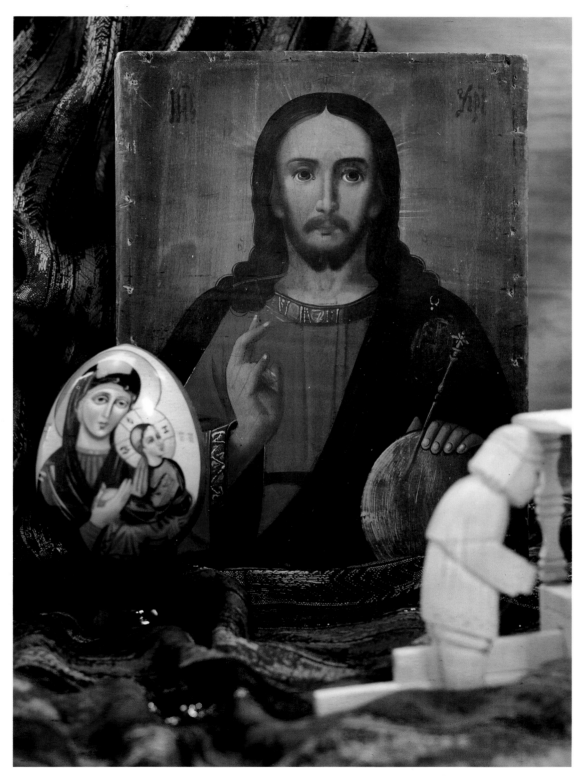

The painting of Christ was probably an old family icon, which would have been displayed in a home rather than in a church, where icons were more elaborate. The area where the original frame was attached is still visible. The painted Russian egg is a modern example, beautifully done, and is probably secular work. The egg, an ancient symbol of rebirth, is a cherished Orthodox symbol of Christ's resurrection.

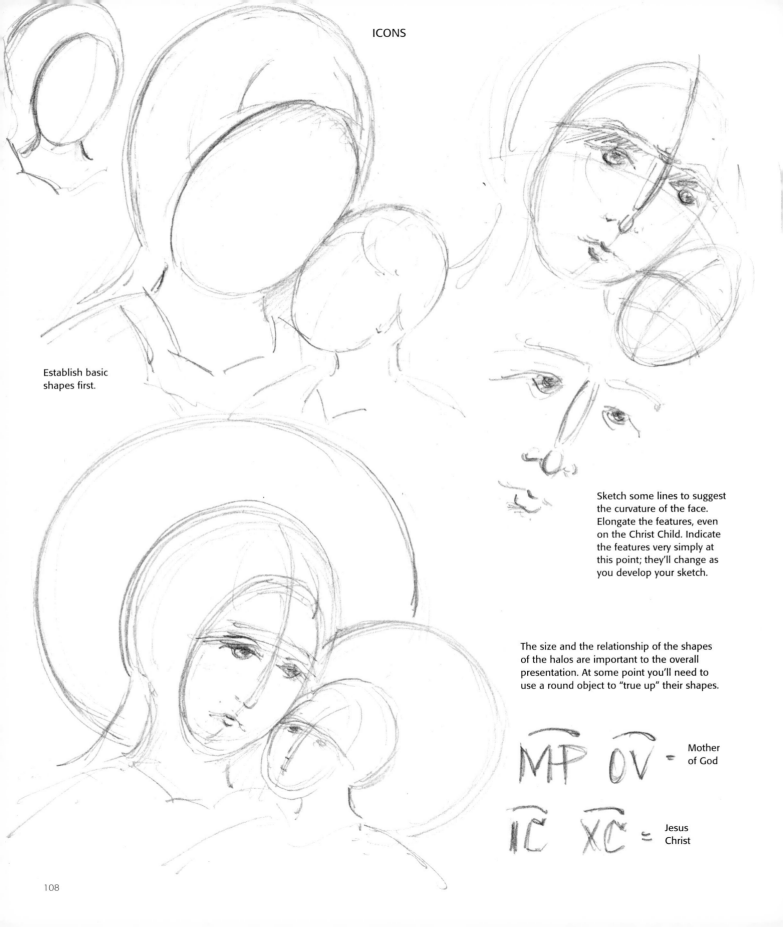

Establish basic shapes first.

Sketch some lines to suggest the curvature of the face. Elongate the features, even on the Christ Child. Indicate the features very simply at this point; they'll change as you develop your sketch.

The size and the relationship of the shapes of the halos are important to the overall presentation. At some point you'll need to use a round object to "true up" their shapes.

\overbrace{MP} \overbrace{OV} = Mother of God

\overbrace{IC} \overbrace{XC} = Jesus Christ

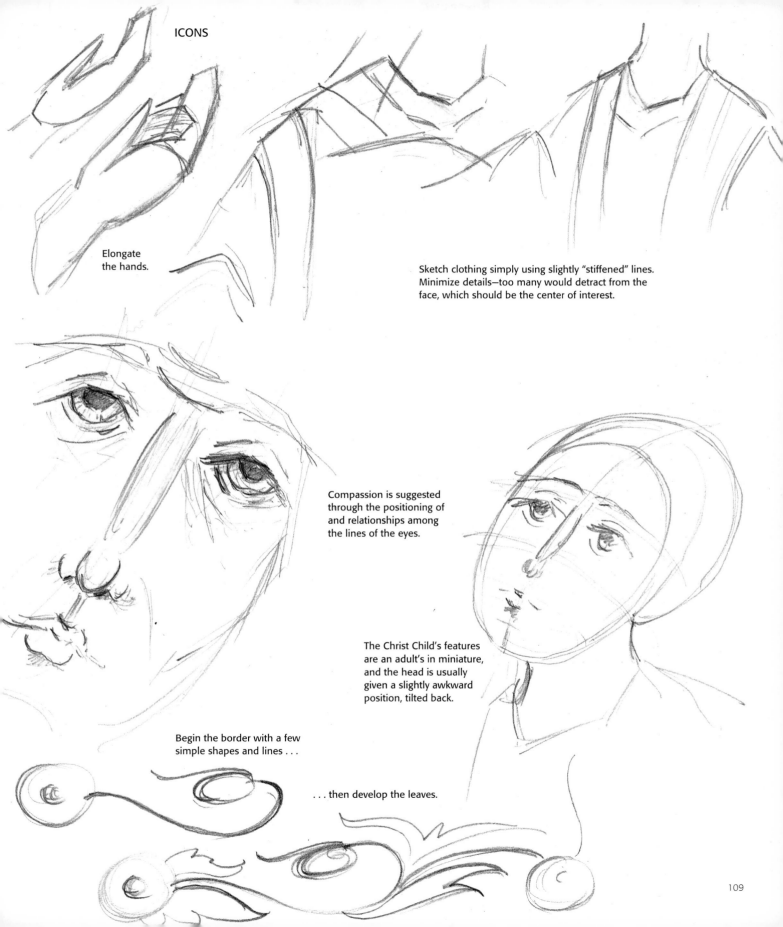

Elongate
the hands.

Sketch clothing simply using slightly "stiffened" lines.
Minimize details—too many would detract from the
face, which should be the center of interest.

Compassion is suggested
through the positioning of
and relationships among
the lines of the eyes.

The Christ Child's features
are an adult's in miniature,
and the head is usually
given a slightly awkward
position, tilted back.

Begin the border with a few
simple shapes and lines . . .

. . . then develop the leaves.

ICONS

PALETTE

Indian red oxide

Red earth

Naphthol red light

Vermilion

Gold oxide

Raw sienna

Yellow oxide

Ultramarine blue + a
touch of burnt umber

Sapphire + a touch
of burnt umber

Teal green

Burnt umber

Carbon black

Smoked pearl

Warm white

Rich gold

Pale gold

SKIN MIXTURES

Gold oxide + burnt umber +
Indian red oxide

Gold oxide + Indian red oxide

Add more gold oxide to the
preceding mixture

Gold oxide + raw sienna

Add yellow oxide to the
preceding mixture

Add increasing amounts of
smoked pearl as needed

BORDER

Undercoat

Shade

Highlight (mixture of rich gold + pale gold)

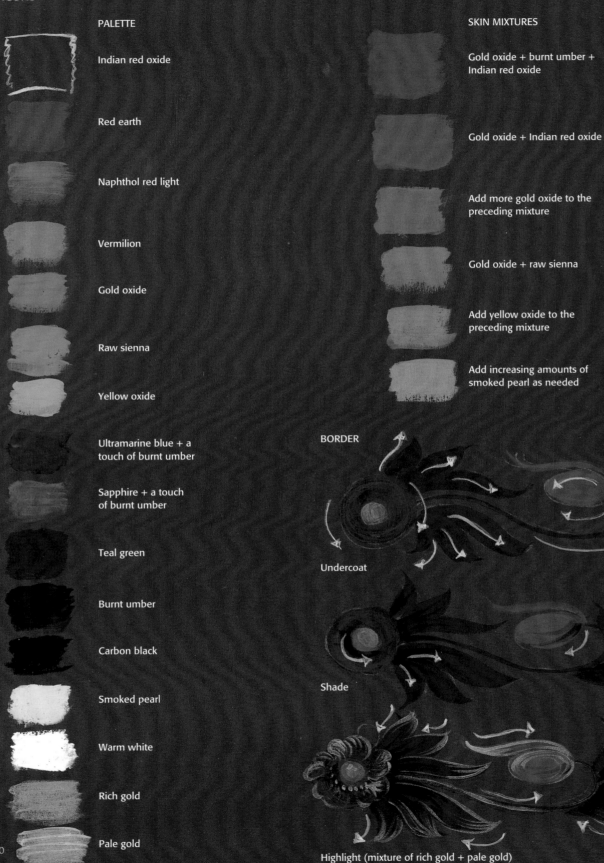

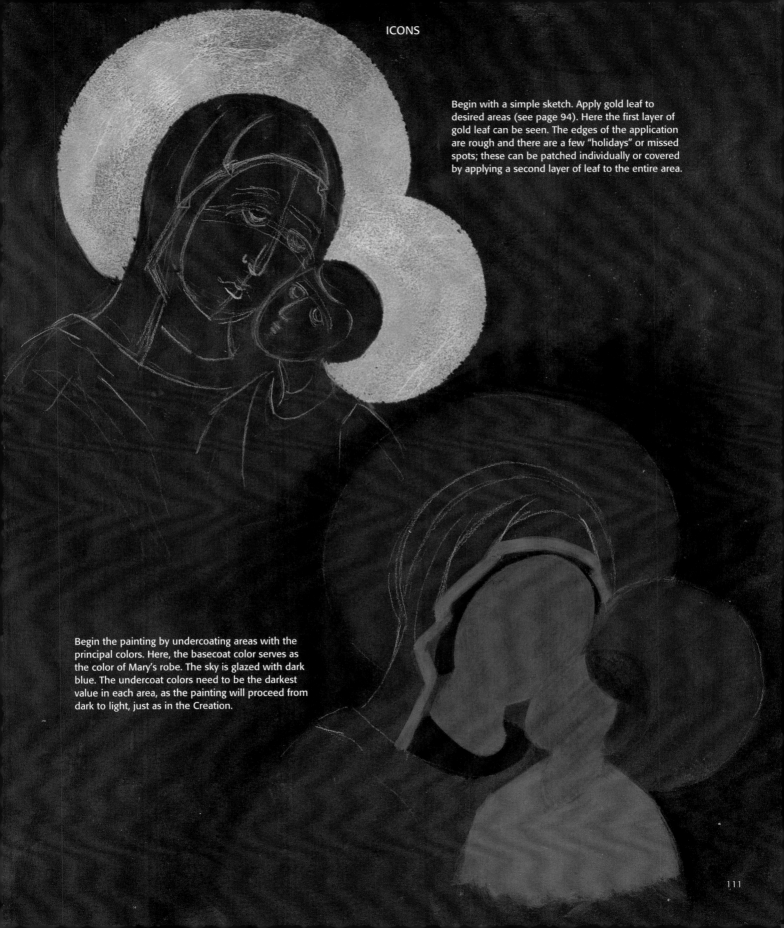

Begin with a simple sketch. Apply gold leaf to desired areas (see page 94). Here the first layer of gold leaf can be seen. The edges of the application are rough and there are a few "holidays" or missed spots; these can be patched individually or covered by applying a second layer of leaf to the entire area.

Begin the painting by undercoating areas with the principal colors. Here, the basecoat color serves as the color of Mary's robe. The sky is glazed with dark blue. The undercoat colors need to be the darkest value in each area, as the painting will proceed from dark to light, just as in the Creation.

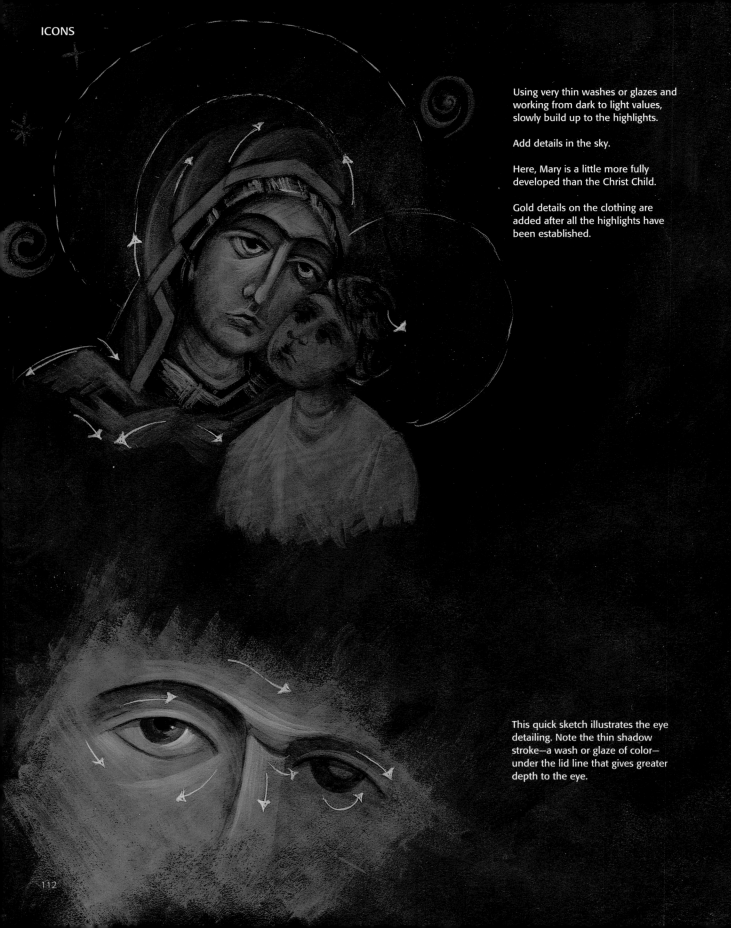

Using very thin washes or glazes and working from dark to light values, slowly build up to the highlights.

Add details in the sky.

Here, Mary is a little more fully developed than the Christ Child.

Gold details on the clothing are added after all the highlights have been established.

This quick sketch illustrates the eye detailing. Note the thin shadow stroke—a wash or glaze of color—under the lid line that gives greater depth to the eye.

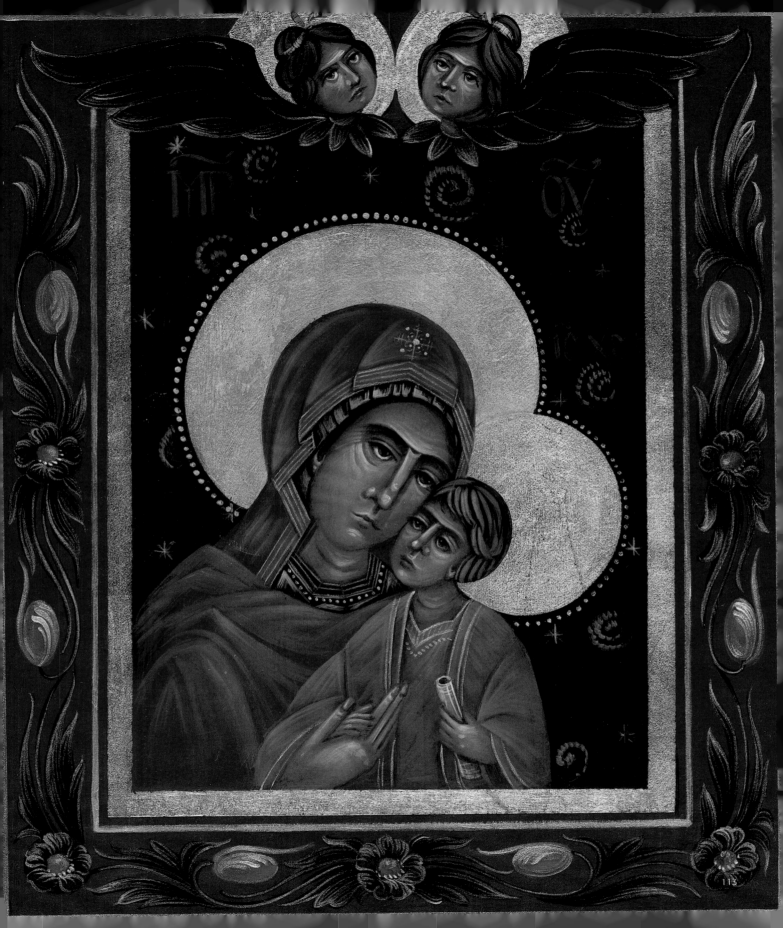

Brides' Boxes

The boxmaker splits the log by hand into thin slivers, smooths the slivers with a handplane, soaks or steams the pieces, then bends them around a wooden form, holding them in place with clamps and handmade wooden pins until they dry. He then drills holes and fastens the bent pieces to a thin, flat top or bottom piece, either round or oval, with small wooden pegs, all of which he has prepared by hand in advance. Finally, he secures the side piece by sewing it with birch root, thin cane, or rushes. A laborious process only just begun.

Now the artist basecoats the sides and top of the box, usually with black. (The wood on the inside and bottom of the box is left "natural," perhaps because the paint is too precious, though maybe it is the artist's time that is too costly.) Then, picking up a smaller brush, he begins to apply red paint to the broad bands that will decorate the sides and maybe the top of the box. The colors, usually a very limited palette, are mixed from the strained sour milk remaining from the morning's churning, a little slaked lime, and pigments ground by the artist himself. These paints dry fairly quickly, so the artist works out the color progression beforehand and mixes paint only as it is needed. In fact, he usually works on a number of boxes at one time, space permitting.

Bit by bit, the designs emerge on the top and sides as the artist uses his brush to develop the basic shapes that will become a "love-pair" in baroque or rococo costume. Sometimes, for a change, he paints an angel, a soldier on horseback, or a group of people. Though he rarely departs from the best-selling designs, each box is slightly different because it is done freehand.

The large floral borders are especially distinctive. The border on the rim of the lid runs in one direction, and the one on the base of the box in the other, two never-ending wreaths. The fact that the flowers on the lid and the base don't align doesn't detract from the design; it proclaims the artist's spontaneity and inspires a unique, refreshing charm. He applies a little beeswax polish—also homemade—if it is available, and the piece is finished.

While examples of decorated bentwood boxes can be traced to the Late Middle Ages, the style shown opposite was popular during the late 1700s and early 1800s. There were other styles, as each area developed its own designs and palette. It is generally believed that most of the decorated boxes came from central or lower Germany, the Thuringian Forest region in particular.

Brides' boxes provided families and many small communities with a means of economic support for several generations. Everyone, from grandparents to young children, were busily occupied in this enterprise, which was usually done in the main room of the home, often only by the light of the fireplace or a pine ingot,

In addition to indicating the regions in Germany and Switzerland in which decorative boxes were made (shown in green), this map illustrates the geographical relationship between these areas and others in Europe in which various styles of painting were practiced.

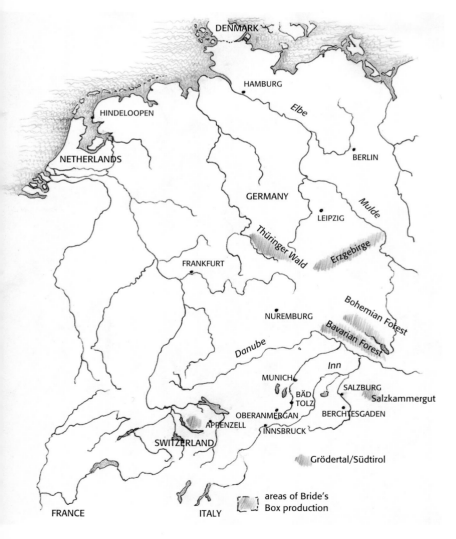

areas of Bride's Box production

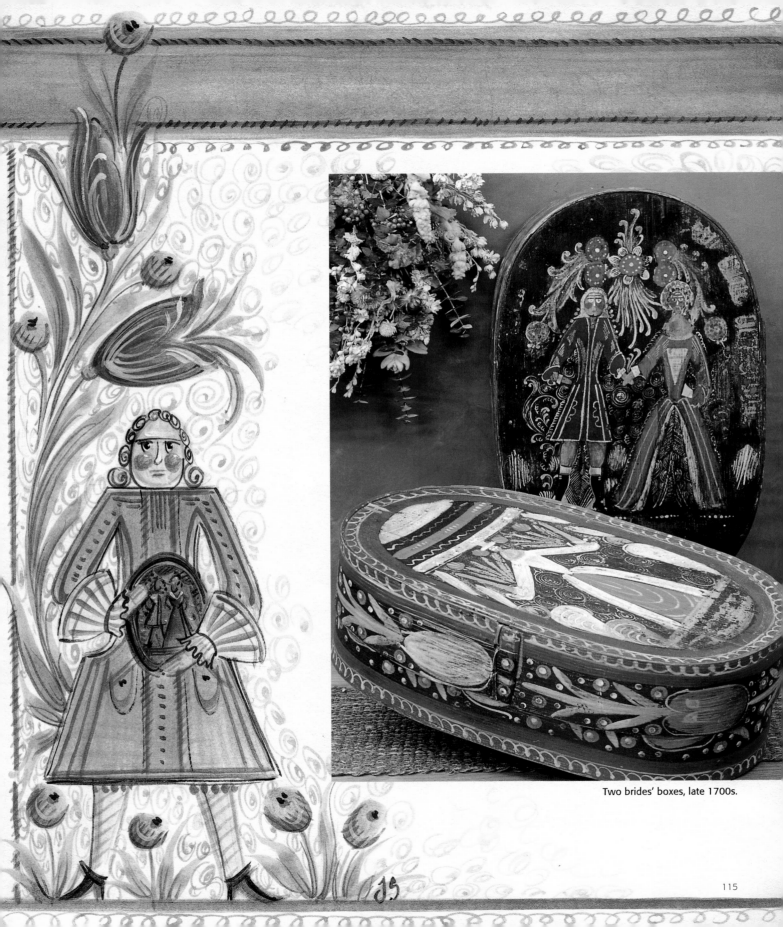

Two brides' boxes, late 1700s.

unless they were fortunate enough to have a candle for the long winter's night. The artists were very proficient at making these casually stroked pieces; the strokes and calligraphic elements seemed to flow effortlessly from their handmade brushes.

Easy to transport, the finished boxes were carried by backpack or boated downriver to the nearest large city and sold by expectant merchants. Some immigrants brought their boxes to America as treasured mementos of their homeland. I once saw a box in a Danish antique store whose lid featured a Danish proverb, suggesting that several boxes may have been specially ordered by a local merchant for his import business.

The strong style is easy to recognize and difficult to reproduce accurately. One would have had to paint these boxes month after month, day in, day out, to attain the freedom of expression that a good example represents. What was the inspiration for this strong graphic style? Could weavings, tapestries, and cross-stitch have contributed some visual elements? The answers are lost in time, but these beautiful boxes can still be seen in many museums around the world and in some private collections, documenting a style of decorative painting that provided income for many mountain families and gave great pleasure to those who owned the boxes it adorned.

Details of the tops and sides of the antique brides' boxes shown on page 115.

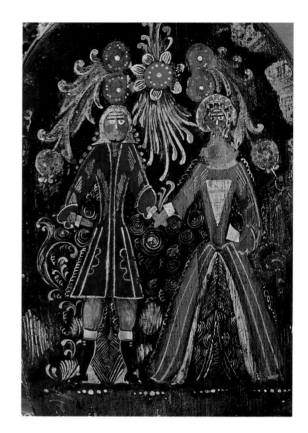

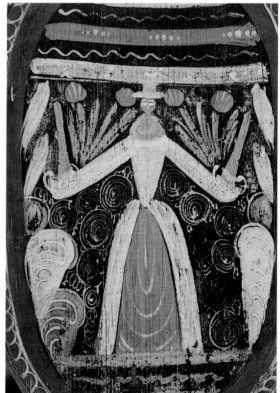

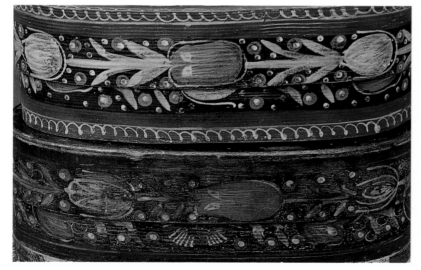

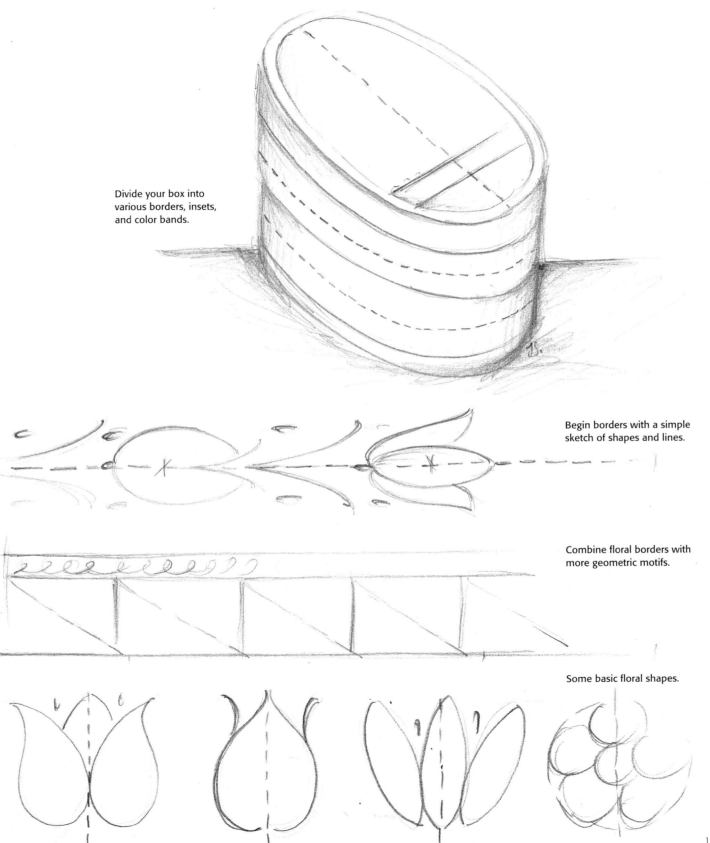

Divide your box into various borders, insets, and color bands.

Begin borders with a simple sketch of shapes and lines.

Combine floral borders with more geometric motifs.

Some basic floral shapes.

Begin shapes simply. Then dress the figures, keeping the feel of geometric shapes very strong.

Personalize your box with a saying or name.

Fill the negative space with liner work "calligraphy."

John & Mary Smith

1988

BRIDES' BOXES: PAINTING TECHNIQUE

PALETTE

Red earth

Gold oxide

Raw sienna

Yellow oxide

Green oxide

Smoked pearl

Warm white

BORDER COLOR PROGRESSION

Undercoat with red earth, then draw divisions.
Stroke first with raw sienna . . .

. . . then with smoked pearl.

Overstroke with casual stripes and other decorative motifs in warm white.

Continue to decorate with strokes of yellow oxide.

A decorated band declares *"Liebe"* (love).

A border for around the edge of the lid.

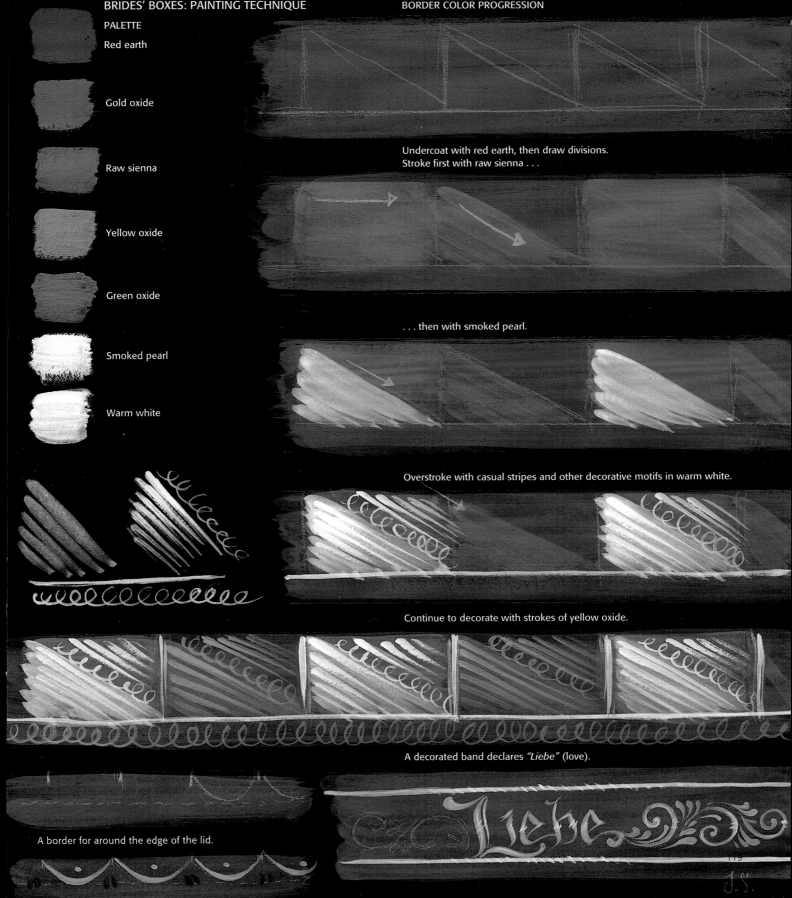

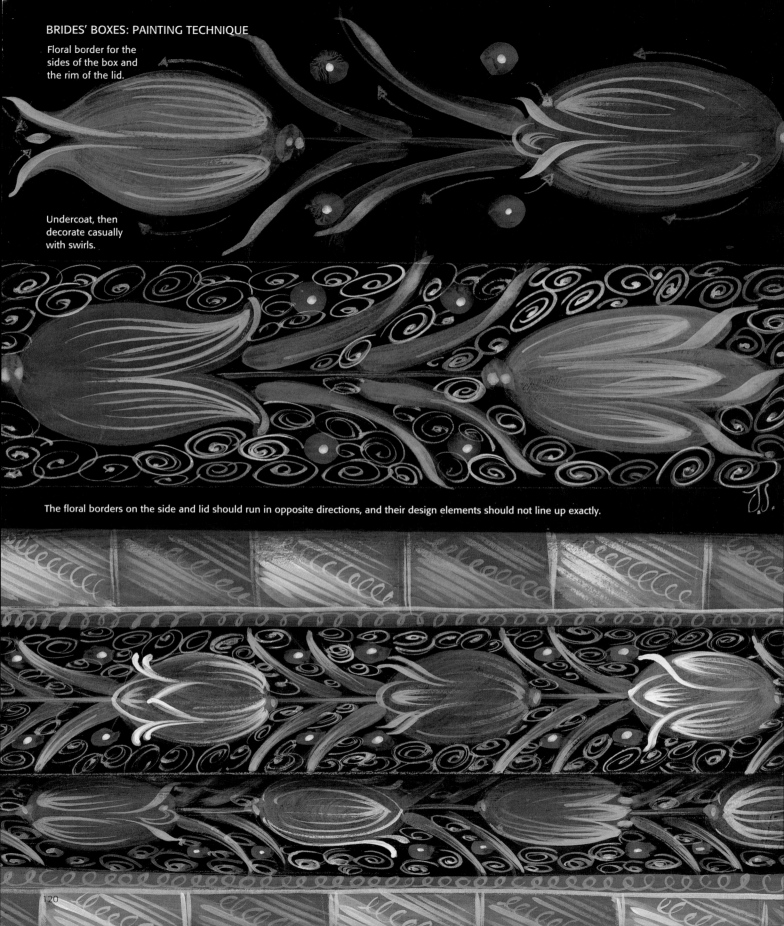

BRIDES' BOXES: PAINTING TECHNIQUE

Floral border for the sides of the box and the rim of the lid.

Undercoat, then decorate casually with swirls.

The floral borders on the side and lid should run in opposite directions, and their design elements should not line up exactly.

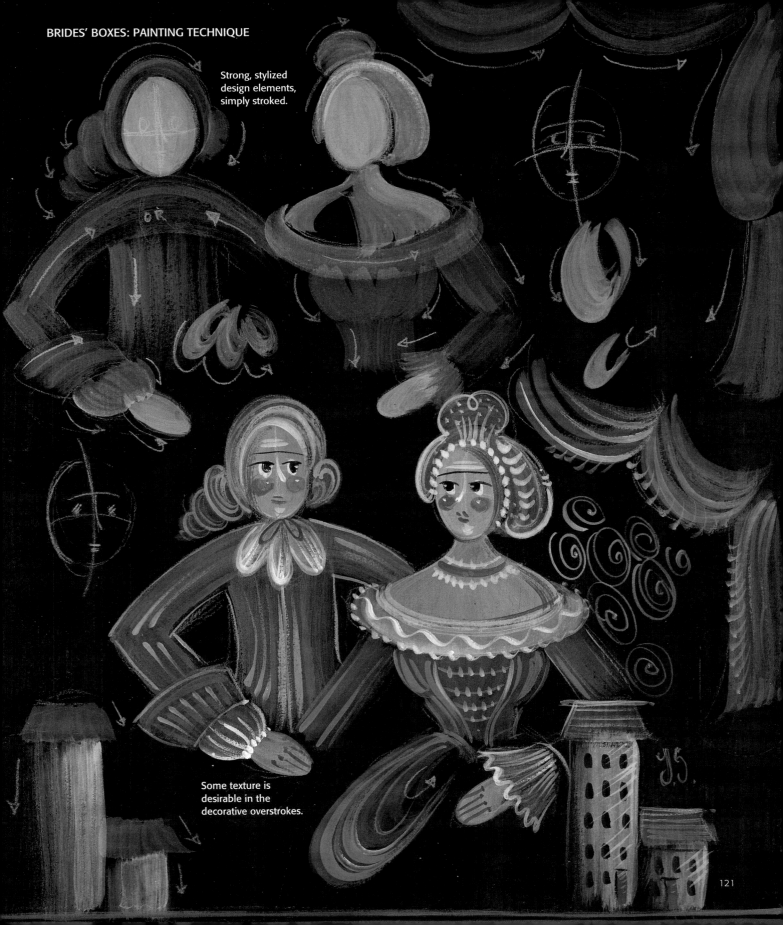

Strong, stylized
design elements,
simply stroked.

Some texture is
desirable in the
decorative overstrokes.

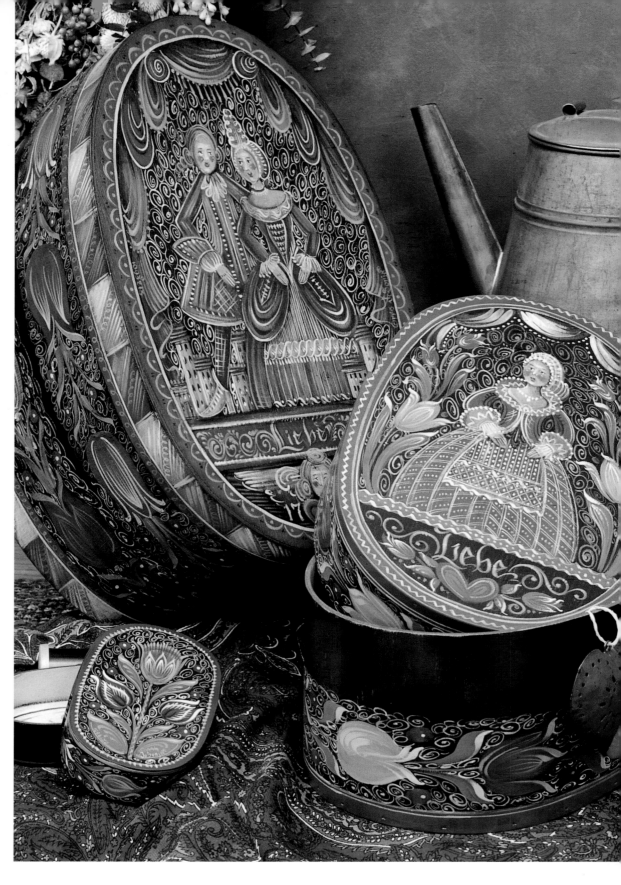

Brides' Boxes

(This page) Contemporary interpretations of brides' boxes. *(Opposite)* Details of the tops and sides of the boxes.

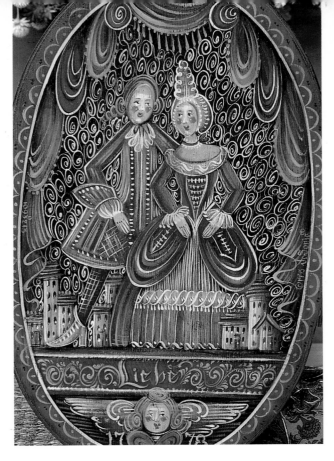

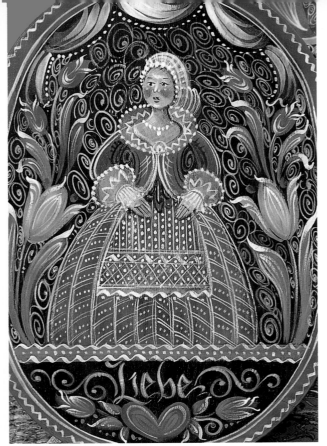

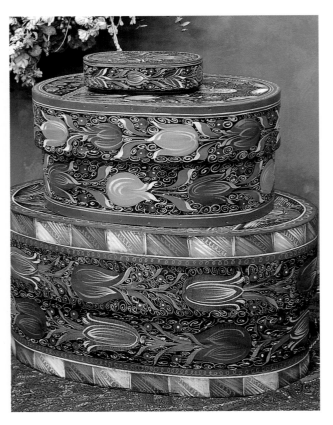

Tolz Rose

Located on the ancient "salt road" and by the River Isar, only 80 miles from Munich, Bäd Tolz is an area with a rich folk art heritage. One of the early market towns of the 14th and 15th centuries, Bäd Tolz's active trade and abundant resources supported many handicrafts. Five churches and a Franciscan monastery saw to the spiritual welfare of this community and of the visitors who came to the health spas for mineral baths and waters. The presence and influence of the church is clearly evident in the designs of the painted items.

Tolz rose is a painting style of the early 1780s from this region that represents an early example of peasant or folk-type painting. The earliest style of furniture decoration from this area seems to have been black stenciled designs over brown wood stain, but by the early 1800s the Tolz rose dominated Bavarian folk design. Colorful bands, borders, and marbling complemented simple designs comprised of large, disk-shaped roses. Other flowers were used to embellish the stylized arrangements, but it was this simple stroke rose that remained the symbol of this area's style of decorative painting. Religious figures and symbolism were also important elements, reflecting the spiritual awareness of the community. It is here that we can observe the aesthetic influence of the Roman Catholic church of the West, and a move away from the stylized icons of the Eastern Orthodox church.

In this area, as in many other Alpine areas, the ownership of painted furniture was a definite status symbol. Painted furniture filled the flower-festooned *Kammerwagen*—the "chamber wagon" used to carry the bride's dowry—that was merrily transported to the home of the new couple by the wedding celebrants. The lavishly decorated wardrobe or armoire was packed with precious linens and other fancies that the bride and her family had lovingly prepared. Brides' buckets, beautifully decorated wooden stave buckets, hung from the sides of the wagon carrying salt from her mother's table, cheese from her father's cow, and even carefully wrapped warm coals from her family's hearth.

TECHNICAL NOTES

Most Alpine styles of decorative painting (including Appenzell; see page 132) used casein, a type of milk-based paint that is made by adding slaked lime to milk protein; some Tolz rose artists still use casein today. The action of the lime on the protein produces an almost clear binder of great durability. Because slaked lime is very caustic, it is usually kept mixed with water in a small bottle. Just before a color is needed, the lime is blended with a small amount of a very smooth fat-free cheese product (available in Europe) and artists' quality dry tempera pigments. Colors are mixed one at a time, so a painting's color progression must be carefully planned. A small amount of linseed oil can be added to prolong drying time, but casein's open time is always very brief. If the process of combining its ingredients is done properly, casein paint should have no odor.

When I've done a "milk painting" at home in the past, I just substituted fat-free cottage cheese for the European product. Since I've been painting in acrylics, however, I've found that they imitate casein beautifully, and without the mess. Today I would only consider mixing my own casein-based paints for a restoration project.

Study pieces painted in the tradition of the Tolz rose style that include the wax-resist "flaking paint" technique (see page 99) for a unique aged look.

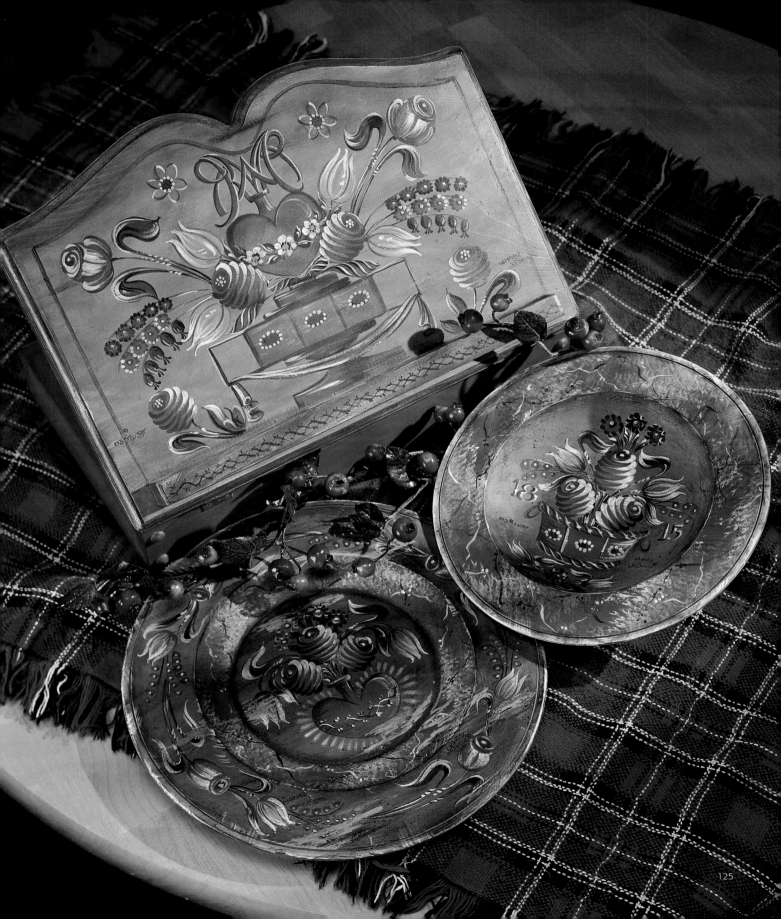

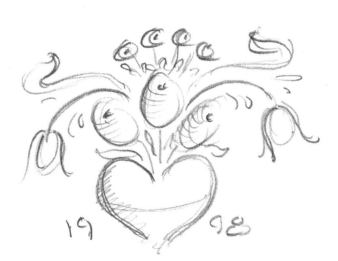

Casual, slightly symmetrical, very open bouquets that primarily featured roses.

Containers were usually drawn flat.

Sometimes a simple, flat scroll frame or a bird was included in the composition. The inset color was usually the same as the background.

Hearts also served as containers.

Simple, repetitive rose borders and color bands framed the composition.

The Crown of Thorns border is a "double lifeline"—the up-and-down movement of the line represents life's ups and downs.

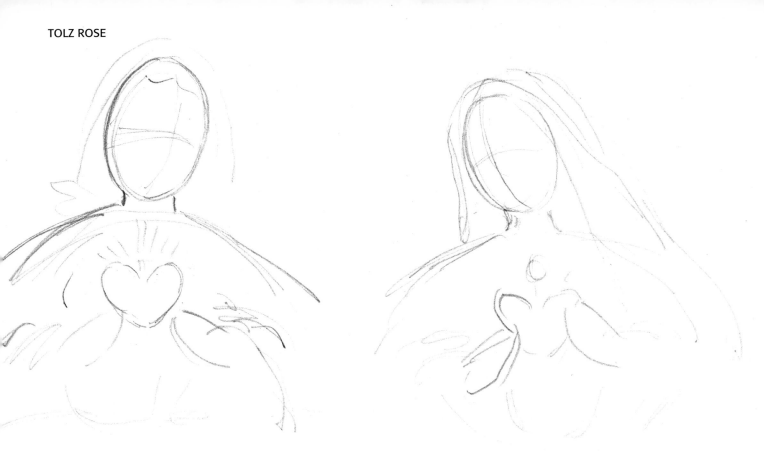

Figures were sometimes included on larger pieces such as cupboards and armoires. Begin your sketches simply, trying to achieve a certain amount of symmetry in the placement of details, so that the doors of the piece look similar. Keep figures simply drawn and slightly naive in style.

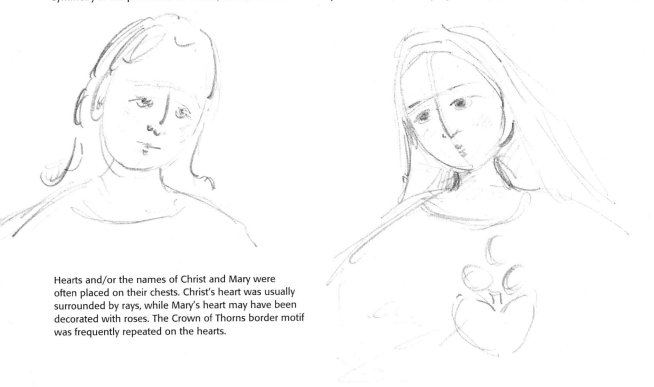

Hearts and/or the names of Christ and Mary were often placed on their chests. Christ's heart was usually surrounded by rays, while Mary's heart may have been decorated with roses. The Crown of Thorns border motif was frequently repeated on the hearts.

TOLZ ROSE

1. Stain-seal wood (see page 38) with matte medium + a little raw sienna + a touch of raw umber or brown earth.

2. Let dry, sand, then carefully apply the wax resist to chosen areas.

3. Casually basecoat with a toned medium blue (sapphire + a touch of nimbus gray) thinned with water.

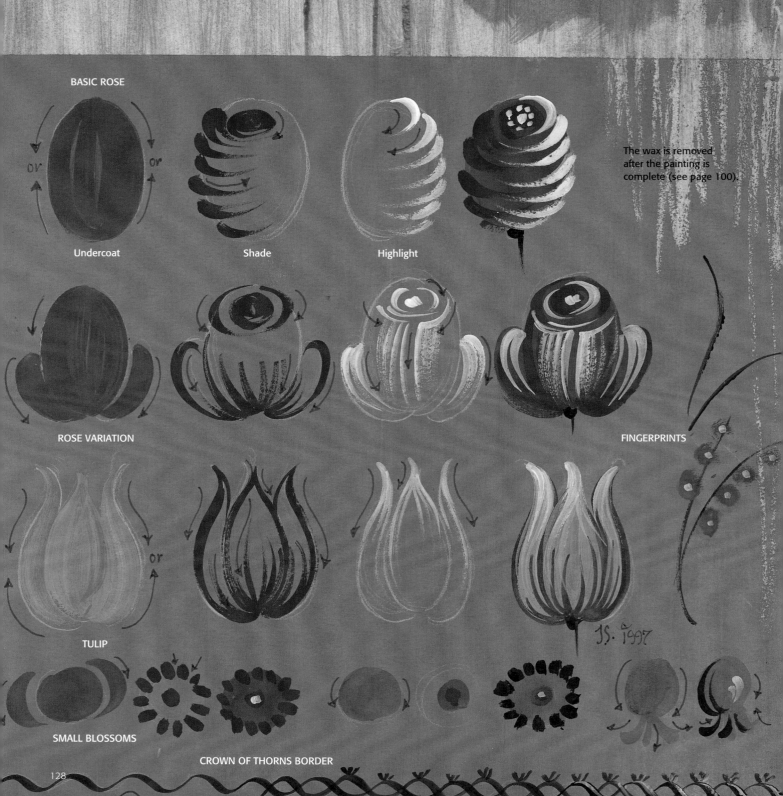

BASIC ROSE

Undercoat

Shade

Highlight

The wax is removed after the painting is complete (see page 100).

ROSE VARIATION

FINGERPRINTS

TULIP

JS. 1997

SMALL BLOSSOMS

CROWN OF THORNS BORDER

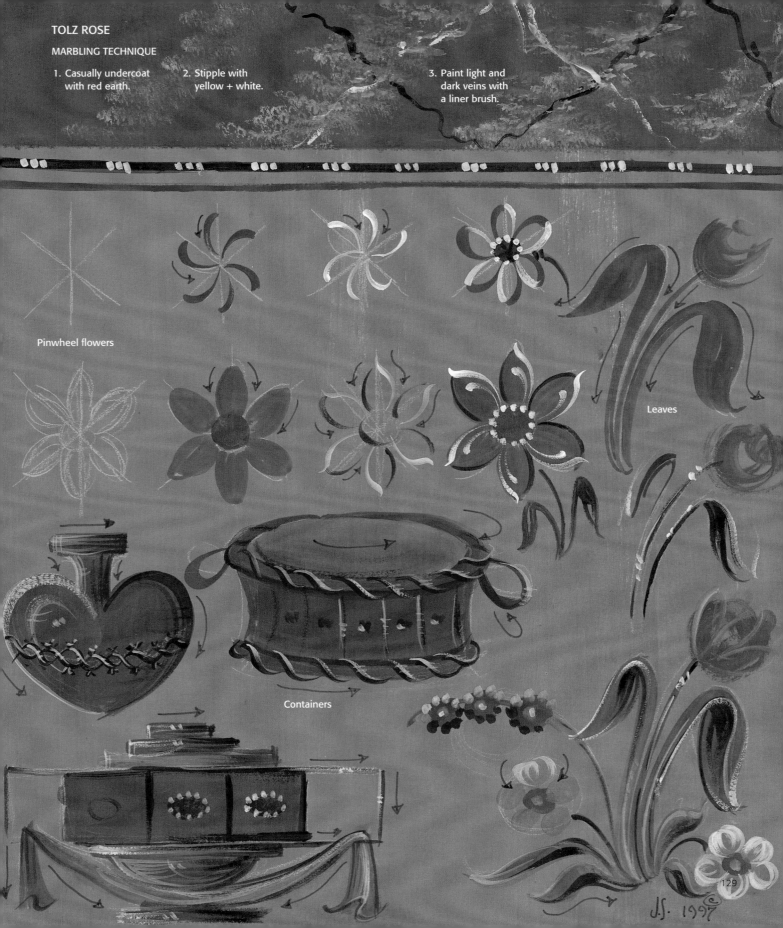

TOLZ ROSE

MARBLING TECHNIQUE

1. Casually undercoat with red earth.

2. Stipple with yellow + white.

3. Paint light and dark veins with a liner brush.

Pinwheel flowers

Leaves

Containers

129

J.S. 1997

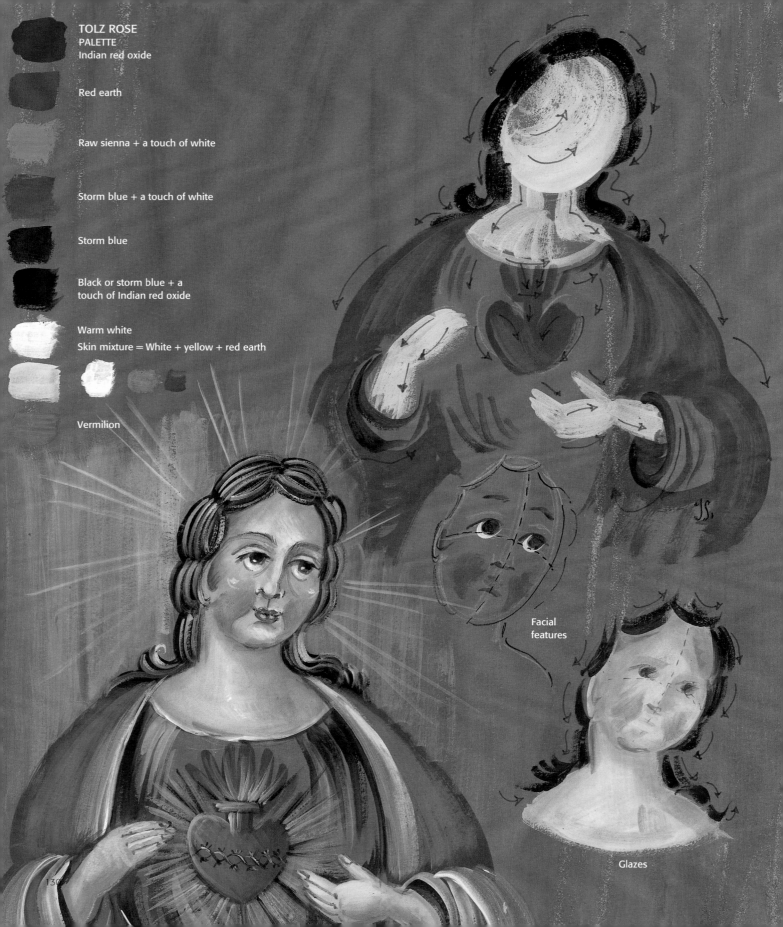

TOLZ ROSE
PALETTE
Indian red oxide

Red earth

Raw sienna + a touch of white

Storm blue + a touch of white

Storm blue

Black or storm blue + a
touch of Indian red oxide

Warm white
Skin mixture = White + yellow + red earth

Vermilion

Facial
features

Glazes

130

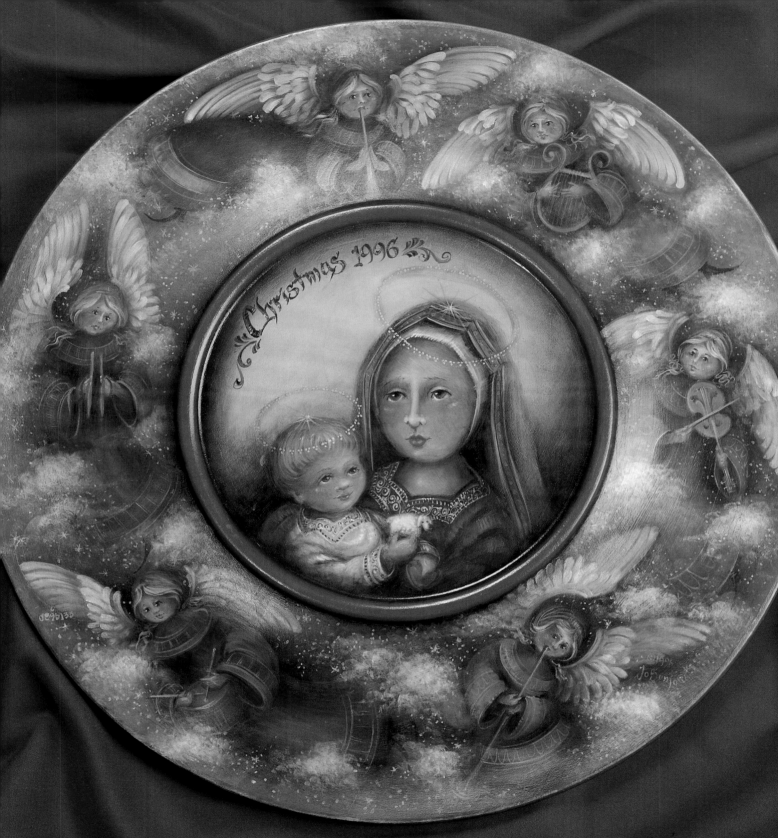

This contemporary painting combines influences of both Eastern and Western church painting traditions. The center is finished with a gloss varnish, while the border is finished with a matte varnish.

Appenzell: The Art of the Cowherd

Beautiful joinery exquisitely detailed with expert chip carving heralds our arrival into the world of Alpine herdsman art. The soft amber glow of aged, natural-colored wood is complemented by a palette of intense colors. These small wooden examples of miniature folk art landscape painting literally sparkle in the rooms of Alpine homes, where large painted trunks, cupboards, and armoires provide storage and impart color to the mostly wood interiors.

The daily lives of the Appenzell people are enriched with design and color. From embroidered clothing to brass-embellished leatherwork, utilitarian items are given loving attention. An important example is the *kubelbodeli,* a wooden bucket fitted with an extra bottom piece made of very thin wood and decorated with painted motifs. The herdsmen carry this special bucket on their shoulders during festive occasions. Among the design elements are the herdsman's name, date of birth, and, sometimes, the area or region of his home. The medium? What else, in this land of the cowherd—casein, or milk-based paints. (See page 124 for a discussion of how casein paints are made.) From the Renaissance vines and tendrils of the 16th century to the softer Biedermeier-influenced florals and pastoral scenes of the early 1800s, the paintings of Appenzell reflect the influence of these major decorative styles, and each style displays a high degree of craftsmanship.

The small landscape paintings also illustrate events from daily life. From the *Alpfahrt,* the popular trek to summer pasture to gentle domestic scenes, we are treated to glimpses of their special moments. Often, in the paintings of the summer trek, the cows' large bells are painted with metallic gold, an unusual touch. Not only do cows wear large bells, but the best "milkers" are given the special honor of a floral bonnet. Large floral arrangements are tied to the legs of the herdsmen's milking stools, which are then inverted on the heads of the leading cows and tied in place with colorful ribbons.

Local artists still paint these miniatures today, and their works may be seen at Alpine galleries and studios. Each artist has his or her own distinctive style. The pieces shown in the photograph opposite are my own interpretation of this style of painting. I purchased the wooden objects in Appenzell, and I attached to each finished piece one of the small brasses that are used to embellish the local costume.

A medley of wooden pieces from Appenzell, from buttermold to milking stool, that are decorated with my interpretation of that region's painting style.

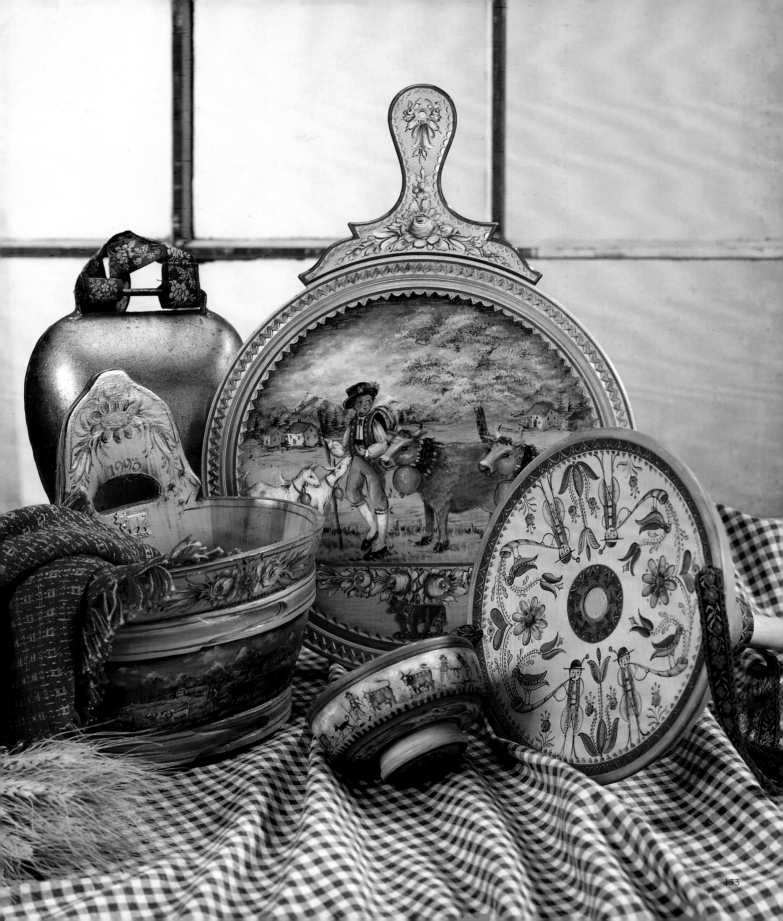

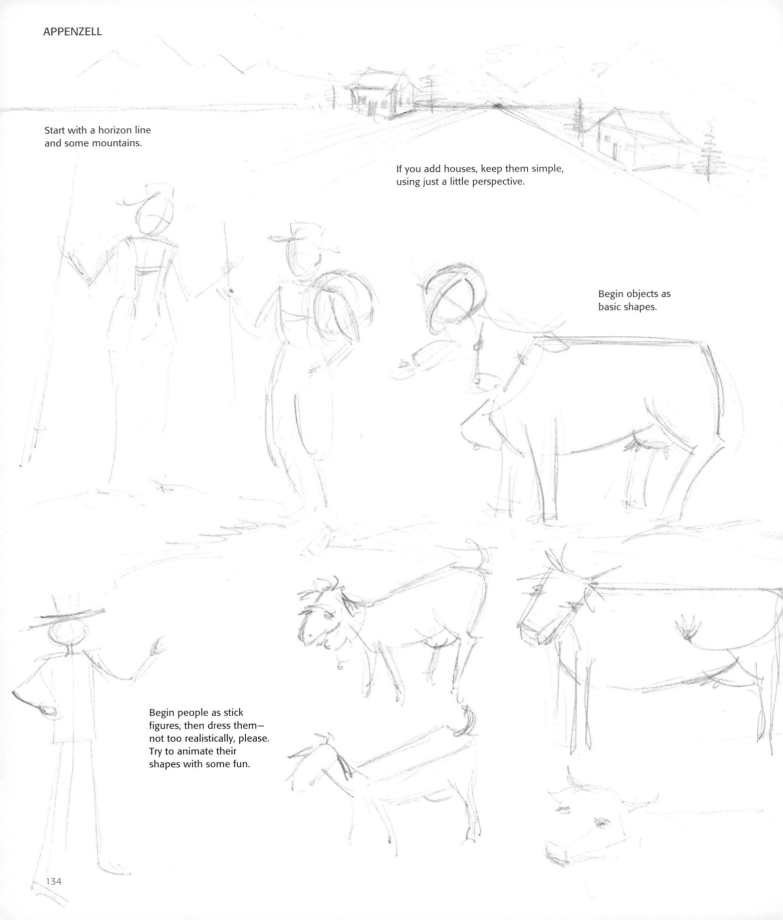

Start with a horizon line
and some mountains.

If you add houses, keep them simple,
using just a little perspective.

Begin objects as
basic shapes.

Begin people as stick
figures, then dress them—
not too realistically, please.
Try to animate their
shapes with some fun.

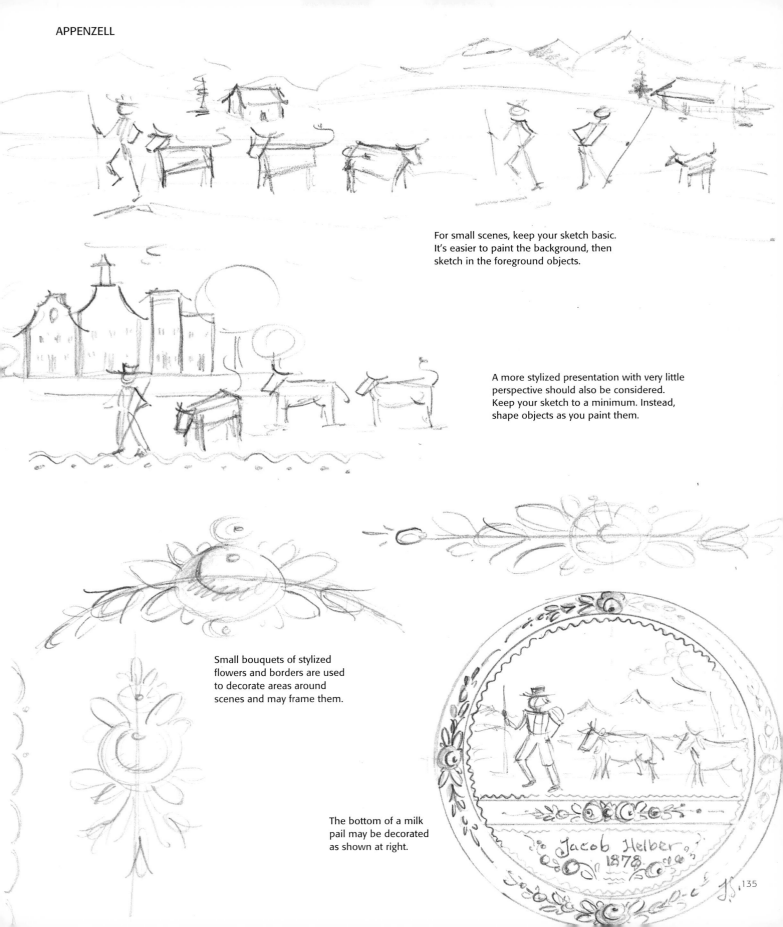

For small scenes, keep your sketch basic.
It's easier to paint the background, then
sketch in the foreground objects.

A more stylized presentation with very little
perspective should also be considered.
Keep your sketch to a minimum. Instead,
shape objects as you paint them.

Small bouquets of stylized
flowers and borders are used
to decorate areas around
scenes and may frame them.

The bottom of a milk
pail may be decorated
as shown at right.

Jacob Helber
1878

135

APPENZELL
PALETTE

Indian red oxide

Naphthol red light

Yellow oxide

Turner's yellow

Ultramarine

Aqua

Ultramarine + yellow oxide

Aqua + Turner's yellow

Brown earth

Carbon black

Warm white

White + red + yellow

Rich gold

Background = White gesso

Apply ultramarine + white with a no. 8 flat.

White

Add Indian red oxide to the brush.

Dark green mixed with yellow oxide

Brown earth

Light green

Sketch the basic shapes of the figures.

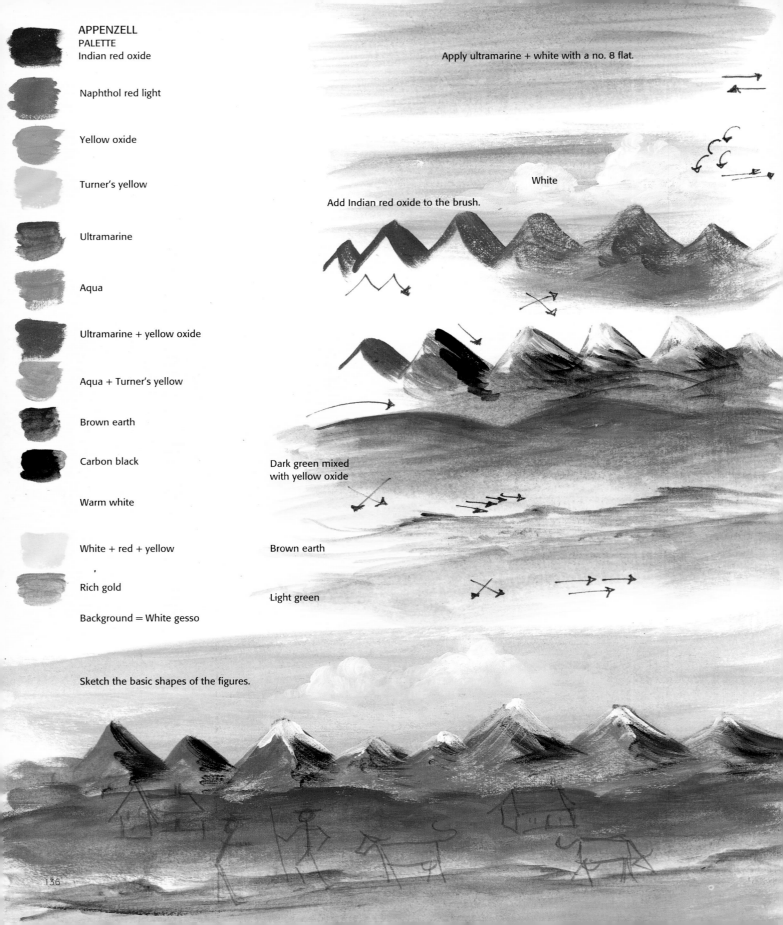

136

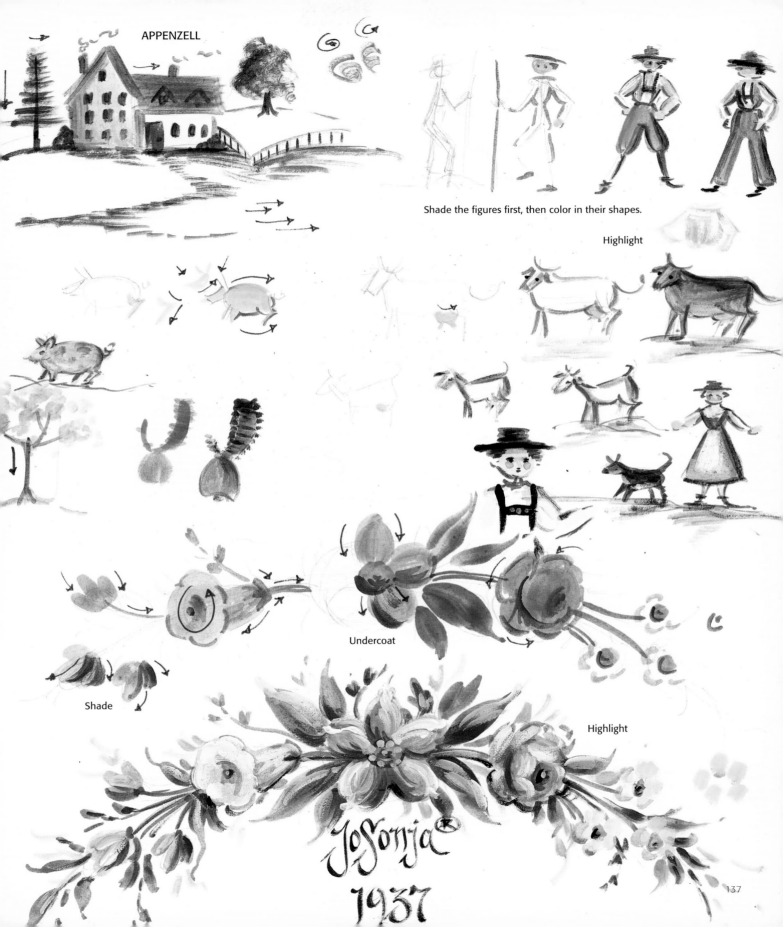

APPENZELL

Shade the figures first, then color in their shapes.

Highlight

Undercoat

Shade

Highlight

JoSonja®
1937

137

Chinoiserie

When objects made and decorated in the Far East were brought to Europe by the Dutch, Portuguese, and English East India companies in the late 1600s, a curious collecting fever took hold of the populace. The influence of Oriental design, which could be seen in palaces, gardens, and porcelains, wasn't really new to Europeans—pieces had been brought back from the Far East on the overland routes since the days of Marco Polo—but shipping made more items available at a lower cost. An increase in supply led to an increase in demand, and demand far outstripped supply. As demand for these items consumed the public, European imitations of Oriental designs called *chinoiserie* were produced.

Workshops all over Europe tried to imitate the beautiful finish of Oriental lacquerware. These pieces were said to be "japanned." It became an obsession, with each workshop developing its own secret "recipes" and processes. The Martin family, working for Madame de Pompadour at Bellevue and Queen Marie Leszczynska at Versailles, became the finest lacquer imitators in France. In 1753, they patented a new type of lacquer that many feel was the basis of their famous *vernis Martin* finish.

The fever continued to spread. It is a matter of record that by the late 1700s there were forty-nine workshops in Venice producing lacquered items. Books offering instruction on Oriental design were published. Ladies' finishing schools included japanning in their curricula.

In the early 1700s, Thomas Johnson of Boston produced japanned items for several cabinetmakers. Philadelphia, New York, Hartford, and Newport also became centers of chinoiserie and lacquerware production. Tall case clocks and japanned highboys (tall chests of drawers) were among the more popular decorated items.

European as well as American chinoiserie influenced virtually every style of folk art. In fact, the quest to perfect the japanning process improved and influenced the quality of almost all decorated items. So if you look at an old piece and think, "that painted design looks slightly Oriental," it was probably meant to be. Many items from this period, from stenciled trays to painted boxes, are often referred to as "japanned" items, or more simply called lacquerware.

TECHNICAL NOTES

Good examples of chinoiserie, from large desks to tea boxes, are very finely detailed, which is what makes them so expensive. The pieces themselves are usually of very fine cabinetry with a lustrous, deep finish.

The small details of chinoiserie require a very smooth background. Several coats of black gesso or a 1:1 mixture of texture medium + the color of choice provide an excellent ground. Background colors are usually dark, such as black, a rich, dark green, or red. When white is used, the contrast of the painted design is heightened with a few touches of black.

Designs comprising Oriental-style figures, houses, trees, and birds delicately fill surfaces. Parts of the design are in low to moderately high relief, which is built up with thick gesso or a 1:1 mixture of texture medium + white paint. Gold paint and gold leaf are then used to emphasize these areas further (some liner work in black may appear within the gold). Gold leaf and gold paint reflect light differently; the leaf is more brilliant. Superior designs exploit this radiance by presenting leafed areas almost as distinct designs, or by incorporating them so they allow the eye to move comfortably throughout the composition. Exquisite borders of fine filigree and small insets finish the presentation.

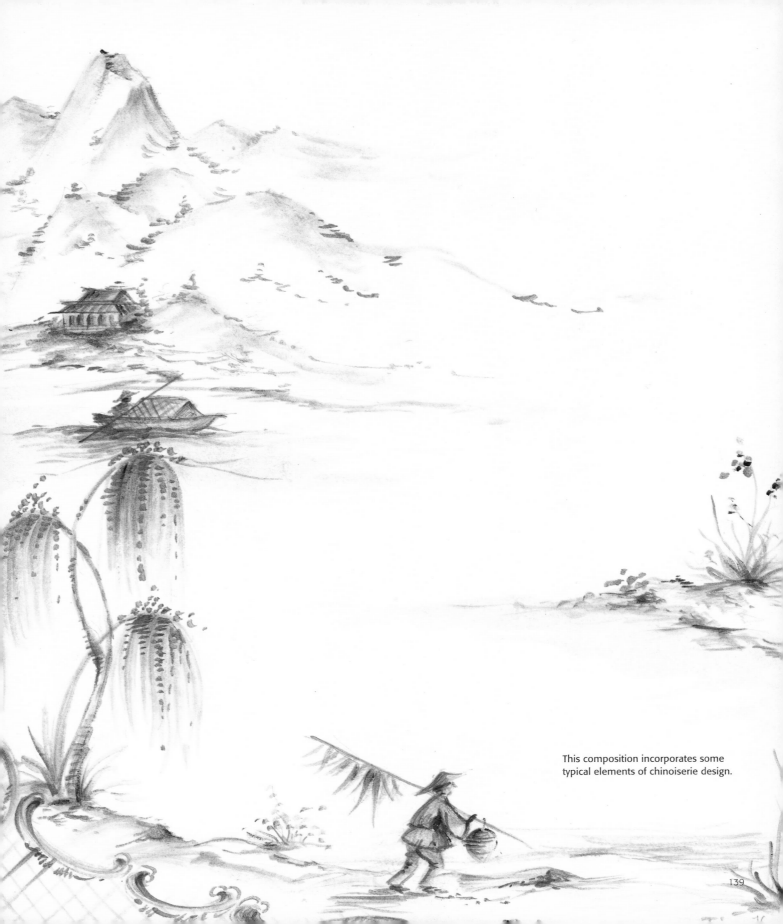

This composition incorporates some typical elements of chinoiserie design.

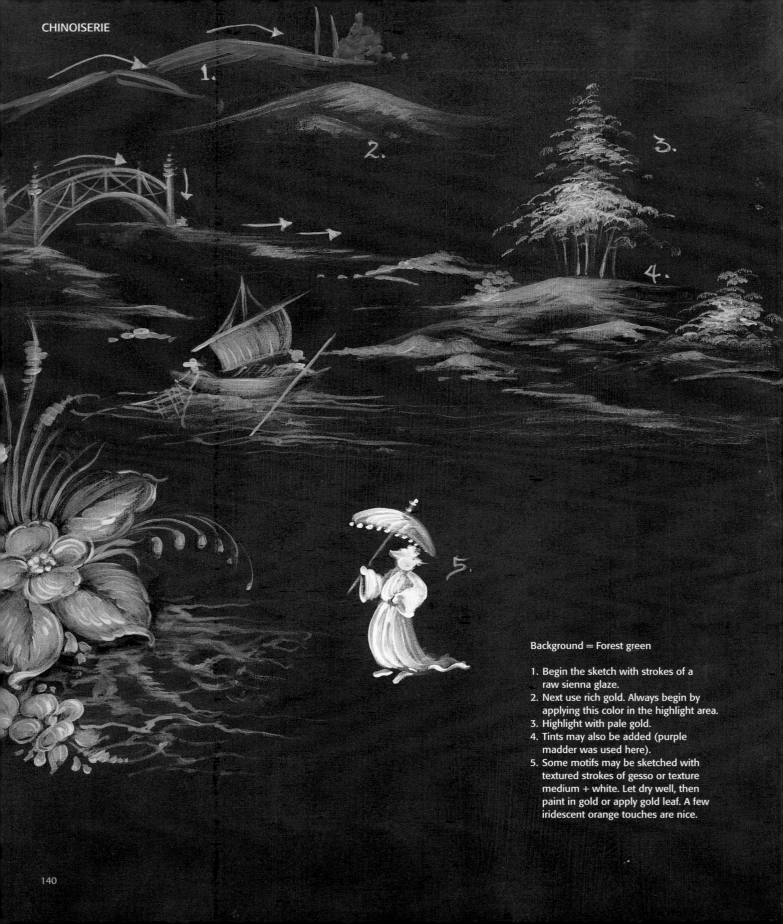

Background = Forest green

1. Begin the sketch with strokes of a raw sienna glaze.
2. Next use rich gold. Always begin by applying this color in the highlight area.
3. Highlight with pale gold.
4. Tints may also be added (purple madder was used here).
5. Some motifs may be sketched with textured strokes of gesso or texture medium + white. Let dry well, then paint in gold or apply gold leaf. A few iridescent orange touches are nice.

English Japanned Wares

English artisans applied their chinoiserie designs and japanning techniques to tin and papier-mâché. Lightweight, fairly easy to manipulate into interesting shapes, and able to withstand a fair amount of heat and abuse, these surfaces seemed to invite decoration. From buttons to carriage door panels, serving trays to copper pots, these items were "japanned," a term used to describe highly varnished items that were simulations of Oriental lacquerware.

In the 1660s, Thomas Algood of Pontypool, Monmouthshire, an enterprising gentleman who researched and developed processes used in the manufacture and decoration of tin items, became known for his lacquered or japanned tinware products. Although the details of his techniques remained trade secrets, it is known that his painted tinware required *stoving* (oven-drying or "setting"), which usually darkened the colors, giving the pieces a lovely amber glow.

Rival businesses were developed in Birmingham and Bilston, and it was in Birmingham that the papier-mâché manufacturing process was perfected. Two manufacturers produced papier-mâché so strong that even furniture could be made from it.

Decorative motifs included painted and stenciled chinoiserie designs, fruits, flowers, birds, and fountains. Gold leaf and inlays of mother-of-pearl were popular embellishments. At one time, beautiful borders made from small broken bits of mother-of-pearl were especially sought after.

Some of the most beautiful examples of English japanning were made by artists who were employed by the tin and papier-mâché manufacturers. These artists were individually trained in the style but had no formal art education. The items they painted, which had unique shapes and uses, were produced in sufficient quantity to satisfy the demands of the marketplace, and their painted designs complemented current decorating styles and color schemes. For without the ability to supply this demand, the market for these items would have disappeared.

TECHNICAL NOTES

The painting technique used for japanning is believed to have originally been done exclusively in oil paints. English japanned wares were painted with so many different motifs that it would be impossible to review them all here, so I've chosen to focus on one of the most popular, the Chippendale flower. Although this motif bears his name, celebrated furniture maker Thomas Chippendale did not originate its design.

Flowers, and sometimes a few dominant leaves, were begun with an undercoat of semitransparent white. Highlights were slowly built up with several layers of semitransparent white, with each succeeding layer applied to a smaller area. The flowers were then painted with layers of color, starting with the most opaque pigments and progressing to tints of very transparent ones, and the item was "stoved" between layers.

Gold leaf was adhered using "tacky" varnish or gold size, an oil-based medium specially formulated for adhering gold leaf. Some metallic details were painted with varnish or gold size to which bronze powder had been added.

Use titanium or warm white to undercoat and highlight flowers. If you're working in acrylics, you can use water or matte medium for these areas. When working in hot or dry conditions, you might have to apply a little of retarder. Be careful here, though, because you don't want the color to bleed out on the edges of the strokes.

Complete the painting, then add gold accents. You might like to use some Kleister Medium or gel medium when layering strokes on the flower, which can also be painted with a sideloaded brush. You might even like to heighten the gold accents with a few touches of iridescent orange; this color, which is slightly different from gold, must be applied carefully. A final light glaze of Indian yellow + a tiny touch of dark red imparts the richness of "stoving" to the surface. Here again, be careful: Although the glaze is scarcely visible on a dark background, it will affect the colors of the painting and gilding more significantly.

English Japanned Wares

English japanned pieces featuring Chippendale-style flowers, birds, and gilded scrolls.

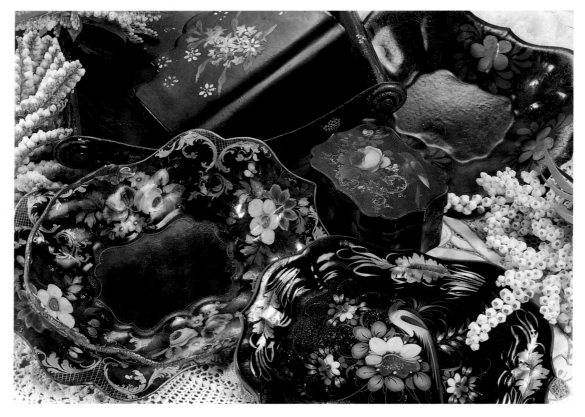

These English pieces are more recent than the ones shown above, probably from the late 19th or early 20th century. On the left is the underside of a shelf that would have been hung high enough so that the painted decoration there could be enjoyed. The small tin tinderbox in the foreground still contains some of its original matches.

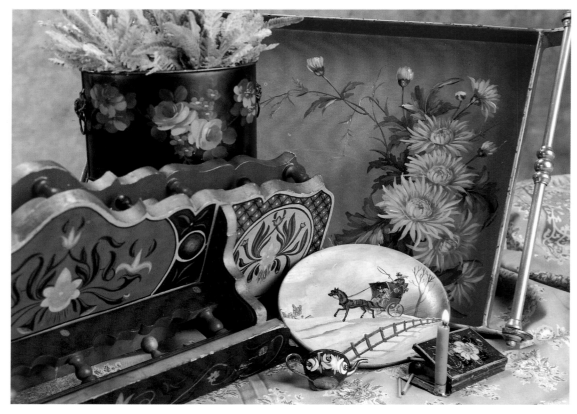

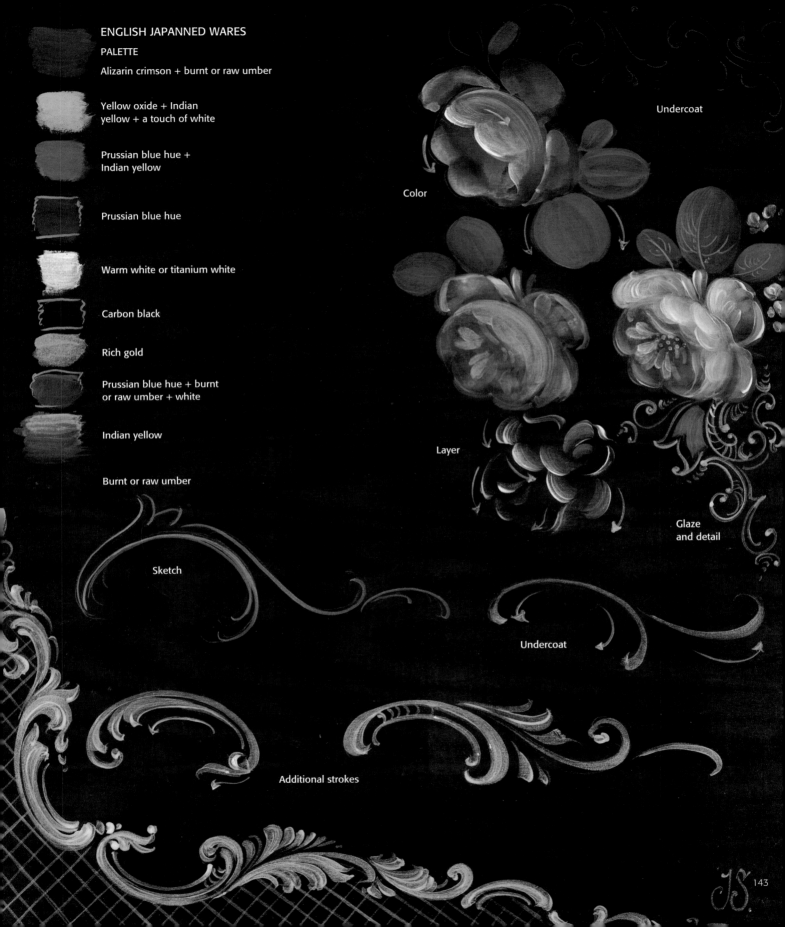

ENGLISH JAPANNED WARES

PALETTE

Alizarin crimson + burnt or raw umber

Yellow oxide + Indian yellow + a touch of white

Prussian blue hue + Indian yellow

Prussian blue hue

Warm white or titanium white

Carbon black

Rich gold

Prussian blue hue + burnt or raw umber + white

Indian yellow

Burnt or raw umber

Undercoat

Color

Layer

Glaze and detail

Sketch

Undercoat

Additional strokes

143

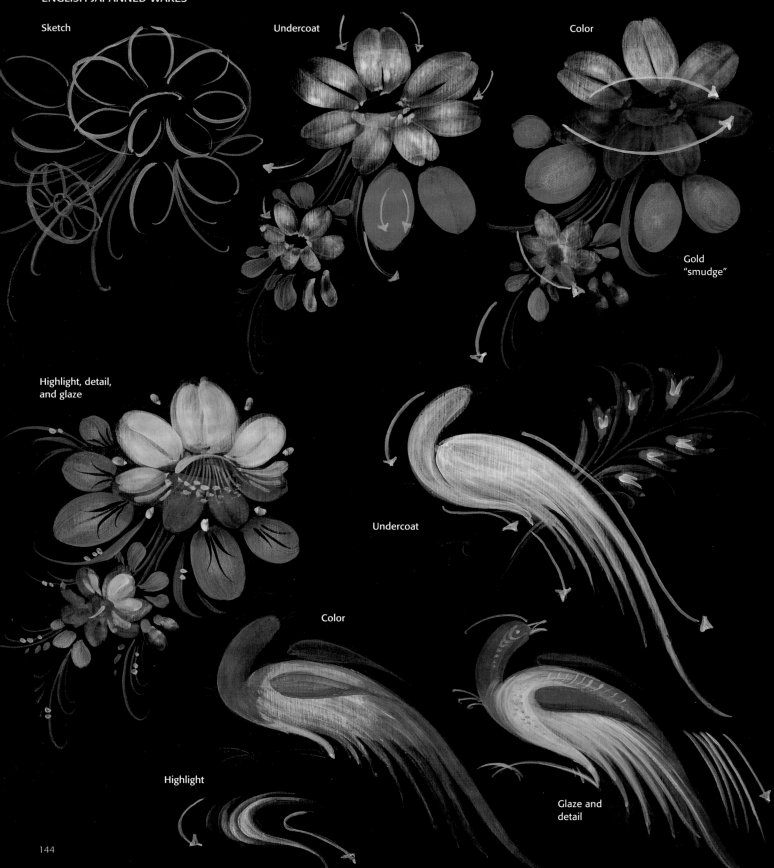

ENGLISH JAPANNED WARES

Sketch

Undercoat

Color

Gold "smudge"

Highlight, detail, and glaze

Undercoat

Color

Highlight

Glaze and detail

144

Russian Lacquered Miniatures

Around the time of the Russian Revolution of 1917, skilled icon artists turned their talents to more secular themes. While revolutionary subjects—soldiers, battle scenes, popular political leaders—were sometimes depicted, more often they painted highly romanticized scenes of village life and Russian fairy tales. Four villages—Palekh, Kholui, Mstera, and Fedoskino—are primarily responsible for this style of painting, which is done on small papier-mâché boxes. Papier-mâché was something of a modern marvel at the time the style was developed: Unlike wood, it didn't warp, split, release tannin, or have a prominent grain.

Though Fedoskino miniatures are painted in oils, and those of the three other villages are done in egg tempera, artists from all four villages use layering techniques similar to those used for icon painting and English japanned wares, frequently beginning a painting on a dark background with an underpainting of lead or zinc white. Highly successful themes are repeated, but each box reflects the individual artist's style and sense of color and display superb craftsmanship and exquisite detailing. The paintings are framed with tiny, intricate, multistroked borders of gold and/or silver.

A diverse collection of Russian lacquered miniature boxes.

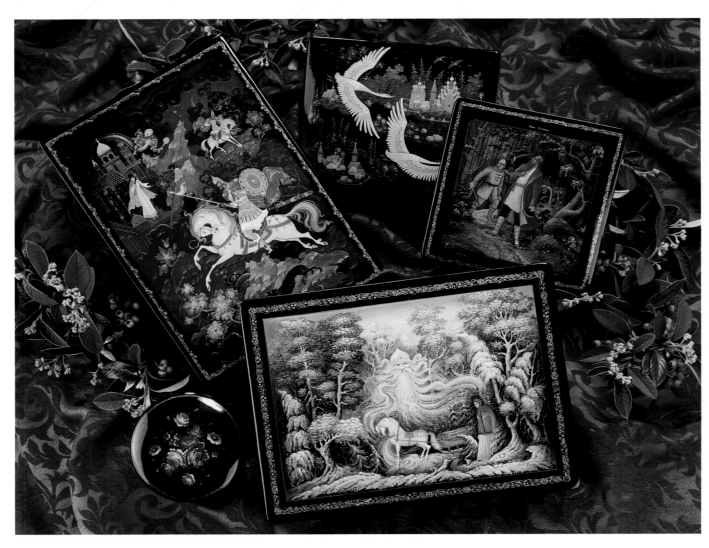

The drawing style and subject matter seen in the works of Palekh, Mstera, and Kholui reflect the icon tradition, while the art of Fedoskino harks back to the enterprising 18th-century merchant who trained his serfs to produce small lacquered snuff and jewelry boxes. Most Palekh paintings are an intriguing interplay of color and technique against a black background. Mstera art uses more subtle color combinations, often on an ivory-colored inset. Highly poetic and slightly romantic, the art of Kholui features somewhat more realistic figures, though it is still stylized and very decorative. Fedoskino paintings often include gold or silver leaf or mother-of-pearl inlay.

Each village trains its artists in its own distinctive style. The Palekh School of Art, for example, accepts only about thirteen to fifteen new students a year into a very extensive 5-year training program, though the entire village is employed in the endeavor, from the assembly of the boxes to the final "lacquering" process. (Oil-based varnish is used in place of lacquer, which would destroy the egg tempera.) The quality of craftsmanship is strictly controlled by a committee of artists that examines each item before approving it for sale.

As a result of political and economic changes, this stable arrangement has undergone some changes. Many imitations have been produced, some of which feature a cheap decal and only a few painted touches. Only by dealing with very reputable importers can one be sure to obtain boxes of the highest quality. I hope that this tradition will survive so that the painting style can grace collections for many years to come.

TECHNICAL NOTES

This very small-scale, intricate work requires a very finely prepared ground. Black, the traditional color, is still the most common, but other colors are also used. Apply three to four coats of black gesso or a mixture of texture medium + acrylic paint, sanding well between coats, to establish a good working surface.

Begin the design with layers of white (as is most often done in the Palekh style), then apply color. Leave some white areas more transparent, and layer the highlights until they're opaque. Before you begin, consider which areas you would like to decorate with gold line work, then avoid intensely shading or highlighting them, which would conflict visually with the gold.

Each village has a distinct way of finishing designs with borders of gold and/or silver filigree, some of which are exquisitely detailed. A 1:1 mixture of rich gold + pale gold makes a very fine color here.

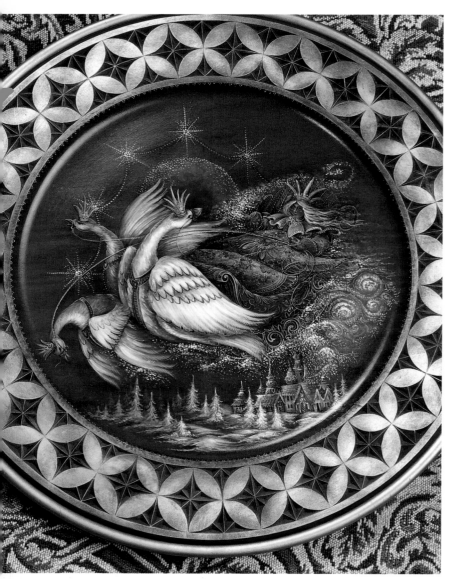

I decorated this plate, "The Snow Queen," using the layering techniques demonstrated on pages 147–148. To impart a Russian "flavor" to the scene, I included a small Russian-style village in the foreground. The wooden plate was turned by Paul Loftness; the beautiful chip-carved border was done by Tim Monska.

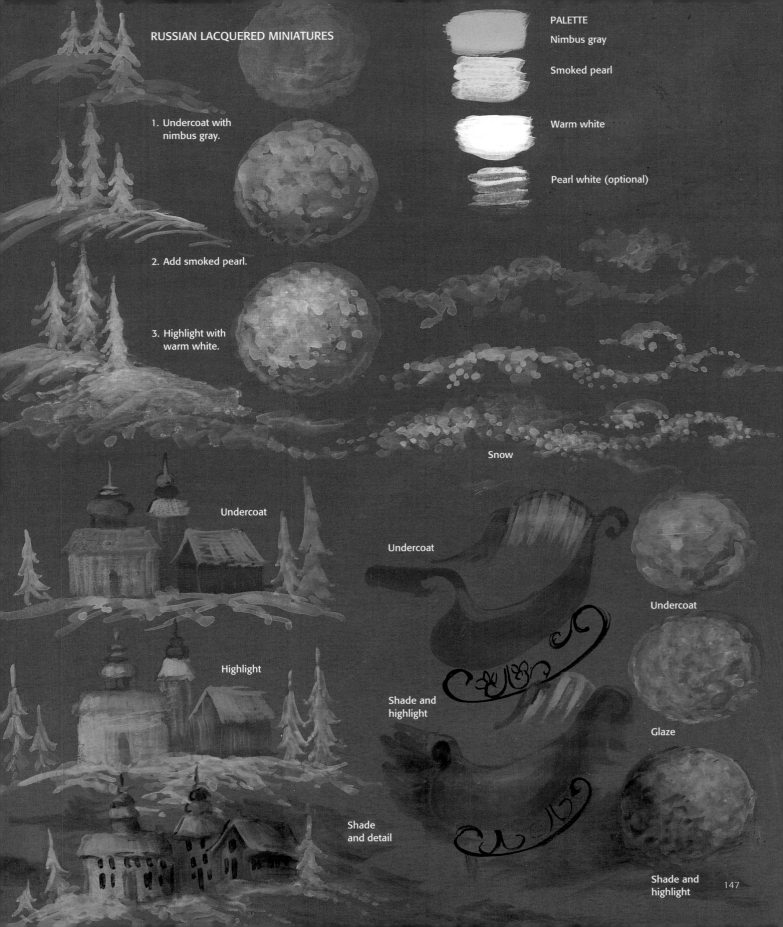

RUSSIAN LACQUERED MINIATURES

PALETTE

Nimbus gray

Smoked pearl

Warm white

Pearl white (optional)

1. Undercoat with nimbus gray.

2. Add smoked pearl.

3. Highlight with warm white.

Snow

Undercoat

Undercoat

Undercoat

Highlight

Shade and highlight

Glaze

Shade and detail

Shade and highlight

147

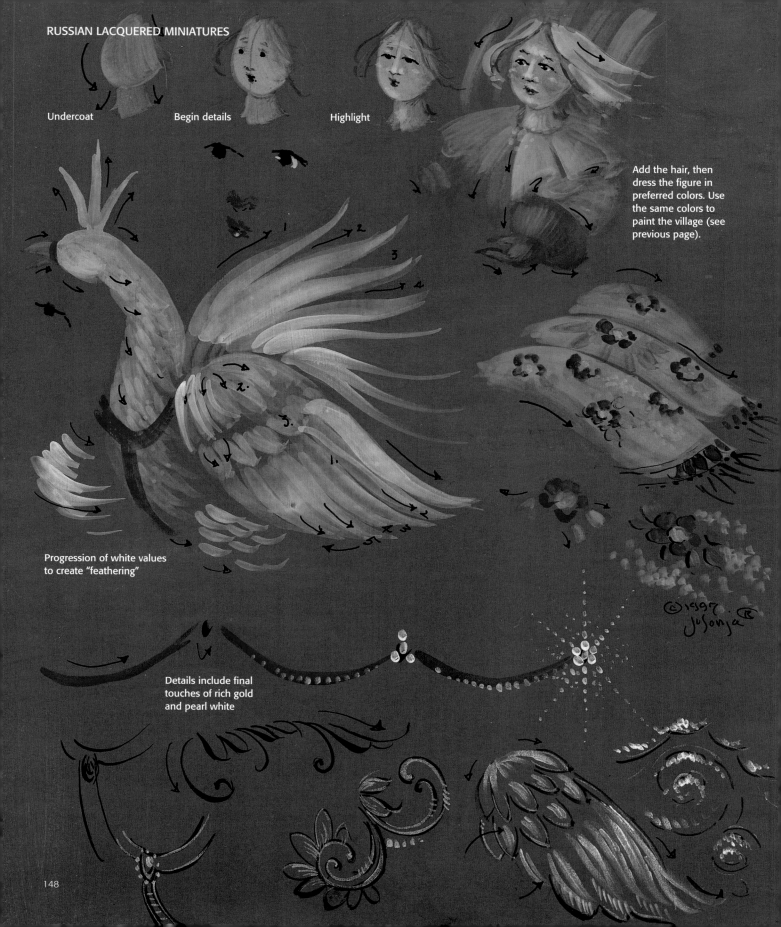

Undercoat

Begin details

Highlight

Add the hair, then dress the figure in preferred colors. Use the same colors to paint the village (see previous page).

Progression of white values to create "feathering"

Details include final touches of rich gold and pearl white

© 1997
JoSonja

Zhostovo Florals

It is generally believed that the first Russian floral trays were produced in the early 1800s in Zhostovo, a small village outside of Moscow. At once functional and decorative, trays provided a nice flat surface for decoration and could be stored, shipped, and displayed with relative ease. Painting workshops were begun in other villages, but this style of painting is usually referred to as Zhostovo because the work produced there was the most influential.

The style was influenced by large centers of Russian art such as Nizhniy Tagil and St. Petersburg. It is also believed that during the mid- to late 1800s, some Russian noblemen sent their serfs to France to be trained in the flower-painting techniques of the time, where they learned about English Chippendale methods, including using white underpaintings and stoving (oven-drying the painted items overnight), which are still used by some artists today. But once these techniques were transported to Russia, the palette became deeper, richer, more intense, higher in contrast, to accommodate the mostly wooden interiors of Russian homes.

As time passed, the artists of the Zhostovo style improved their techniques and methods of production until they achieved an extremely beautiful, highly refined style of floral stroke painting, still practiced today. These artists receive intense training, and eventually develop an extremely high level of brushstroke skill after painting for many years, day in and day out. Because today's Zhostovo artists are more conscious of color theory, some trays feature complexly and intensely colored paintings, while others are done with toned or less intense palettes, in a deliberate attempt to adapt to softer decorating trends.

The highly developed technical skill of these artists is an inspiration to all decorative artists who love strokework, providing an excellent example of this style's potential and challenging beginners to develop their own brushstroke skills.

TECHNICAL NOTES

Similar to the English Chippendale technique (see page 141), early examples of this style used white underpaintings in varying degrees of transparency for the composition's principal flowers and some of the leaves, especially those within the center of interest. Improvements in the quality and coverage of artists' pigments have led to some changes in technique; whether these changes will benefit your painting simply depends on the quality of your paints: If they are inadequately pigmented you will either have to resort to using several layers of paint, or to try underpainting some of the flowers in white.

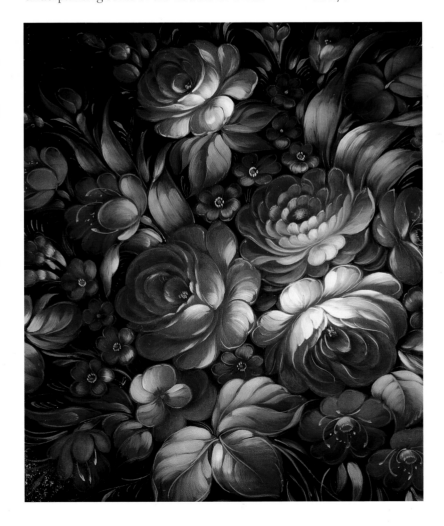

A detail of the center of a Russian Zhostovo tray that typifies the beautiful colors and strokework of the style.

A beginner-level rose is used to demonstrate the layering technique (see pages 151–154). Begin the flowers with a simple brush sketch of thin white, then build up or layer strokes of white onto the highlight areas. Because they are background elements, leaves are underpainted with either warm or cool colors. Fruits, when included, should be underpainted in white.

Each element is then colored. Stroke blending wet-in-wet is preferred. Moisten the area with medium, apply the local color of the motif, then either dress or tip the brush with the highlight color and stroke in the highlights.

The flowers and leaves are often edged or outlined with delicate linework. The amount that's used varies with each artist and presentation. If you decide to incorporate this into your composition at the sketch or underpainting stage, you can do it all in off-white, which will then be subtly tinted as each element is filled in with color.

It's also traditional to reshade the tips of leaves and some of the flowers with a deep burgundy color (purple madder was used in the demonstration) that should be as transparent as possible. A 1:1 mixture of rich gold + pale gold is perfect for painting finely filigreed borders.

On this tilt-top table, the Zhostovo-style flowers-and-fruit composition is circular, directing the viewer's eye around the surface in a fairly even manner, rather than centrally focused. In the background is the interior of the stain-painted linen cupboard (see page 82).

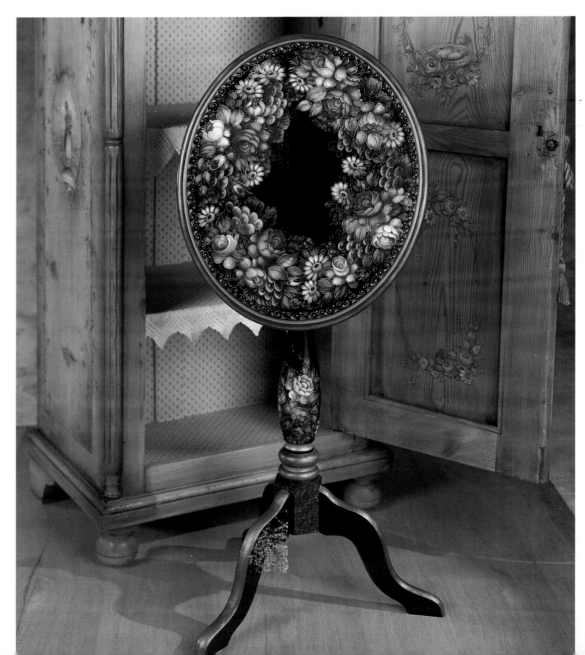

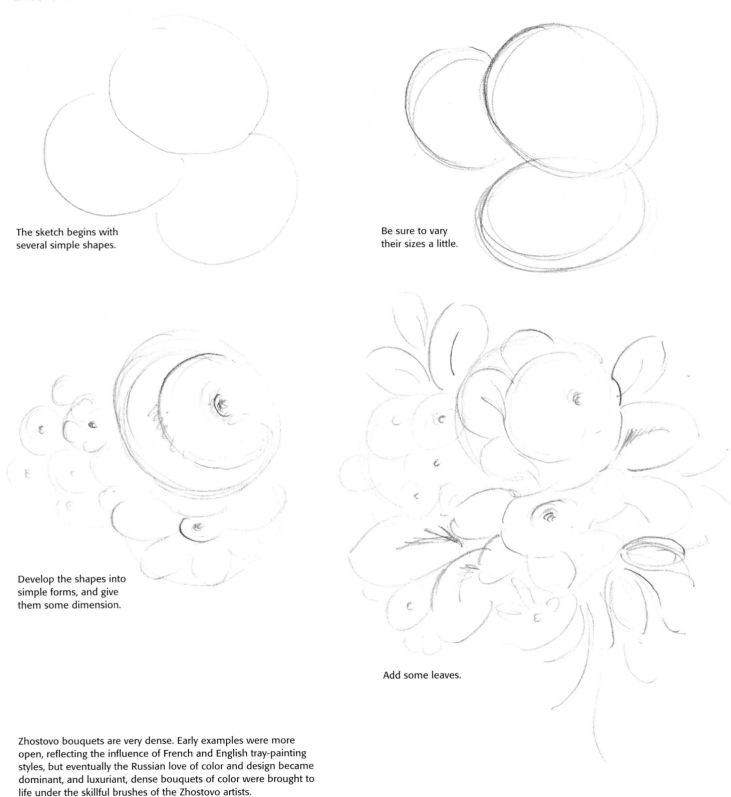

The sketch begins with several simple shapes.

Be sure to vary their sizes a little.

Develop the shapes into simple forms, and give them some dimension.

Add some leaves.

Zhostovo bouquets are very dense. Early examples were more open, reflecting the influence of French and English tray-painting styles, but eventually the Russian love of color and design became dominant, and luxuriant, dense bouquets of color were brought to life under the skillful brushes of the Zhostovo artists.

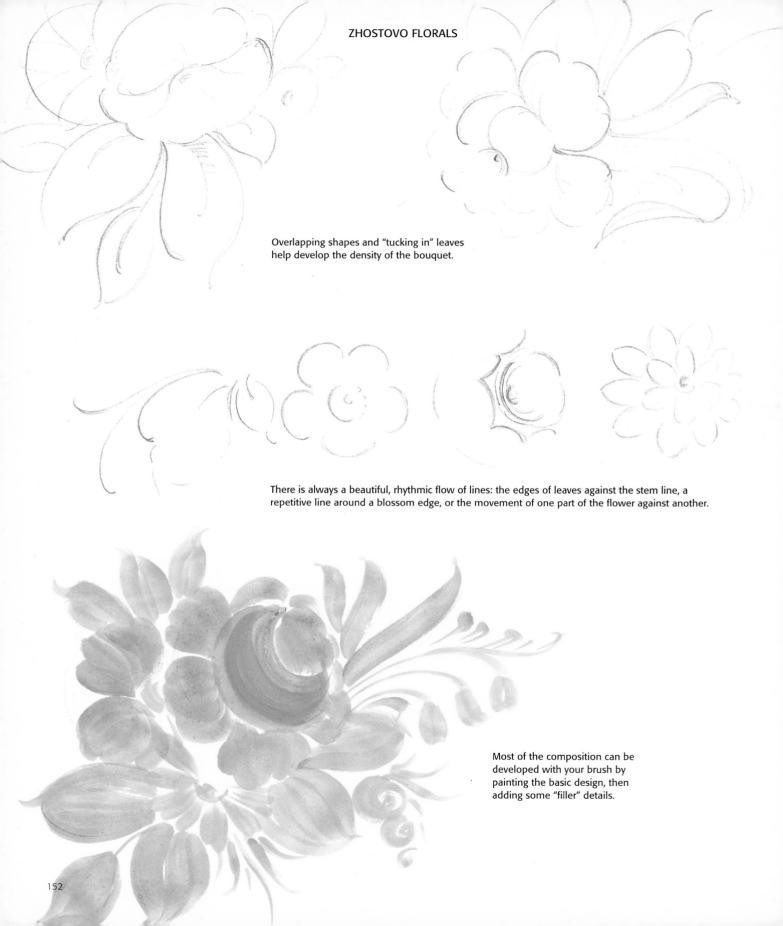

Overlapping shapes and "tucking in" leaves help develop the density of the bouquet.

There is always a beautiful, rhythmic flow of lines: the edges of leaves against the stem line, a repetitive line around a blossom edge, or the movement of one part of the flower against another.

Most of the composition can be developed with your brush by painting the basic design, then adding some "filler" details.

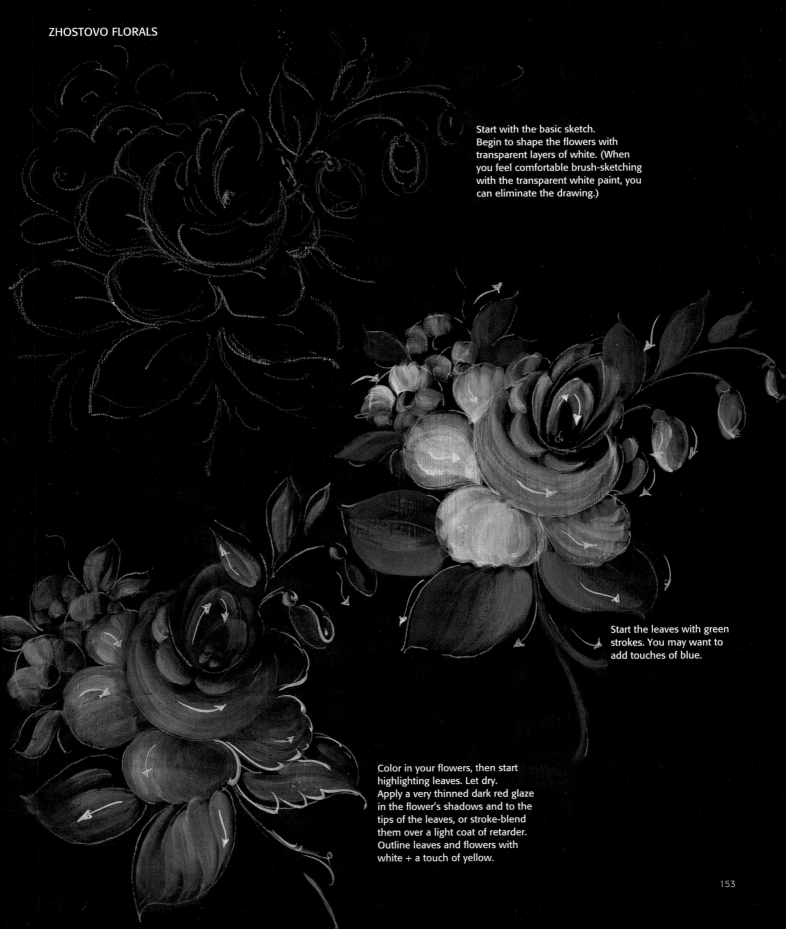

Start with the basic sketch.
Begin to shape the flowers with
transparent layers of white. (When
you feel comfortable brush-sketching
with the transparent white paint, you
can eliminate the drawing.)

Start the leaves with green
strokes. You may want to
add touches of blue.

Color in your flowers, then start
highlighting leaves. Let dry.
Apply a very thinned dark red glaze
in the flower's shadows and to the
tips of the leaves, or stroke-blend
them over a light coat of retarder.
Outline leaves and flowers with
white + a touch of yellow.

153

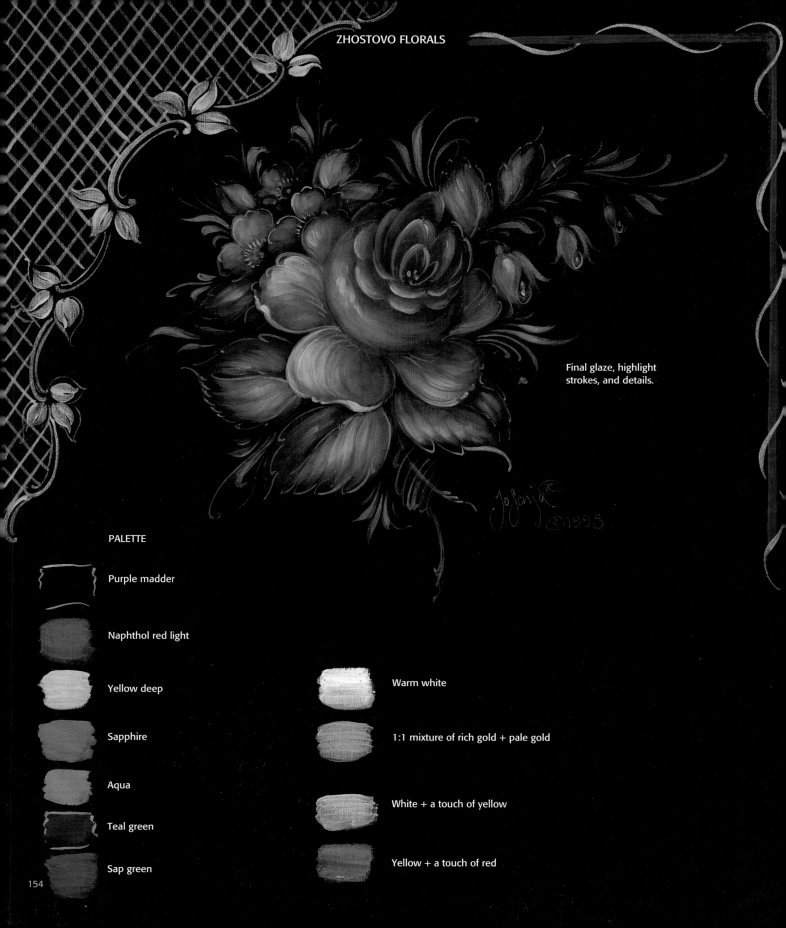

Final glaze, highlight strokes, and details.

PALETTE

Purple madder

Naphthol red light

Yellow deep

Warm white

Sapphire

1:1 mixture of rich gold + pale gold

Aqua

White + a touch of yellow

Teal green

Sap green

Yellow + a touch of red

Venetian Florals

Italy (and Venice in particular) has had a long history of decorative painting and of commerce in painted wares. Of course, it must be said that it was wealth, and the display of such wealth, that created a wonderful marketplace for all the decoration. With so many tourists attending special events and festivals in Venice and Rome, painted items were purchased as souvenirs, which helped spread their painting techniques to other countries. From painted fans to elaborately decorated furniture, one could expect to see a superior level of expertise from the highly trained Venetian artisans.

The examples of this style that I've collected all have interesting surface details. All the pieces shown below were prepared with gesso. If you look carefully at the surface of the large tray, you can see where some air bubbles popped as they dried, leaving what appear to be small "pit" marks. This effect was common on old gesso-prepped pieces, as air bubbles became trapped in the wet gesso as it was mixed or applied.

The handbeaten sheet iron tray with the pierced edge shown on page 157 was also prepped with gesso, but there it seems to have been applied very thickly, incised with a special tool, then the areas were gold leafed. If you look closely at the flowers, as well as at some of the leaves and scrolls, you can see textured strokes. Probably worked in thickened gesso, each stroke is distinct, which gives a sculptured, low-relief effect to the painting. This technique was to be emulated in many other early styles of painting from other areas.

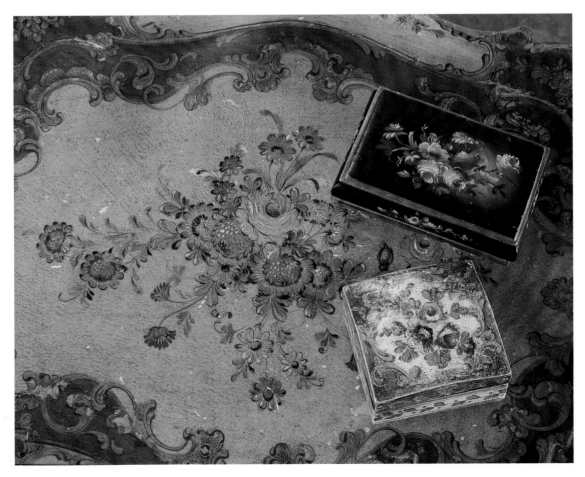

Venice's long history of creating decorative painted items for many markets, from Scandinavia to Spain, has cultivated a very skillful and well-planned presentation. These old pieces reflect a beautiful style of decorative painting that includes a little impasto work. The large, beautifully shaped wooden tray in the background is actually the top to a wooden table.

VENETIAN FLORALS

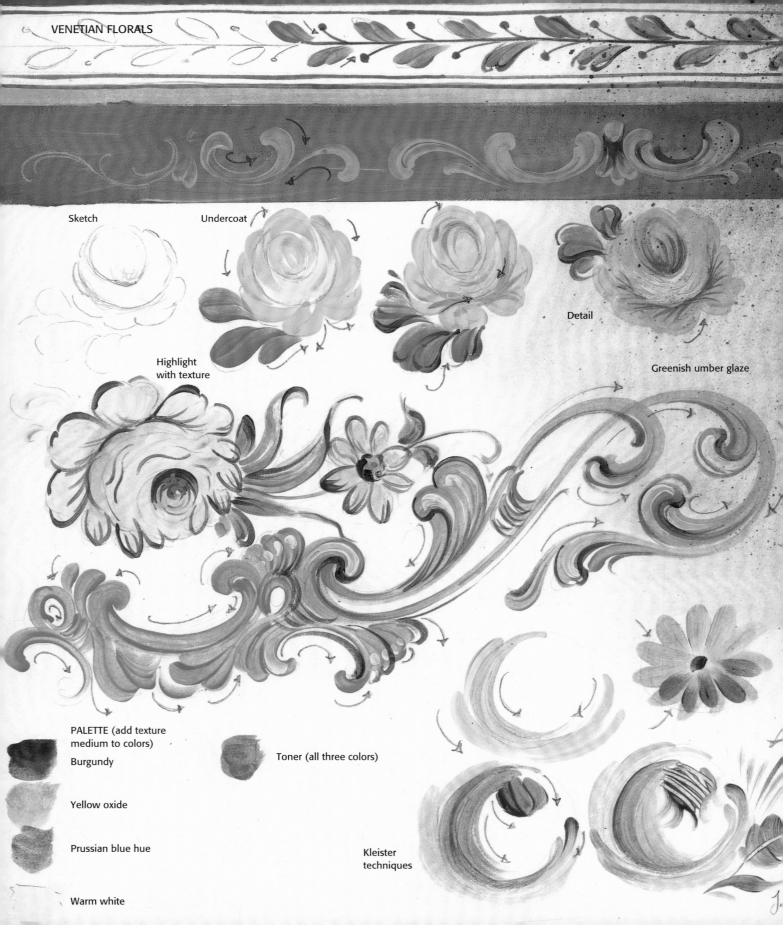

Sketch

Undercoat

Highlight
with texture

Detail

Greenish umber glaze

PALETTE (add texture
medium to colors)

Burgundy

Toner (all three colors)

Yellow oxide

Prussian blue hue

Kleister
techniques

Warm white

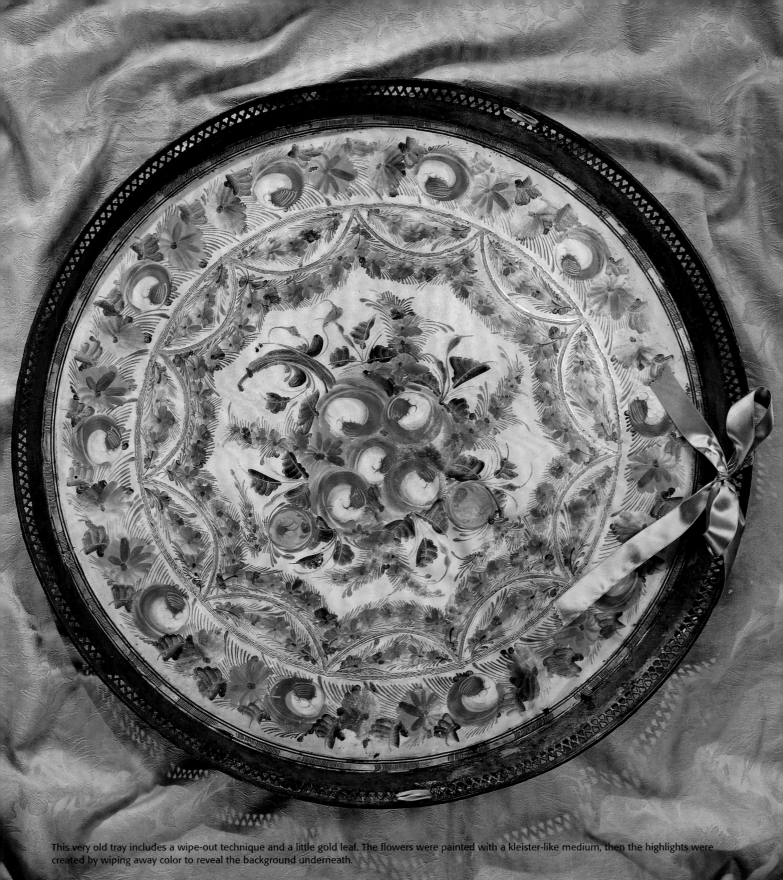

This very old tray includes a wipe-out technique and a little gold leaf. The flowers were painted with a kleister-like medium, then the highlights were created by wiping away color to reveal the background underneath.

Norwegian Rosemaling

Come away with me and let me share with you some of the beauty of Norway and its style of folk art painting, rosemaling. This land of my father's parents is a land of contrasts. Long, dark winter nights intermittently illuminated by the brilliant, shimmering light of the aurora borealis or a crackling fire. Dark, often black, *bunader* (folk costumes) enriched with vibrant embroidery and sparkling gold or silver filigreed jewelry and buttons. Sea and snow. Black and white.

Long, gentle summer days. Vibrant greens and blues tempered by the soft grays of the night's half-light. Smoky, smoldering remains of a summer night's campfire softly glowing against the granite grays and meltwater blues of the deep fjords. The squawking, squeaking, lively Hardanger fiddle, the peaceful lapping of the water along the shoreline of a fjord.

Stylized flower forms and acanthus-inspired scrolls decorate objects, walls, and ceilings with lush, plantlike designs. An animal, a house, a person, a bird, or a fantasy figure sometimes punctuates a design and lends a bit of whimsy to a composition that could easily become monotonous and repetitious. The variety of motifs attest to the wonderful imagination and creativity of a people with a rich cultural background and an unwavering belief in the worth of individual expression.

Regional styles of painting developed, perhaps due in part to limited contact with the outside world in some of the more remote areas, but certainly to pride of tradition. These traditions did not stagnate in mindless repetition. These culturally aware people realized the need for new inspiration and

Rosemaled pieces from the Os region, near Bergen, Norway. Painted in the late 1800s and early 1900s, these small pieces were easy to transport. Many of them were brought to America by Norwegian immigrants.

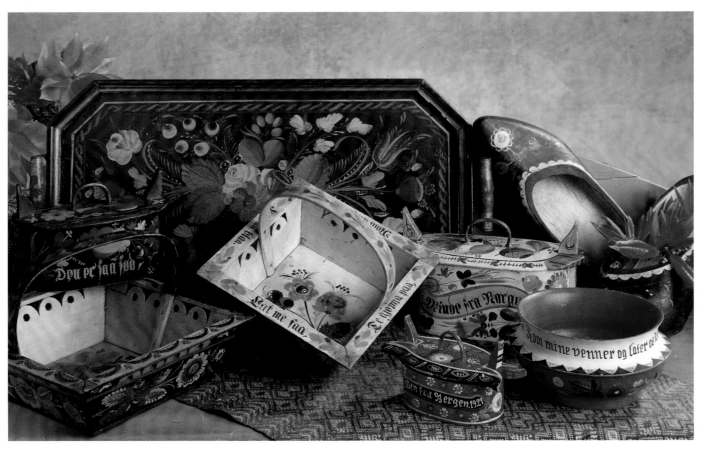

expression, as can be observed in the works of the early 1800s, in which a blending of styles occurred as travel between areas increased.

A limited palette of colors and a strong sense of the power of simple designs contributed to rosemaling's early success. When the designs became too complex and too colorful to be easily enjoyed, rosemaling began to dwindle in popularity. Industrialization also played a role in its decline, but part of the fault must lie with the artists who did not or could not change with the times. Art and decoration did not die.

It is impossible to cover every style of rosemaling in this book, so I'm offering just a taste: an introduction to the Os style. Os painting is a very ornate floral style. Its colors and style easily complement the modern approach to decorating, particularly eclectic decors.

The Vesterheim Norwegian-American Museum continues to serve as the cornerstone of research and education for Norwegian-American culture in the United States, including the various styles of rosemaling (see page 284 for contact information). Educational tours to Norway are offered, and visiting Norwegian artists as well as popular American rosemalers teach at the museum. A rosemaling newsletter is offered, through which some news of active regional rosemaling associations may be obtained.

Sigmund Aarseth was the first rosemaler from Norway to teach in the United States. This inspirational artist continues to encourage us with his unique, creative, and powerful Telemark-style work. Next came Nils Ellingsgaard, an artist of the Hallingdal tradition, who not only inspired decorative artists with his brush but with his pen and camera too, as he has devoted years to researching and documenting antique pieces to promote study and interest in the art form. His books are a treasured part of our rosemaling collection. I turned to Nils for help when adapting rosemaling techniques to acrylics, and I extend grateful thanks to him and to the Vesterheim Museum for their help and educational opportunities.

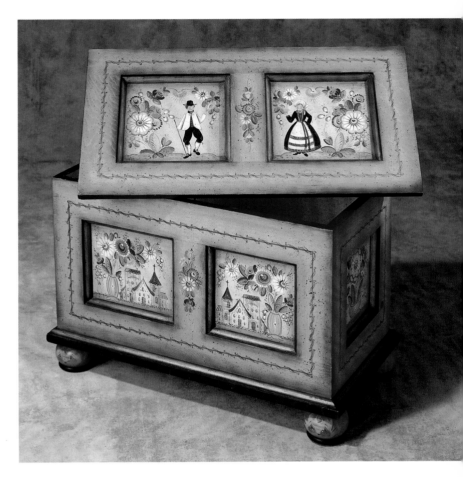

TECHNICAL NOTES

Most of the early rosemaling paintings done in the United States were painted in oils, but the interest in using acrylics for rosemaling is increasing. Developing an acrylic technique for rosemaling has given me many happy and rewarding hours of painting. The challenge of working on pieces for the annual Rosemaling Exhibition at Vesterheim has inspired me to reach for higher goals in technique and design. As an artist, I am grateful for this opportunity.

The stroke-blending technique, which is shown on page 162, gradually diminishes color within highlights and shading by repeating the same stroke to extend an area of color while decreasing pressure for succeeding strokes. The brush is not reloaded during this process.

A trunk decorated with a contemporary interpretation of Os rosemaling.

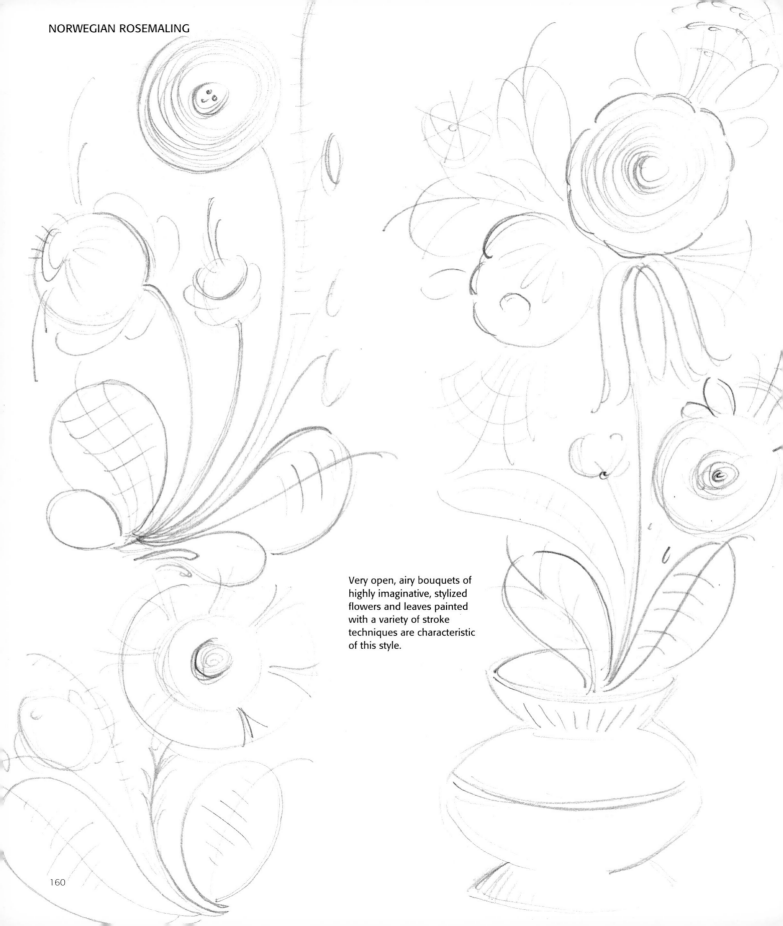

Very open, airy bouquets of highly imaginative, stylized flowers and leaves painted with a variety of stroke techniques are characteristic of this style.

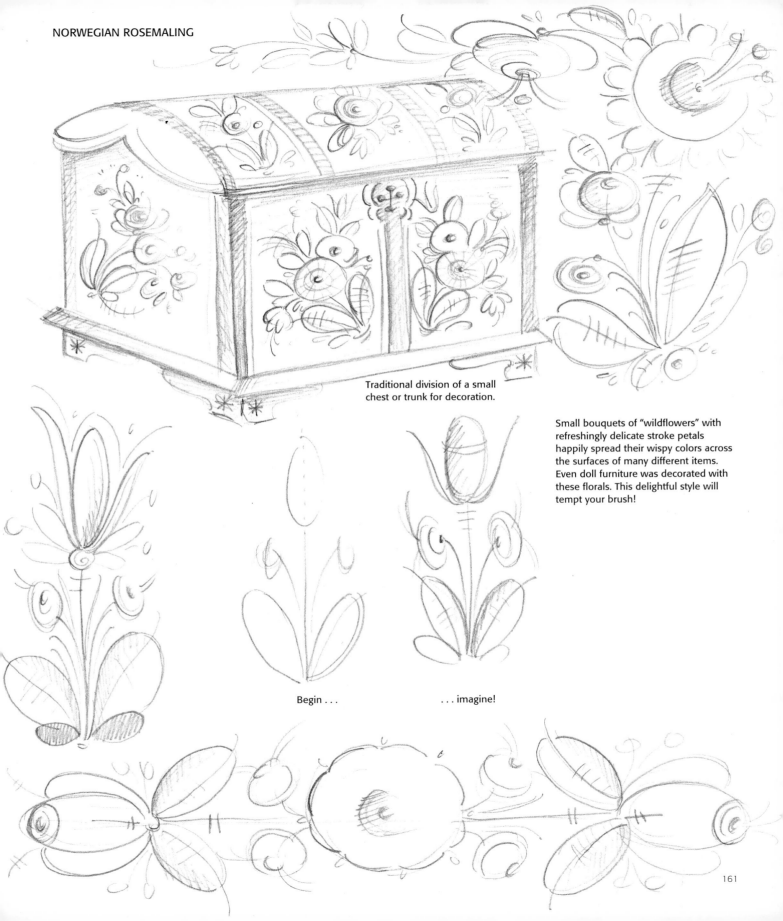

Traditional division of a small chest or trunk for decoration.

Small bouquets of "wildflowers" with refreshingly delicate stroke petals happily spread their wispy colors across the surfaces of many different items. Even doll furniture was decorated with these florals. This delightful style will tempt your brush!

Begin . . .

. . . imagine!

NORWEGIAN ROSEMALING

PALETTE

Burgundy

Naphthol crimson

Turner's yellow

Prussian blue hue

Warm white

Turner's yellow + Prussian blue hue

Toner (yellow + red + blue)

Rich gold

Burgundy + blue

Kleister Medium

Undercoat Shade Detail

Stroke-blending with Kleister Medium

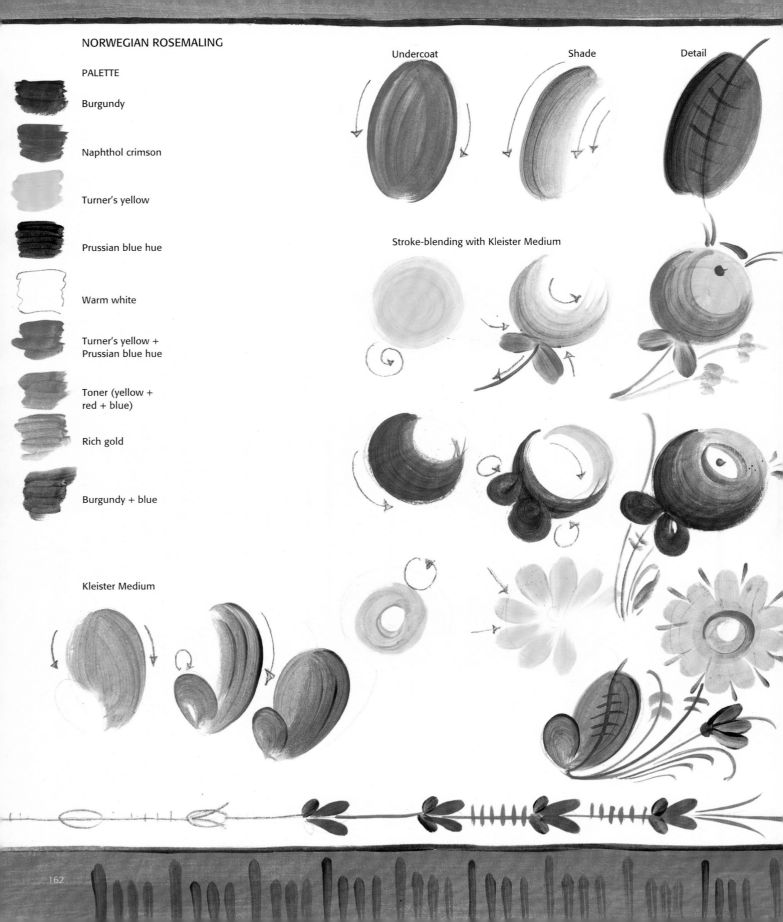

NORWEGIAN ROSEMALING

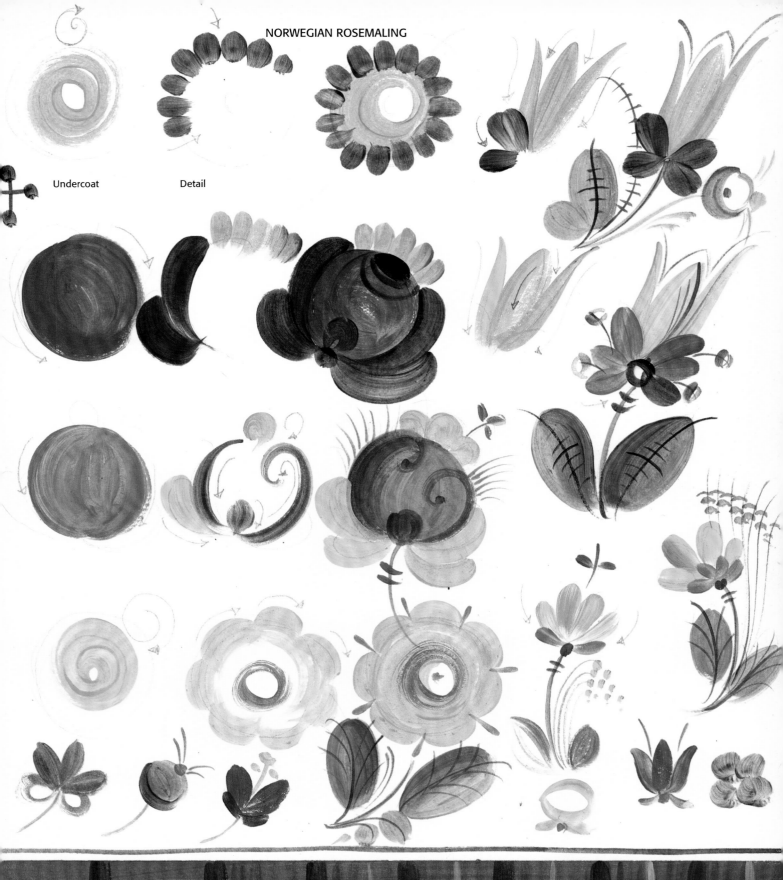

Undercoat Detail

Dala Painting

Northwest of Stockholm, from the province of Dalarna in central Sweden, comes a beautiful style of folk painting called Dala painting. The paintings often recounted Bible stories or recorded special events. When done on walls, a happy, simple palette of light colors and light backgrounds were typical. Spattering is also a very common form of wall decoration, especially on lower-wall areas. Furniture was also painted, but it was usually done in medium-value or dark colors featuring simple designs and lots of faux finishes. Kleister techniques usually frame painted areas on furniture.

The artists traveled during the summer, when roads were passable, to take measurements and orders. They returned home to paint through the winter, working on on large pieces of heavy paper or on long strips of gesso-primed linen, then delivered their work the following summer.

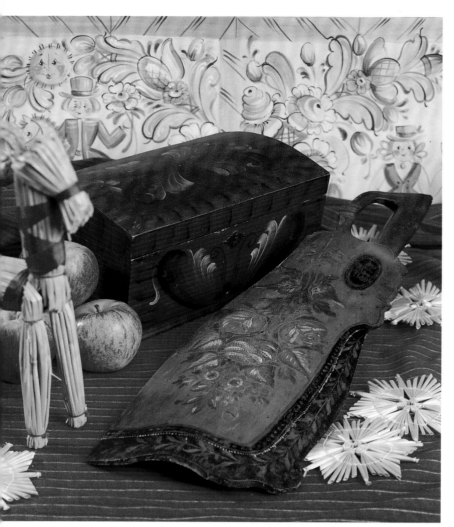

Two old pieces of Swedish folk art. The small trunk is painted with the furniture style of Dala painting. A traditional "love gift," the wooden scrutching knife (flax knife) is from Halsingland, which has its own regional style.

TECHNICAL NOTES

Kurbits or gourd trees are a distinctive motif of this style. Swedish artists took inspiration from the story of Jonah—who fell asleep in the hot sun and was shaded by a gourd tree that God had commanded to grow over him—painting an imaginative, highly stylized version of the plant. At first the *kurbits* was rendered somewhat realistically, evoking actual small gourds or pumpkins and squash blossoms, but as time went on the forms became less recognizable as the painter's imagination and style became more dominant. *Kurbits* decorate many scenes, are usually much larger than other pictorial elements, and sometimes fill most of the negative space.

Tempera paints were traditionally used for Dala painting. The binder for these paints is glue, usually a fish-based glue. Glue-based temperas are also referred to as *distemper,* meaning that pigments were "tempered" in with the glue. So if you should happen to read about distemper in connection with Swedish painting, rest assured that the work isn't diseased—it simply was painted with glue-based tempera paints.

DALA PAINTING

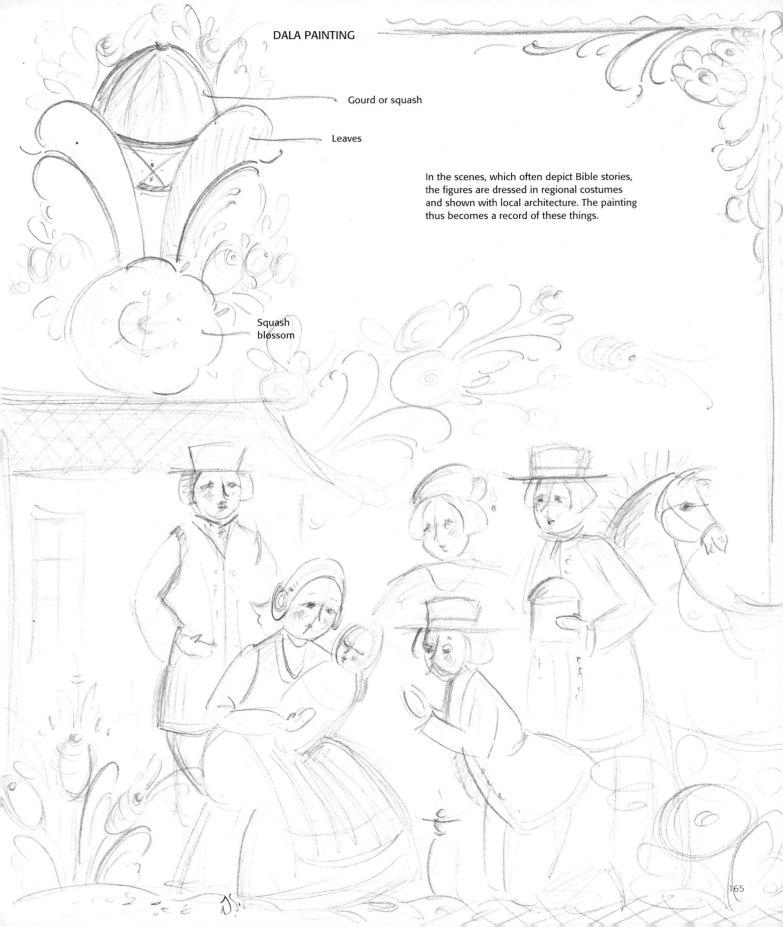

Gourd or squash

Leaves

Squash blossom

In the scenes, which often depict Bible stories, the figures are dressed in regional costumes and shown with local architecture. The painting thus becomes a record of these things.

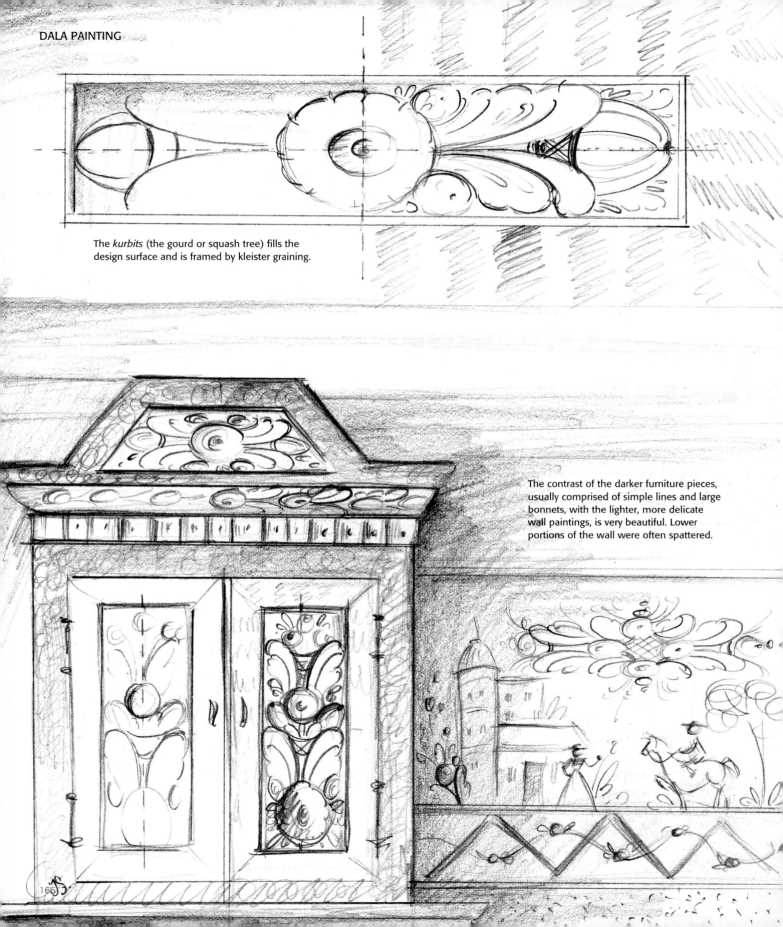

The *kurbits* (the gourd or squash tree) fills the design surface and is framed by kleister graining.

The contrast of the darker furniture pieces, usually comprised of simple lines and large bonnets, with the lighter, more delicate wall paintings, is very beautiful. Lower portions of the wall were often spattered.

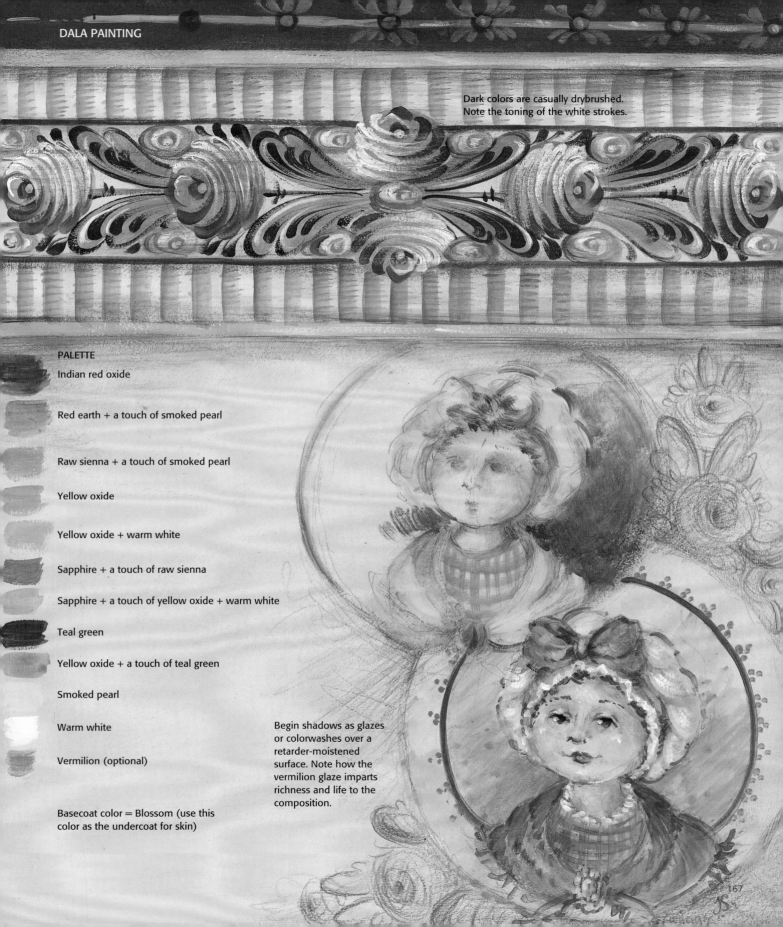

Dark colors are casually drybrushed.
Note the toning of the white strokes.

PALETTE

Indian red oxide

Red earth + a touch of smoked pearl

Raw sienna + a touch of smoked pearl

Yellow oxide

Yellow oxide + warm white

Sapphire + a touch of raw sienna

Sapphire + a touch of yellow oxide + warm white

Teal green

Yellow oxide + a touch of teal green

Smoked pearl

Warm white

Vermilion (optional)

Basecoat color = Blossom (use this
color as the undercoat for skin)

Begin shadows as glazes
or colorwashes over a
retarder-moistened
surface. Note how the
vermilion glaze imparts
richness and life to the
composition.

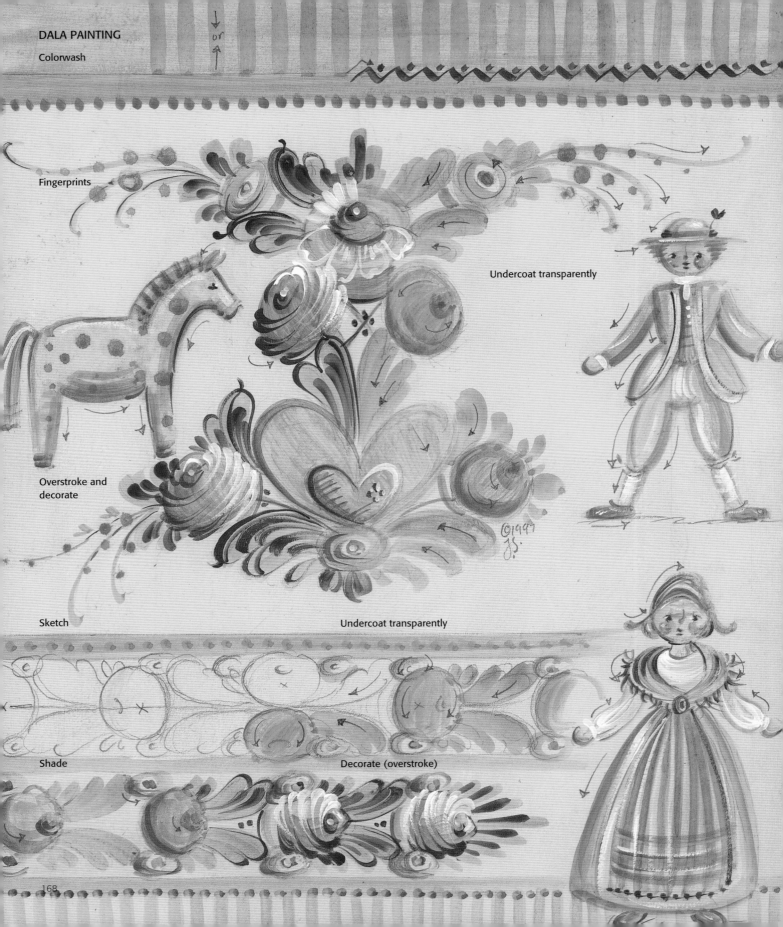

DALA PAINTING

Colorwash

Fingerprints

Undercoat transparently

Overstroke and decorate

Sketch

Undercoat transparently

Shade

Decorate (overstroke)

©1997
JS.

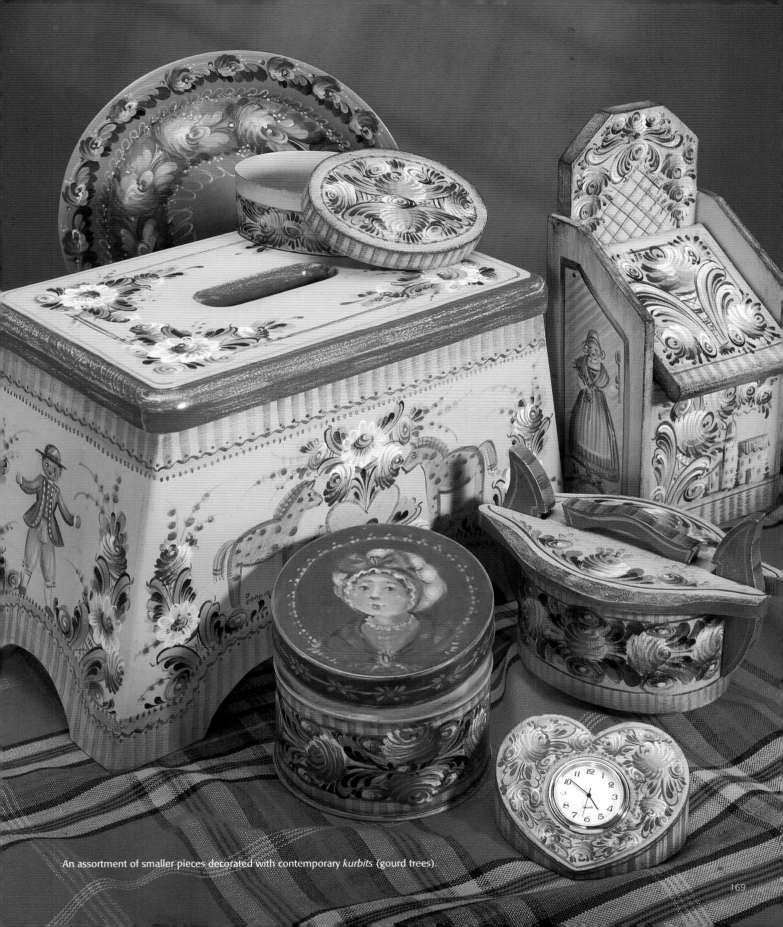

An assortment of smaller pieces decorated with contemporary *kurbits* (gourd trees).

English Narrow Boat Painting

A simply stroked rose in beautiful bright colors complemented by graphic borders in bold contrasting colors epitomizes the charming appeal of traditional narrow boat painting.

It seems that narrow boat painting began when a group of people wanted to decorate their "homes away from home" while traveling along England's canal system transporting various commodities, including coal. Months spent on the long narrow barges spawned many ingenious ideas until, during the mid-1800s, a very strong style emerged. This style, which included even harness brasses and crocheted "headdresses" for the draft horses that were sometimes employed to pull the narrow boat along parts of the canal, is a prime example of the good folk adapting to a necessary way of life and using painted decoration to make their surroundings as beautiful as possible. And, in truth, they painted everything, from the doors to the water bucket, which was known as a "Buckby bucket."

Many scholars and painters have speculated as to the origins of this style. Was it inspired by other decorated transportation equipment, or by painted tin trays and coffee pots (Pontypool wares)? The possibility exists. Certainly the stylized floral elements and their arrangements bear a striking resemblance to the Beidermeier style that occurred about the same time, and to examples of the then-popular Berlin rose needlework. Whatever the inspiration, the result is delightful and fun!

Early examples included figures and animals, but landscapes eventually won out to such an extent that the style is often simply called "castles and roses." The most highly favored scenes were the most boldly simplified. Why all this streamlining? Much of the simplification evolved as labor costs rose, making hourly wages a major consideration. There was even a time when the boatmakers tried to do away with handpainted decoration, but the boat people refused to live and work on the industrially sterile barges (bless them) and the painters returned to work. Visual presentation was also a factor in the style's simplicity. If you are standing on terra firma watching the passing boats, you cannot see refined techniques—they are lost. Therefore, a bold, simple presentation is the most delightful.

TECHNICAL NOTES

Oil-based enamel housepaints "fortified" with tube oils was the traditional medium. As a surface weathered, the elements and the wear and tear of daily life would exact its toll, the paints became brittle and chipped and flaked off, and would have to be redone.

The emphasis here is on color, graphic design (including lettering), and a stylized presentation of flowers and landscapes. For maximum visual impact, plan some bold borders and group the flowers in clusters. Though stroke-blended techniques were once used, crisp, clean, precise strokes are favored today. A faux finish oak wood graining, usually bordering door panels, is wonderful for its simplicity of technique, which gives the eye a place to rest.

The Canal Museum in Towcester, Northamptonshire, which sponsors painting demonstrations and has a well-stocked gift shop with an excellent selection of books and canalware, is a wonderful source of inspiration (see page 284 for contact information). It is possible to plan a vacation tour of the canals on a decorated boat, but be prepared for some exercise, as the tourists steer the vessel and man the locks.

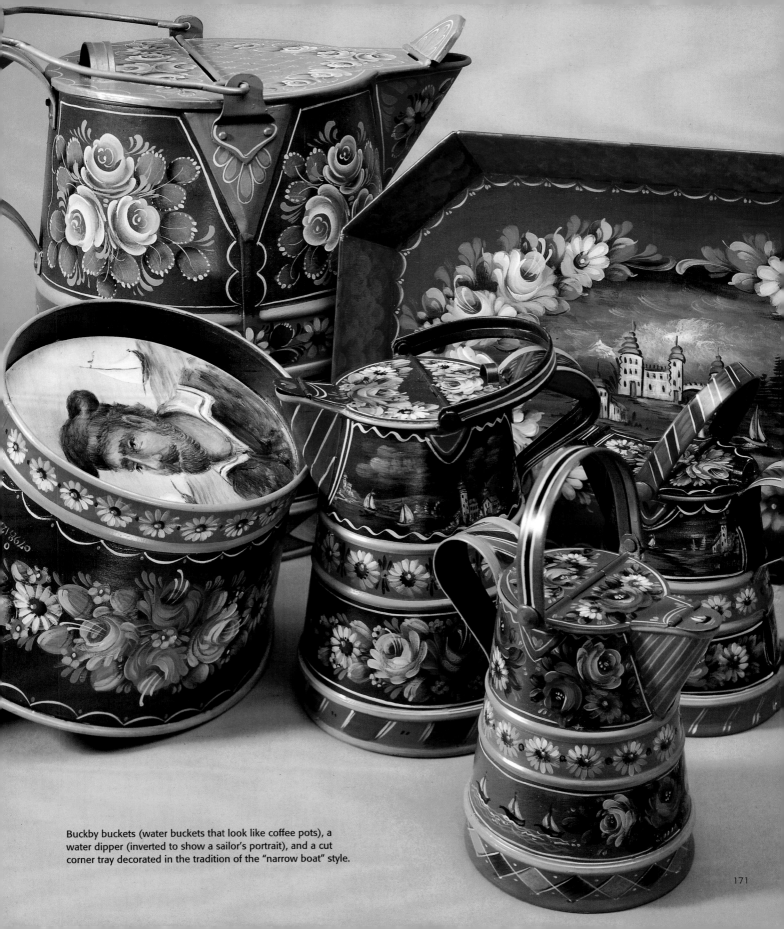

Buckby buckets (water buckets that look like coffee pots), a water dipper (inverted to show a sailor's portrait), and a cut corner tray decorated in the tradition of the "narrow boat" style.

171

BORDERS

Yellows can be warmed with a touch of vermilion. NOTE: Highlights are not traditional.

JS. 97

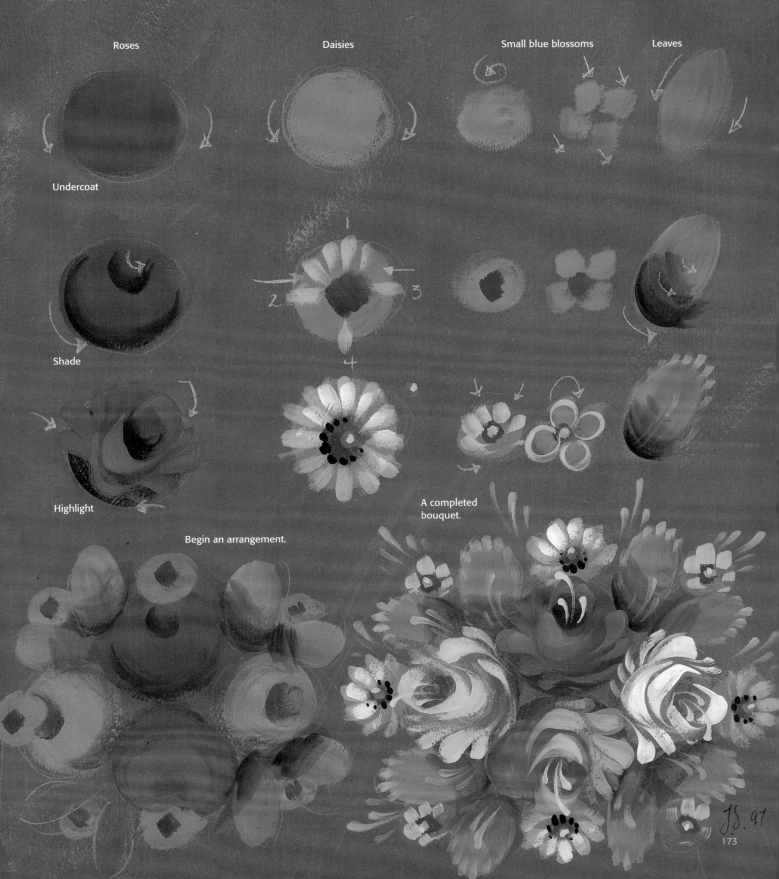

ENGLISH NARROW BOAT PAINTING

Roses

Daisies

Small blue blossoms

Leaves

Undercoat

Shade

Highlight

Begin an arrangement.

A completed bouquet.

JS.91

Sky may be either drybrushed or solid.

Clouds may be dabbed or swirled.

Simply stroked mountains

Shadows

Snows

Foothills to lawn in lighter greens

Repeat the blues in rivers or lakes using horizontal strokes.

Use vertical strokes for castles.

Trees and bushes: Use dabs or strokes.

The stroke progression for a simple boat.

JS 97

ENGLISH NARROW BOAT PAINTING

Oak graining technique
Background = Pale yellow (primrose)
Barrier coat: Clear glaze medium

Casually apply Kleister
Medium + raw sienna +
a touch of brown earth.

Grain by combing.

Make marks (medullary rays or silver graining) with the corner of a new eraser.

PALETTE

Indian red oxide

1:1 mixture of naphthol crimson + red earth

Rose pink

Gold oxide

Raw sienna

Turner's yellow + a touch of red

Teal green + moss green

Moss green

Sapphire

Aqua + a touch of warm white

Brown earth

Carbon black

Nimbus gray

Warm white

Scenes on light backgrounds may be undercoated with colorwashes; retarder techniques may be used where some transparency is desired.

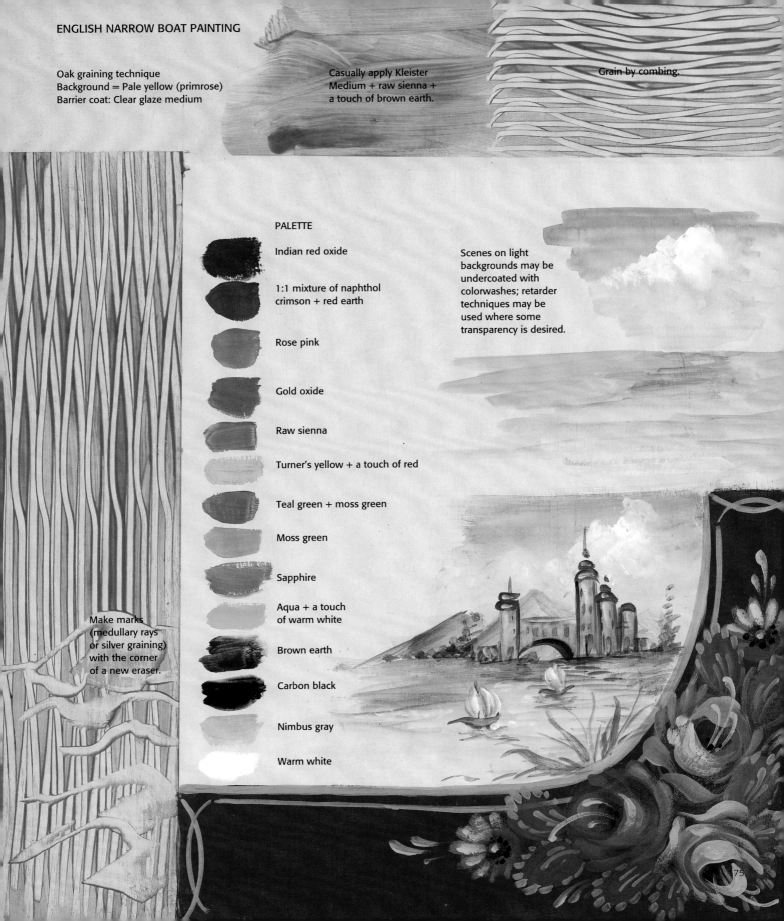

French Tôle

On the third floor of the Decorative Arts Museum, the Louvre, in Paris, I found a small cupboard filled with beautifully decorated tinware, some of whose shapes were very unique. Scenes and florals painted with great skill were framed with strokework borders, many of which were done in metallic paints. It was tole painting, but unlike anything that is called tole painting today.

This style was certainly a major contribution to the decorative arts field, but we must not forget the competition between Queen Marie Leszczynska at Versailles and Madame de Pompadour at Bellevue (the wife and mistress, respectively, of Louis XV) as they decorated walls and furniture, with a few fans on the side. Wallpapers were handpainted, as were fabrics, which were also blockprinted and batiked. Wealth and its display once again joined forces to provide artists with work and to maintain the interest in painted decoration.

Miniature stroke flowers and the classic French ribbon painted over a crackled background decorate the small tin items shown at left. The small booklet, either a diary or appointment book, is decorated with a miniature portrait. The small rectangular piece held a little box of matches. The larger circular piece, which has a glass protector over the painting, was probably an ashtray. A charming set, collected piece by piece over the years, but about which very little is yet known.

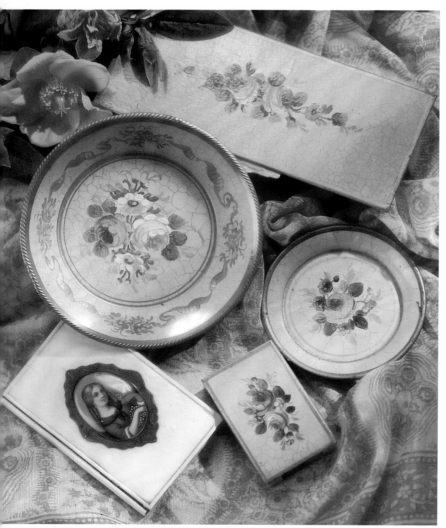

Stroke flowers and ribbons decorate these small tin pieces with crackled backgrounds. Note the miniature portrait on the small appointment book.

TECHNICAL NOTES

Backgrounds may be crackled (see page 100); a small or tight crackle pattern is better suited to the miniature flowers. Pearl or iridescent white also makes a lovely background, but because it is translucent you should basecoat the piece first with gesso before applying two to three coats.

Scenes may be blended over a retarder-moistened surface (see page 79). Some areas, like the waves on the seascape in the paintings shown opposite, contain no blending.

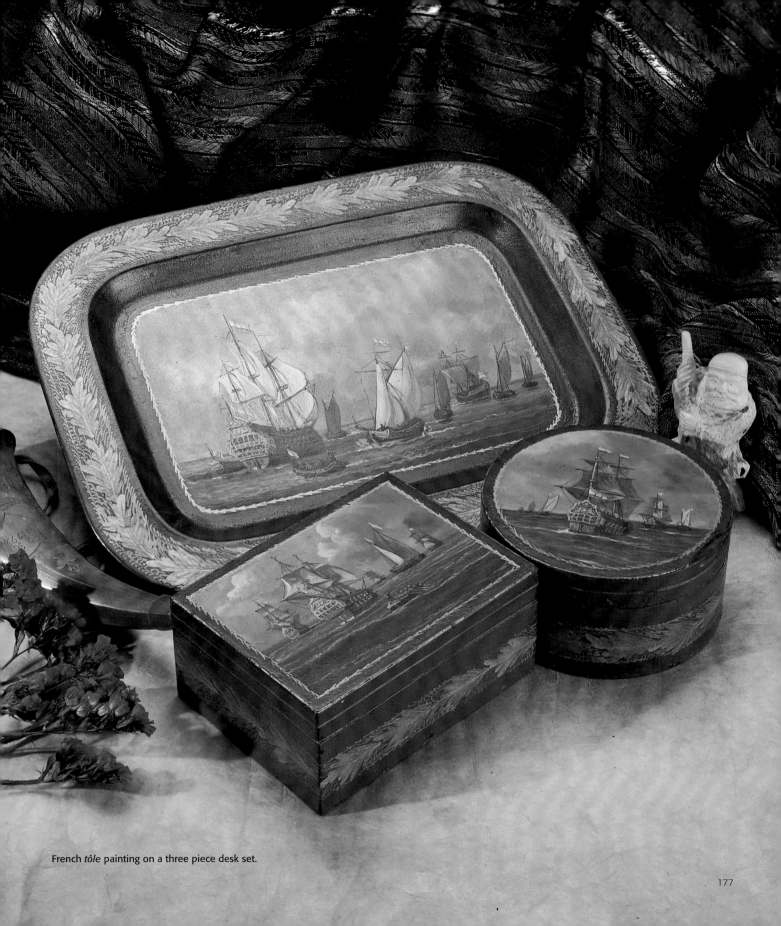

French *tôle* painting on a three piece desk set.

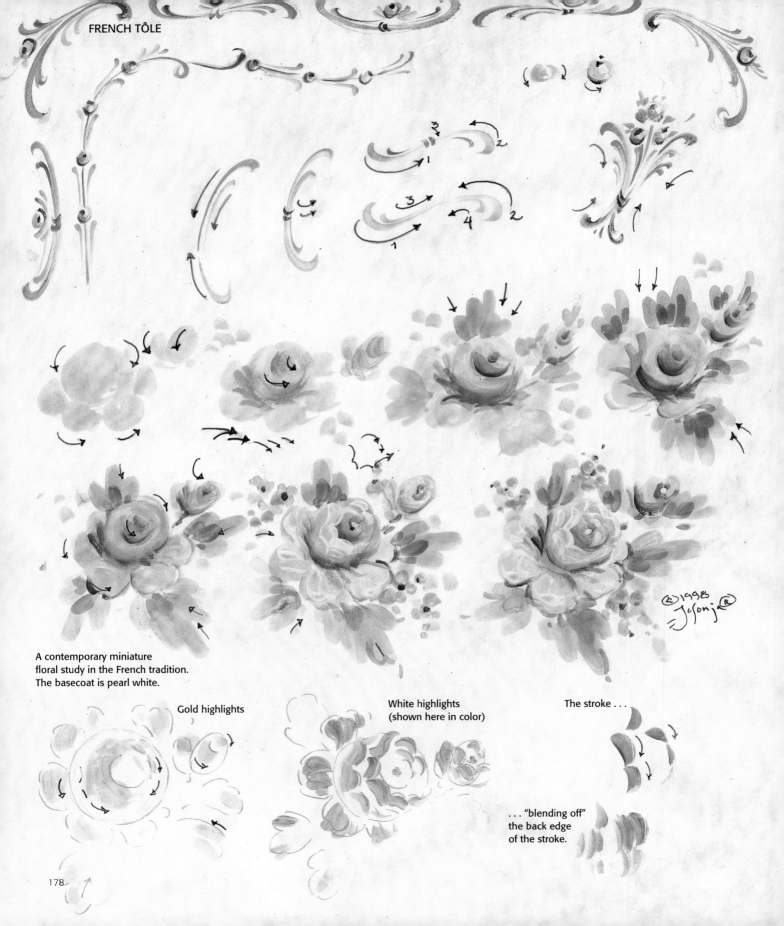

A contemporary miniature
floral study in the French tradition.
The basecoat is pearl white.

Gold highlights

White highlights
(shown here in color)

The stroke . . .

. . . "blending off"
the back edge
of the stroke.

©1998
JeSonja®

178

Hindeloopen

In North Holland, by the sea, sits the very precious small town of Hindeloopen. Artists still paint there today, five studios at last count, and there's also a delightful museum filled with tables, beds, cupboards, boxes, sleds, and many other items for your viewing pleasure. Each artist has his or her own personal style and palette. The fact that the artists of Hindeloopen have been able to maintain a market for painted items is a testament to their ability to appeal to the general public, their business acumen, and their aesthetic sensibility, all of which contributes to the respect for and awareness of painted decoration.

My husband and I love the Hindeloopen style and have a number of pieces in our home. Their color schemes work well no matter where we put them, which is one of the most important things that can be learned from the style: If you paint pieces that your customers can use anywhere, they will return to buy more items, having experienced the joy of not having to worry about color scheme.

The Hindeloopen artists' secret is simply an astute use of color, typically a limited palette of toned colors, an augmented primary color scheme of red, yellow, blue, and green. Sometimes a monochromatic blue scheme that some artists refer to as "porcelain painting" is used, and, less frequently, browns on natural or stained wood.

Early pieces in this style are usually very heavily decorated, accented with a very simple marbling technique and touches of carving with bands and stripes of gold. Birds, flowers, scrolls, and sometimes fruits cover their main design areas, while a biblical scene or a landscape depicting a bygone era may be showcased on the primary surface. The scrolls are very round, highlighted with tints and shadowed with shades of the main color. To paint them, casual strokes are applied individually; no blending is done here. Other motifs are also painted with a casual stroke technique. This is one of the few folk painting styles in which a fairly consistent light source may be indicated, though some artists are more precise in their placement of highlights than others.

TECHNICAL NOTES

Most of the Hindeloopen artists still paint in oils, allowing the painting to dry between steps. I noticed that acrylic paints in various mixed colors were available in shops next to their studios, which is understandable because acrylics are perfect for this technique. Use Kleister Medium or gel medium for marbling (see page 90) and retarder when a little blending is desired for landscapes.

On page 182 I share my own interpretation of the Hindeloopen style, in which I try to achieve a very elaborate design. Following the traditional style, I used toned colors, and mixed shades for the shadow strokes and tints for the highlights. Although drybrushing isn't a traditional Hindeloopen painting technique, I love using it to indicate shadows and highlights. The soft, broken color lends an impressionistic effect to the overall presentation.

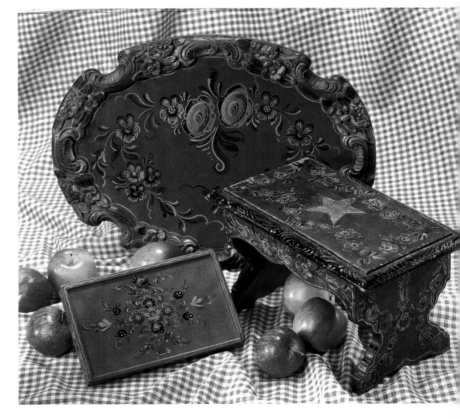

Old examples of the Hindeloopen style. The handcarved tray and footstool are very old.

HINDELOOPEN

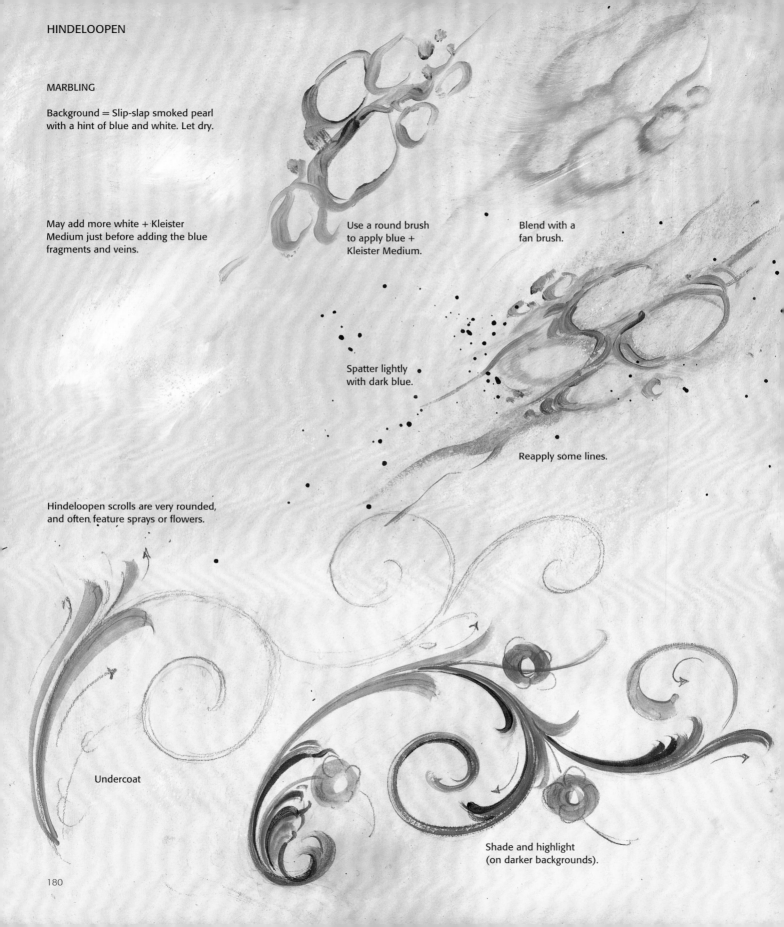

MARBLING

Background = Slip-slap smoked pearl with a hint of blue and white. Let dry.

May add more white + Kleister Medium just before adding the blue fragments and veins.

Use a round brush to apply blue + Kleister Medium.

Blend with a fan brush.

Spatter lightly with dark blue.

Reapply some lines.

Hindeloopen scrolls are very rounded, and often feature sprays or flowers.

Undercoat

Shade and highlight (on darker backgrounds).

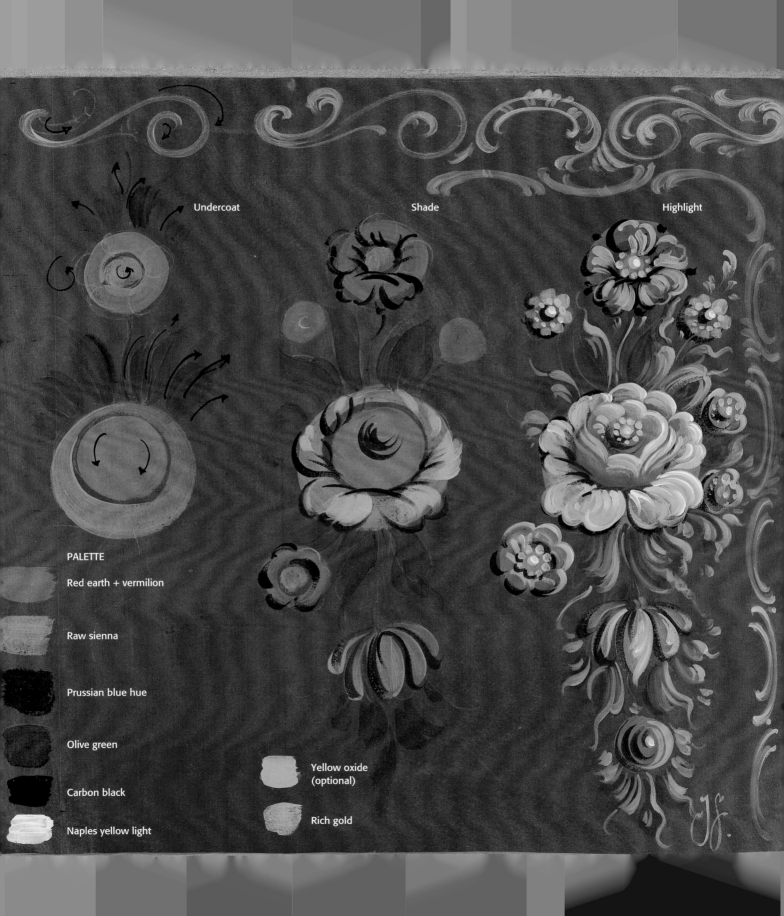

Undercoat

Shade

Highlight

PALETTE

Red earth + vermilion

Raw sienna

Prussian blue hue

Olive green

Carbon black

Naples yellow light

Yellow oxide
(optional)

Rich gold

Hindeloopen

Contemporary interpretations of the Hindeloopen style. Since the tables are usually displayed folded, their undersides are more heavily decorated.

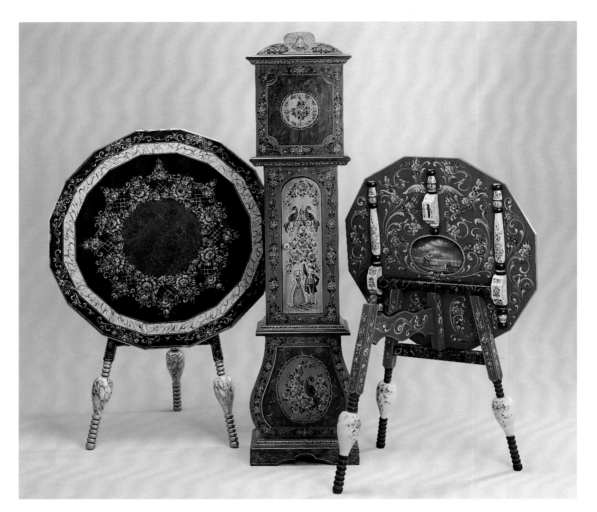

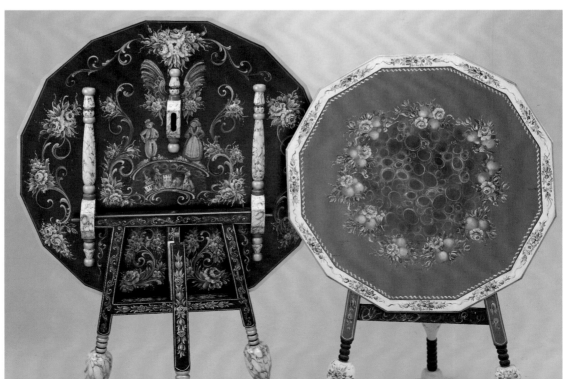

Other Influences

UKRAINIAN FLORALS

From the Petrokievka school in Ukraine comes a beautiful stroke style of painting flowers. Done mostly by women working in egg tempera, the style is full of detail, casually flowing, and colorful. The very active, free-flowing strokework is accented with tipping, dots, and beautiful stroke variations. (The teardrop or reverse comma stroke can be seen on the daisylike flowers at right and below.) This style contrasts well with the geometric designs of the *psyanky* (decorated eggs), for which this area is also well known.

TOYS

A variety of toys, including carvings, eggs, dimensional wooden items, small storage boxes, and noisemakers, are embellished by decorative artists. Norwegian fjord ponies, Swedish horses and roosters, Russian *matroskas,* and Japanese *kokeshi*—all over the world, the surfaces of toys shine with colorful strokes and glossy finishes.

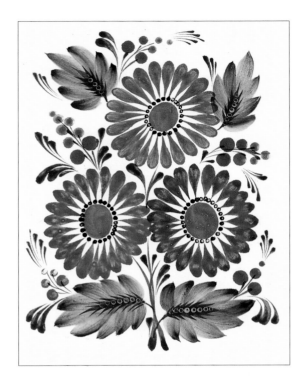

Each spring in Ukraine, kitchens are whitewashed and redecorated with fantastic bouquets of painted flowers before the Easter blessing.

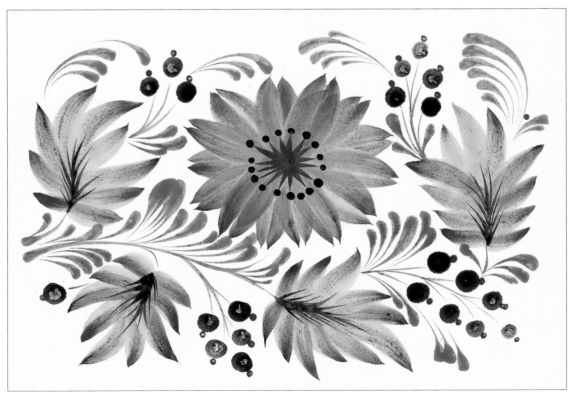

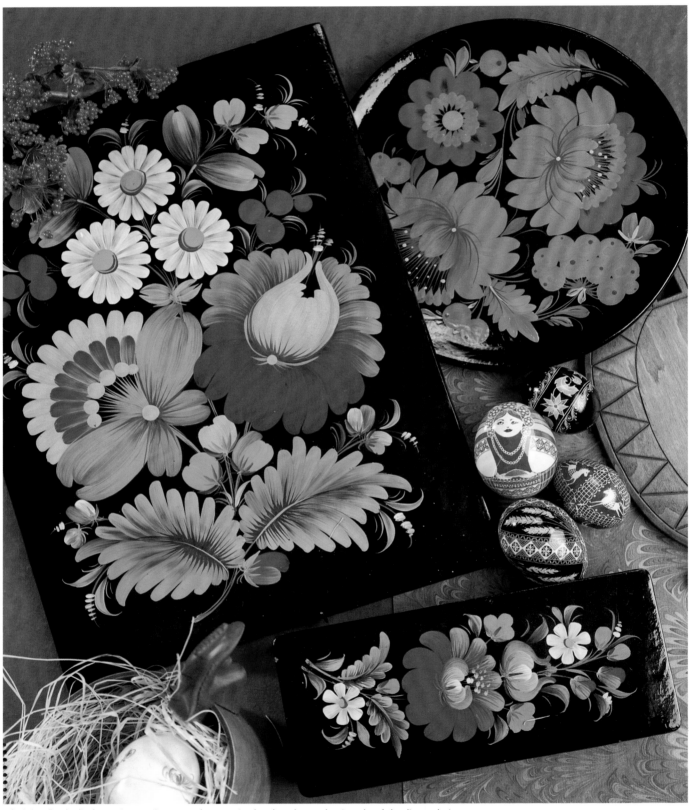

Ukrainian florals display an impressive array of contrasting brushstrokes and unique brush-loading techniques.

Various media are used to decorate these items, following each country's or region's preferences and traditions. Some objects reflect time-honored decorative traditions, though in some areas, such as Russia, recent political changes have disturbed them, precipitating the rapid evolution of new styles and ideas. We must wait to see whether these newer styles will stand the test of time.

MEXICAN DECORATIVE STROKES

Doubleloaded brushstrokes usually form the flowers, birds, animals, and figures in the folk or peasant art from this area. Great imagination is shown in the development of the simple shapes that can be indicated by these colorful stroke variations. While newer paintings use colors as vibrant and intense as a hot chili pepper and are usually painted in oils, the surfaces of the older pieces shown below, right, have been mellowed with time and were probably done in either tempera or casein. The colors may at times seem *too* intense, but they are returning to favor for home decorating. Yellows, pinks, oranges, magentas, and violets, contrasted with aqua blues and lime greens, recall the gardens of the Southwest, where the brilliance of the sunlight tends to mute their colorful displays.

Santos, or saint paintings, are as important to Mexicans as the icon is to Orthodox Christians. *Retablos* (painted dimensional figures and scenes) contribute variety to the decor. Sometimes shaped from clay, sometimes from wood, their stylized representational forms spring to life with the most intense colors.

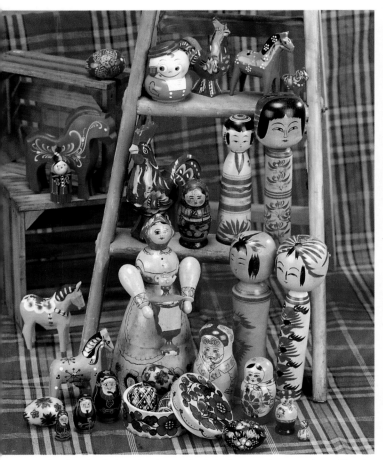

Brushstroke designs, borders, and stripes decorate these toys in traditional motifs that are generations old. On the lowest rung of the ladder is a very rare and old *matroska* that separates at the midline. Often these dolls contain several smaller dolls that "nest" within one another, as illustrated by the sets shown in the foreground, left and right.

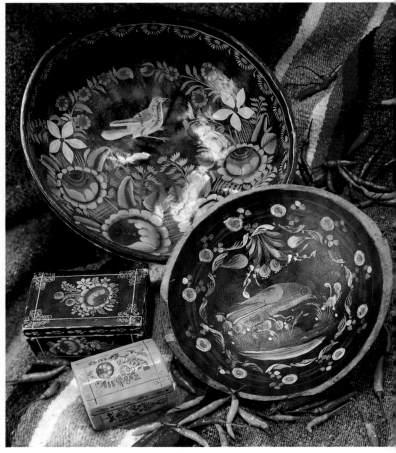

An assortment of old Mexican pieces. The bowl at top, which is made from a large gourd, is covered inside and out with stroke designs. Delicate lines and imaginative foliage frame the center of each composition. Trunks or small chests from this area often have distinctively shaped lids, an example of which can be seen on the small yellow box.

185

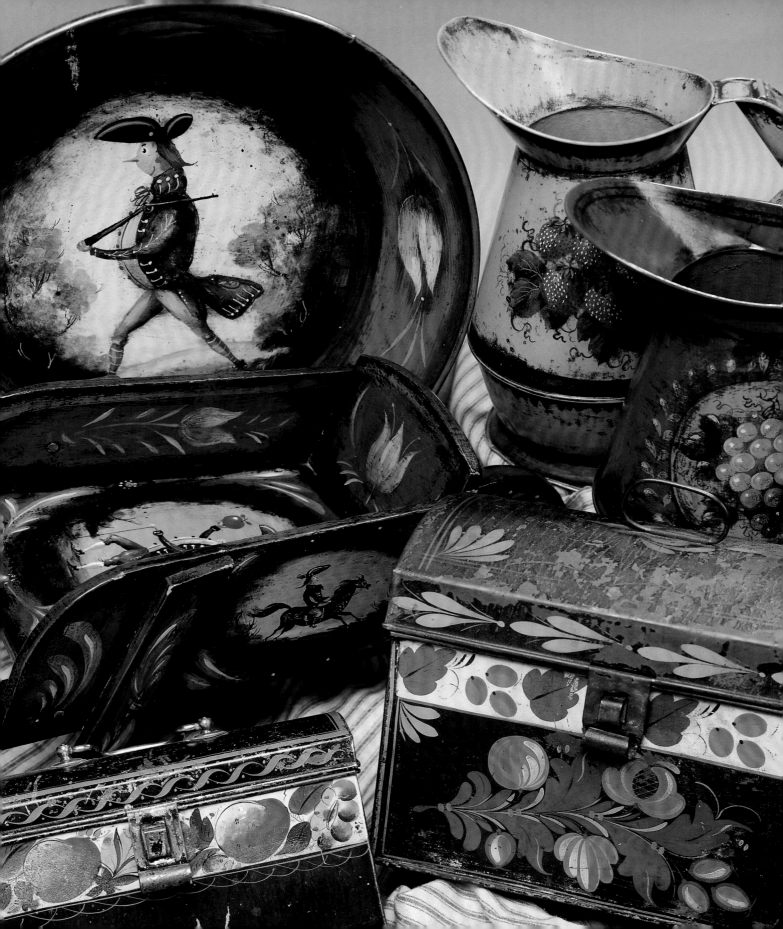

7 Expanding the Traditions to the New World

It was a New World. Survival was difficult. (We don't think of the Founding Fathers as immigrants—we usually just call them "the Colonists"—but they were.) Eventually some form of painting appeared—maybe only a tavern sign or a small chest—but painted decoration was inevitable.

That the painters of the day publicized their services is a matter of record. Artist William Matthew Prior advertised that he could paint a "flat portrait" in 1 hour for $2.95, including the frame and glass. Itinerant painters—limners, they were often called—traveled the countryside decorating walls, or painting portraits of prize bulls or of the master of the house. Stencils and paintings on walls and floors, fireboards, theorems (stenciled paintings on velvet), and "mourning" pictures (scenes of family members at graveside) flowed from their handmade brushes. It's been said that one itinerant, Rufus Porter, published a recipe for wall paint made from beets, and that another, using the stenciled shape of a head and shoulders as his guide, would paint portraits for a modest fee. Sadly, the latter story is in dispute. I think it enjoyable, and that it speaks well of what is called "Yankee ingenuity." It certainly reminds us that these painters could adapt to the current decorating "fancies" of their customers, using their wits and whatever materials were available.

When you can look beyond the primitiveness of some of the paintings, you have to be impressed with their techniques. To simply express large areas of foreground as one color with "spots" or dabs of a darker color, or to stack all the houses on top of each other, like cordwood, required great courage—or at least a very hungry tummy. Holding a box over a candle flame to "grain" it with soot, plucking turkey feathers to "vein" a marbled doorpost, and so on go the ideas—ideas that fire our own creativity with renewed inspiration and that essential quality for an artist: courage.

Country Tin Painting

This important contribution to the history of American decorative art began in the latter half of the 18th century, when Edward Pattison of Berlin, Connecticut, opened a small shop on the Hartford and New Haven Path. The shiny, lightweight pieces of tin quickly caught the attention of colonial homemakers. As demand increased, so did interest in tin production. Pattison taught others to make tin, which required a widening of sales opportunities. In stepped the traveling salesman.

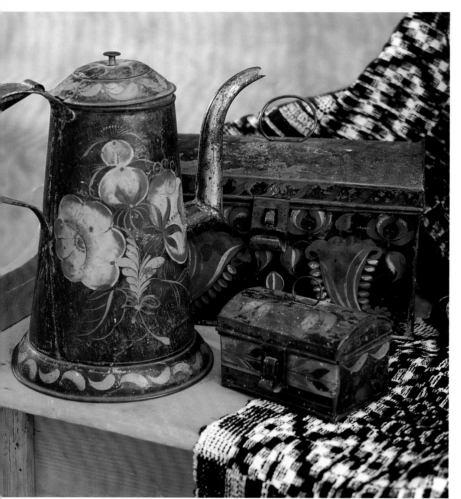

Several examples of old country tin painting photographed against an old handwoven coverlet. The crookneck coffee pot and the small box have asphaltum backgrounds.

Tin peddlers trekked by foot, wagon, and cart. Some pieces were sold, while others were bartered. It wasn't unusual for a peddler to return with a wagon-load of bartered goods more valuable than the original load of tin. Imagine, if you will, a wagon-load of tin: Pots and pans hanging around the sides, banging and clattering over a rutted, uneven road, so that everyone knew when the "tin man" was coming. Delightful stories arose about these early salesmen. The reputations of some preceded them, making them unwelcome at local taverns and inns.

It was just a short time before other shops appeared and, after the Revolutionary War, the decoration of tin began. The decorators in each shop developed a distinct style. A serious student of early American country tin painting can probably tell you where a piece came from just by looking at the motifs, colors, striping, and strokes, even though most pieces were unsigned. The "flowering" of tin was not a "primitive" folk art. The young artists, both men and women, were trained before they could lay a brush on an item, and many developed a very skillful technique.

A limited palette, stylized forms, and brushstroke flourishes characterize this style of decorative painting, which was usually done on a black background, although asphaltum (a slightly translucent dark reddish brown), cream, "country yellow" (yellow oxide), green, and red backgrounds were also produced as decorated tinware become more fashionable. The asphaltum background, which was developed following the discovery and refining of petroleum, seems to have been very popular, as the sheen of the new tin glowing through the semitransparent color must have been very attractive.

The process of basepainting and varnishing tin was often referred to as japanning, a term that reflects the efforts of the English decorators of the 17th century who worked to imitate the Oriental lacquerware that was imported into Europe at that time.

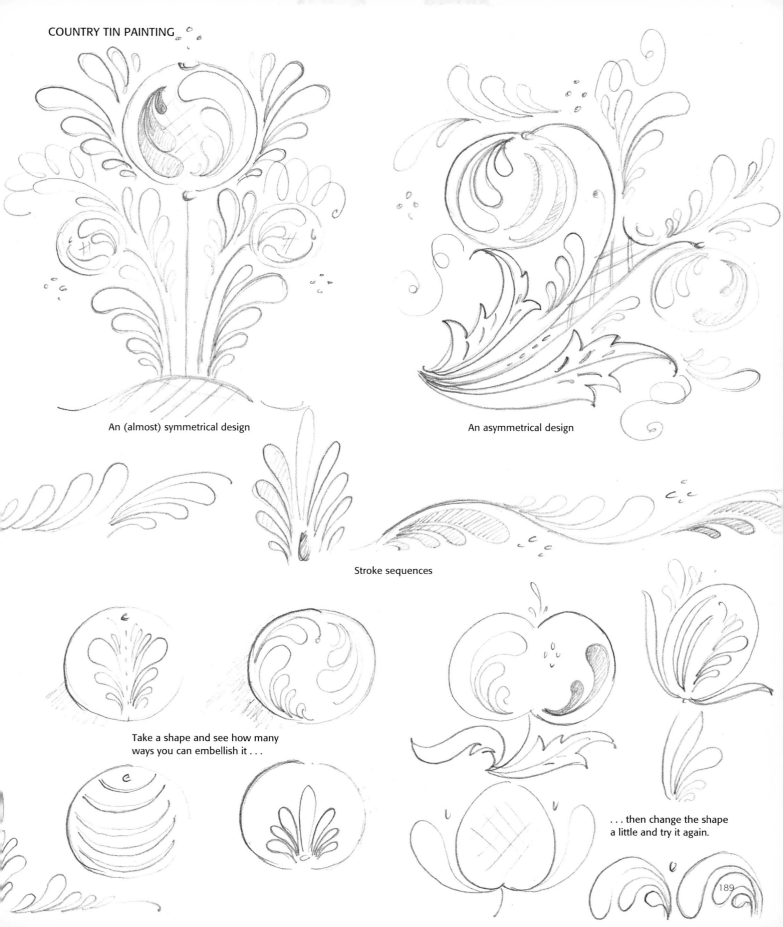

An (almost) symmetrical design

An asymmetrical design

Stroke sequences

Take a shape and see how many
ways you can embellish it . . .

. . . then change the shape
a little and try it again.

189

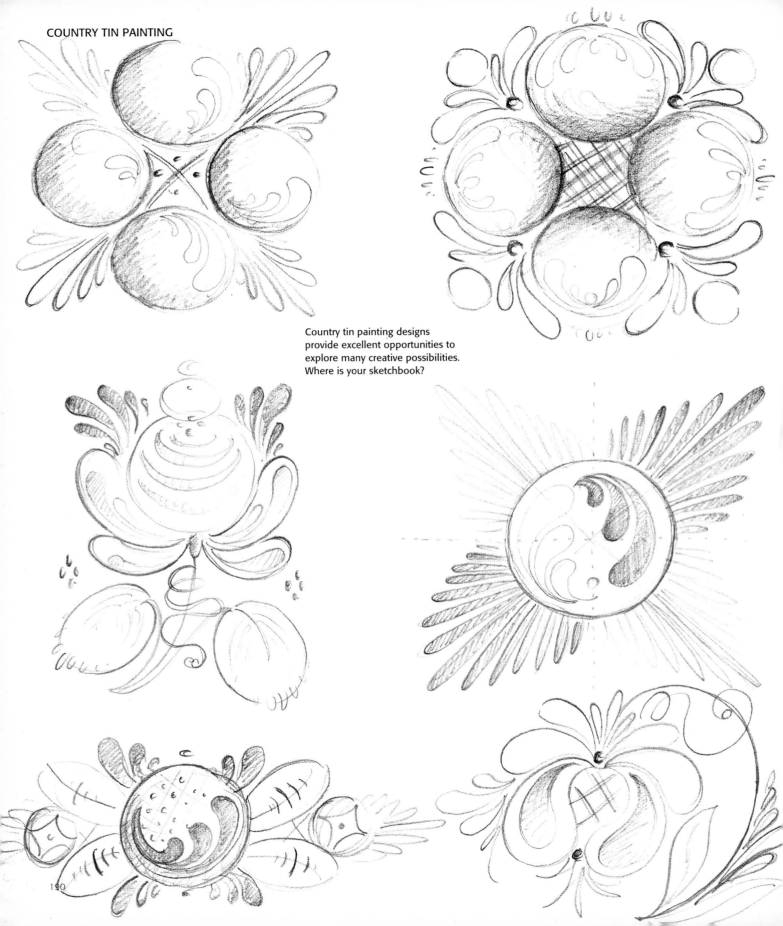

Country tin painting designs
provide excellent opportunities to
explore many creative possibilities.
Where is your sketchbook?

COUNTRY TIN PAINTING

PALETTE

Burgundy

Red earth + vermilion

Yellow oxide + a touch of the preceding red mixture

Yellow oxide + carbon black

OR

Yellow oxide + Prussian blue hue

Smoked pearl

Carbon black

Optional: Salmon (red earth + vermilion + a touch of smoked pearl)

Hatching

Crosshatching

Dots

Casual ribbons (S strokes)

Stripes of various widths

Color bands (either opaque or slightly semitransparent)

Flowing stroke borders

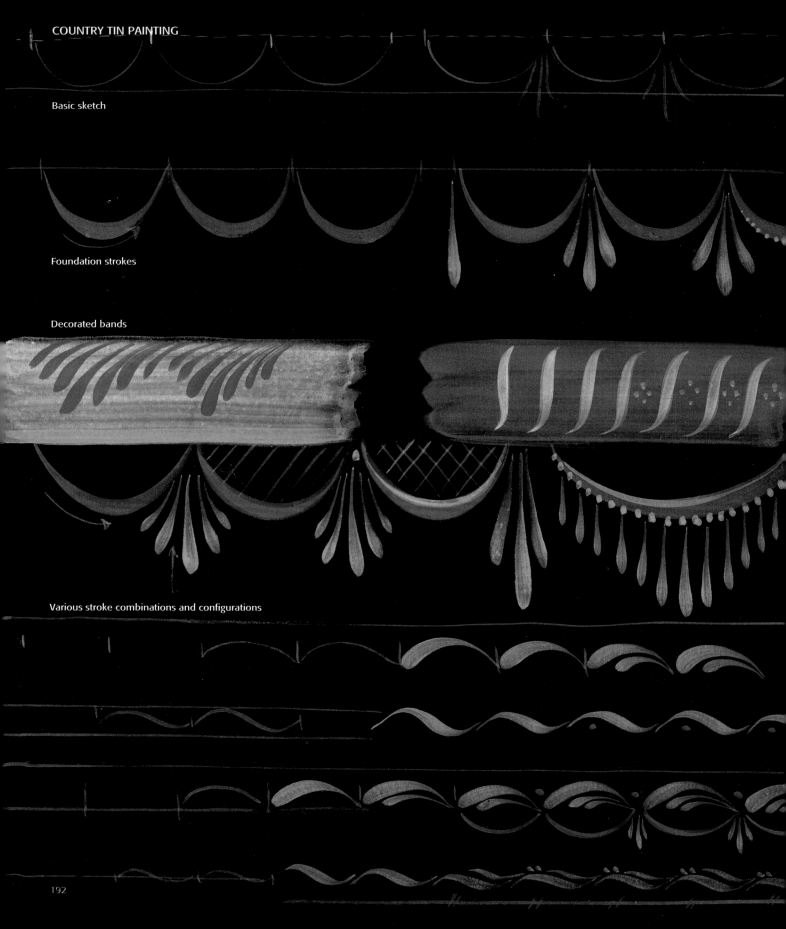

Basic sketch

Foundation strokes

Decorated bands

Various stroke combinations and configurations

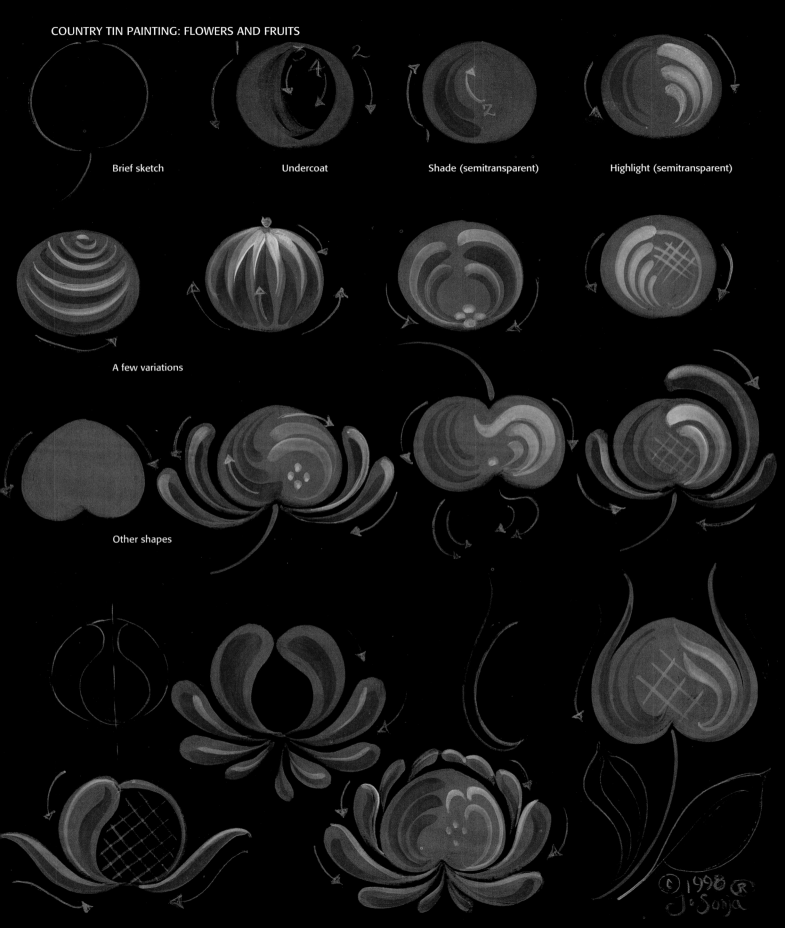

COUNTRY TIN PAINTING: FLOWERS AND FRUITS

Brief sketch

Undercoat

Shade (semitransparent)

Highlight (semitransparent)

A few variations

Other shapes

© 1998 Jo Sonja

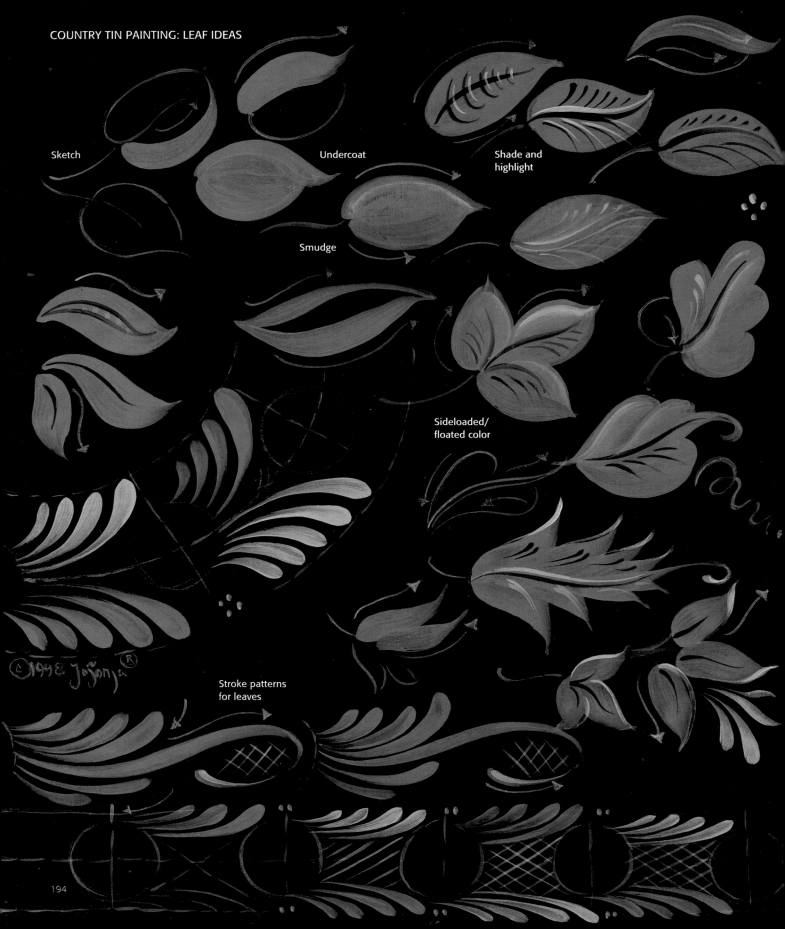

Sketch

Undercoat

Shade and highlight

Smudge

Sideloaded/ floated color

© 1998 Jansonja ®

Stroke patterns for leaves

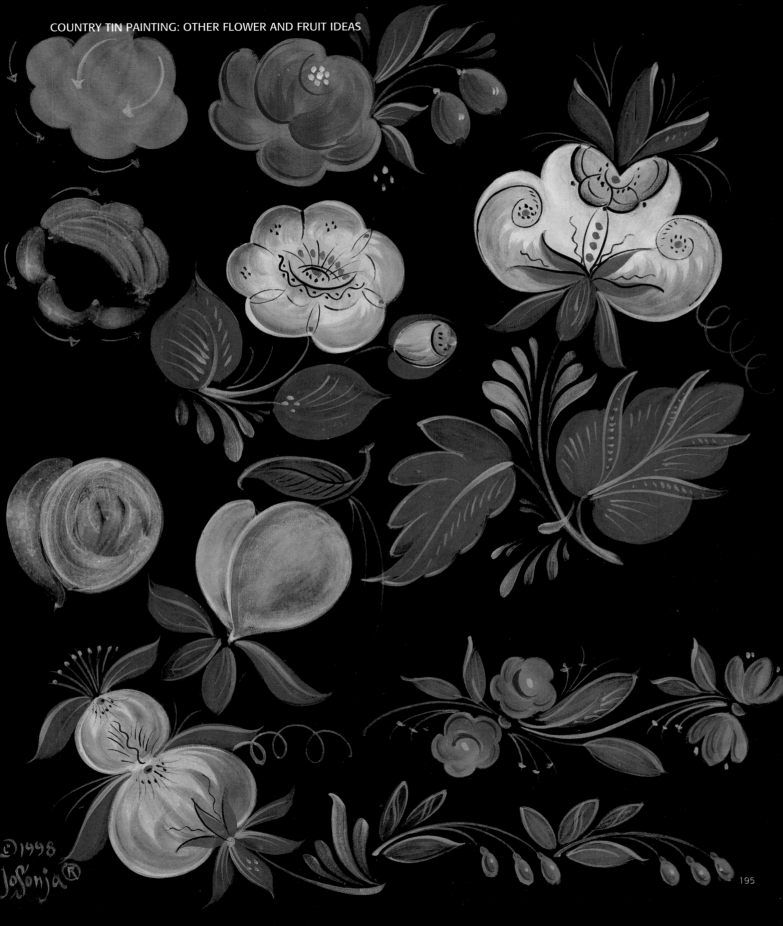

Fraktur

Freckled tulips and bug-eyed birds, rosy red hearts and guardian angels. Red barns with hex signs, sgraffito, and slip-decorated redware pottery. Painted cupboards, chests, and tin. Cozy warm quilts, coverlets, and woolly mittens. Apple pie and cracker pudding, sausages and sauerkraut, hot fragrant coffee. All of these colors and motifs, sights and smells, proclaimed a warm welcome to the Pennsylvania Dutch home.

Immigrants from southeastern Germany, Switzerland, and Alsace, seeking relief from religious persecution, pursued William Penn's promise of freedom and land, bringing with them a love of decoration, color, and design. Their schoolmasters and ministers presented decorated bookplates and frontispieces, awards of merit, birth and baptismal certificates (*Geburtsurkunde* and *Taufscheine*), marriage and house blessings (*Haus-segen*); families "illuminated" their genealogies and children practiced their handwriting in *Vorschriften,* beautiful handwritten copybooks; would-be suitors might give heart-and-hand love tokens or valentines. These pieces of paper, delightfully decorated with watercolor and ink, are collectively called *Frakturs,* a term derived from *Fractur-schriften,* the style of handlettering that was typically featured, which sought to imitate a German style of calligraphy and an early printer's typeface of the same name. These records were decorated with the kinds of motifs that were prized by the Pennsylvania Dutch (actually a corruption of *Deutsch,* which means "German"), from primitive, naturalistic representations of the familiar (houses, trees, and flowers), to traditional symbols of royalty (lions, crowns, and eagles), to the otherwordly or exotic (unicorns, peacocks, and mermaids). Two other important motifs were the *distelfink* (which literally translates as "thistlefinch"), a highly stylized bird painted "jest fer pretty" (see opposite for an example), and the heart, which was originally a symbol of the love of God but had come to signify romantic love, courage, hospitality, loyalty, and fidelity.

These documents not only recorded special moments in the lives of a group of people who contributed much to the cultural life of America, but provide links between America and Europe, as well as between the modern and the medieval.

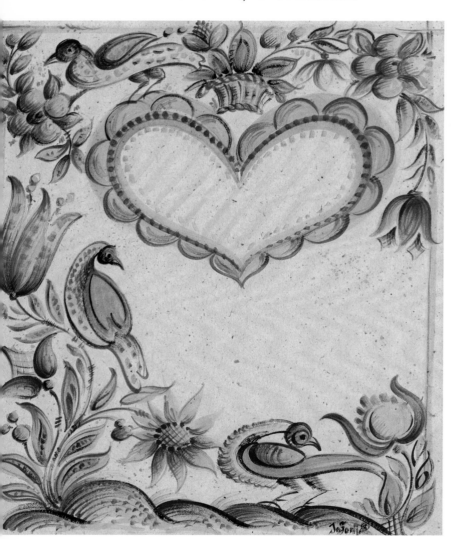

A contemporary example of Fraktur featuring a heart, distelfinks, and tulips.

FRAKTUR

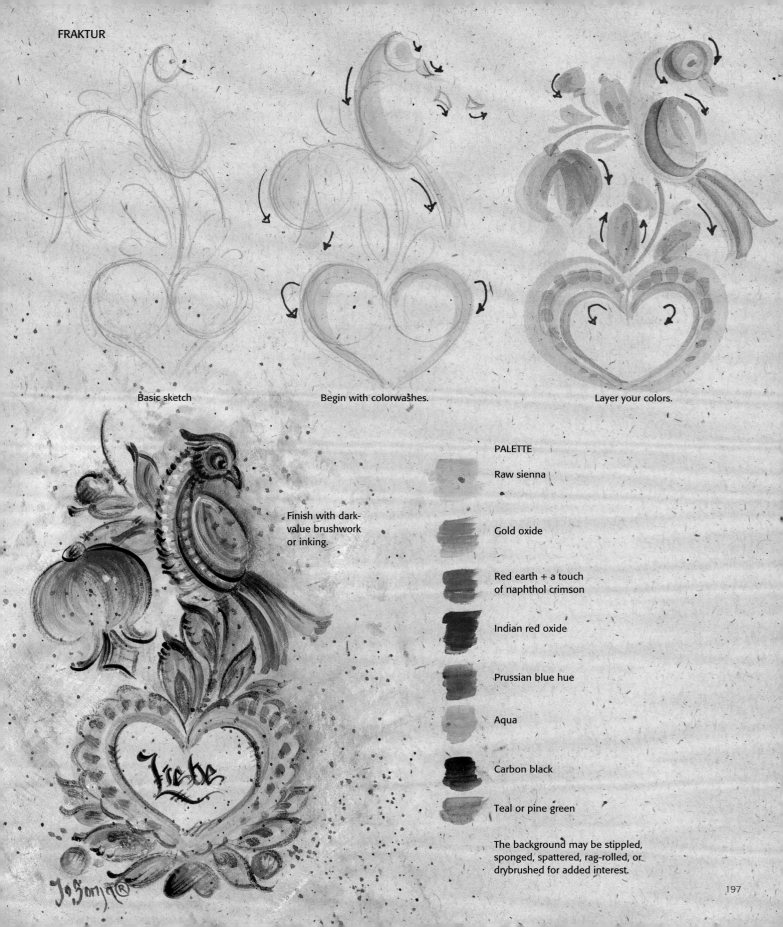

Basic sketch

Begin with colorwashes.

Layer your colors.

Finish with dark-value brushwork or inking.

PALETTE

Raw sienna

Gold oxide

Red earth + a touch of naphthol crimson

Indian red oxide

Prussian blue hue

Aqua

Carbon black

Teal or pine green

The background may be stippled, sponged, spattered, rag-rolled, or drybrushed for added interest.

197

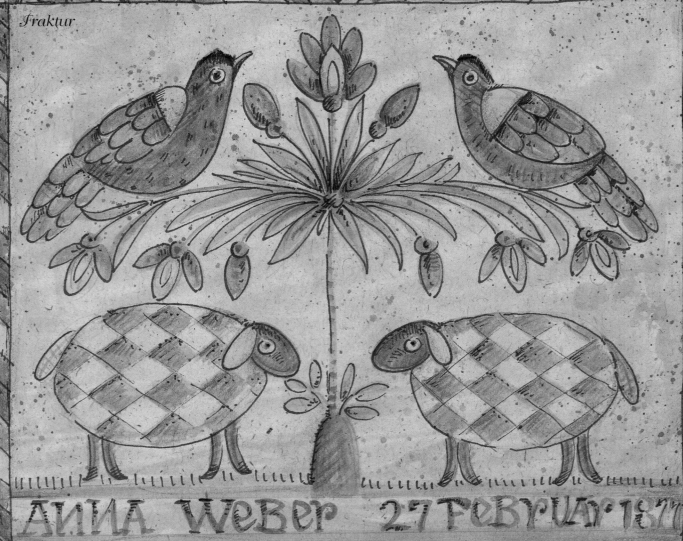

ANNA WEBER 27 FEBRUAR 187

ANNA WEBER

Emigrating to Waterloo County, Ontario, Canada, at the age of 11, Lancaster County, Pennsylvania–born Anna Weber (1814–88) was to become a prolific Fraktur artist during the later years of her life.

Working with a limited palette of ochre, blue, green, violet, and a few times, pink, Anna Weber produced paintings at a time when the popularity of Fraktur work had declined. (There was very little Fraktur produced in North American German communities after 1850.) Of special significance are her "checkerboard" or "dappled" animals and birds (which recall pieced quilts), the use of fuchsias and pansylike flowers, and her unique lettering style. Her work is a very fine example of the modernization of the Fraktur style, a late 19th-century artist relating to her tradition and to her times in a very creative way.

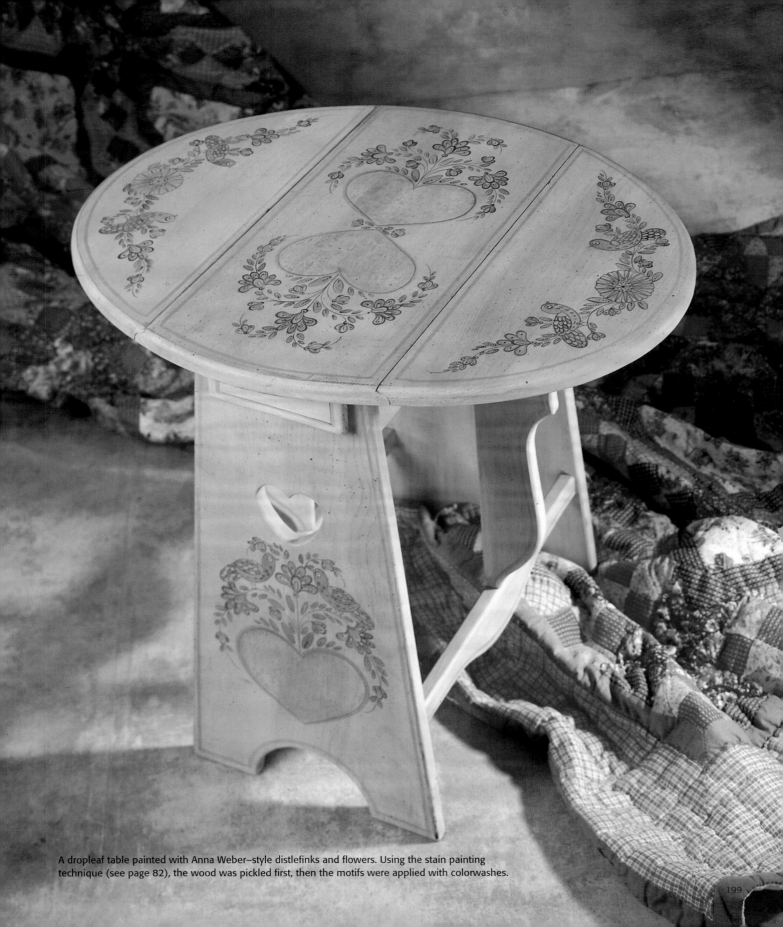

A dropleaf table painted with Anna Weber–style distlefinks and flowers. Using the stain painting technique (see page 82), the wood was pickled first, then the motifs were applied with colorwashes.

MORAVIAN FRAKTUR

The Moravian immigrant communities practiced a naturalistic style of Fraktur that featured flowers. The Fraktur's text or message was usually surrounded by a wreath of flowers. Roses, anemones, primroses, morning glories, violas, daisies, asters, and forget-me-knots were just a few of the flowers that were gathered together in decorative wreathlike designs around handlettered certificates, bookplates, and birthday greetings.

Many examples of this style, which was practiced from the late 1700s to the late 1800s, have been preserved. Three generations of the van Vleck family (Henry, son Jacob, and grandson Henry Jacob), bishops in the Moravian church, are known to have painted these floral presentations. A small tin box, decorated with similar floral motif, bearing the initials "HJVV," has also been found. Louisa Charlotte Kramsch Blickensderfer (1795–?) has also been recognized as an artist of this painting tradition. A birthday greeting surrounded by a delightful heart-shaped wreath, which she painted in 1858, was the inspiration for the work shown below.

There is much speculation as to the origin of this stylish departure from other forms of Fraktur. It should be remembered that small handpainted glassware pieces and reverse-painted glass panels were popular decorative items from this period. These treasured objects (glass was rare) could have easily been included in an immigrant's trunk as treasured mementos from childhood homes, and may have been the inspiration of this style of Fraktur.

Rose wreath motif after the work of Louisa Charlotte Kramsch Blickensderfer, Moravian Fraktur artist.

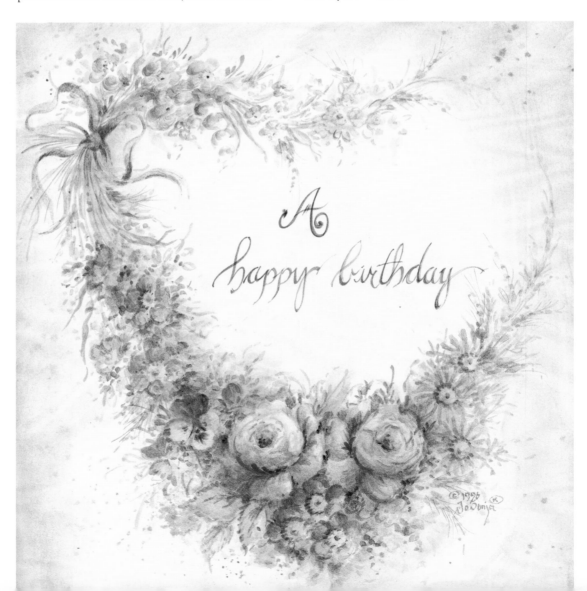

MORAVIAN FRAKTUR

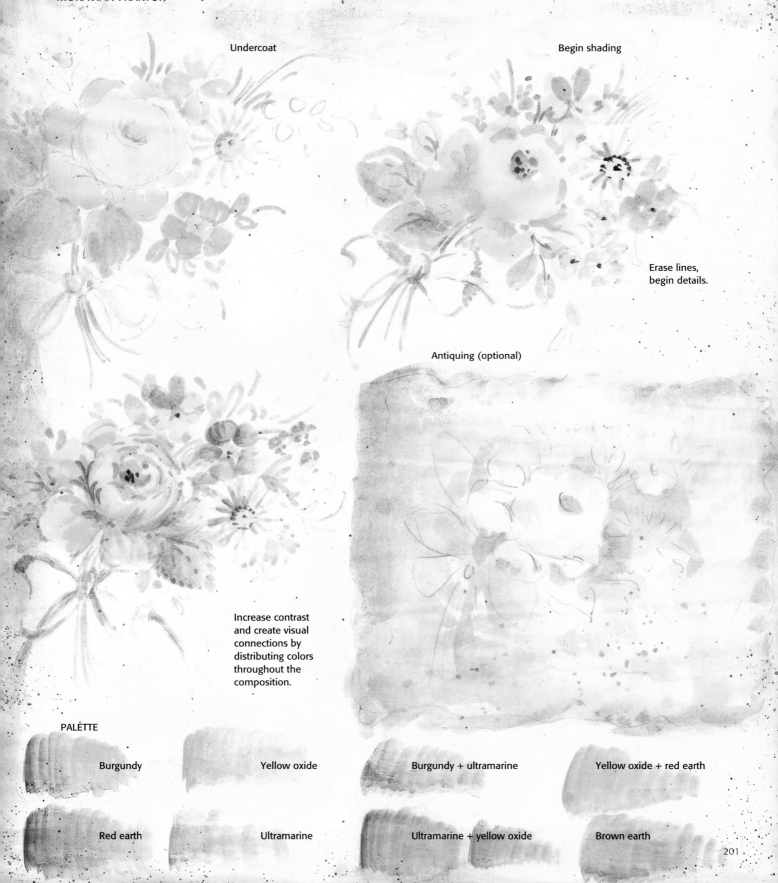

Undercoat

Begin shading

Erase lines,
begin details.

Antiquing (optional)

Increase contrast
and create visual
connections by
distributing colors
throughout the
composition.

PALETTE

Burgundy

Yellow oxide

Burgundy + ultramarine

Yellow oxide + red earth

Red earth

Ultramarine

Ultramarine + yellow oxide

Brown earth

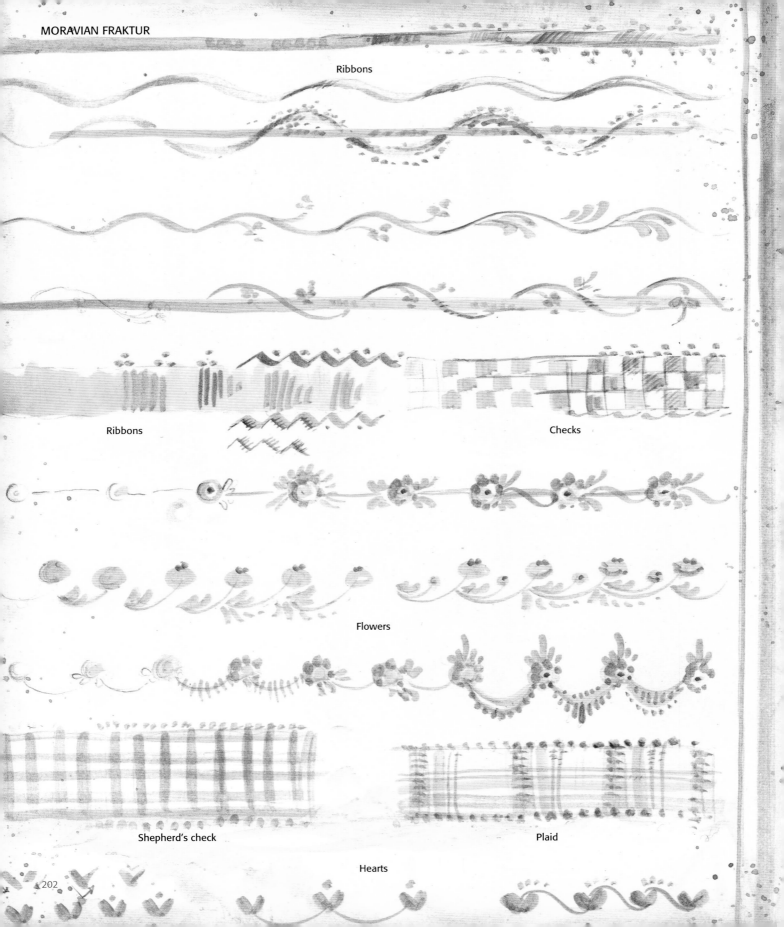

Ribbons

Ribbons

Checks

Flowers

Shepherd's check

Plaid

Hearts

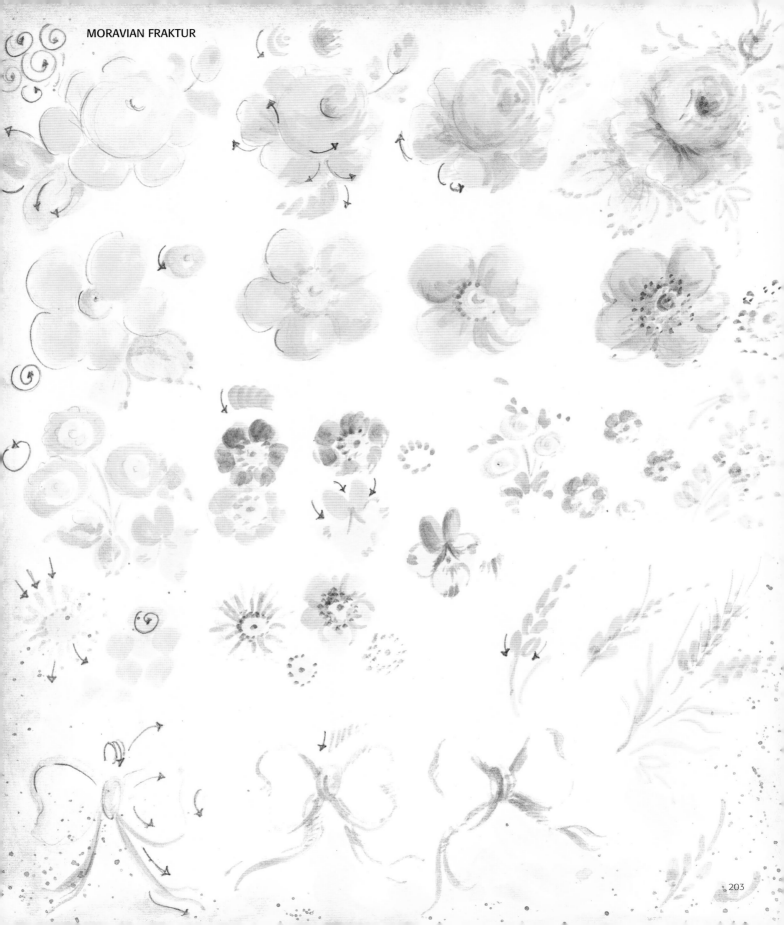

Rebirth: Collecting Mementos

Driven by the need for religious or personal freedom, or simply a desire for opportunity, the European immigrants of the mid-1800s to early 1900s brought to America a few small precious mementos from their homelands. These objects were keepsakes of the past, offered comfort in times of need, and held memories of loved ones and warm and welcoming hearths.

As these people embraced their new country, their art, music, and lifestyles merged with those from other countries. (Who can listen to bluegrass music and not hear the refrain of a Scandinavian fiddle song or an Irish folk tune?) When decorating their new homes, they improvised with whatever resources their new land had to offer while adding bits of their cherished cultures, displaying the mementos of their homelands in places of special honor. Once a family's American identity was fully established, however, these mementos were relegated to the attic or barn, where they awaited rediscovery. The items that were lucky enough to be saved from the trash bin sat as the world around them became enthralled with the machine-made items of "modern" man.

The late 1800s to the early 1900s in the United States was also an era of collecting. Vast fortunes had been made by seizing the opportunities that America had offered. Many began to realize the need to preserve and cherish the unique handmade items from its mix of cultures, and personal wealth provided the necessary funds.

Such collections eventually were bequeathed to (or became) museums. The Abby Aldrich Rockefeller Folk Art Center in Williamsburg, Virginia; the Shelburne Museum in Shelburne, Vermont; the Museum of American Folk Art in New York City; The Henry Francis du Pont Winterthur Museum in Winterthur, Delaware; and the New York State Historical Association in Cooperstown, New York, are just a few institutions that house important collections of American decorative arts. Some small ethnic museums were also begun, but it would take another generation or two before the search for "roots" really sparked an interest in their existence.

When the Great Depression hit, fortunes were lost, but the interest in American and immigrant art had been established. Per Lysne began to rosemale "smorgasbord" plates. Peter Hunt salvaged old furniture and decorated it with charmingly simple, bright designs. Peter Ompir collected old things, including a lot of tin items, and decorated them with funny little "Colonial"-style figures and fruits and flowers using rich, heavily glazed colors.

These decorative artists eventually gained national recognition. By the end of World War II, America was ready for the brightly colored, folksy designs of Peter Hunt and Peter Ompir. The work of Per Lysne was especially appealing to Scandinavian-Americans who were investigating their ethnic origins. As the demand for painted decoration grew, those who couldn't afford to buy original pieces purchased mass-market reproductions or tried to make their own. Designs were reproduced on wallpapers and fabrics, and printed decals appeared on tin and glass items. In the late 1940s and early 1950s, magazine articles and how-to books continued to spark interest, while "paint-by-mail" and other correspondence courses offered design and instruction.

The interest in decorative painting took hold, which led to the creation of small stores and painting groups. In 1973, a small group in the Midwest founded the National Society of Tole and Decorative Painters, known today as the Society of Decorative Painters. It took only six months for decorative painters on the West Coast to hear about it. Although it took a little longer for international interest to develop, sister organizations have been started in Australia, New Zealand, Japan, Canada, England, France, Argentina, and Brazil. We look forward to the day we can meet and share ideas. In the meantime, open-air museums that display collections of traditional items continue to be established across Europe. As these collections grow, we get a better picture of the importance of handpainted items to individual communities and more in-depth information about artists.

Peter Hunt

What made Peter Hunt's work unique? He loved to paint wonderful, bright, simple motifs, and he was really good at taking old or cast-off objects and turning them into useful as well as decorative objects; for example, adding wooden legs to an old tub and turning it into a patio planter or a container to serve iced drinks, or removing the insides of an old organ and turning it into a unique desk complete with a host of angels making heavenly music for the eyes.

He admonished other decorative painters to paint for fun, reminding us that folk art was the happiest form of decoration that exists. To paint emotionally, without inhibitions. To become totally involved with the selection and preparation of an object as well as its decoration. To put it aside when tired and take a walk. To avoid methods of mass production that were intended to turn a profit, in order to keep decorative painting a unique, creative, and personal experience.

Born in New York City and raised in a New Jersey suburb, Hunt moved to Provincetown, Massachusetts, early in his career, where he established a group of shops that he called his "Peasant Village" and hired a group of artists who helped him carry out his designs. He took inspiration from his European travels, acquiring many ideas from Swedish and Hungarian folk art, but always interpreted them in his own style, never copying. During the late 1950s, prominent individuals and businesses sought his work once his style was "discovered" and became trendy. His designs were also mechanically reproduced on fabrics, wallpaper, glass, and tinware.

Two books about his painting techniques were published, *Peter Hunt's Workbook* (1945) and *Peter Hunt's How-To-Do-It Book* (1952). *Peter Hunt's Cape Cod Cookbook* contains many excellent regional recipes as well as his folk art illustrations. As one of the leaders in the rediscovery of American folk art, he will be remembered for his colorful decoration and enthusiastic insight.

Hunt's paints were oil-based house enamels tinted with artists' oil paints. This very fluid paint flowed nicely from the brush to make the comma and S-stroke forms that he favored. His red, pink, blue, yellow, and green designs on mostly white backgrounds were lightly glazed with "Turkey Umber" (raw umber). The whimsy of a chair or table with legs of different colors, polka-dot horses, or hens on nests filled with decorated eggs captured American hearts during the era of pink Cadillacs and aqua blue swimming pools.

He had some other color combinations, including a blue-and-white "willowware" palette, and also painted trompe l'oeil and marbling, but it was his hearts-and-flowers look (see below) that charmed the lighthearted child in each of his fans. He said, "If you paint a barn red, make it very red indeed. If you paint a pear tree, make the pears tremendous, to admit no doubt that it is a pear tree." Well done, Peter Hunt!

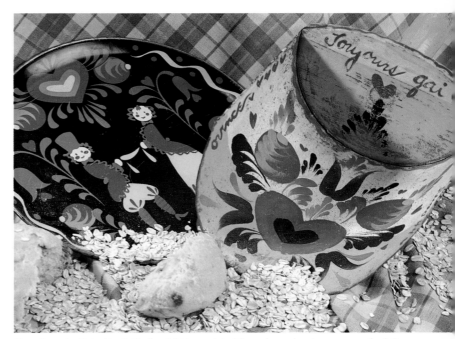

Two pieces by Peter Hunt: On the right is a painted tin-and-wood grain scoop; on the left, a decaled tray that was produced for the giftware market.

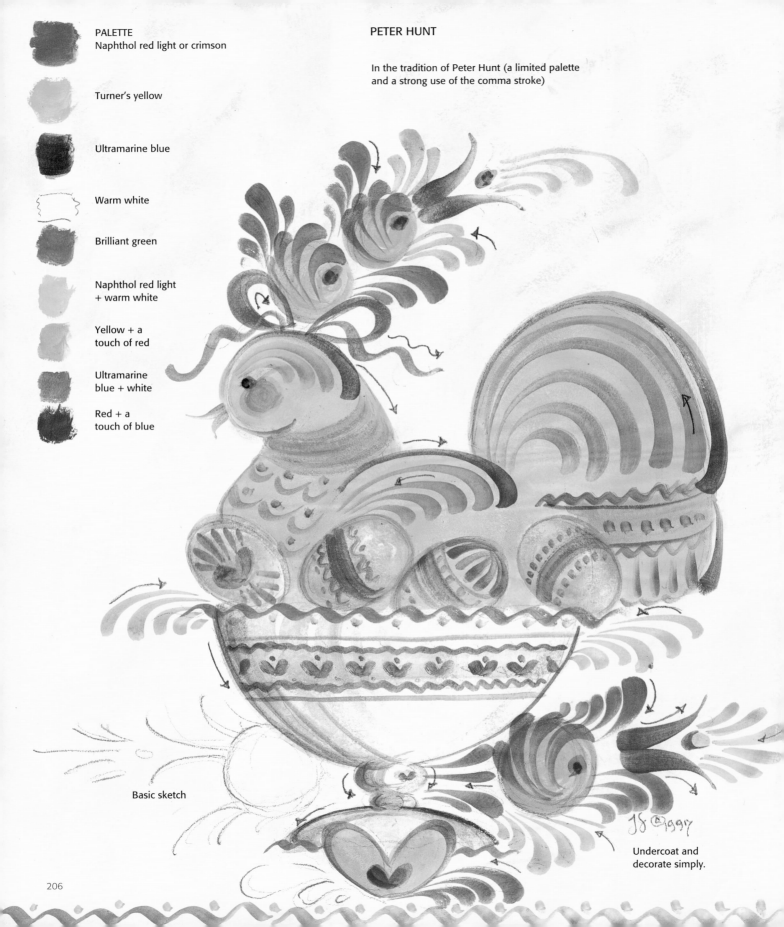

PALETTE
Naphthol red light or crimson

Turner's yellow

Ultramarine blue

Warm white

Brilliant green

Naphthol red light
+ warm white

Yellow + a
touch of red

Ultramarine
blue + white

Red + a
touch of blue

PETER HUNT

In the tradition of Peter Hunt (a limited palette
and a strong use of the comma stroke)

Basic sketch

Undercoat and
decorate simply.

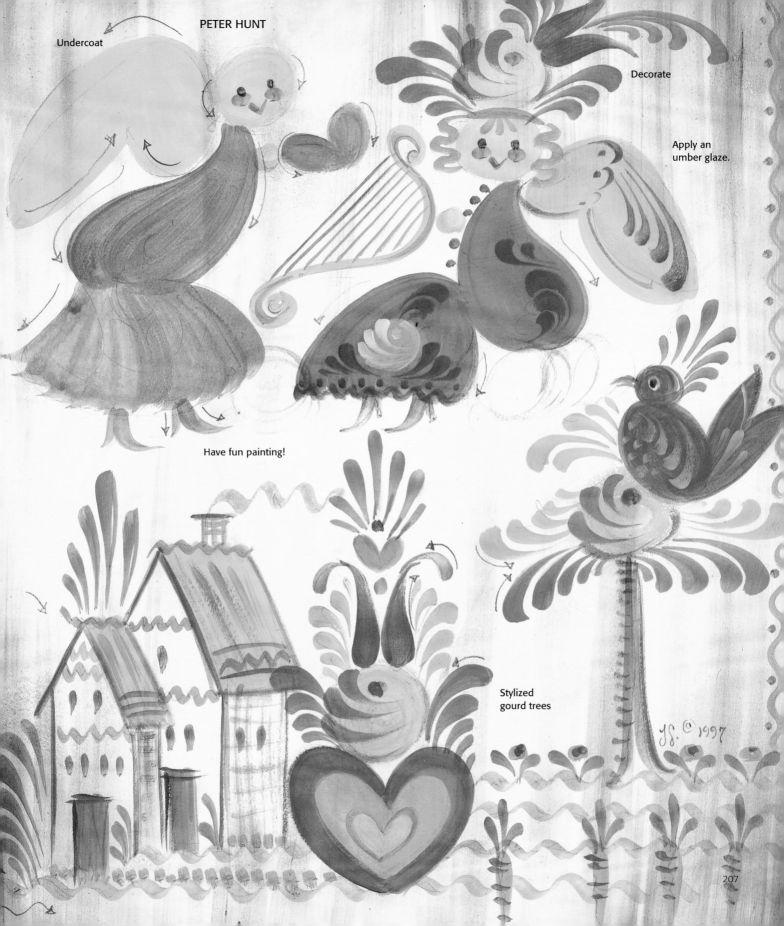

PETER HUNT

Undercoat

Decorate

Apply an
umber glaze.

Have fun painting!

Stylized
gourd trees

JS. © 1997

207

Peter Ompir

(Below left) This contemporary chest, which was painted using the Peter Ompir technique, features simple, stylized fruits and birds as well as a heavily glazed bright red background.

(Below right) An assortment of tin and wood items, new and old, decorated with stroke techniques and heavy glazing.

Peter Ompir began decorating practical household objects, old and new, during the Depression era of the 1930s. Having grown up in Pennsylvania and lived in New York City, he was well acquainted with the painting styles of the Pennsylvania Dutch and the early Dutch New Yorkers, and his work displays influences of both styles. His work sparked great demand and soon was carried by some of the more exclusive department stores. He had received formal fine-art training at several schools, but it was his distinctive decorative style that made his pieces so sought after. Painting on old tin and wood items, his "Colonial"-style men, fanciful birds, and fat tulips were complemented by a heavy glazing technique that richly subdued his bright colors.

As the demand for his style continued to grow, he was joined by another artist, Warner Wrede. The two moved to an old farmhouse in Vermont in the 1950s, then finally settled in Sheffield, Massachusetts, during the 1960s. At one time they employed five or six other artists to help produce their pieces, all of which were signed with Ompir's name until his death in 1979, when Wrede, carrying on this tradition, began to sign them with his own name.

It was Peter Ompir's work that inspired the early Oregon painters, who taught me how to paint in his style—the first I learned. We began by working in oils, although we know now that his pieces were painted with tempera. It is believed by many collectors that Ompir antiqued his pieces with oil paints, though the same striking effect can be achieved with the Old-World Wash and Scrub acrylic technique discussed on page 268. You may prefer the softer look of the antiquing method discussed in Chapter 5 on page 84. As with so many aspects of decorative painting, this is simply a matter of personal preference, so you may choose to vary the look of the antiquing on your pieces from time to time, as I do.

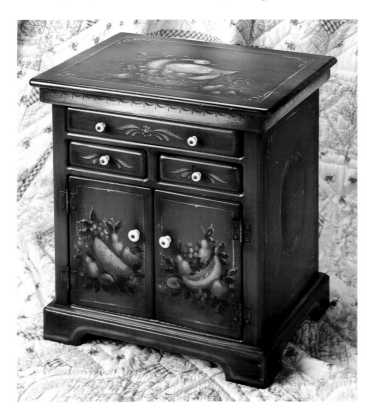

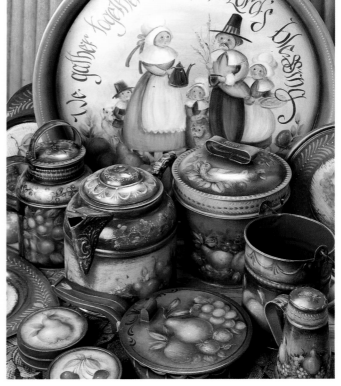

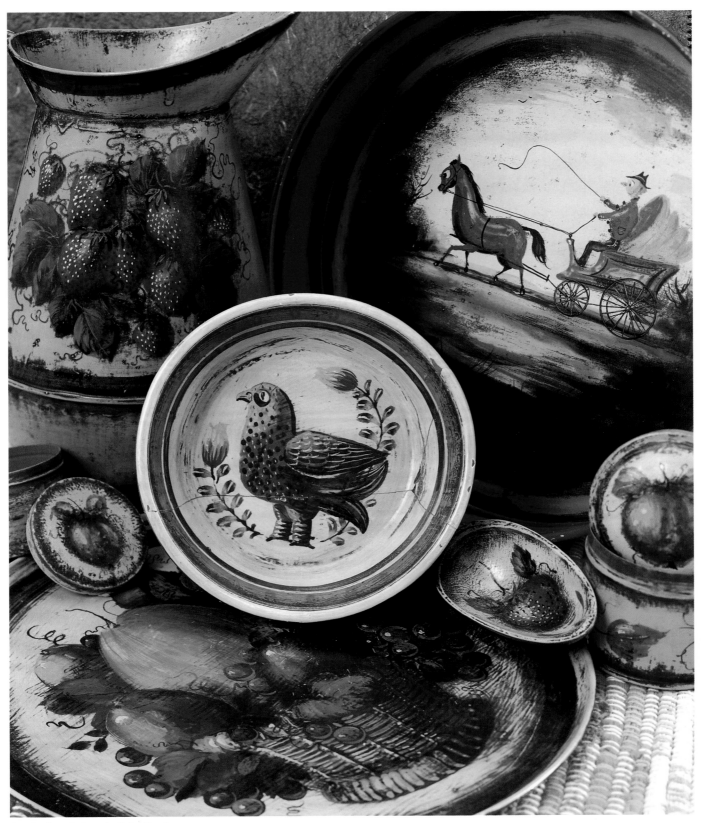

A collection of pieces by Peter Ompir.

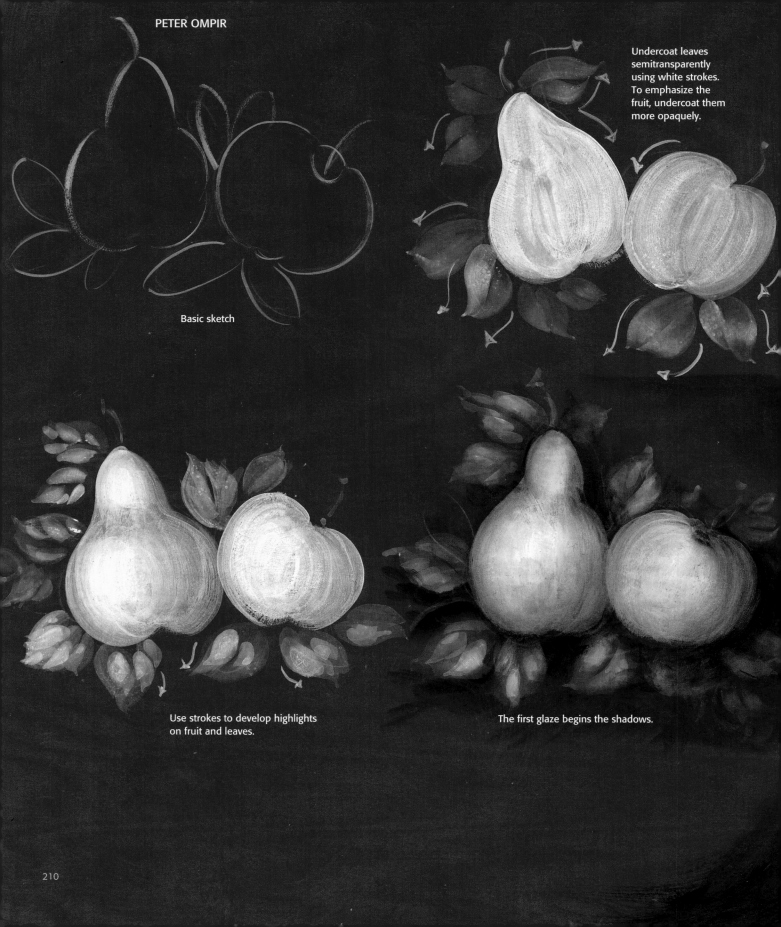

PETER OMPIR

Basic sketch

Undercoat leaves
semitransparently
using white strokes.
To emphasize the
fruit, undercoat them
more opaquely.

Use strokes to develop highlights
on fruit and leaves.

The first glaze begins the shadows.

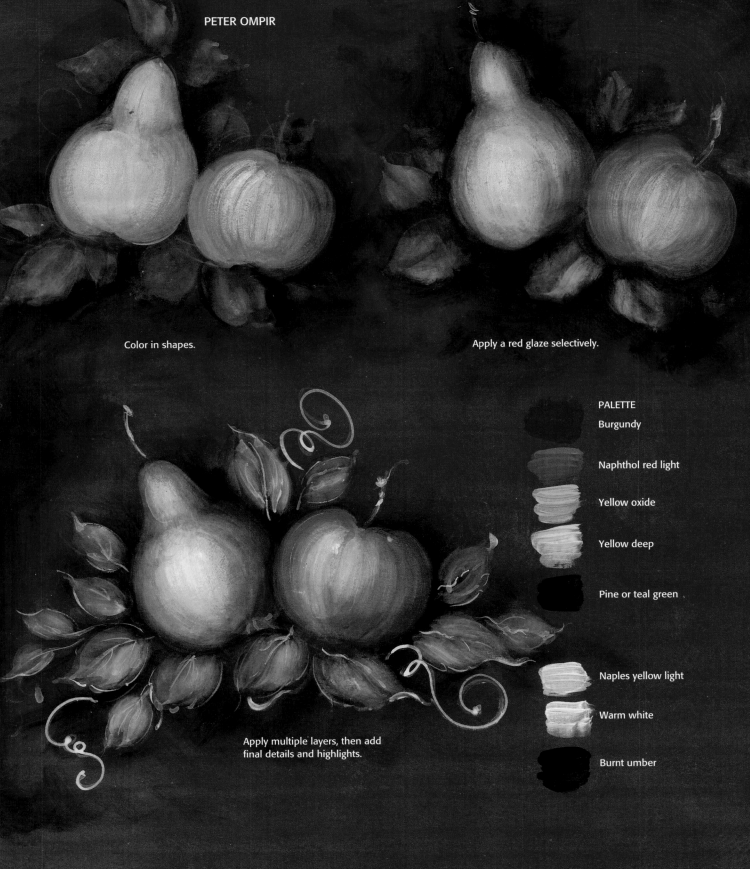

PETER OMPIR

Color in shapes.

Apply a red glaze selectively.

PALETTE

Burgundy

Naphthol red light

Yellow oxide

Yellow deep

Pine or teal green

Naples yellow light

Warm white

Burnt umber

Apply multiple layers, then add
final details and highlights.

Per Lysne

Per Lysne (pronounced pear LIZ-nay) is often remembered by his friends as a kind-hearted man with a fine sense of humor and a gentle outlook on life. Visitors were welcome to watch him as he painted in his garage studio, though he rarely gave lessons. He designed his own patterns, but once a design was done he painted it freehand. He did not approve of painters who traced or copied his designs, feeling that everyone should do his or her own work.

Born and raised in Lerdahl, Sogn, in western Norway, he apprenticed at an early age to his father, Anders Olsen, a well-known painter and interior decorator who had won national awards and whose work was included in the 1898 Paris Exhibition. At the age of 27, in 1907, Per Lysne and his wife immigrated to the United States and settled in Stoughton, Wisconsin, where, along with many other Norwegian immigrants, he was employed at one of the city's two wagon factories, painting scrolls and stripes on wagons.

A very practical man, Per tried to design and paint art that would sell to the American consumer. Wooden plates were not decorated in Norway, but here he found a great market for his smorgasbord plates. (This is an interesting point, because the word *smörgåsbord* is Swedish, not Norwegian.) An order from Marshall Fields' Chicago store for 500 plates and from the American Friends of Norway for 200 plates illustrate their popularity.

During the 1930s he was "discovered" by the press. Articles documenting his techniques and traditions appeared in newspapers and magazines. So when the Great Depression hit in 1929, and the demand for painted wagons slackened, he expanded his work into home decor.

From hundreds of small items to the interiors of several homes, where he would live until a job was complete (like the old decorative painters of Norway), his designs began the rebirth of interest in rosemaling in the United States. Per Lysne died September 28, 1947, at the age of 67. He had achieved national recognition, but many decorative artists and devoted collectors felt that his fame was only beginning. Today we honor his memory by calling him the "Father of American Rosemaling."

TECHNICAL NOTES

Working in a style very much like the Os style of rosemaling (see page 158), Per used a combination of tube oils and house enamels for his paints. His colors were light and bright, usually on ivory or white backgrounds. His designs featured airy bouquets of stylized flowers—his radish roses were particularly distinctive—that he completed with handlettered sayings. His very fine linework, which he painted with a quill brush, is clearly evident.

(Left and center) "Smorgasbord plates" painted by Per Lysne, who is often called the "Father of American Rosemaling." *(Right)* A plate by Karl Reese, a rosemaler of just a slightly later date.

PER LYSNE

Here are some flowers after the work of Per Lysne, including his famous "radish rose," with sincere apologies for copying his work, of which he did not approve.

Compare these flowers to the ones on pages 160–163—you'll recognize his brushwork, shapes, and arrangements. See page 162 for the palette.

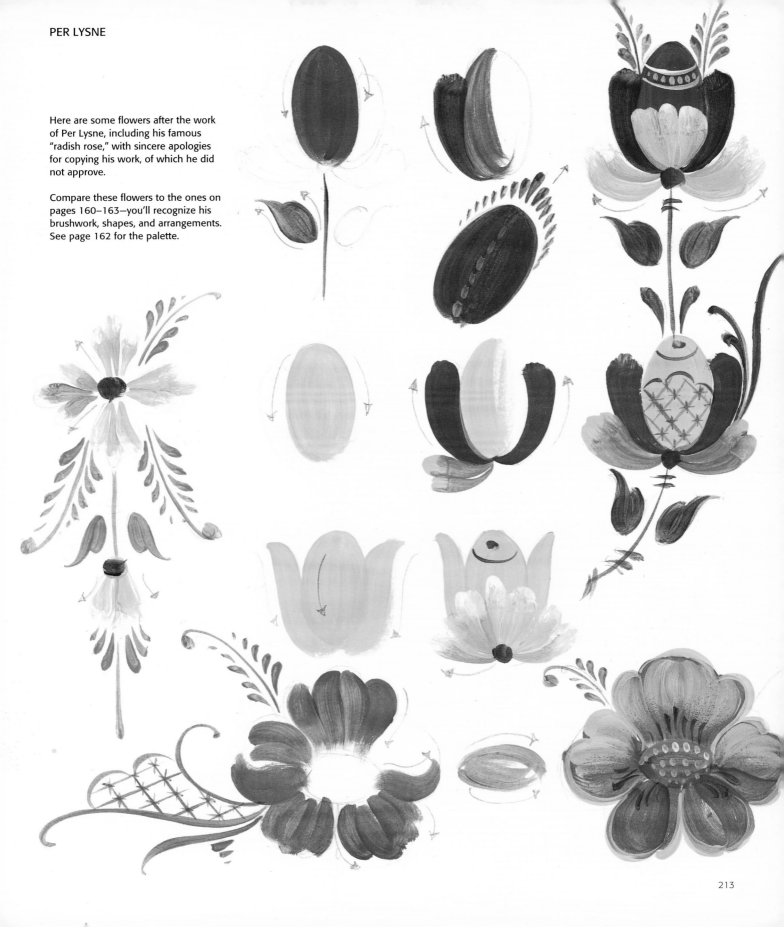

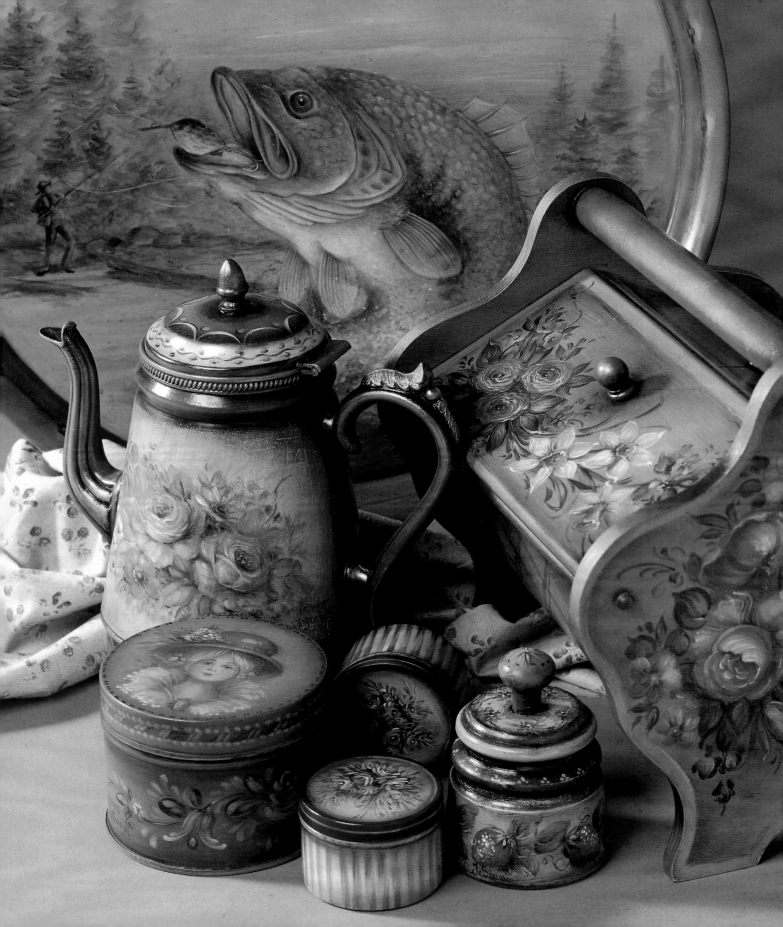

8 *Contemporary Expressions: The Tradition Continues*

Where does one tradition end and another begin? Fascinated by the beautiful history of this art and driven by a deep desire to express my own creativity through its techniques, I think the answer to that question ultimately doesn't matter. There is only one truth for me: I must paint. I must learn from the old what decorative painting is. I want to understand the traditions.

A great portion of the fun comes from sharing my ideas with other artists. The joy of helping someone discover that he or she can paint is immeasurable. Perhaps this has been my biggest motivation and purpose.

But the joy unfolds, expanding outward. Think of the grandchild who proudly shows his friends the toy box that his grandfather made and his grandmother painted, the toy box that is to become a chairside table in his later years, memories flooding his mind every time he touches it. Finally, it is passed on to his son or daughter. Will they cherish it? Probably not. Relegated to the attic, it will sit, neglected and unloved, until some collector claims its value. The tradition continues.

Which approach is the most faithful to the tradition of decorative painting? It is certainly not copying. Copying is done only to preserve and understand the tradition, and to help novice artists of any age realize that they can paint and to create in them a desire to explore their own ideas and creativity. Can today's decorative artists use ideas from the past? Yes. Can those ideas be used in new ways? That is the goal. Has the artist developed a style and skill level that will appeal to customers? Wonderful! Must the items always be for paying customers? No. Can painting be done as a hobby? Definitely. And here, perhaps, lies the truth of folk art, its spirit and intent: The spirit in which the object was created, and the reason for which it was done.

The Merry Makers

Peter Hunt (see page 205) once remarked that he took his inspiration from Swedish (see page 164) and Hungarian designs. So I decided to research old Hungarian herdsman designs as a possible source of inspiration for my own work. The Hungarians called these figures "Merry Makers" and decorated them with designs adapted from their beautiful embroidery and appliquéd clothing. Techniques for designs and backgrounds are shown below and on the following pages, which I use to illustrate some personal contemporary expressions.

Some contemporary interpretations of the Hungarian herdsman painting style, one of Peter Hunt's sources of inspiration.

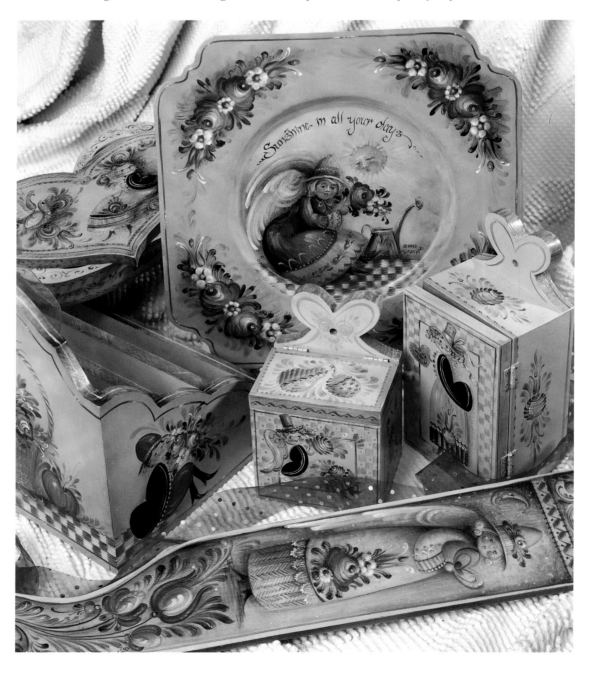

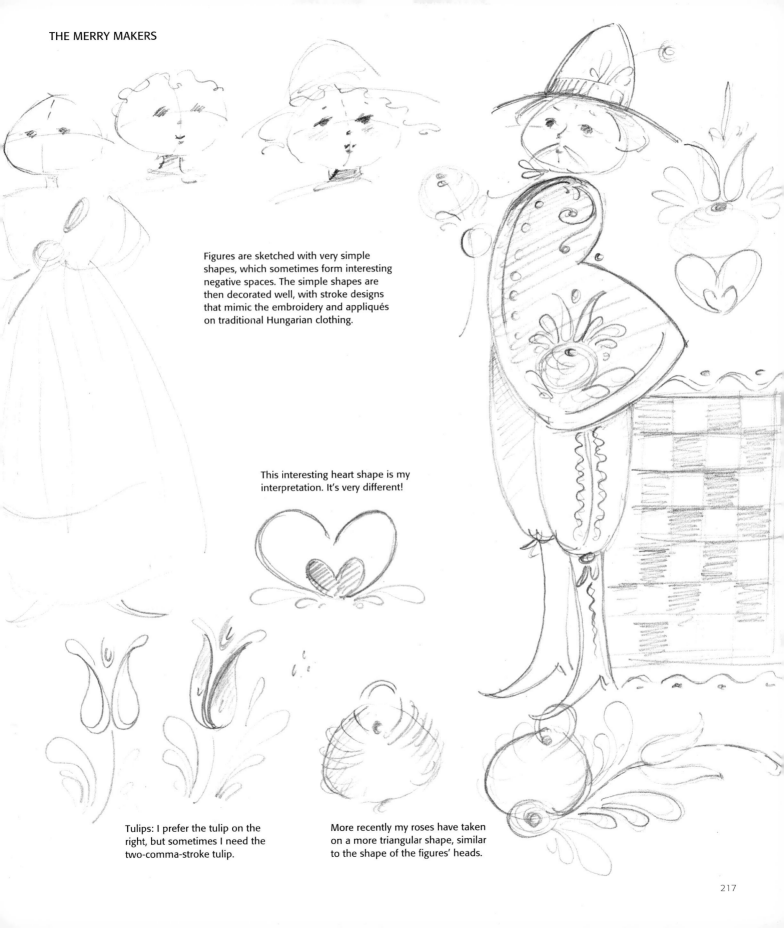

Figures are sketched with very simple shapes, which sometimes form interesting negative spaces. The simple shapes are then decorated well, with stroke designs that mimic the embroidery and appliqués on traditional Hungarian clothing.

This interesting heart shape is my interpretation. It's very different!

Tulips: I prefer the tulip on the right, but sometimes I need the two-comma-stroke tulip.

More recently my roses have taken on a more triangular shape, similar to the shape of the figures' heads.

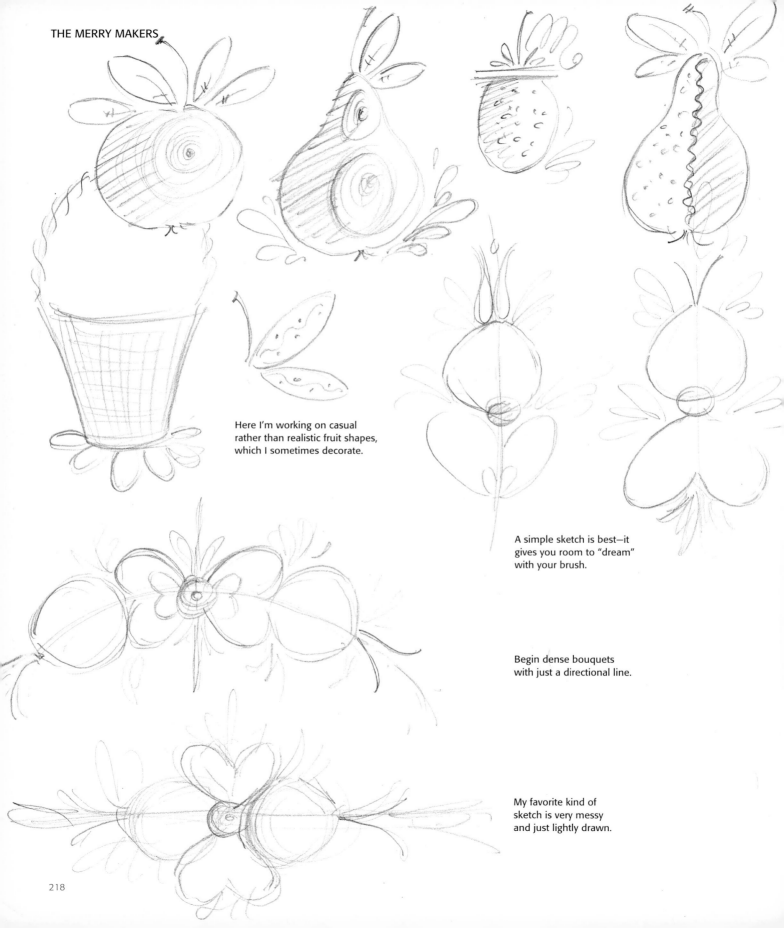

Here I'm working on casual rather than realistic fruit shapes, which I sometimes decorate.

A simple sketch is best—it gives you room to "dream" with your brush.

Begin dense bouquets with just a directional line.

My favorite kind of sketch is very messy and just lightly drawn.

THE MERRY MAKERS

Apply a glaze of gold oxide
over a primrose background
using a slip-slap motion.

Soften the glaze as desired
using a soft oval mop brush.

Stripe =
Plum pink

Colorwash

PALETTE

Indian red oxide

Naphthol crimson

Rose pink

Plum pink

Gold oxide

Raw sienna

Turner's yellow

Prussian blue hue

Sapphire

Aqua

Pine green

Burnt umber

Carbon black

Smoked pearl

Warm white

Shade with Prussian blue hue + a touch of naphthol crimson

Highlight with a tint of aqua; stripe with smoked pearl

Use a large brush and a slip-slap motion to drybrush white over smoked pearl.

Colorwash

Detail

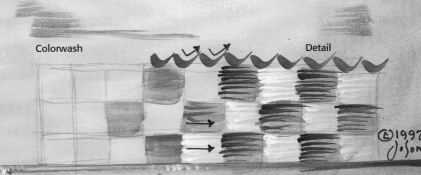

© 1997 Jo Sonja

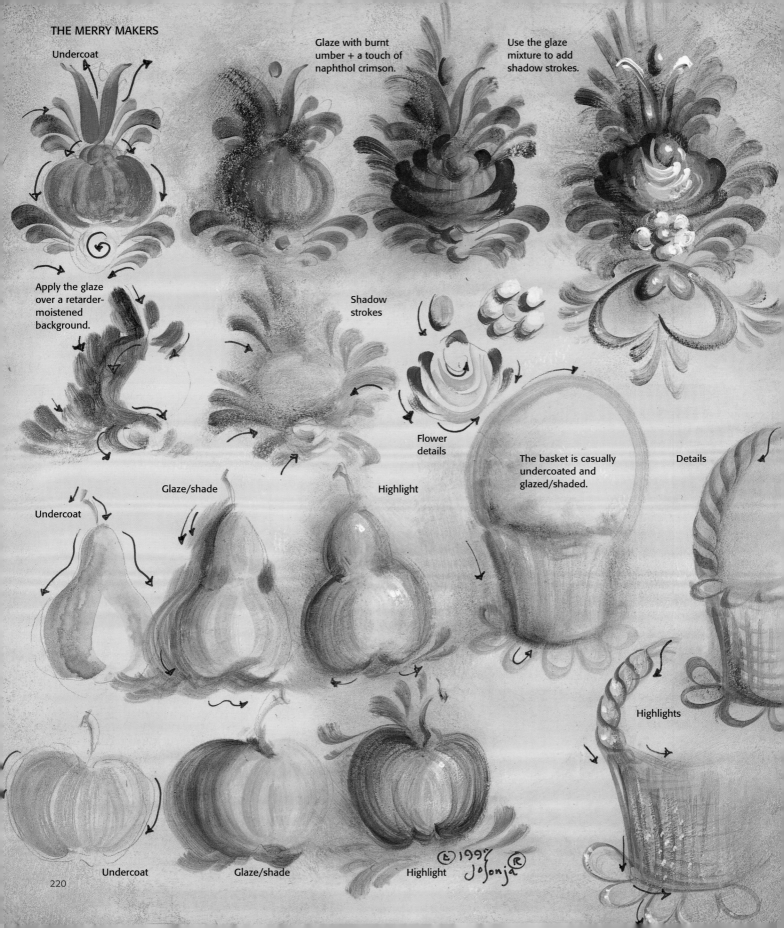

THE MERRY MAKERS

Undercoat

Glaze with burnt umber + a touch of naphthol crimson.

Use the glaze mixture to add shadow strokes.

Apply the glaze over a retarder-moistened background.

Shadow strokes

Flower details

The basket is casually undercoated and glazed/shaded.

Details

Undercoat

Glaze/shade

Highlight

Highlights

Undercoat

Glaze/shade

Highlight

© 1997 Jo Sonja ®

220

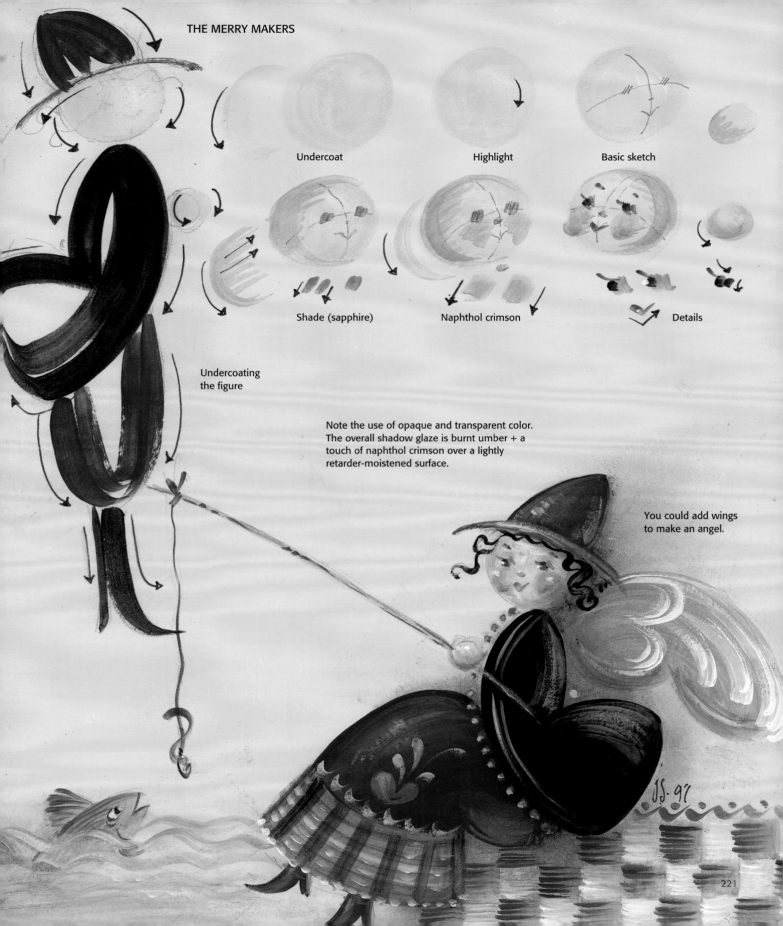

THE MERRY MAKERS

Undercoat

Highlight

Basic sketch

Shade (sapphire)

Naphthol crimson

Details

Undercoating
the figure

Note the use of opaque and transparent color.
The overall shadow glaze is burnt umber + a
touch of naphthol crimson over a lightly
retarder-moistened surface.

You could add wings
to make an angel.

JS. 97

221

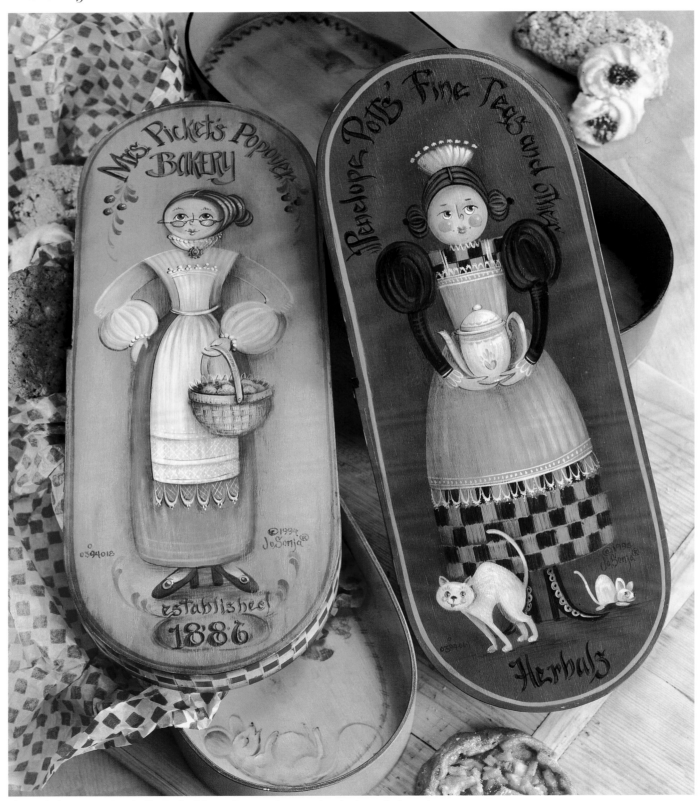

These two boxes are painted with a stylized figure of my own interpretation that is purely decorative.

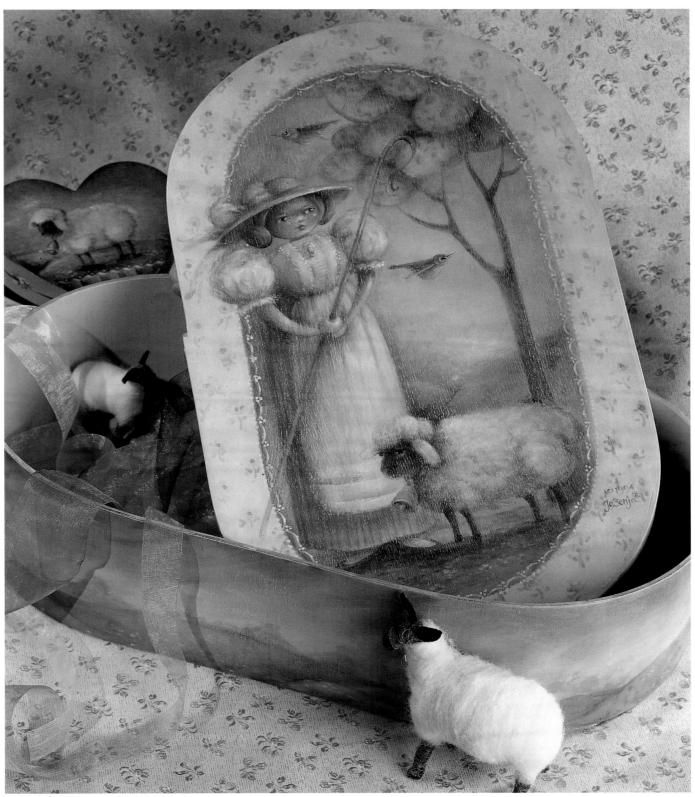

The design on this ribbon box includes a very soft rendition of the stylized figure. The edges of the shapes as well as the color presentation were softened by using retarder-blending and glazing techniques, then the finished painting was lightly sanded before varnishing.

Miniatures

Before photography was invented, painting was one of the only ways to create a human likeness. Miniature paintings made such likenesses easy to carry. Since they were intended to represent individuals rather than idealized or stylized types, these paintings were usually more detailed and finely rendered than most other types of decorative figure paintings. The palette and technique varied greatly, depending on the artist's training and personal style.

In the tradition of painted miniatures, these small portraits combine blending and stroke techniques to make a more realistic representation.

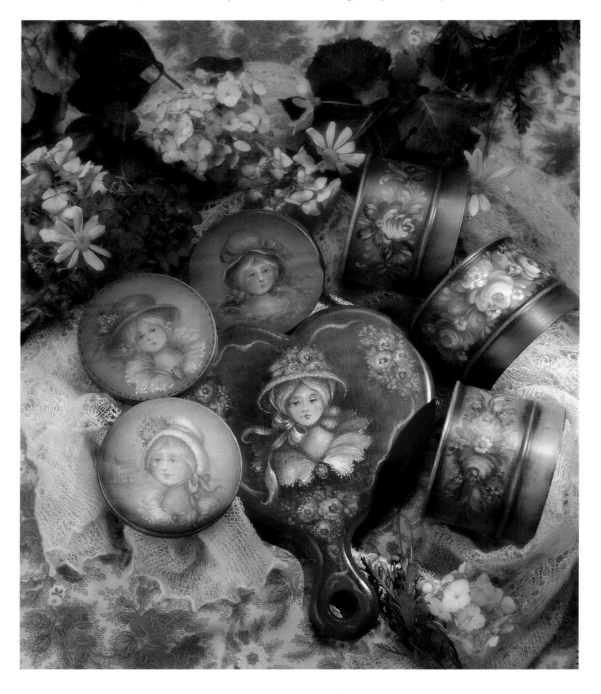

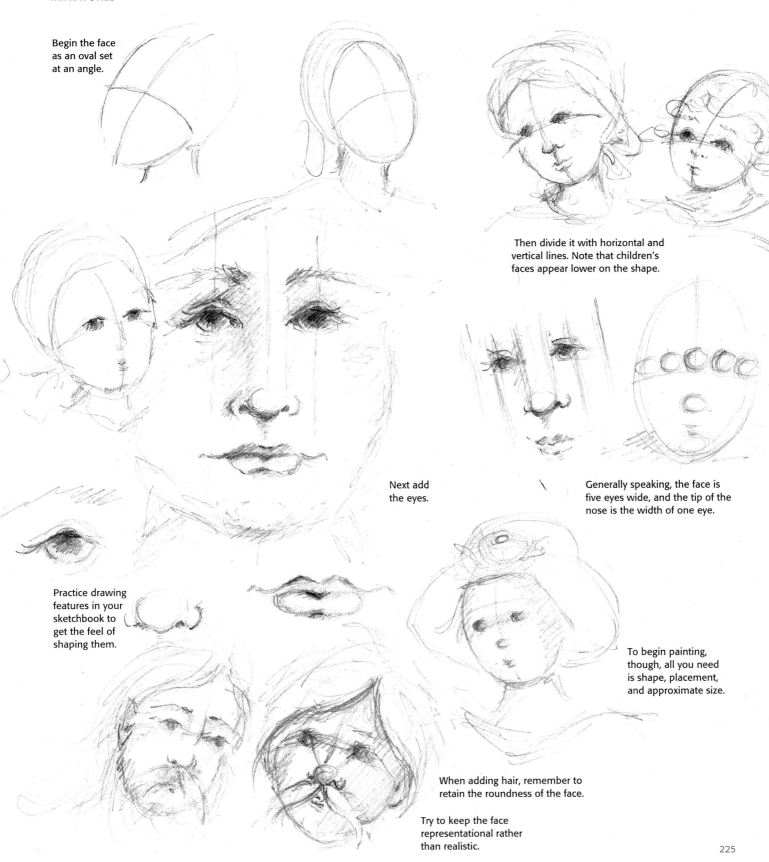

Begin the face as an oval set at an angle.

Then divide it with horizontal and vertical lines. Note that children's faces appear lower on the shape.

Next add the eyes.

Generally speaking, the face is five eyes wide, and the tip of the nose is the width of one eye.

Practice drawing features in your sketchbook to get the feel of shaping them.

To begin painting, though, all you need is shape, placement, and approximate size.

When adding hair, remember to retain the roundness of the face.

Try to keep the face representational rather than realistic.

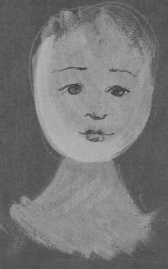

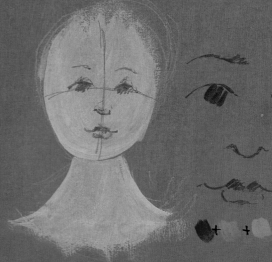

Undercoat the head and
neck (retarder is optional).

Transfer the features
and the sketch . . .

. . . or add them freehand.

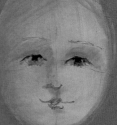

Apply the shading
(with retarder).

Undercoat
the eyes.

Add the pupil
and eyelid lines.

Begin adding highlights
(with retarder).

Layer additional
highlights.

Begin the
clothing and hair.

The whites of the
eyes are optional.

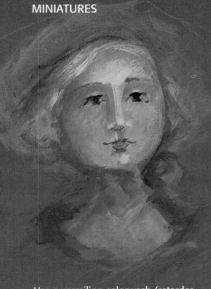
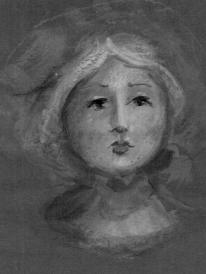
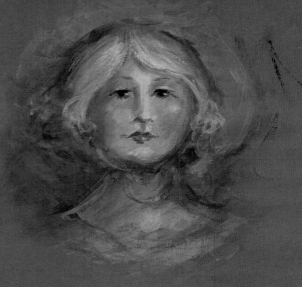

Use a vermilion colorwash (retarder optional) to tint the cheeks, tip of the nose, chin, and lips, and to create touches of color within the hair.

Apply additional tints of naphthol red light; correct the shading.

For the final highlights, use white or a skintone base (the latter is softer). Touches of amethyst are optional.

PALETTE

Burgundy

Naphthol red light

Vermilion

Gold oxide

Raw sienna

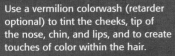

Yellow oxide

Prussian blue hue

Sapphire

Amethyst (optional)

Carbon black

Skintone base

Warm white

Faces are fun. Enjoy them! No two faces are identical. Practice will help you discover and define your personal preferences.

Soft-Stroke Flowers

I've developed some techniques for painting flowers that are soft and yet are rendered with basic brushstrokes. The basic sketch and palette remains the same; only the technique varies—sometimes I blend the strokes, sometimes I prefer to drybrush them. In the demonstrations that follow, I use some very beautiful colors that I've softened and made slightly less intense by toning all of them with the same color—in this case, gold oxide—so that they would all work well together.

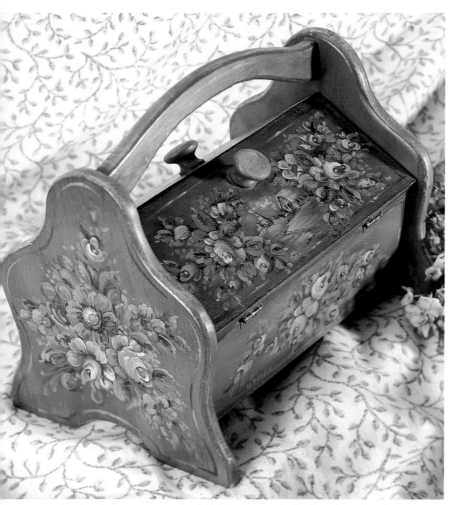

Drybrush techniques were used to highlight these stroke florals and to soften the background colors.

BLENDED FLOWERS

Working on a lightly retarder-moistened surface, undercoat the sketch with unaltered color, omitting any texture medium. (The retarder can also be brush-mixed with the paint as you work.) Climatic conditions will come into play here; in very dry areas you may prefer a 1:1 mixture of Flow Medium + retarder. Let dry or quick-dry (see page 78) thoroughly.

To shade the design, moisten the surface with retarder, then add darker values, stroke-blending as you go (see page 162 for an example of stroke-blending). Repeat the same procedure to apply highlights, where some texture is desirable. Paint alone may provide sufficient texture, but you may wish to mix it with some texture medium.

DRYBRUSHED FLOWERS

This technique requires a brush with a firm touch so that you can easily handle working with the less fluid paint. You can use an old brush, but only as long as it can still make recognizable strokes.

Begin by moistening the surface with water or retarder, then undercoating the sketch; let dry. Shade with darker values, using the color to develop the flower's form. As you apply subsequent layers of shading, load the brush with progressively less paint, letting the color granulate as you work. Apply the highlights in the same manner. Some texture in the highlights is very nice.

TEXTURED FLOWERS

Combine equal parts paint and texture medium. In every step of the painting, from undercoating to highlights, create contrasts with texture, working to emphasize this contrast in the center of interest and when applying highlights. To accentuate the textured effect, apply a final dark glaze to the completed painting.

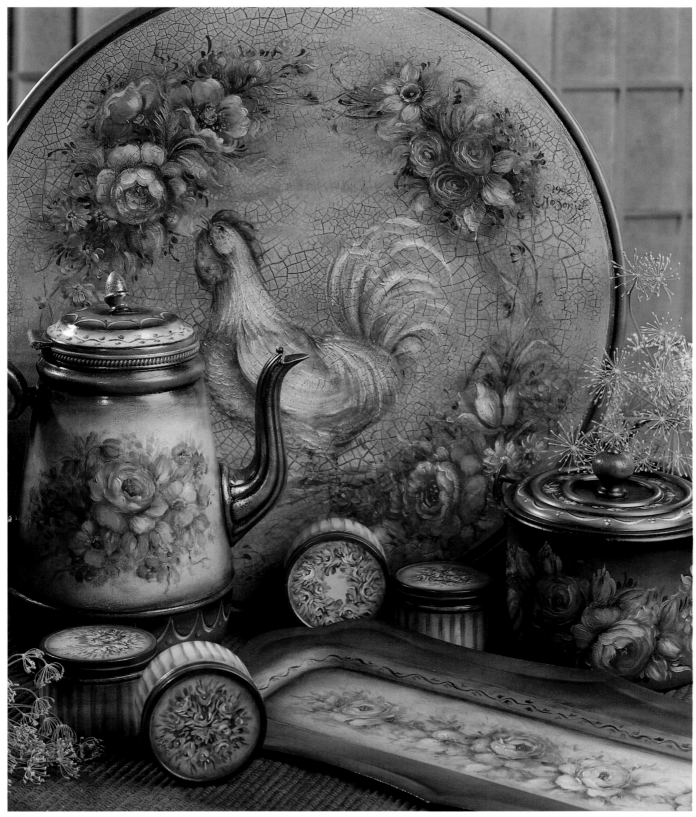

A collection of pieces decorated with softly stroked flowers.

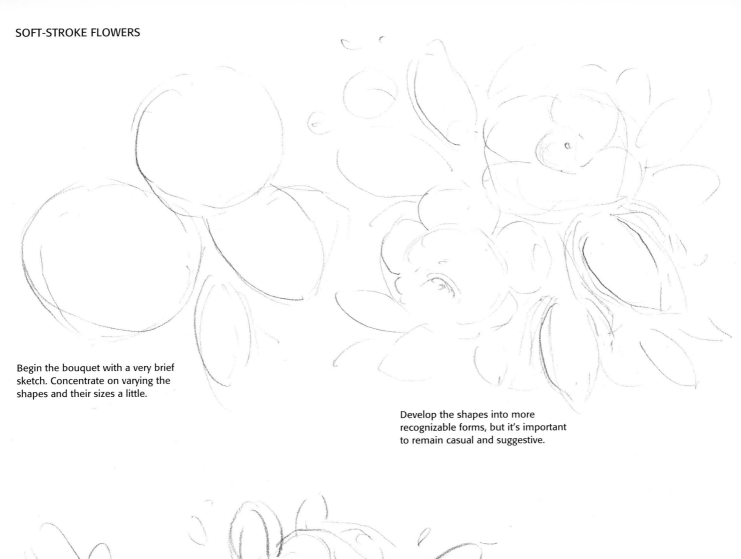

Begin the bouquet with a very brief sketch. Concentrate on varying the shapes and their sizes a little.

Develop the shapes into more recognizable forms, but it's important to remain casual and suggestive.

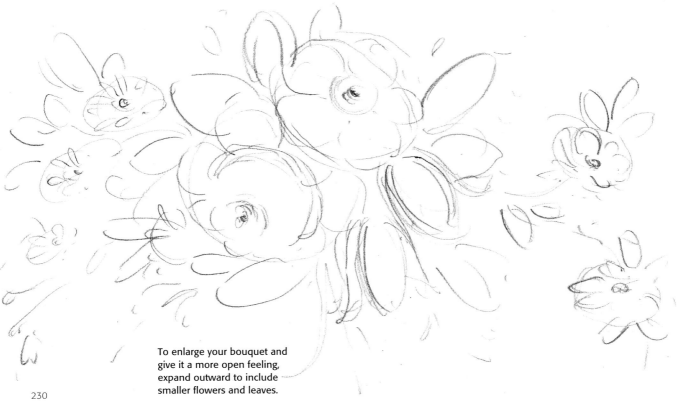

To enlarge your bouquet and give it a more open feeling, expand outward to include smaller flowers and leaves.

SOFT-STROKE FLOWERS

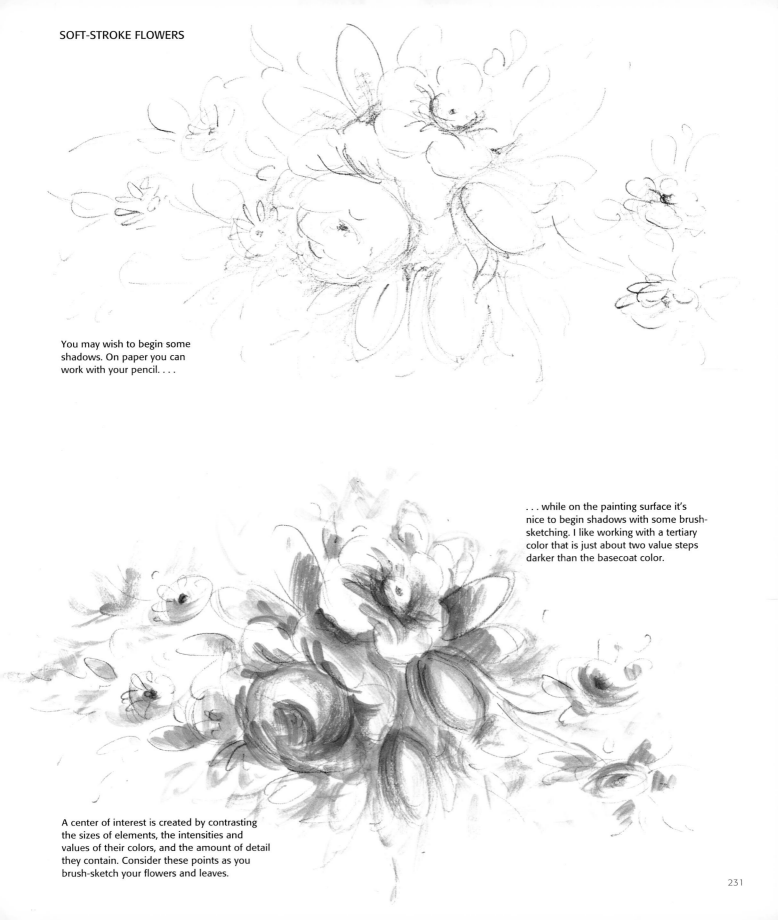

You may wish to begin some shadows. On paper you can work with your pencil. . . .

. . . while on the painting surface it's nice to begin shadows with some brush-sketching. I like working with a tertiary color that is just about two value steps darker than the basecoat color.

A center of interest is created by contrasting the sizes of elements, the intensities and values of their colors, and the amount of detail they contain. Consider these points as you brush-sketch your flowers and leaves.

SOFT-STROKE FLOWERS

PALETTE

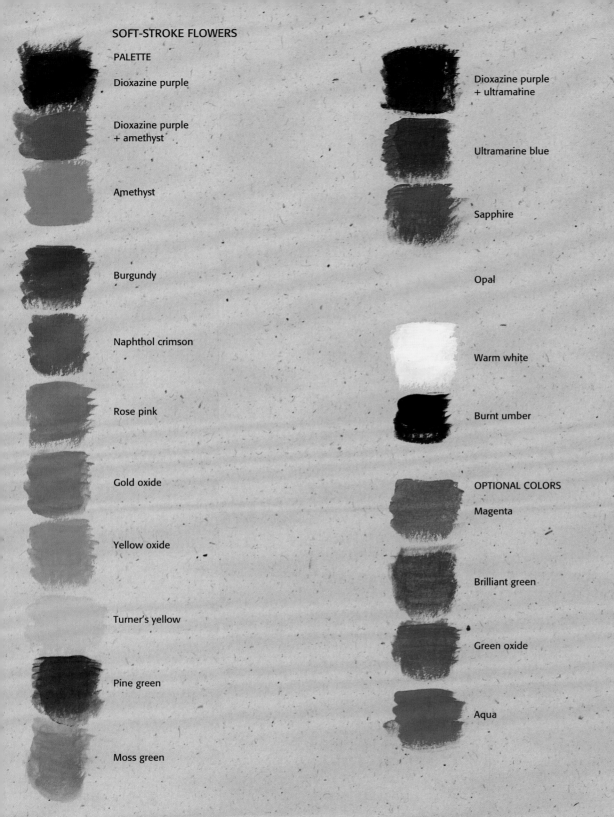

Dioxazine purple

Dioxazine purple
+ amethyst

Amethyst

Burgundy

Naphthol crimson

Rose pink

Gold oxide

Yellow oxide

Turner's yellow

Pine green

Moss green

Dioxazine purple
+ ultramarine

Ultramarine blue

Sapphire

Opal

Warm white

Burnt umber

OPTIONAL COLORS

Magenta

Brilliant green

Green oxide

Aqua

Each color has been toned with a small amount of gold oxide. For textured florals, mix the paint with
an equal amount of texture medium; this gives the paint a little translucency, making it fun to layer.

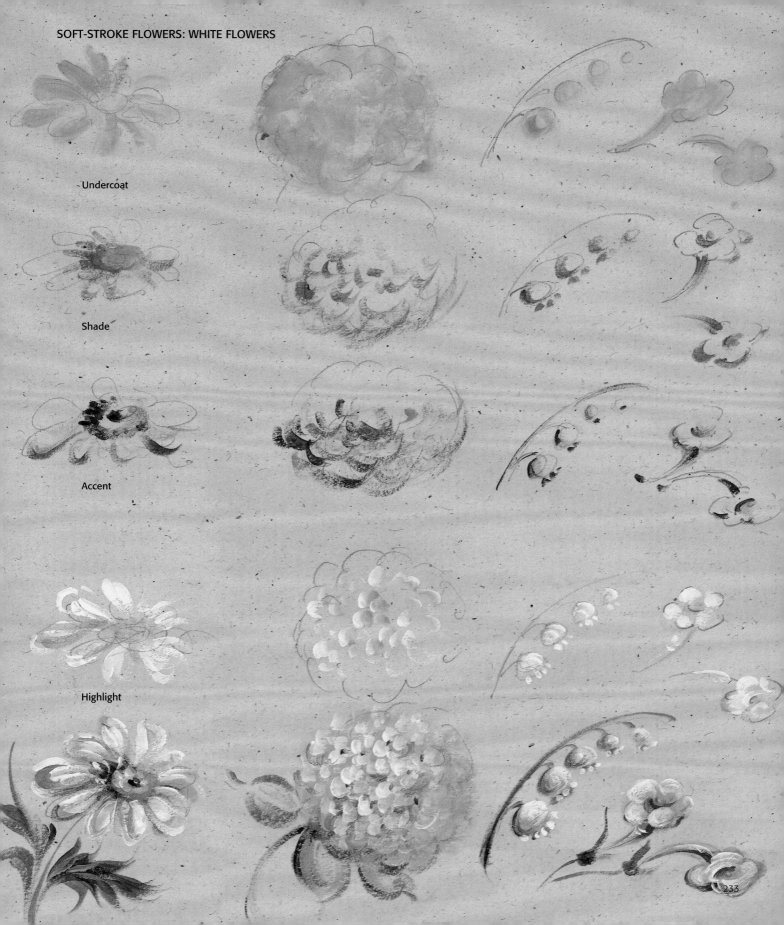

SOFT-STROKE FLOWERS: WHITE FLOWERS

Undercoat

Shade

Accent

Highlight

233

Undercoat

Shade and accent

Highlight and detail

Undercoat

Shade

Accent

Highlight

235

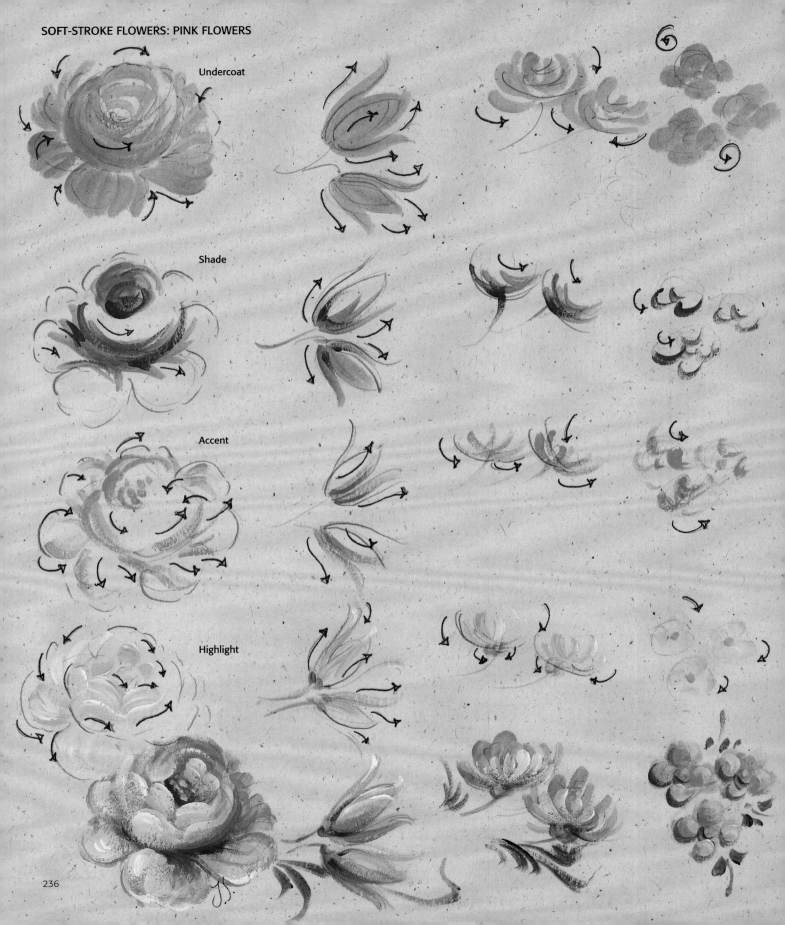

SOFT-STROKE FLOWERS: PINK FLOWERS

Undercoat

Shade

Accent

Highlight

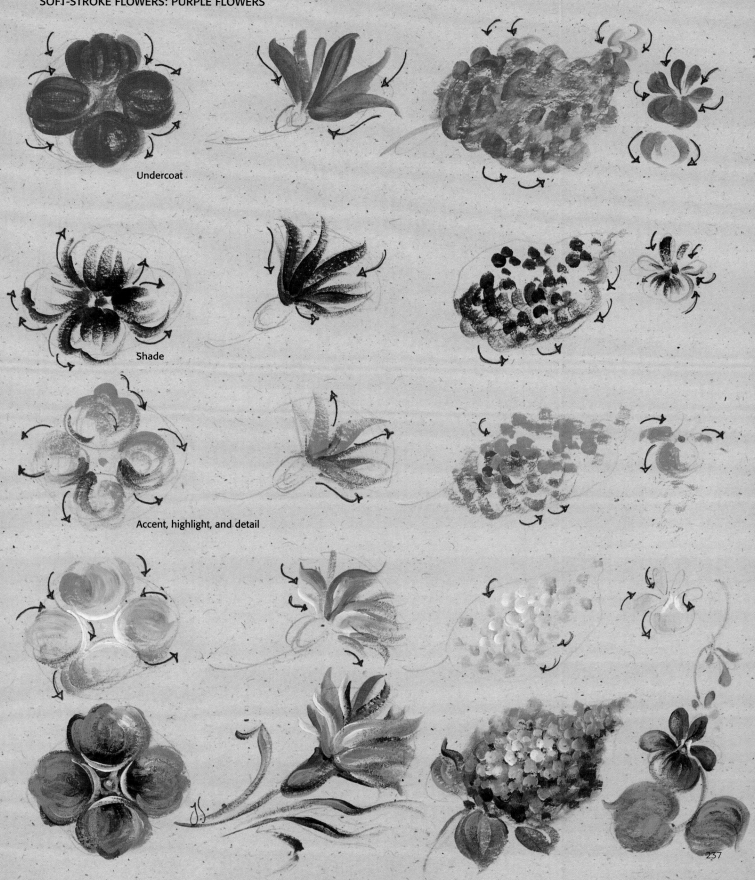

Undercoat

Shade

Accent, highlight, and detail

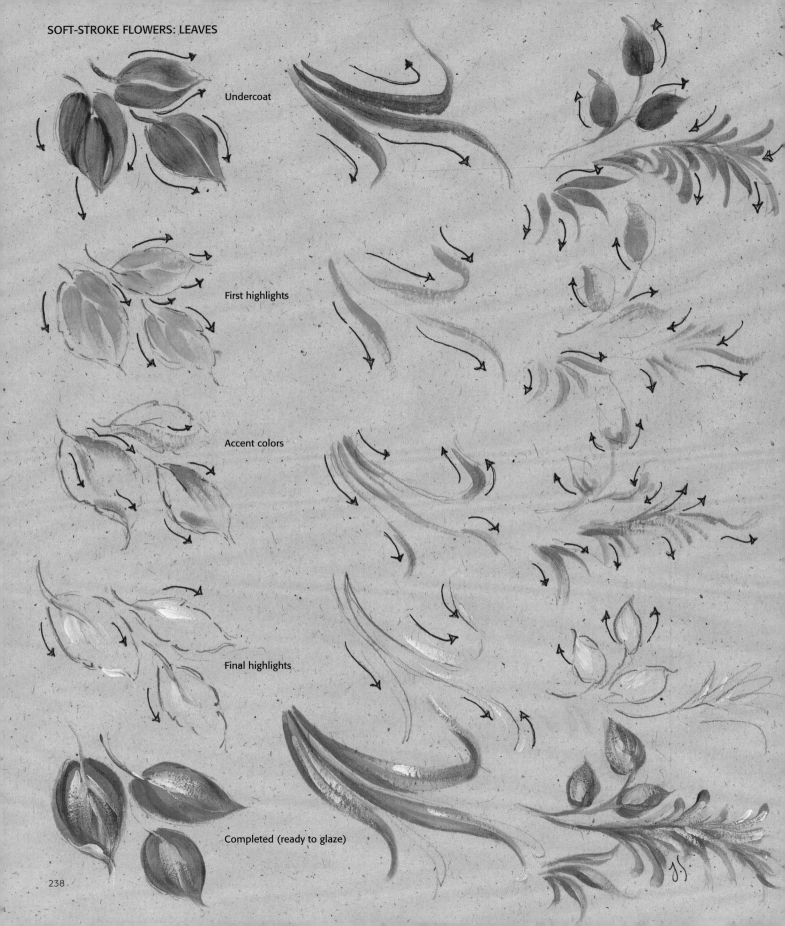

SOFT-STROKE FLOWERS: LEAVES

Undercoat

First highlights

Accent colors

Final highlights

Completed (ready to glaze)

SOFT-STROKE FLOWERS: DECORATIONS FOR SMALL FLORAL TINS

Background = Blossom

First glaze = Gold oxide

Band = Indian red oxide + pine green

Colorwash vertical stripes = Gold oxide

Stripe = Vermilion

Second glaze = Dioxazine purple + a touch of pine green

PALETTE

Dioxazine purple

Burgundy

Gold oxide

Yellow oxide

Pine green

Warm white

Vermilion

Vermilion + warm white

Pine green + yellow oxide

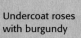
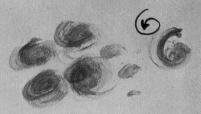

Undercoat roses with burgundy

Shade roses and start leaves
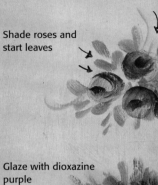

Glaze with dioxazine purple

Highlight

Layer

Detail
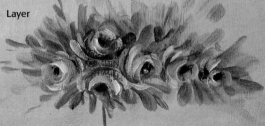

239

Golden Scrolls

The scroll has been a fundamental decorative element since prehistoric times. Its shapes and configurations have varied greatly, indicating either the period of time or the region in which it was painted.

One of the classic decorative painting scrolls, the traditional Hindeloopen scroll (see page 180) is very rounded and symmetrical, and different sections of it may vary in hue. Its shadows and highlights are indicated as separate strokes rather than blended. By contrast, Telemark rosemaling scrolls are very asymmetrical, usually semitransparent to transparent, and include linework in dark and light values. As in many historical styles, you may find a few conflicting examples as artists searched for their own expression.

It's important for beginning artists to understand that there is no one right way to paint scrolls. However, in order to paint a piece that represents a particular period or region with any degree of accuracy, you must study and duplicate its distinctive style and techniques. I created the contemporary scroll design shown on the box below, left, and in the study pages that follow as an introduction to scroll-painting techniques. The design is very lyrical and easy to understand, and the painting technique and palette have broad appeal. The bird on the side of the box provides a brilliant spot of discordant color that is subtly repeated on the lid in the sky and water. The inside edge of the lid is drybrushed with the blue-and-red faux finish shown along the inside edge of page 242.

The two basic strokes used to paint scrolls—the C and the S—are rendered large and casually, flowing like long feathers, and may divide slightly at the ends. I used a no. 4 or 5 long-pointed sable round brush, which is well suited for making teardrops and other thin-to-thick strokes. A larger detail brush, which also has a full "belly," or midsection, and a long, thin point, would also work well.

Paint the scrolls with gold oxide, the tulips with Indian red oxide, and the accessory strokes and tulip highlights with red earth. Once the main segment of the scroll has been embellished with featherlike strokes, highlight here and there with a touch of vermilion. Some texture is lovely as well. A hint of yellow oxide or yellow oxide + a touch of Naples yellow gently highlights the gold oxide portion of the scroll. With this easy method, you can concentrate on on the shape of the scroll itself and its accessory strokes.

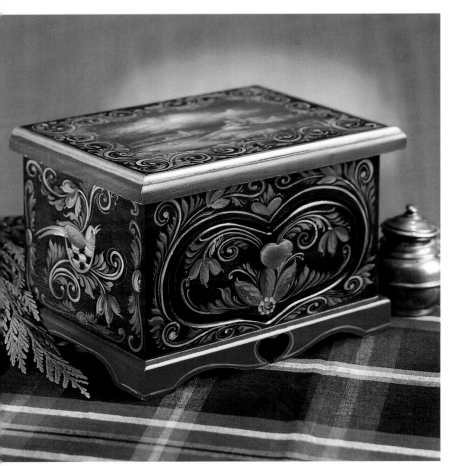

A medium-size jewelry or desk box decorated with a contemporary scroll design.

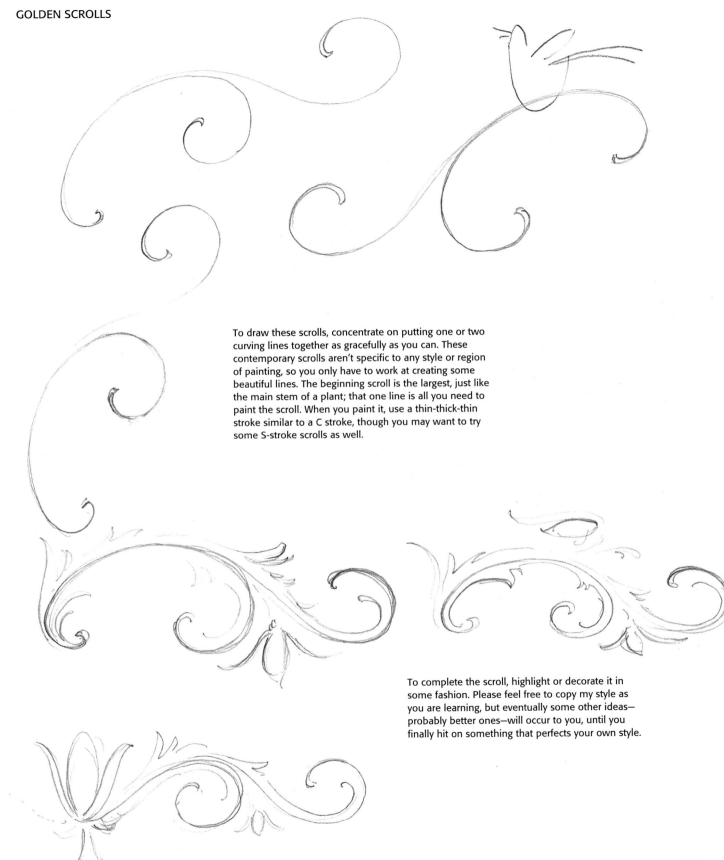

To draw these scrolls, concentrate on putting one or two curving lines together as gracefully as you can. These contemporary scrolls aren't specific to any style or region of painting, so you only have to work at creating some beautiful lines. The beginning scroll is the largest, just like the main stem of a plant; that one line is all you need to paint the scroll. When you paint it, use a thin-thick-thin stroke similar to a C stroke, though you may want to try some S-stroke scrolls as well.

To complete the scroll, highlight or decorate it in some fashion. Please feel free to copy my style as you are learning, but eventually some other ideas—probably better ones—will occur to you, until you finally hit on something that perfects your own style.

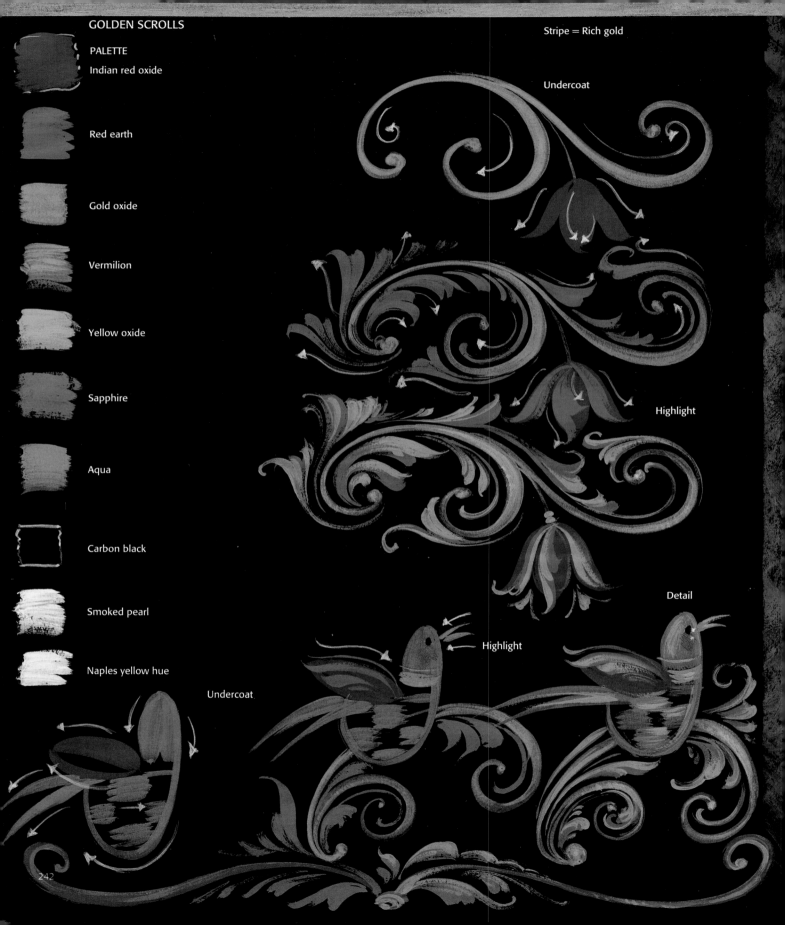

GOLDEN SCROLLS

Stripe = Rich gold

PALETTE
Indian red oxide

Red earth

Gold oxide

Vermilion

Yellow oxide

Sapphire

Aqua

Carbon black

Smoked pearl

Naples yellow hue

Undercoat

Highlight

Detail

Highlight

Undercoat

242

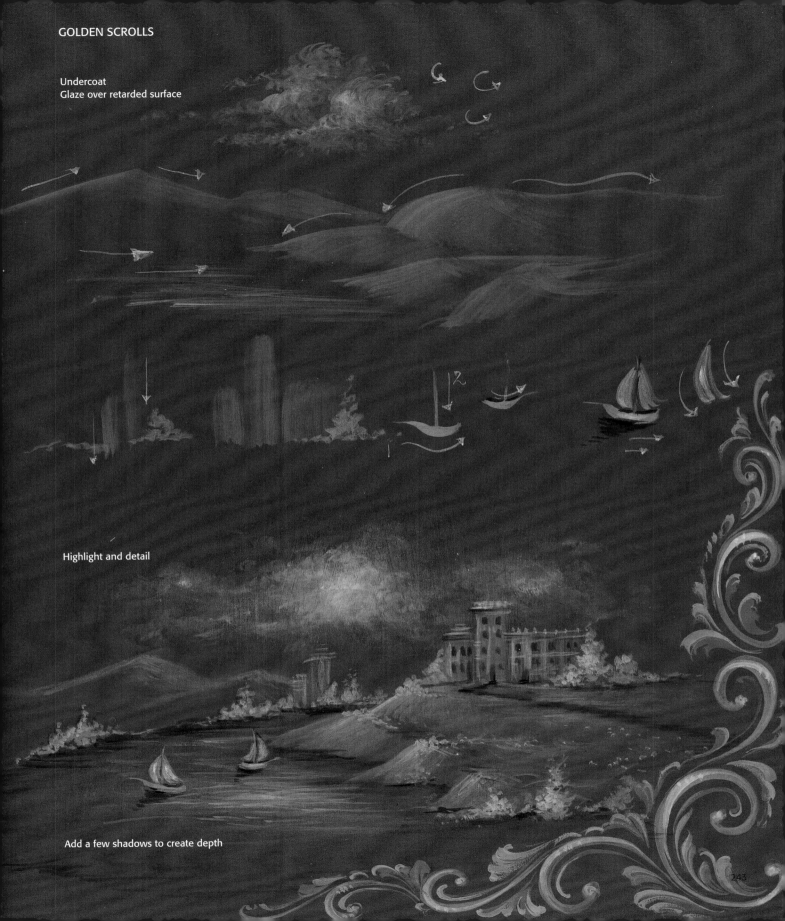

GOLDEN SCROLLS

Undercoat
Glaze over retarded surface

Highlight and detail

Add a few shadows to create depth

243

The Autumn Rose of Telemark

The Autumn Rose of Telemark is a contemporary painting style in the tradition of rosemaling from the Telemark region of Norway. It's relatively easy to copy; all you need is a picture of it and a knowledge of the technique used. Then it's a matter of developing the skills to present the technique in a competent manner. But it's quite a different challenge to develop your own style.

It's hard enough to describe what you mean by "your own style," let alone do it. I find that I must study the costumes, dances, carvings, embroideries, and other aspects of a culture or an area before I can present a style of painting in my own way. This kind of preparation is fun—I love every minute of it. One of the greatest thrills of my painting experience was a comment made by the Norwegian judge at the Vesterheim Nordic Fest about my blue-ribbon entry: "Looks like we have a painter with her own style. Very beautiful." It only took me 30 years!

One of the most fascinating aspects of the beautiful Telemark style of rosemaling is the endless variety of stroke combinations that can be contained within one painting. The great challenge lies in never repeating the same flower twice. The background color is incorporated into the painting with transparent stroke techniques, providing decorative artists with yet another way to explore and experiment with color.

In order to control the transparency of the paints, (this palette usually includes some opaque pigments), I mix them with Kleister or gel medium. To impart a little more texture to the strokes, I also add some texture medium. My favorite concoction consists of 2 parts Kleister or gel medium + 1 part texture medium, which I keep in a 35mm film canister until I'm ready to combine it with my paints (1:1) whenever I want more transparency and texture, like in highlight areas. To load the brush, I dress it in plain Kleister or gel medium, then sideload it with the highlight color/medium mixture. With this technique, I can control the paint very easily and still give the highlights some texture. The same technique can also be used for shadow strokes. When you need longer working time, apply a light coat of retarder (for acrylics) or a very thin coat of linseed oil (for oils) over the painting surface. The trick is to apply just the right amount, something that only comes with experience. (See "Retarding a Surface," page 79.)

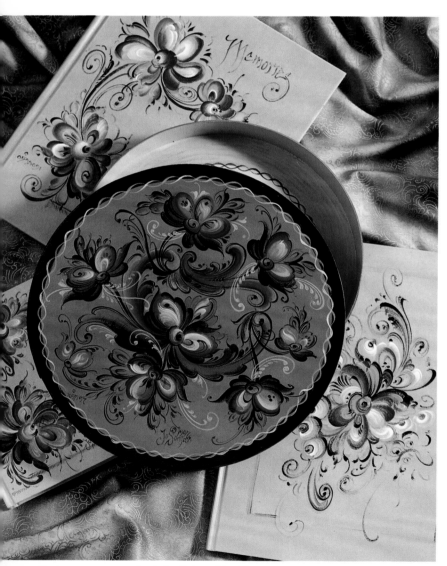
Contemporary rosemaling in the Telemark tradition.

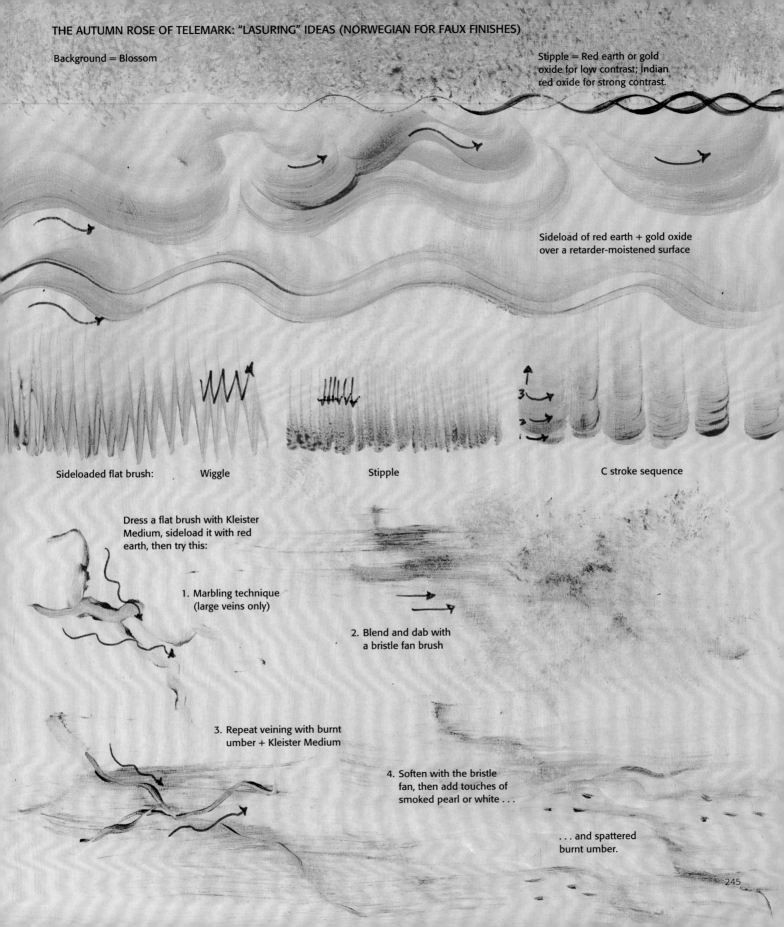

THE AUTUMN ROSE OF TELEMARK: "LASURING" IDEAS (NORWEGIAN FOR FAUX FINISHES)

Background = Blossom

Stipple = Red earth or gold oxide for low contrast; Indian red oxide for strong contrast.

Sideload of red earth + gold oxide over a retarder-moistened surface

Sideloaded flat brush: Wiggle Stipple C stroke sequence

Dress a flat brush with Kleister Medium, sideload it with red earth, then try this:

1. Marbling technique (large veins only)

2. Blend and dab with a bristle fan brush

3. Repeat veining with burnt umber + Kleister Medium

4. Soften with the bristle fan, then add touches of smoked pearl or white . . .

. . . and spattered burnt umber.

Chisel-edge wiggle = Burnt umber + dioxazine purple

PALETTE

 Dioxazine purple

 Red earth

Gold oxide

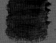 Yellow oxide

 Storm blue + teal green

Light teal (background color)

 Burnt umber

Carbon black (optional)

Smoked pearl

Border = Light teal

Band = Storm blue + burnt umber
OR storm blue + teal green

Background = Rosehip

Sideloaded brush techniques

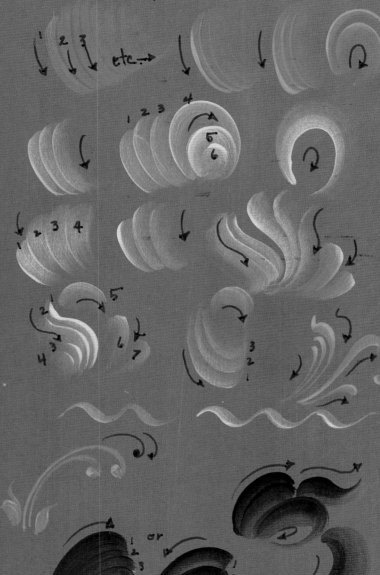

Chisel-edge wiggle = Kleister Medium + dark blue mix

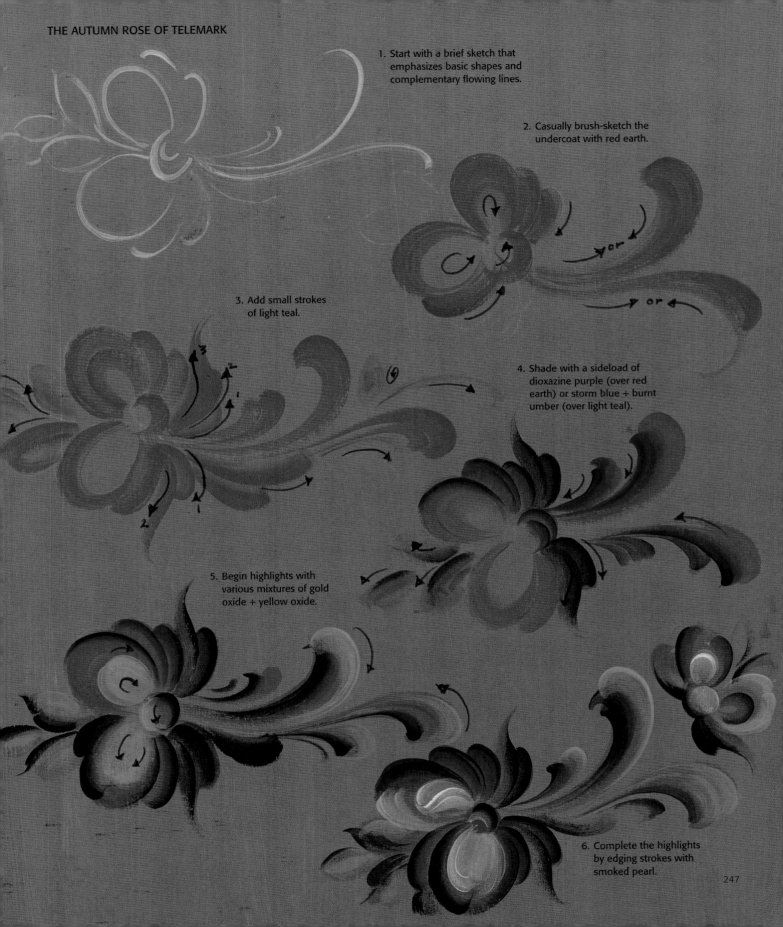

1. Start with a brief sketch that emphasizes basic shapes and complementary flowing lines.

2. Casually brush-sketch the undercoat with red earth.

3. Add small strokes of light teal.

4. Shade with a sideload of dioxazine purple (over red earth) or storm blue + burnt umber (over light teal).

5. Begin highlights with various mixtures of gold oxide + yellow oxide.

6. Complete the highlights by edging strokes with smoked pearl.

247

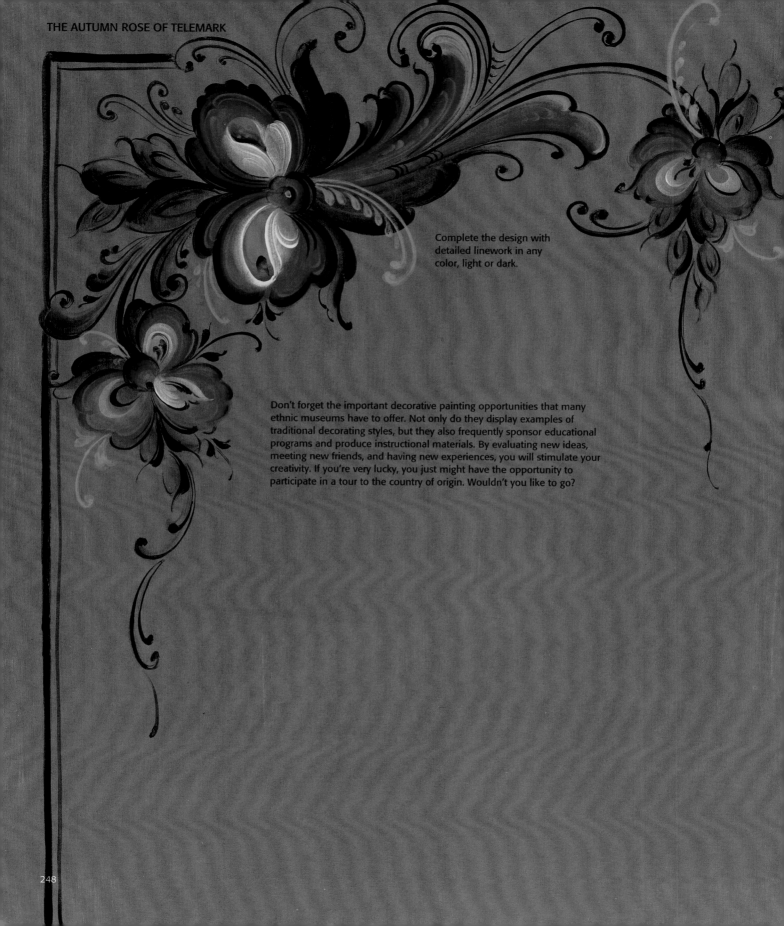

Complete the design with detailed linework in any color, light or dark.

Don't forget the important decorative painting opportunities that many ethnic museums have to offer. Not only do they display examples of traditional decorating styles, but they also frequently sponsor educational programs and produce instructional materials. By evaluating new ideas, meeting new friends, and having new experiences, you will stimulate your creativity. If you're very lucky, you just might have the opportunity to participate in a tour to the country of origin. Wouldn't you like to go?

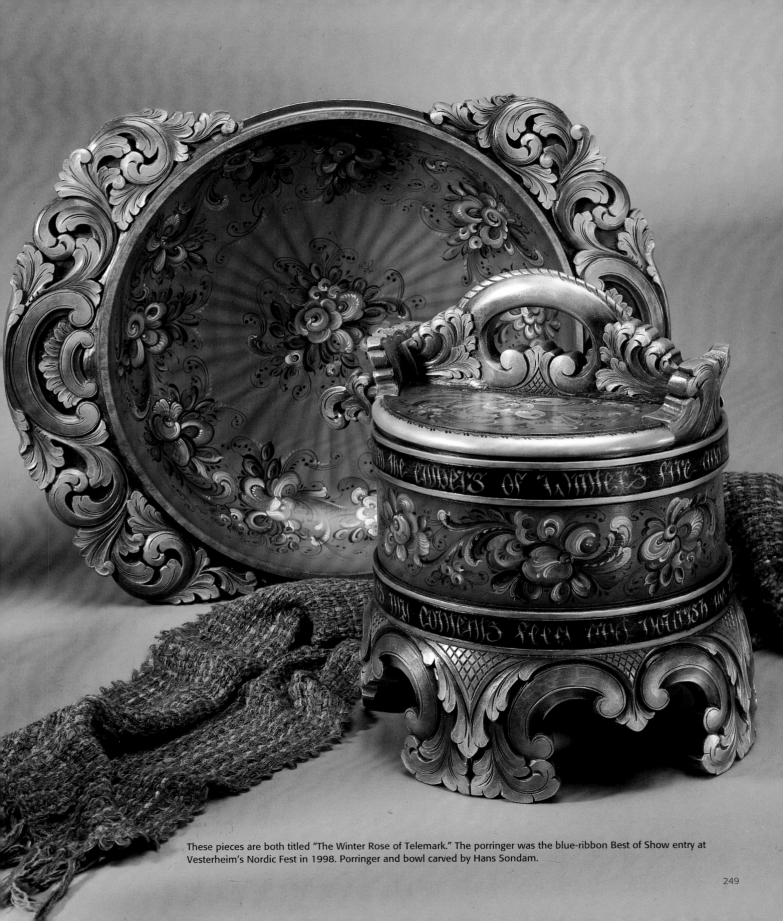

These pieces are both titled "The Winter Rose of Telemark." The porringer was the blue-ribbon Best of Show entry at Vesterheim's Nordic Fest in 1998. Porringer and bowl carved by Hans Sondam.

Glazed Strawberries

The first motif I was taught to paint was a strawberry. I was so thrilled! It was so awful! We learn to enjoy those things just for the wonderful learning experience. Since then I've always loved strawberries, especially on a golden yellow background. My contemporary version uses a completely different technique—it requires no blending at all. I hope you enjoy it.

Your first task is to find a strawberry shape that pleases you. (If you think about it, there are many that are already familiar to you.) Then start work on the leaves. (Strawberry leaves usually grow in threes.) Add a tendril or two, a small flower, and you're on your way. Of course, a lovely stroke border or stripe completes the presentation perfectly.

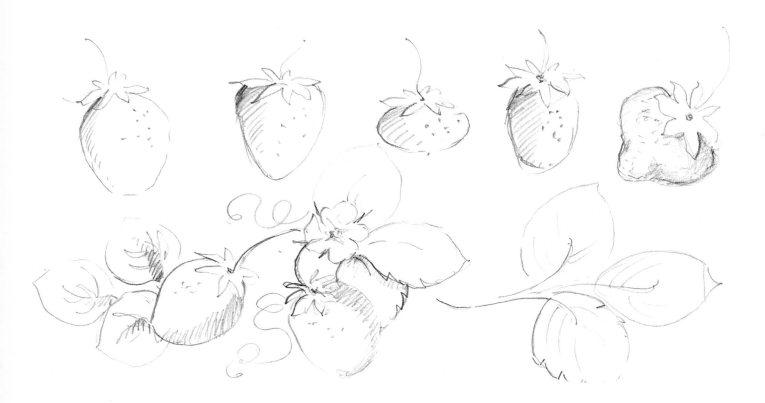

These wooden and tin items glow with the beautiful colors of strawberries.

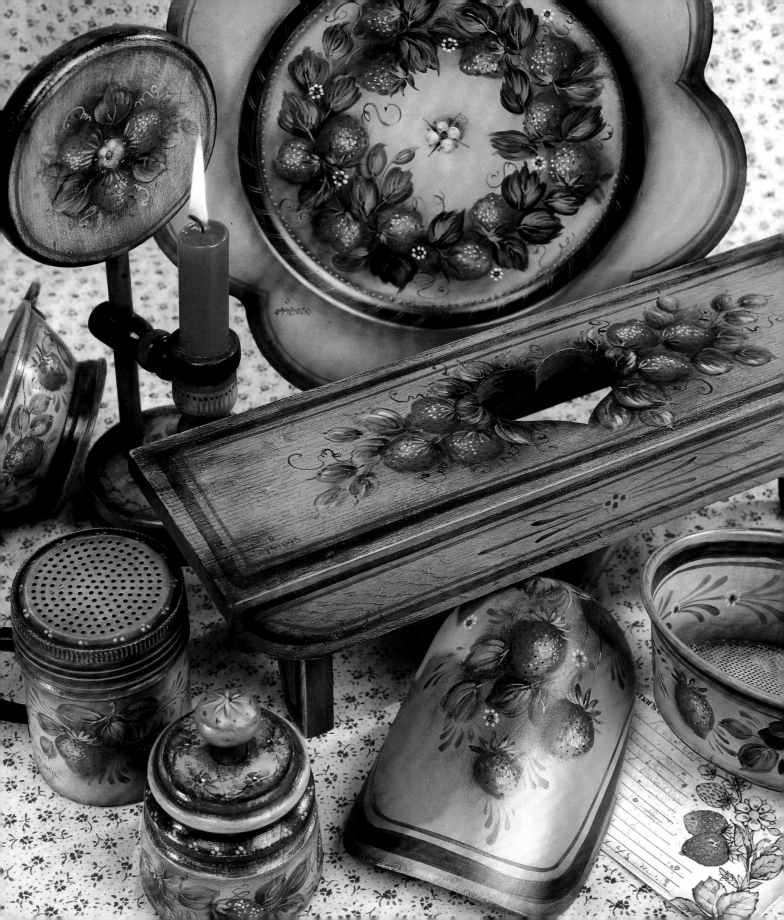

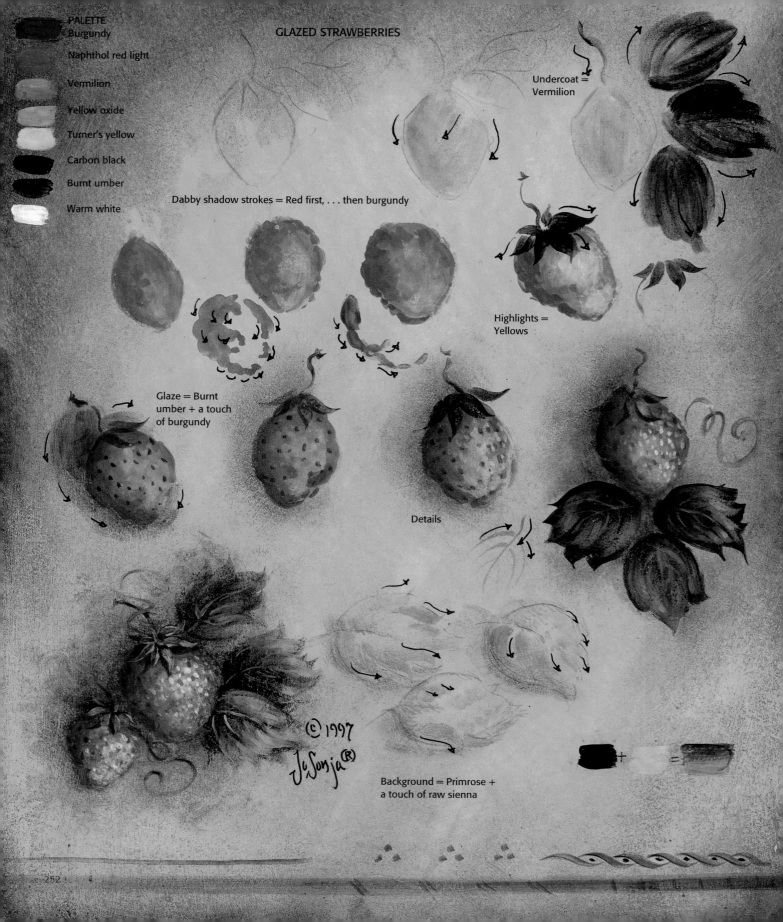

PALETTE
Burgundy

Naphthol red light

Vermilion

Yellow oxide

Turner's yellow

Carbon black

Burnt umber

Warm white

GLAZED STRAWBERRIES

Undercoat =
Vermilion

Dabby shadow strokes = Red first, . . . then burgundy

Highlights =
Yellows

Glaze = Burnt
umber + a touch
of burgundy

Details

© 1997

Jo Sonja ®

Background = Primrose +
a touch of raw sienna

252

Spotted Roosters, Speckled Hens

This is a contemporary expression that combines some of the "flavors" of country tin painting (see page 188) with the whimsy of Fraktur painting (page 196). I took some country tin–style flowers, placed them in a Fraktur-style bean pot, added whimsical chickens using an interesting technique, and finished them with some fun borders (note the spotted one), all of which gave me a unique look and yet reflected a little tradition—something I love to do!

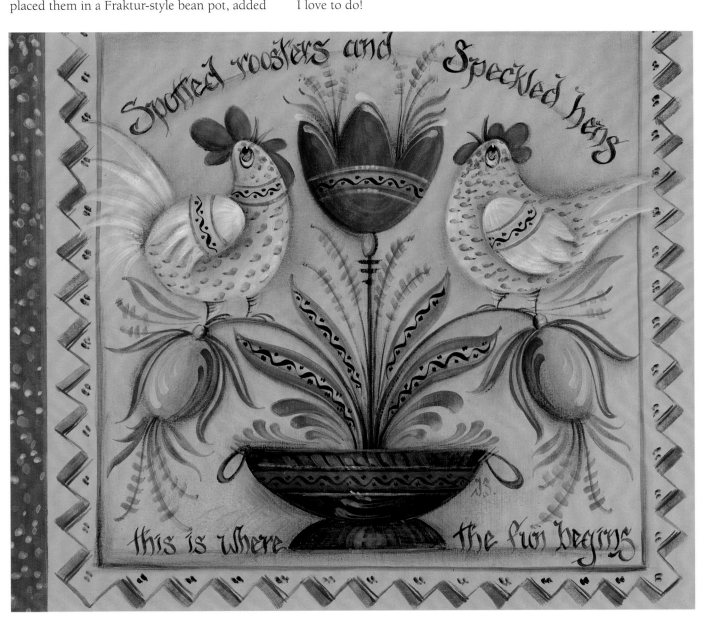

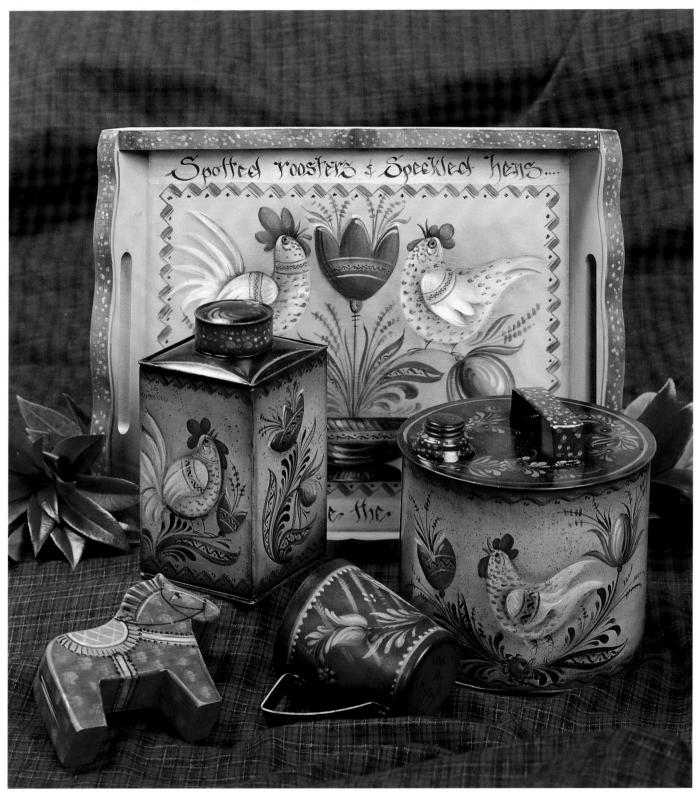

This whimsical duo is fun to paint on many items.

SPOTTED ROOSTERS, SPECKLED HENS

Begin your sketch with a few basic shapes. The flowers start with circles and ovals. The stem lines provide the primary movement within the design, but the tips of the S-stroke leaves and tulip petals also have a graceful flow.

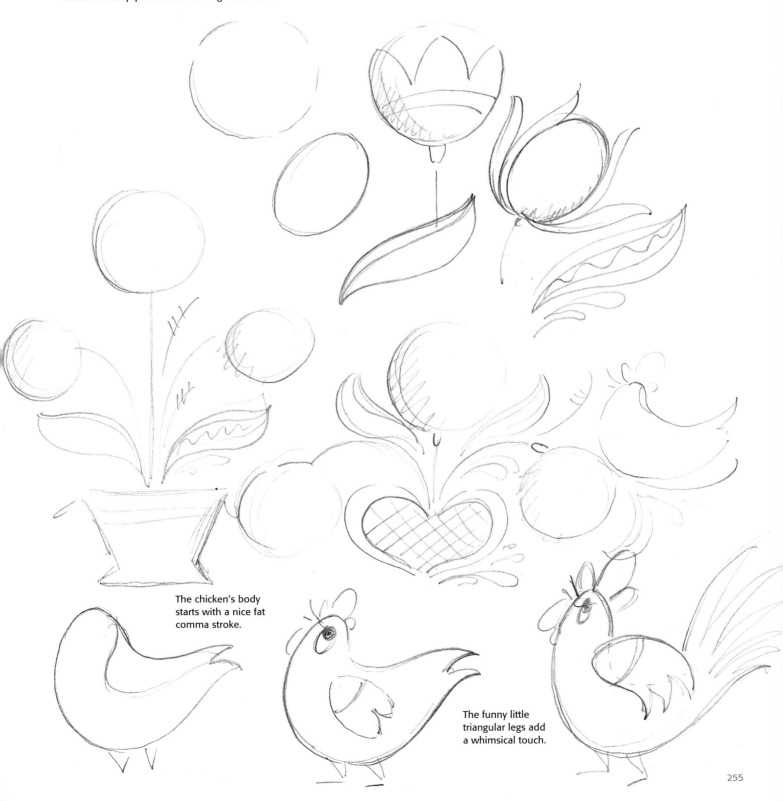

The chicken's body starts with a nice fat comma stroke.

The funny little triangular legs add a whimsical touch.

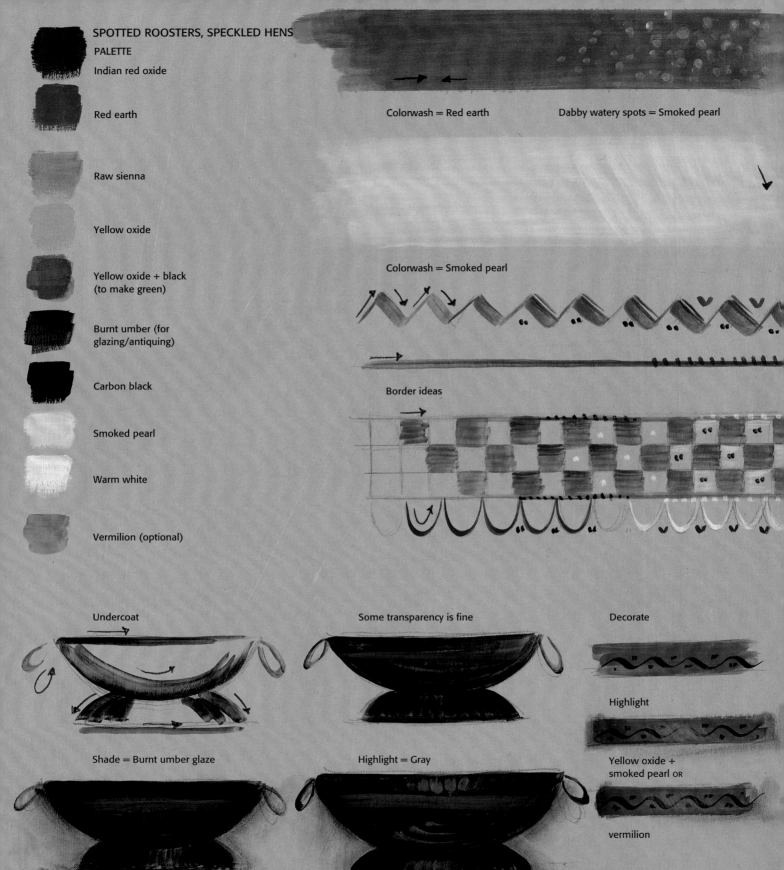

SPOTTED ROOSTERS, SPECKLED HENS

PALETTE

Indian red oxide

Red earth

Raw sienna

Yellow oxide

Yellow oxide + black
(to make green)

Burnt umber (for
glazing/antiquing)

Carbon black

Smoked pearl

Warm white

Vermilion (optional)

Colorwash = Red earth

Dabby watery spots = Smoked pearl

Colorwash = Smoked pearl

Border ideas

Undercoat

Some transparency is fine

Decorate

Highlight

Shade = Burnt umber glaze

Highlight = Gray

Yellow oxide +
smoked pearl OR

vermilion

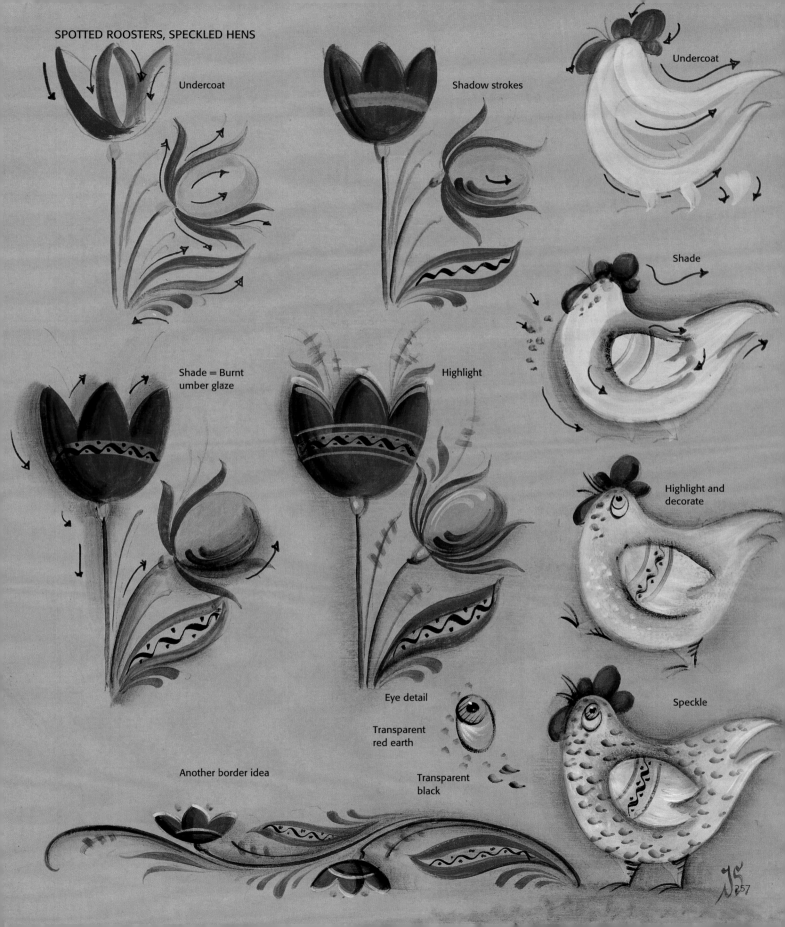

SPOTTED ROOSTERS, SPECKLED HENS

Undercoat

Shadow strokes

Undercoat

Shade

Shade = Burnt umber glaze

Highlight

Highlight and decorate

Eye detail

Transparent red earth

Transparent black

Speckle

Another border idea

257

Pheasants

To share some ideas for feathering techniques, I chose the beautiful plumage of the pheasant. The pheasant is a game bird that is very familiar to me from childhood; if pheasants aren't native to your area, you can probably study one at a local zoo. I chose to paint these a little more casually, more decoratively, rather than to recreate them perfectly. Several precedents for this type of painting can be found, especially during the Victorian period. The Victorians' love of color and hunting and fishing themes made birds, animals, and fish popular decorative motifs.

The plumage of the pheasants contrasts richly against the soft colors and techniques of the background.

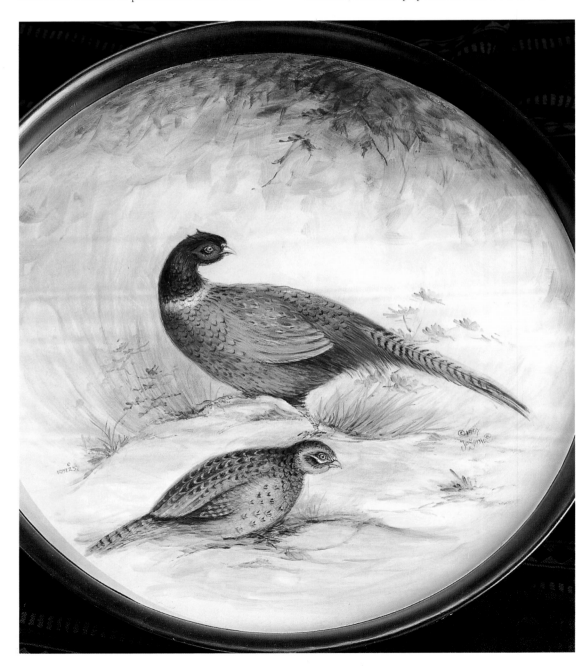

The drawing begins
with an egg shape.

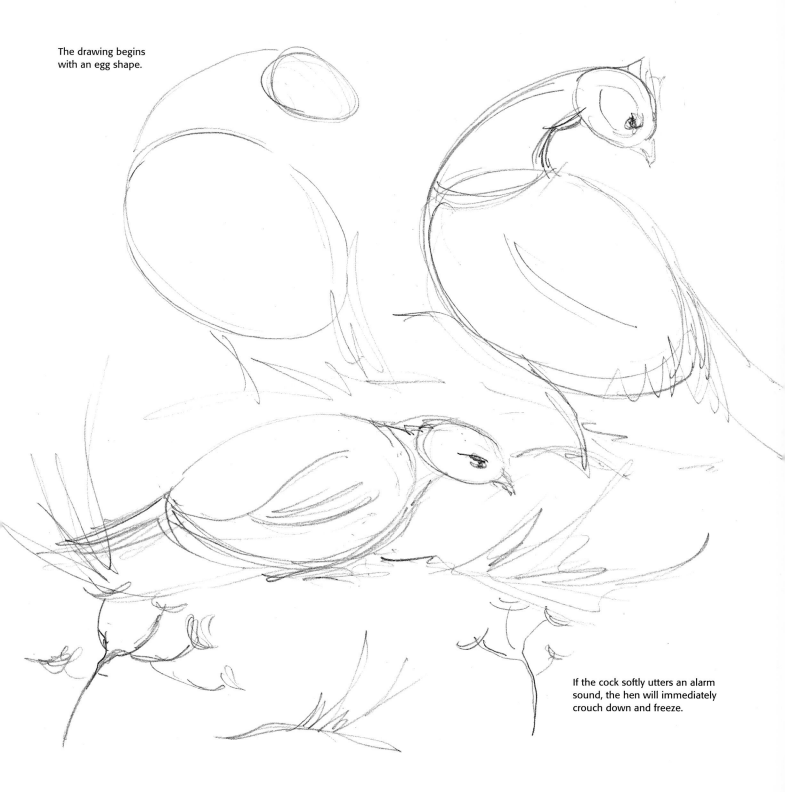

If the cock softly utters an alarm
sound, the hen will immediately
crouch down and freeze.

PHEASANTS

PALETTE

Dioxazine purple

Naphthol red light

Vermilion

Amethyst

Gold oxide

Yellow oxide

Pine green

Brilliant green

Brown earth

Carbon black

Warm white

Provincial beige

Lightly begin to indicate foliage and ground over a lightly retarder-moistened surface.

Undercoat the birds with beige, then define feather groupings with additions of brown earth. Undercoat the rooster's head casually.

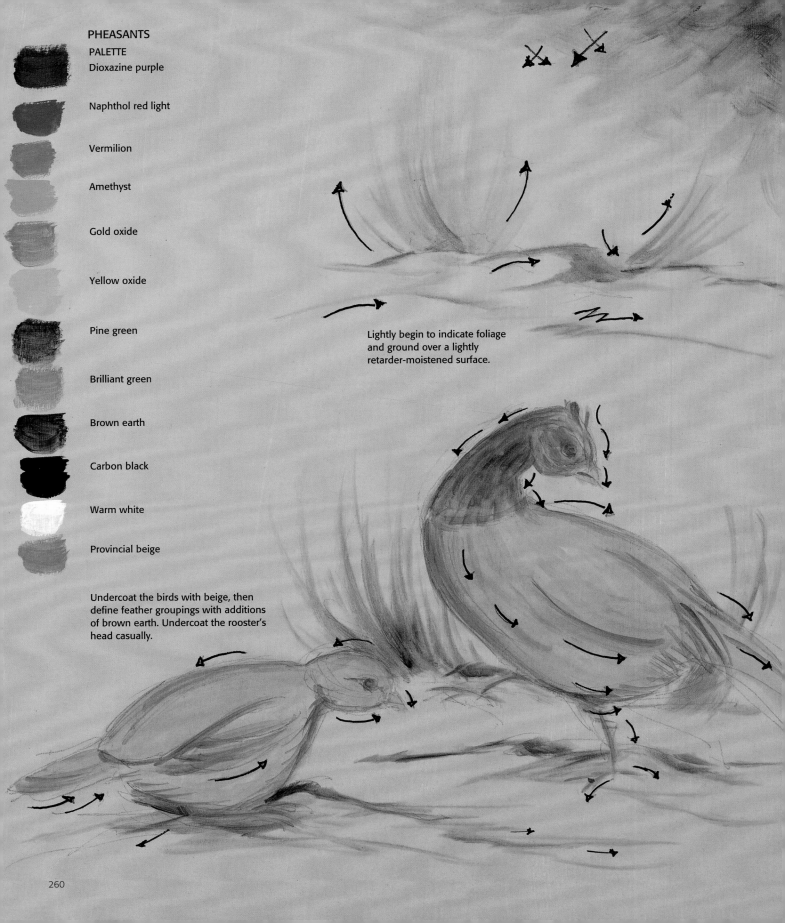

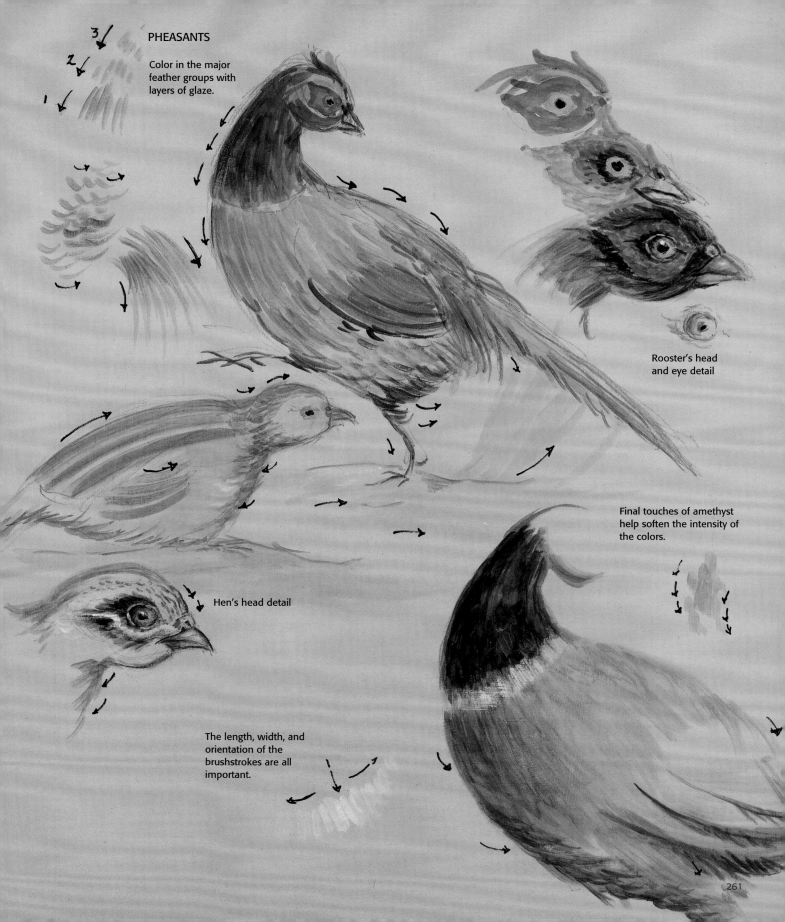

PHEASANTS

3
2
1

Color in the major feather groups with layers of glaze.

Rooster's head and eye detail

Final touches of amethyst help soften the intensity of the colors.

Hen's head detail

The length, width, and orientation of the brushstrokes are all important.

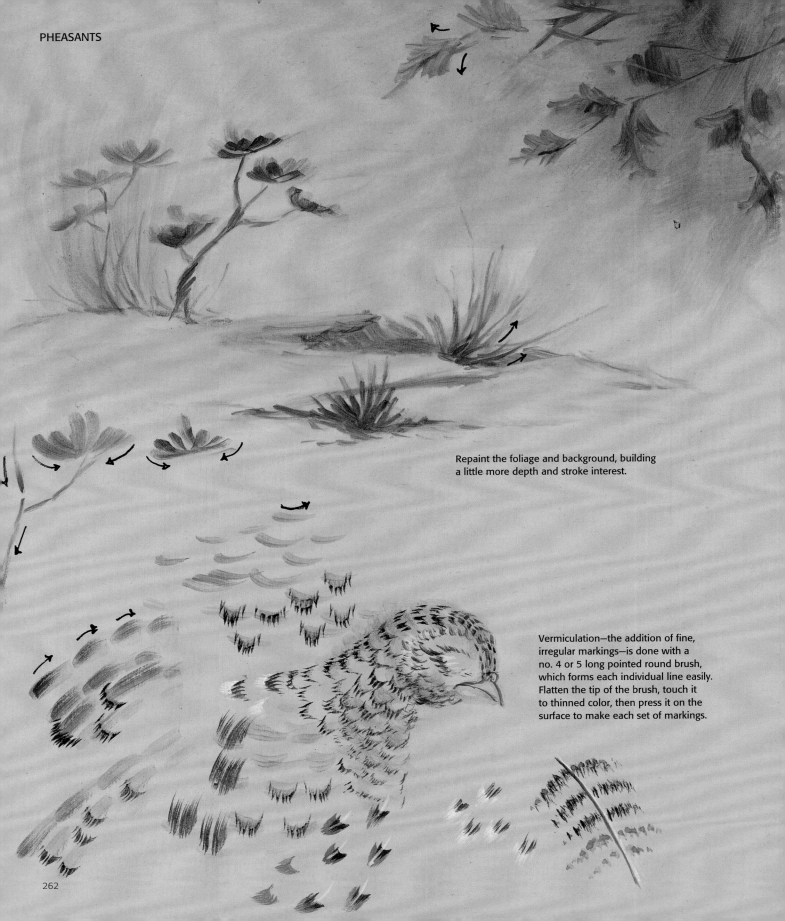

Repaint the foliage and background, building a little more depth and stroke interest.

Vermiculation—the addition of fine, irregular markings—is done with a no. 4 or 5 long pointed round brush, which forms each individual line easily. Flatten the tip of the brush, touch it to thinned color, then press it on the surface to make each set of markings.

Large-Mouth Bass

To create the painting of a pleasant evening or early morning fishing scene on page 267, I used a combination of transparent and opaque stroke techniques that I mingled with just a touch of iridescent color. The background has been kept simple and soft—there's not much detail, just a soft presentation of toned complements (blue and orange)—so that the fish would remain the center of interest.

There is something so peaceful about this time of day at water's edge. Then just imagine the powerful splash as the bass explodes from the water, trying to shake loose the irritating plug. I can just hear Jerry's voice as he calls to me to "look at that!" Then, "Did you see him leap out of the water?" The battle of wits has begun. Jerry will be very careful not to harm the bass, and will cautiously release it to continue the life cycle.

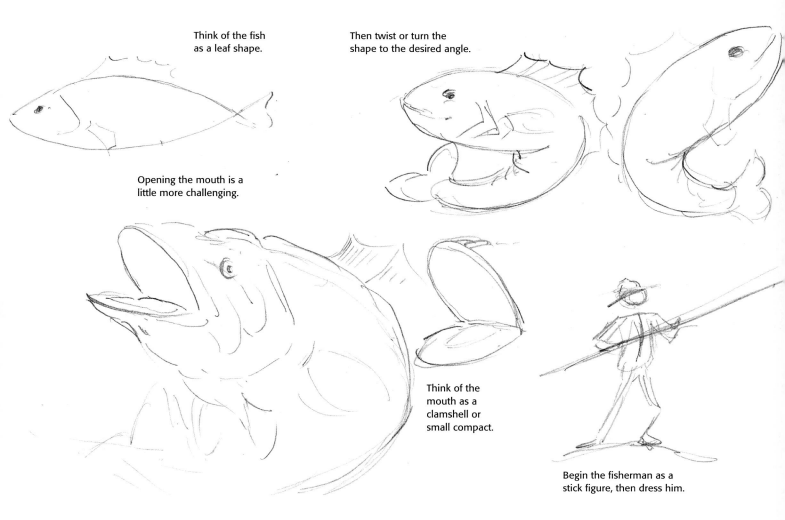

Think of the fish as a leaf shape.

Then twist or turn the shape to the desired angle.

Opening the mouth is a little more challenging.

Think of the mouth as a clamshell or small compact.

Begin the fisherman as a stick figure, then dress him.

263

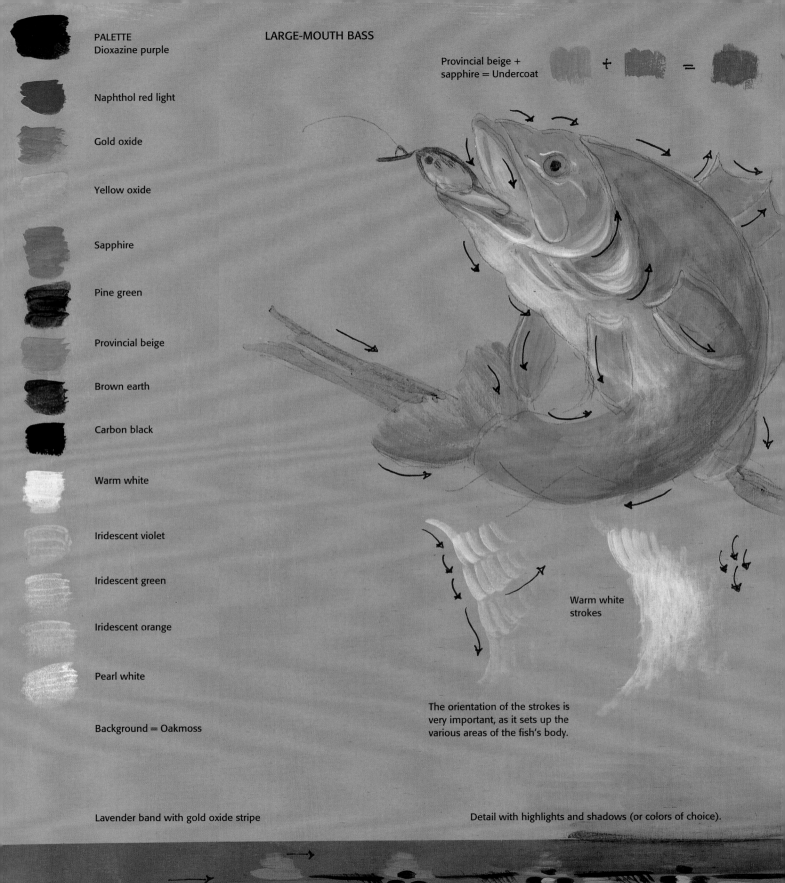

PALETTE
Dioxazine purple

Naphthol red light

Gold oxide

Yellow oxide

Sapphire

Pine green

Provincial beige

Brown earth

Carbon black

Warm white

Iridescent violet

Iridescent green

Iridescent orange

Pearl white

Background = Oakmoss

LARGE-MOUTH BASS

Provincial beige +
sapphire = Undercoat

Warm white
strokes

The orientation of the strokes is
very important, as it sets up the
various areas of the fish's body.

Lavender band with gold oxide stripe

Detail with highlights and shadows (or colors of choice).

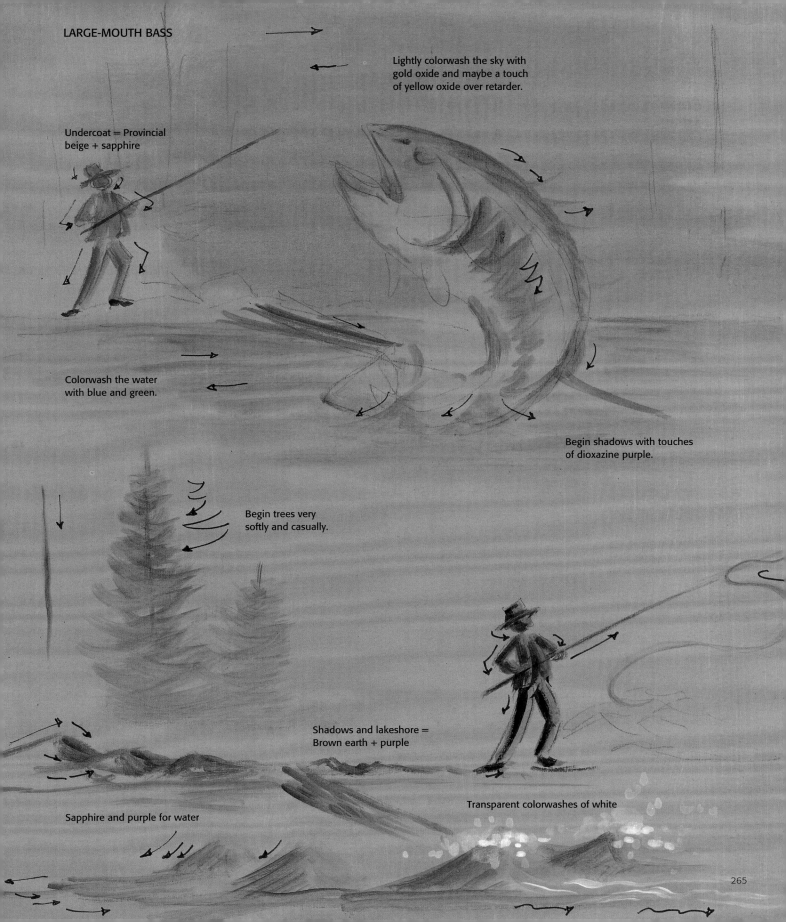

Lightly colorwash the sky with gold oxide and maybe a touch of yellow oxide over retarder.

Undercoat = Provincial beige + sapphire

Colorwash the water with blue and green.

Begin shadows with touches of dioxazine purple.

Begin trees very softly and casually.

Shadows and lakeshore = Brown earth + purple

Sapphire and purple for water

Transparent colorwashes of white

265

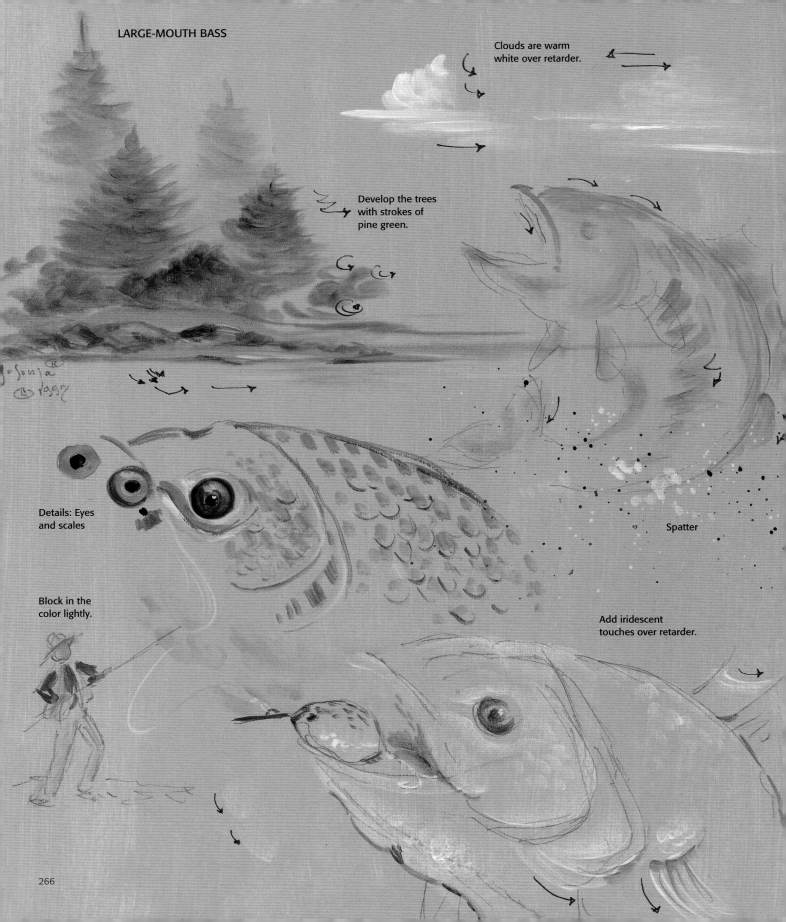

LARGE-MOUTH BASS

Clouds are warm white over retarder.

Develop the trees with strokes of pine green.

Details: Eyes and scales

Block in the color lightly.

Spatter

Add iridescent touches over retarder.

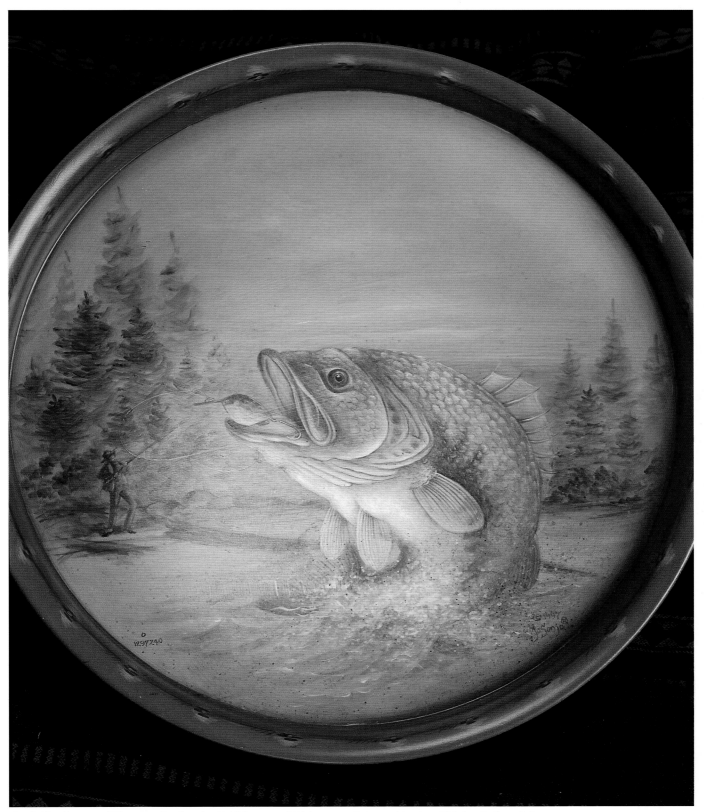

Gently blending some iridescent colors into the highlight areas of this large-mouth bass adds a beautiful glow to the painting.

Old-World Wash and Scrub

I developed this technique to emulate the beautiful old antiquing method that can be seen on some of Peter Ompir's best pieces (see page 209). Especially appealing is the look he achieved when he sanded back here and there after layering glazes of various colors. His glazing was often done over a brushstroked background that was textured enough so that the strokemarks were revealed during the sanding process. It's believed that his glazes were oil-based, and that the process of applying them was long and complex. The variation I've devised is completely water-based and cleans up easily with soap and water.

1. Begin by basecoating the surface with a 1:1 mixture of the background color + All Purpose Sealer. You don't have to be accurate with the proportions, but you MUST use All Purpose Sealer. Let dry well, at least overnight, but several days is better.

2. You may want to begin your design by sketching it, then applying a colorwash, as I sometimes do. But as you can see from the study page shown opposite, most of it will be lost during the scrub-and-sand step.

3. Glaze the entire surface with a colorwash of paint + water. The ratio of paint to water will vary, depending on the transparency of the color you use. Don't worry about streaks—they don't matter—but if you would rather avoid them, add some retarder to the mixture, which then will take longer to dry. Let dry thoroughly.

4. Using either the same color as you used in step 3 or a slightly different one, darken the area surrounding the design with the glazing technique described on page 84. If you need a longer open time, work over a retarder-moistened surface. Wipe back the glaze a little if you feel that it looks too dark. Let dry well (again, overnight is best).

5. Begin to remove the glaze by *gently* scrubbing the surface with a small scrub pad and water. Do NOT scrub hard—you'll remove too much paint. As you scrub, a colored slurry will develop. When this happens, stop and wipe the surface with a clean damp rag or paper towel to remove the slurry.

 If you've removed too much color, reapply the second layer of glaze, let it dry, then apply a barrier coat of Clear Glaze Medium and let it dry overnight before scrubbing again.

 When you've removed as much of the glaze as you want, stop, let the surface dry, then gently sand it, first with #180- to #220-grit sandpaper, then with #400-grit. Wipe it clean.

6. In the example on page 270, I undercoated the motif with colorwashes of storm blue and highlighted it with strokes of a warm white colorwash. The layering of the slightly translucent colors creates a lovely depth.

7. In the final step, I casually outlined the elements of the motif and added details with permanent black ink. (I used an Itoya .01-tip marking pen.) Before you start, make sure that the ink and your varnish are compatible. Just make a few pen marks on your palette, let them dry, then brush a spot of varnish over them. If the ink lifts off, try a different brand of marking pen.

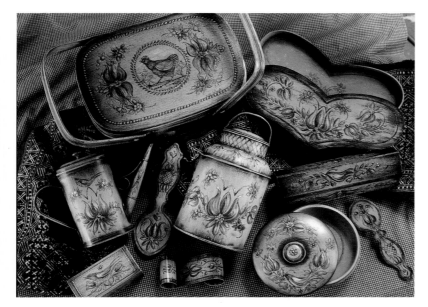

A medley of objects decorated with the wash-and-scrub technique.

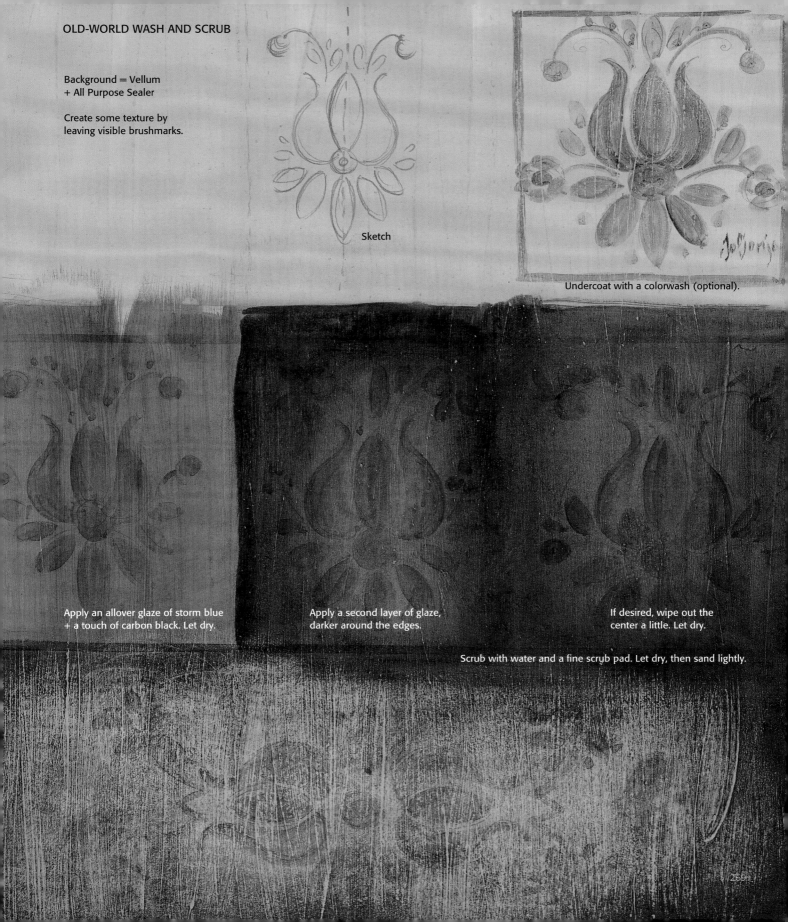

OLD-WORLD WASH AND SCRUB

Background = Vellum
+ All Purpose Sealer

Create some texture by
leaving visible brushmarks.

Sketch

Undercoat with a colorwash (optional).

Apply an allover glaze of storm blue
+ a touch of carbon black. Let dry.

Apply a second layer of glaze,
darker around the edges.

If desired, wipe out the
center a little. Let dry.

Scrub with water and a fine scrub pad. Let dry, then sand lightly.

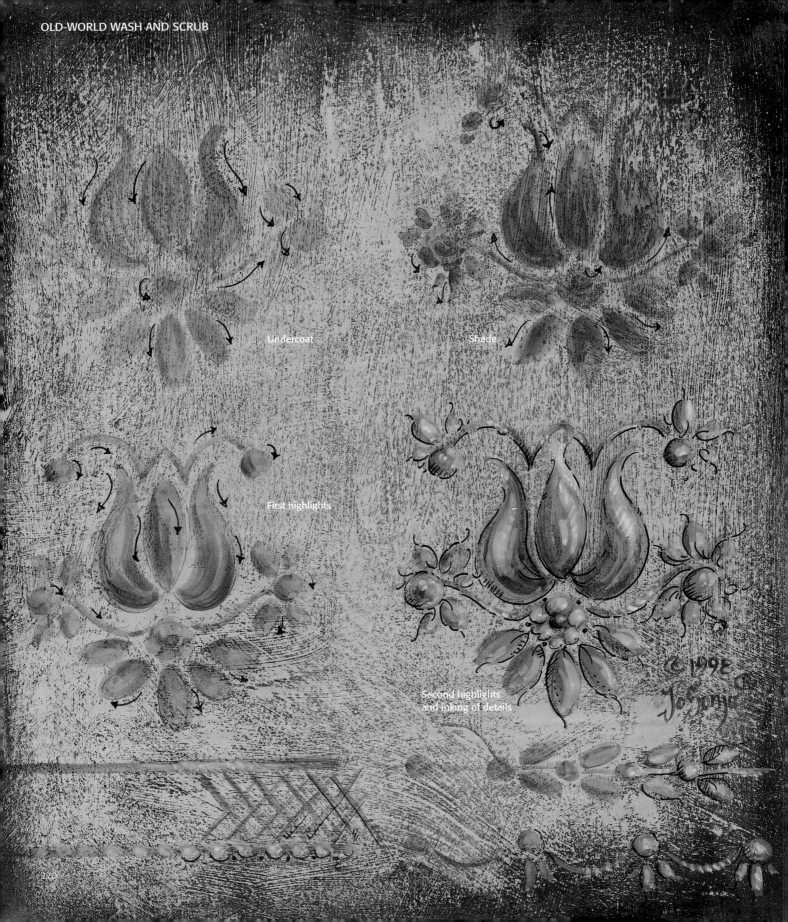

Undercoat

Shade

First highlights

Second highlights
and inking of details

© 1992
Johanne

Designing to a Theme: Tulips

I'd like to take the opportunity to show you how to design to a theme. For example, tulips are a very old decorative motif. If you take your sketchbook to the local library, you'll find many variations from centuries past. Look for old tulip shapes in a book on early Greek or Egyptian art. (Sometimes you'll get lucky and find a book that is only about ornamentation. You'll often find recent reprints on the sale table of a very large bookstore. I have at least ten different titles that I use for my design classes.) When you find an old shape that appeals to you, sketch it in your book, noting the title of the book and the page number. That way, you'll always be sure that you have a shape that is safe for you to begin with, at least until you really feel secure about copyright questions.

Next, take the shape and begin to play with it. (Don't think about color yet.) Make some repetitive borders, then try some small designs, say, for the center of a small plate or the lid of a heart-shaped box. Symmetrical or repetitive designs are usually a bit easier (except when you have to make them precisely balanced or consistent). Now you'll find that you need a leaf, a small scroll, or line to connect them. Go back to your reference book if you need some ideas.

Once you have a couple of design ideas you can start to think about color. Look through magazines and books and go to paint stores and fabric shops, concentrating only on color combinations and color schemes. Find one you really like and develop a good, simple palette.

Make a study board and basepaint it. Paint a color band, or maybe a stripe. Now transfer or resketch your tulip shape. You don't have to know how you're going to decorate it yet; in fact, it's better if you don't. Think only about how the position of the principal colors can be used to accentuate the elements of the design so that it's even more pleasing.

Consider which painting techniques to use for shading and highlighting, or to otherwise embellish your design. Look through this book to get some ideas. You could always create dimension by blending dark values for the shadows and light ones for the highlights—you should really "stretch" yourself and try to be more creative than that—but if that's the look you want, you could drybrush them or mix them with Kleister Medium to give them a little more interest.

Seek out an object or two. Prepare them, then test your ideas. You may find that you need to adjust the palette, the size or proportions of the tulip, or of another design element. This is a good way to start. You really don't know what you need or how to solve problems until you meet them head on. You must work them out slowly if you expect to develop your own style and avoid copying anyone else's.

At this point, a second opinion—the eye of a good painting friend or teacher—can be most helpful. You must remember that it's only an opinion, not a truth. There are no rules. Don't restrict yourself by reciting rules that make you feel safer. The artist who gets rave reviews is the one who steps out and tries something new. The masses will follow.

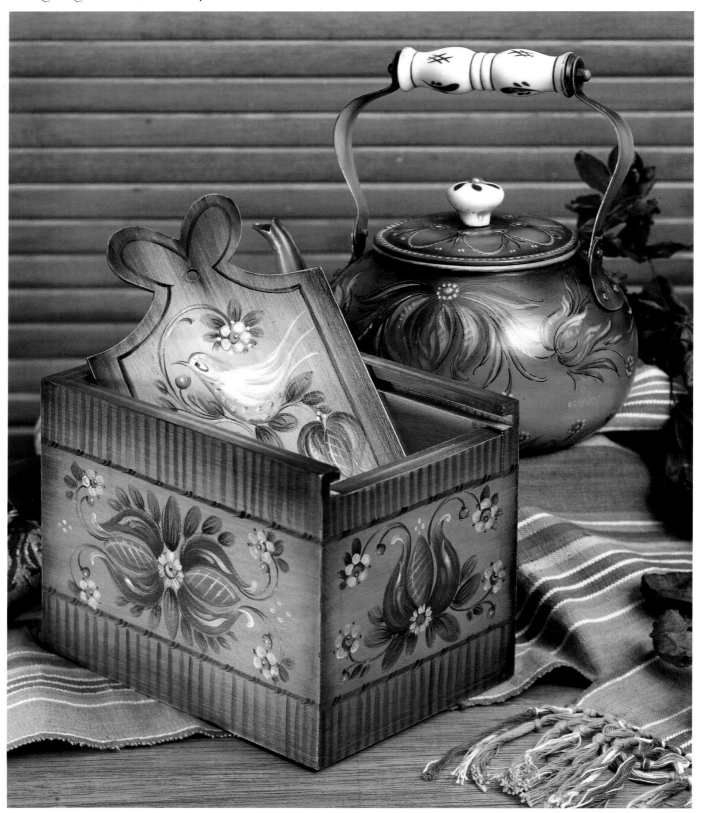

Choosing pieces that are different sizes and proportions will challenge you to come up with new ideas.

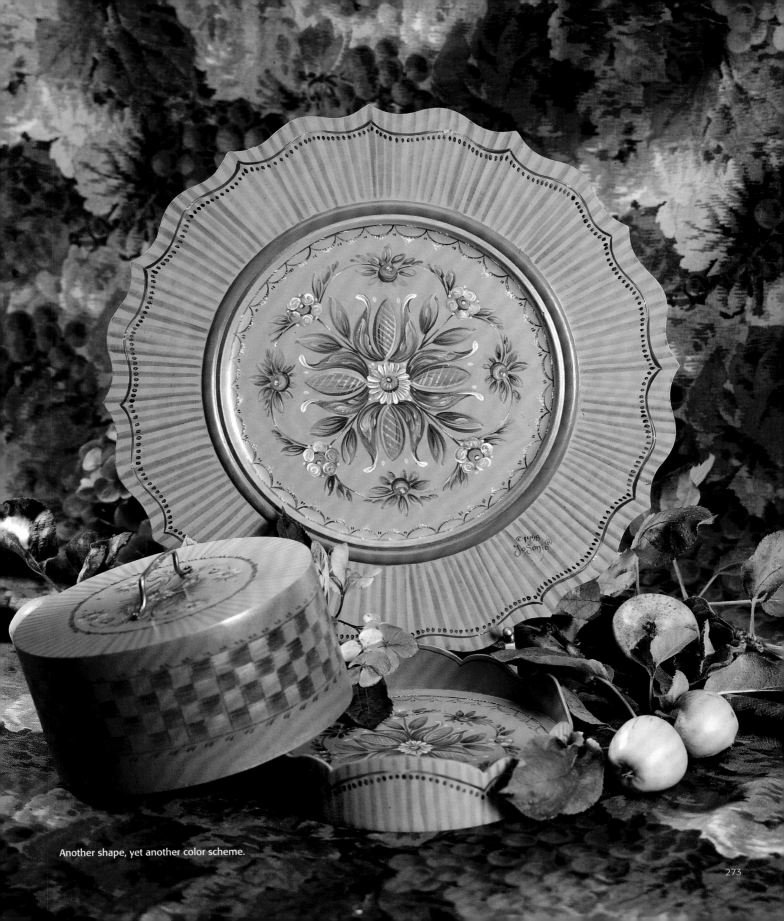

Another shape, yet another color scheme.

273

Find a shape. Express it simply.

Add leaves or a scroll.

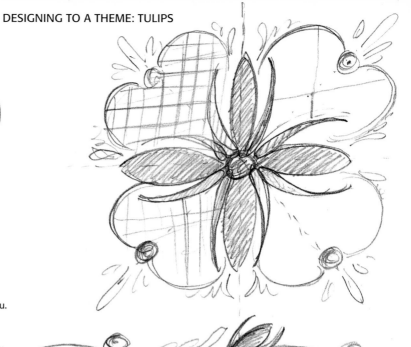

Make quick sketches of some ideas. Don't let trivial matters hinder you.

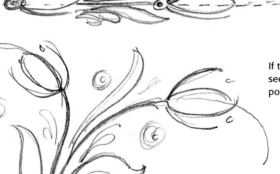

If the quick sketches seem to have some possibilities . . .

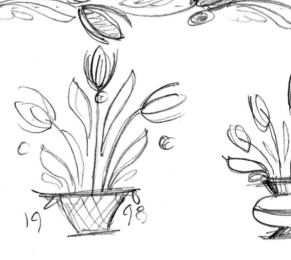

. . . then begin to think about color. Work out your ideas on a practice board. Start with values first.

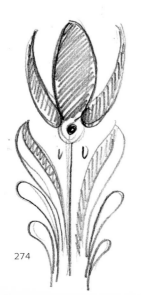

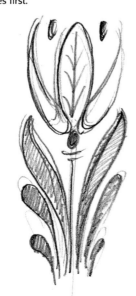

Consider which painting techniques you might use.

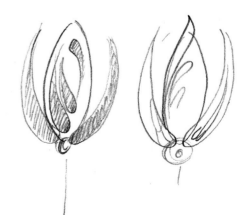

When you've combined all these things and developed a look that's unlike anyone else's, you have an idea that you can copyright. On the following pages I'd like to show you how I developed some tulip ideas in this way.

274

Teal or forest green

Red earth + warm white

Background = Deep plum

PALETTE

Dioxazine purple

Indian red oxide

Red earth

Red + white

Yellow oxide

Pine green

Carbon black

Warm white

Naples yellow light OR
yellow oxide + white +
a touch of pine green

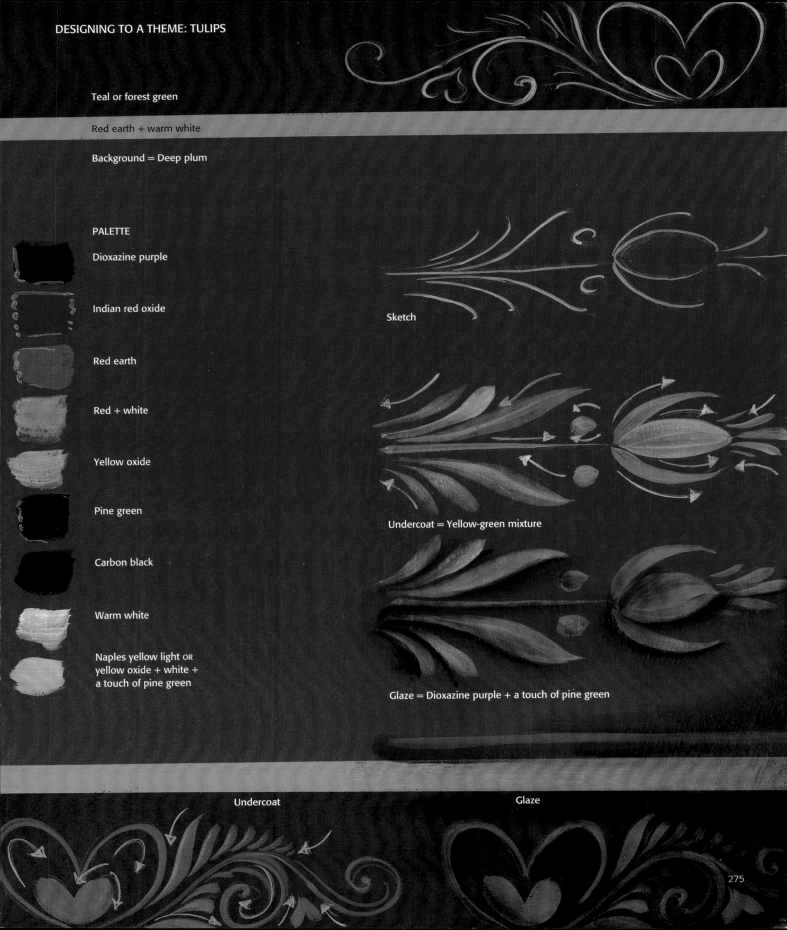

Sketch

Undercoat = Yellow-green mixture

Glaze = Dioxazine purple + a touch of pine green

Undercoat

Glaze

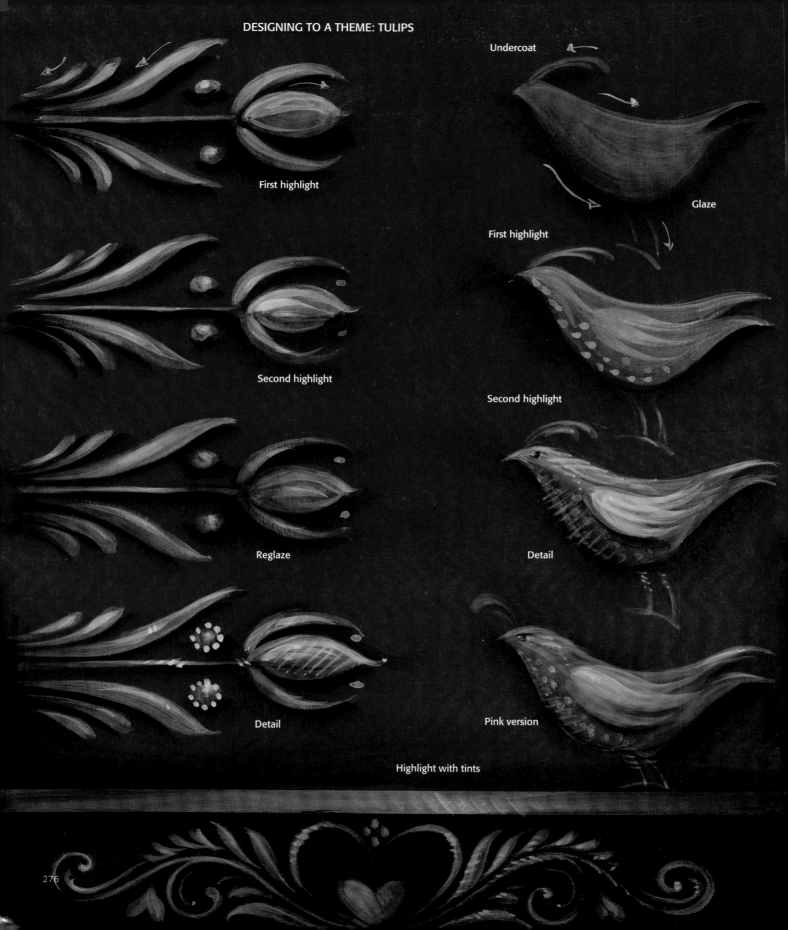

First highlight

Undercoat

Glaze

First highlight

Second highlight

Second highlight

Reglaze

Detail

Detail

Pink version

Highlight with tints

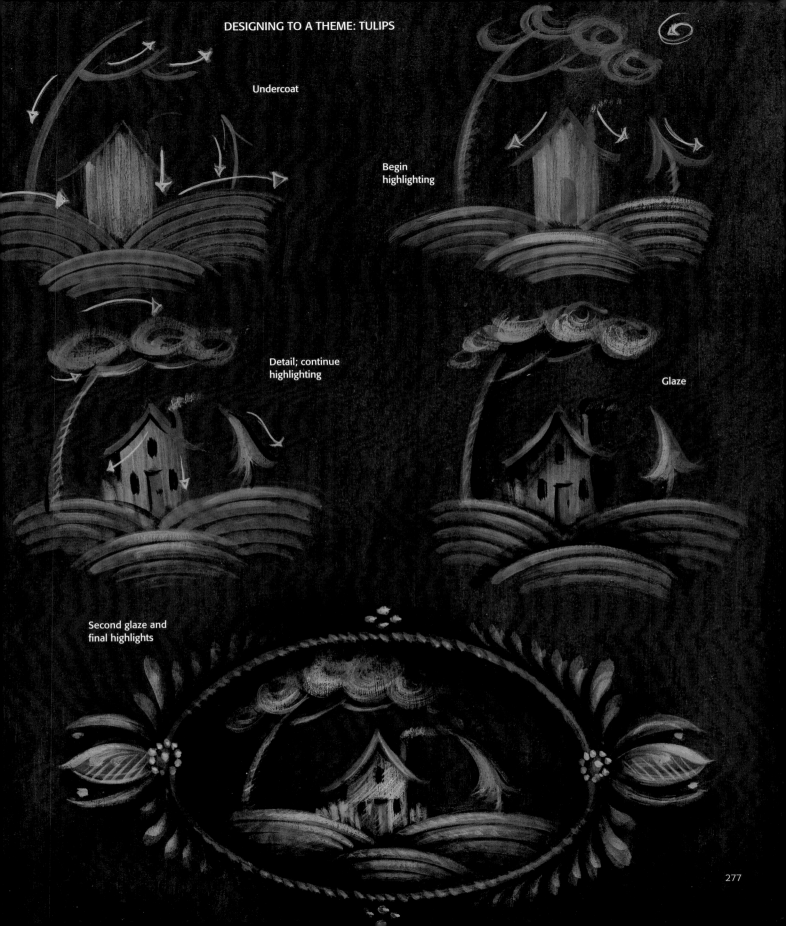

Undercoat

Begin
highlighting

Detail; continue
highlighting

Glaze

Second glaze and
final highlights

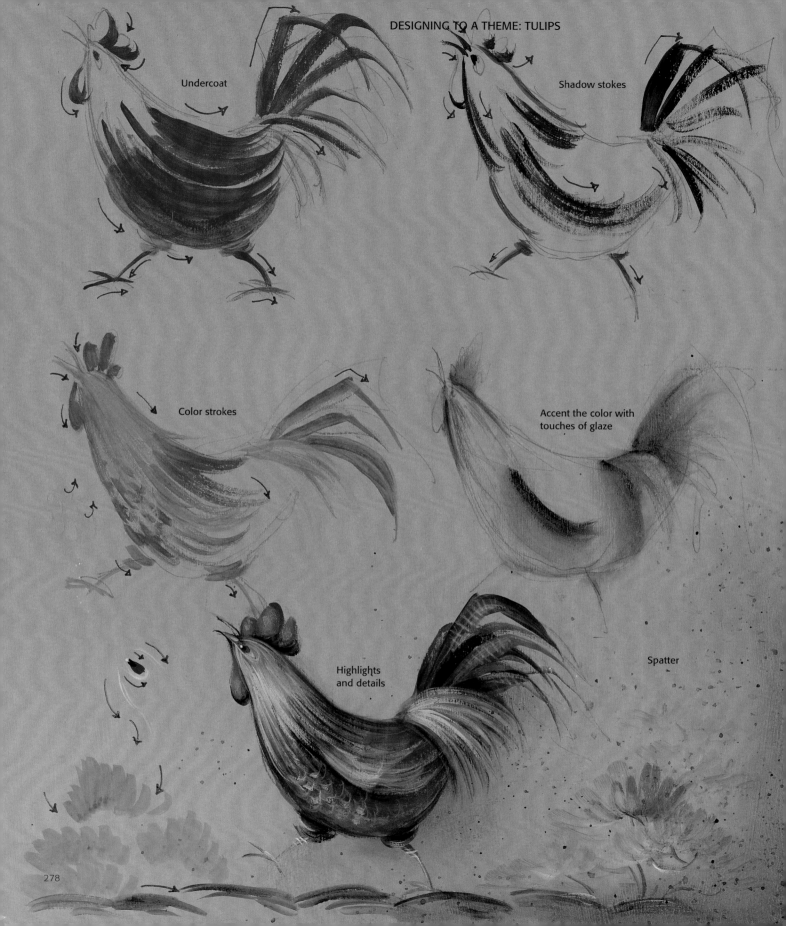

Undercoat

Shadow stokes

Color strokes

Accent the color with
touches of glaze

Highlights
and details

Spatter

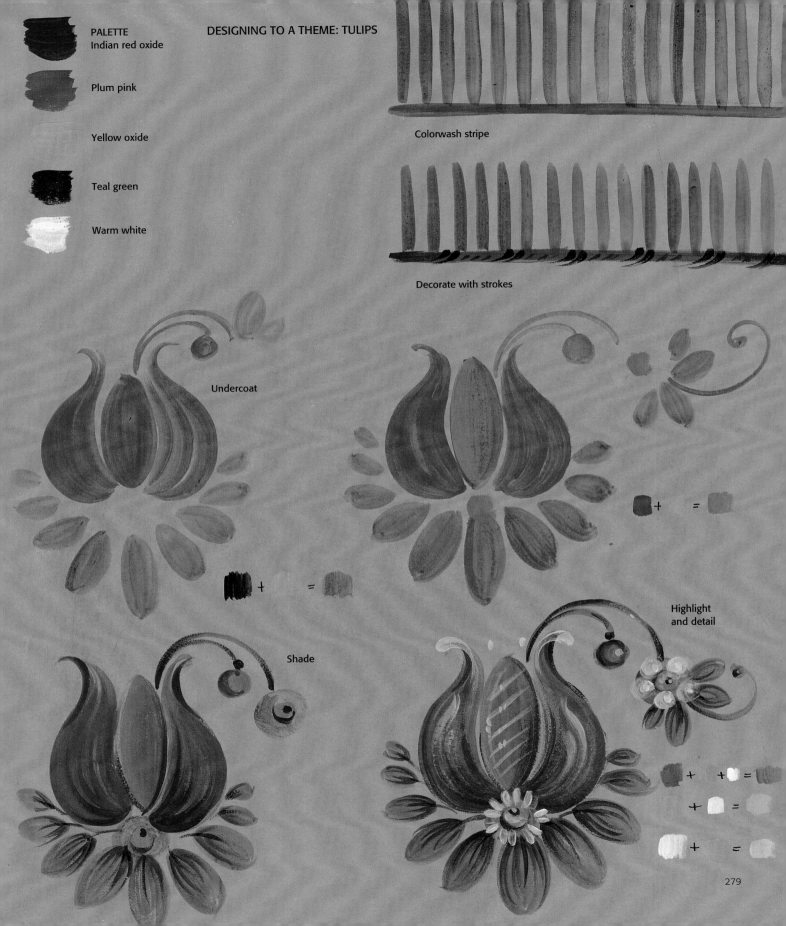

PALETTE
Indian red oxide

Plum pink

Yellow oxide

Teal green

Warm white

DESIGNING TO A THEME: TULIPS

Colorwash stripe

Decorate with strokes

Undercoat

Shade

Highlight
and detail

279

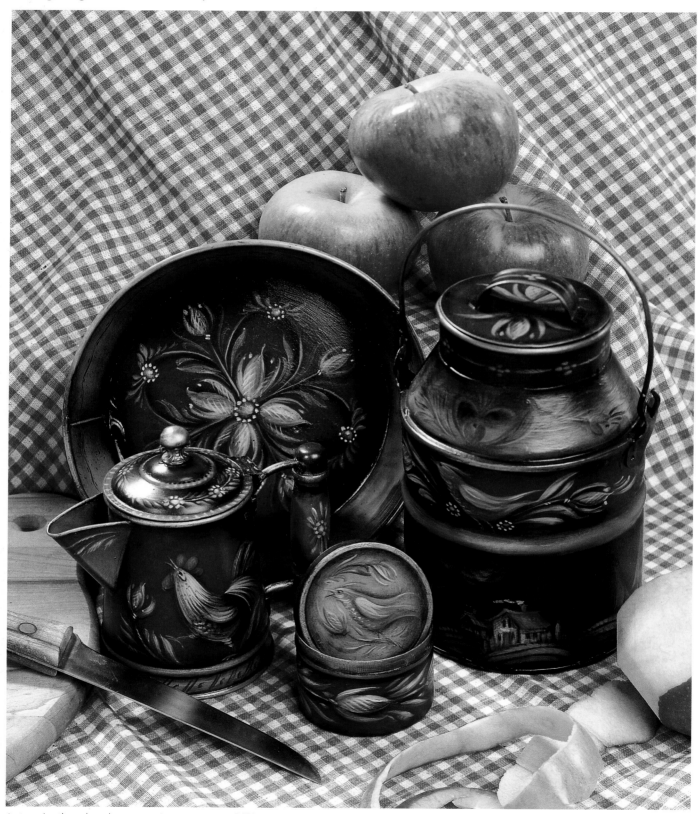

Just varying the color scheme can give you new possibilities. . . .

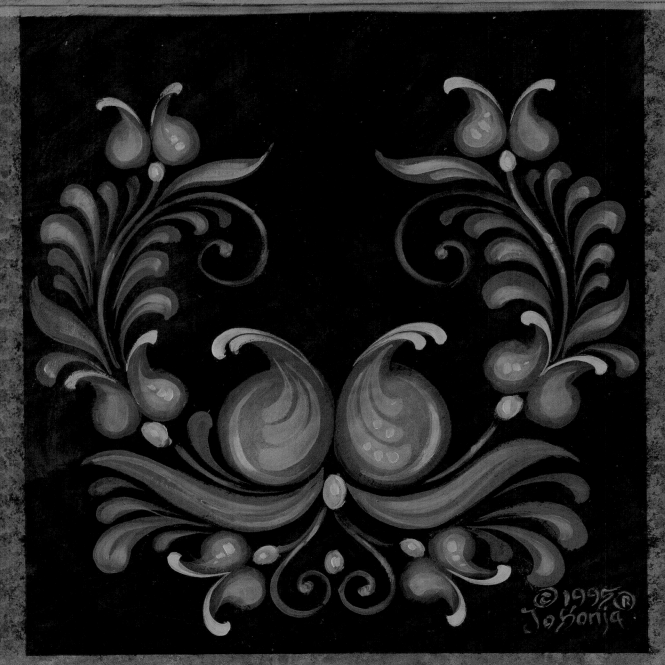

© 1997® JoSonja

. . . and the possibilities can go on and on.

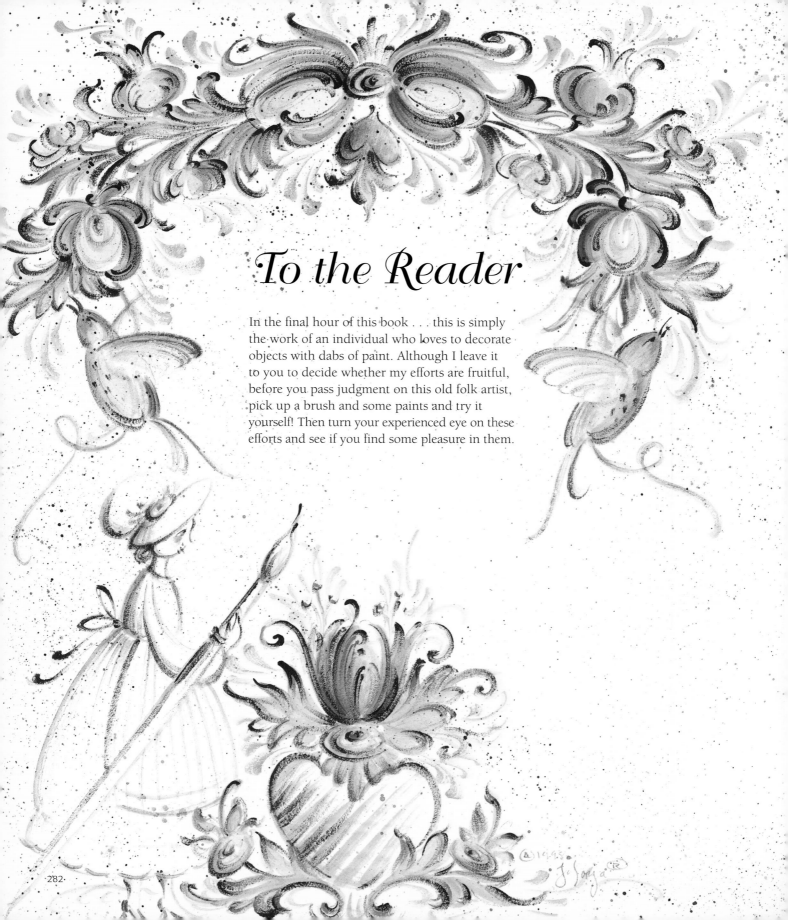

To the Reader

In the final hour of this book . . . this is simply the work of an individual who loves to decorate objects with dabs of paint. Although I leave it to you to decide whether my efforts are fruitful, before you pass judgment on this old folk artist, pick up a brush and some paints and try it yourself! Then turn your experienced eye on these efforts and see if you find some pleasure in them.

Suggested Reading

Ayres, James. *British Folk Art.* Woodstock, New York: The Overlook Press, 1977.

Bird, Michael S. *Ontario Fraktur.* M. F. Feheley Publisher Limited, 1977.

Bishop, Robert, and Coblentz, Patricia. *American Decorative Arts.* New York: Harry N. Abrams Publishers, 1982.

Boguslavskaya, I. *Zhostovo Painted Trays.* Moscow: Interbook, 1994.

Coffin, Margaret. *American Country Tinware.* New York: Galahad Books, 1968.

Cuisenier, Jean. *French Folk Art.* San Francisco: Kodansha International Ltd., 1977.

Dampierre, Florence. *The Best of Painted Furniture.* New York: Rizzoli International Publications Inc., 1987.

DeVoe, Shirley Spaulding. *English Papier-Mâché of the Georgian and Victorian Periods.* London: Barrie and Jenkins, 1971.

Ellingsgaard, Nils. *Norwegian Rose Painting.* Oslo: Det Norske Samlaget, 1988.

Fales, Dean A. *American Painted Furniture.* New York: E. P. Dutton, 1979.

Fel (editor), Hoffer, Tamas, and Csillery. *Hungarian Peasant Art.* Budapest: Corvina Press, 1969.

Grotz, George. *The Furniture Doctor.* Garden City, New York: Doubleday and Company, Inc., 1962.

Guliayev, Vladimir. *The Fine Art of Russian Lacquered Miniatures.* Leningrad: Aurora Art Publishers, 1989.

Hansen, H. J. *European Folk Art.* New York: McGraw-Hill Book Company, 1968.

Hofer, Tamas, and Fel (editors). *Hungarian Folk Art.* New York: Oxford University Press, 1979.

Hornung, Clarence P. *Treasury of American Design.* New York: Harry Abrams, Inc., 1950.

Impey, Oliver. *Chinoiserie.* New York: Charles Scribner's Sons, 1977.

Itten, Joseph. *The Elements of Color.* New York: Van Nostrand Reinhold Company, 1970.

Krapivina, Irina. *Russian Hand-painted Trays.* Leningrad: Aurora Art Publishers, 1986.

Lewery, A. J. *Narrow Boat Painting.* London: David & Charles, 1979.

Lewery, Tony. *Flowers Afloat.* Devon, England: David & Charles, 1996.

Lichten, Frances. *Folk Art of Rural Pennsylvania.* New York: Charles Scribner's Sons, 1946.

Lipman, Jean. *American Folk Decoration.* New York: Dover Publications, Inc., 1951.

McCann, Michael. *Artist Beware.* New York: Watson-Guptill Publications, 1979.

Martin, Gina, and Tucker, Lois. *American Painted Tinware: A Guide to Its Identification.* Volume 1. New York: Historical Society of Early American Decoration, Inc., 1998.

Mavrina, T. *Gorodets Folk Painting.* Leningrad: Aurora Art Publishers, n.d.

Mayer, Ralph. *The Artist's Handbook of Materials and Techniques.* Third Edition. New York: The Viking Press, 1978.

Nelson, Marian (editor). *Norwegian Folk Art: The Migration of a Tradition.* New York: Abbeville Press, 1995.

Plath, Iona. *The Decorative Arts of Sweden.* New York: Charles Scribner's Sons, 1948.

Ritz, Gislind M. *The Art of Painted Furniture.* New York: Van Nostrand Reinhold Company, 1971.

Schlee, Ernst. *German Folk Art.* New York: Kodansha International Ltd., 1980.

Stephenson, Jonathan. *The Materials and Techniques of Painting.* New York: Watson-Guptill Publications, 1989.

Swank, Scott. *Arts of the Pennsylvania Germans.* New York: W. W. Norton & Company, 1983. Published for The Henry Francis du Pont Winterthur Museum.

Weiser, Frederick, and Heany, Howell J. *The Pennsylvania German Fraktur of the Free Library of Pennsylvania.* 2 volumes. Breinigsville, Pennsylvania: The Pennsylvania German Society, 1976.

Source Directory

ACRYLIC PAINTS AND MEDIUMS

Chroma, Inc.
205 Bucky Drive
Lititz, Pennsylvania 17543
(800) 257-8278
Fax (717) 626-9292
*Manufacturer of Jo Sonja's® Artists'
Acrylics and mediums*

ASSOCIATIONS

Historical Society of Early
American Decoration, Inc.
c/o Beverly McCarthy,
　Administrative Assistant
61 West 62nd Street - 3rd floor
New York, New York 10023-7015
*A group of artists and associates that
promotes research, records examples,
maintains exhibits, and carries on
the work of founder Esther Stevens
Brazier in the preservation of early
American decoration*

Society of Decorative Painters
393 North McLean Boulevard
Wichita, Kansas 67203-5968
(316) 269-9300
FAX (316) 269-3535
email: sdppubs@southwind.net
www.decorativepainters.com
*A registry for and source of
interchange among artists,
manufacturers, retailers, and
associated members*

DECORATIVE ARTS MUSEUMS AND COLLECTIONS

The Abby Aldrich Rockefeller
Folk Art Center
307 South England Street
Williamsburg, Virginia 23187-1776
(800) HISTORY
FAX (804) 221-8915
http://www.history.org/

American Swedish Institute
2600 Park Avenue
Minneapolis, Minnesota 55407
(612) 871-4907
FAX (612) 871-8682
http://americanswedishinst.org/

Bayou Bend Collections and
Gardens
Museum of Fine Arts, Houston
1 Westcott Street
Houston, Texas
(713) 639-7750
http://mfah.org/bayou.html/

The Canal Museum
Stoke Bruerne, Towcester
Northamptonshire NN1Z 7SE
England
44 (0604) 862229

The Henry Francis du Pont
Winterthur Museum
Route 52
Winterthur, Delaware 19735
(800) 448-3883
FAX (302) 888-4880
http://www.winterthur.org/

Historic Deerfield, Inc.
P.O. Box 321
Deerfield, Massachusetts 01342
(413) 774-5581
FAX (413) 773-7415
http://www.historic-deerfield.org/

Museum of American Folk Art
2 Lincoln Square
New York, New York 10023-6214
(212) 977-7298
FAX (212) 977-8134
http://www.musee-online.org/

Museum of International Folk Art
Museum of New Mexico
706 Camino Lejo
Santa Fe, New Mexico 87504-2087
(505) 827-6350
FAX (505) 827-6349
http://www.state.nm.us/moifa/

New York State Historical
Association
Fenimore House
Lake Road
Cooperstown, New York 13326
(607) 547-2533
FAX (607) 547-5384
http://www.cooperstown.net/

Old Sturbridge Village
1 Old Sturbridge Village
Sturbridge, Massachusetts 01566
(508) 347-3362
FAX (508) 347-5375
http://www.osv.org/

Philadelphia Museum of Art
26th Street and Benjamin
　Franklin Parkway
Philadelphia, Pennsylvania 19130
(215) 763-8100
FAX (215) 236-4465
http://www.philamuseum.org/

Shelburne Museum, Inc.
U.S. Route 17
Shelburne, Vermont 05482
(802) 985-3346
FAX (802) 985-3346

Vesterheim Norwegian-American
Museum
502 West Water Street
Decorah, Iowa 52101
(319) 382-9681

Index

Painted by me

1998

JS

From me to thee. If this is not rightly
written, then the art remained in the pen.

(anon. ～ from an old fraktur)